The Lumière Galaxy

SEVEN KEY WORDS
FOR THE CINEMA TO COME

Francesco Casetti

Columbia University Press
New York

Columbia University Press
Publishers Since 1893
New York Chichester, West Sussex
cup.columbia.edu
Copyright © 2015 Columbia University Press
All rights reserved

Library of Congress Cataloging-in-Publication Data

Casetti, Francesco.
The Lumière galaxy : seven key words for the cinema to come / Francesco Casetti.
 pages cm. — (Film and culture)
Includes bibliographical references and index.
ISBN 978-0-231-17242-4 (cloth : alk. paper) — ISBN 978-0-231-17243-1
(pbk. : alk. paper) — ISBN 978-0-231-53887-9 (ebook)
1. Motion pictures. 2. Digital media–Influence. I. Title.

PN1994.C34223 2015
384'.8–dc23

2014030122

∞

Columbia University Press books are printed on permanent
and durable acid-free paper.
This book is printed on paper with recycled content.
Printed in the United States of America
c 10 9 8 7 6 5 4 3 2 1
p 10 9 8 7 6 5 4 3 2

COVER DESIGN: Martin N. Hinze
COVER PHOTOS: (*left*) Portrait d'Auguste Lumière, ca. 1890 (Collection Institut
Lumière, Lyon); (*right*) portrait de Louis Lumière, ca. 1890
(Collection Institut Lumière, Lyon)

References to websites (URLs) were accurate at the time of writing.
Neither the author nor Columbia University Press is responsible for URLs
that may have expired or changed since the manuscript was prepared.

The Lumière Galaxy

FILM AND CULTURE
John Belton, Editor

Film and Culture
A series of Columbia University Press

Edited by John Belton
For the list of titles in this series, see page 295.

Contents

ACKNOWLEDGMENTS *vii*

Introduction *1*

1. Relocation *17*

2. Relics/Icons *43*

3. Assemblage *67*

4. Expansion *99*

5. Hypertopia *129*

6. Display *155*

7. Performance *179*

8. The Persistence of Cinema in a Post-Cinematic Age *203*

NOTES *217*
BIBLIOGRAPHY *265*
INDEX *281*

Acknowledgments

During the many years I have been working on this book, my intellectual debts have increased. I am particularly grateful to Vinzenz Hediger, who wanted me to appear as the keynote speaker at the Vienna Conference of the NECS (European Network for Cinema and Media Studies) in 2007, where I discussed some of the ideas developed in this book; to Annette Kuhn, who invited me to the *Screen* Conference in Glasgow in 2009, where I presented the first draft of chapter 7; to Catherine Fowler and Paola Voci, who supported my Evans Fellowship at Otago University in 2011, during which I worked on chapters 1 and 2, being rewarded also by their extraordinary sense of friendship; to Bernhard Siegert and Lorenz Engell, to whom I owe one of the most productive periods in my recent life, my fellowship at IKKM-Weimar in summer 2012 (and to the other fellows of the year: among them Volker Pantemburg, John Caldwell, Weilhong Bao, Thomas Elsaesser, Thomas Levin, and Sigrid Weigel); to Meta Mazaj, who asked me to deliver the keynote address for the conference "The End of the Cinema and the Future of Cinema Studies," held at the University of Pennsylvania in April 2012, where I presented chapter 4; to Laura Mulvey and Mark Lewis, who invited me to open the series "The City and Its Moving Images," where I lectured on *hypertopia*. Thanks also to Phil Rosen, Michele Cometa, Pina De Luca, Ioanna Angelidou, Winfried Pauleit, Margrit Tröhler, Laurent Creton, Roger Odin, Roberto

De Gaetano, and Guglielmo Pescatore, who gave me the opportunity to speak in front of an audience about my work in progress.

Antonio Somaini and Peppino Ortoleva are accomplices, and their support and advice have been priceless. Sara Sampietro helped me between 2006 and 2009 to do some field work on the new forms of spectatorship that turned out to be very instructive. For years, I have always discussed my research with my colleague Maria Grazia Fanchi; many pages of this book resonate our conversations. As usual, my thanks to Silvio Alovisio and Luca Mazzei for helping me in my archival research on Italian early film theory. My gratitude also to Raymond Bellour and Pietro Montani for useful conversations at different stages of the work. The manuscript or parts of it have been read by Malte Hagener, Paul North, Giacomo Manzoli, Franco Marineo, Ruggero Eugeni, Federica Villa, Francesco Pitassio, Mauro Carbone, Ji-hoo Kim, and Andrea Pinotti—my gratitude for their generosity and insight. Special thanks to Jimena Canales: The book found its final structure after a long discussion with her.

My colleagues at Yale deserve special thanks: I have learned a lot from passionate discussions with Carol Jacobs, Charles Musser, Brigitte Peucker, Katie Trumpener, Katie Clark, J. D. Connor, Aaron Gerow, Ron Gregg, Laura Wexler, and John Mackay. Part of the book was discussed at the Humanities Intramural Seminar, organized by Martin Hägglund: my thanks go to him and to Howard Bloch, Gary Tomlinson, Rudiger Campe, Ruth Yeazael, Tony Kronman, Bryan Garsten, Steven Smith, Tina Liu, and Josh Billing. David Joselit, with whom I have co-taught two courses, gave me the precious opportunity to share many ideas. Thanks to Emily Greenwood and Tamar Gendler for a fruitful intellectual engagement in the Mellon Initiative. Many of the ideas developed in this book have been debated in my seminars: a special recognition to my graduate students—particularly to Mal Ahern, Luca Peretti, and Andrej Tolstoy, who asked me to address the closing remarks at the Graduate Conference "Expanding Cinema." Dudley Andrew is my "American brother" more than my "American friend": all my gratitude for his closeness, his generosity, and the extraordinary gift of dedicating to me his *What Cinema Is!* His suspicious attitude toward so-called postcinema has been a constant caveat in the face of my excess of enthusiasm; I have been impelled to dive deeper into my topic. This book is in dialogue with his.

Preparatory papers have been published in the journals *Screen*, *Fata Morgana*, *Screening the Past*, *Necsus*, and *Link*: even when the same title, they have been deeply rewritten for the book. Chapter 6 has been published with another title and in a different form as the opening text in *Public Spaces, Media Screens*, edited by Chris Berry, Janet Harbord, and Rachel Moore. I want to thank the editors and publishers for letting me use this previously published material. Daniel Leisawitz has provided the translation of the pages previously written in Italian, and he also helped me to improve the parts directly written in English. I am greatly indebted to his efforts and his patience: The book owes much to him. For the final revision of the manuscript, I worked side by side with Michael Cramer: He helped me to find the best way of expressing my ideas, displaying extraordinary competence, great insight into my work, and a marvellous sense of elegance—something needed for a book that is not written in my mother tongue.

Special thanks to Jennifer Crewe, director at Columbia: this is the second book that I have had the pleasure to publish with her. I would also like to acknowledge the hard work put in by the production team: Roy Thomas, production editor, Chris Curioli, copyeditor, and Ben Kolstad, who coordinated the production of this book.

The impulse to write this book arose from different episodes. When my previous book, *Eye of the Century*, was published, many friends and some of my reviewers asked me to write something on what at the time I called "cinema 2.0." *The Lumière Galaxy* is an answer to their request. During my first steps in this project, another suggestion came from an anonymous bus driver: I was refusing to get out from the shuttle to Newark Airport, claiming that the film that was screened onboard had not yet run to its end—and the driver answered that, being complimentary, due to a traffic jam, the movie was not properly a movie. I found it an interesting riddle. But what really moved me onward was a discussion with my wife, Ornella, with whom I watch movies in film theaters and on the large television screen in our living room. During screenings at home, she wants me to stay silent; once I reacted claiming that we were at home, where conversations are usual, and she replied that as a matter of fact we were watching a movie. This book is an attempt to understand why we were watching a movie and why we had to behave consequently, even if at home. The book, of course, is dedicated to Ornella.

The Lumière Galaxy

Introduction

CINEMA'S DEATH, SURVIVAL, AND (MAYBE) REINCARNATION

During the 1982 Cannes Film Festival, Wim Wenders asked several directors to enter the Hotel Martinez's room 666, sit in front of a movie camera, beside a television monitor, and respond to a series of written questions placed on a table. The questions revolved around one central problem: In the face of the growing weight of other media such as television and confronted with the transformations related to the progressive introduction of electronic technologies, "is cinema a language about to get lost, an art about to die?" The responses varied in tone: Jean-Luc Godard, while casting continual glances toward the tennis match unfolding on the small screen next to him, declared "We must leave, I am going to die." Monte Hellman, after explaining that he records films to watch at home—but never does so—simply thought "there are good times and bad times" for cinema, as for other things. Noel Simsolo replied that "It is not cinema that is dying, but rather the people who make it." Werner Herzog, after observing that to respond to such a demanding question, one needs to at least take off one's shoes, declared barefoot that the cinema would survive because "where life touches us most directly that's where you will find cinema." Steven Spielberg predicted that in the

coming years, cinema would expand its boundaries, and Michelangelo Antonioni declared "it will not be difficult to transform ourselves into new men, adapted to new technologies."

Watching *Chambre 666*, the film that collects all of these responses, more than thirty years later produces an odd effect[1]: The transformation that cinema has undergone since 1982 has been much more radical than could have ever been imagined. The advent of digital technologies, which transformed the character of image and sound, and the processes of convergence, which led different media to integrate, have resulted in entirely unforeseen scenarios. The cinema is no longer only a strip of film to be passed through a projector aimed at a screen inside a public space; it is also a DVD that I play at home to relax, or a video I follow in a museum or in a gallery, or content that I download from the Internet onto my computer or my tablet. Similarly, the newspaper is no longer only a sheaf of printed paper pages; it is also a series of windows I open on my tablet. And the radio is no longer an apparatus for tuning in to various broadcast stations; it is also an aural flow that I can access on my telephone. Media have ceased to be identified with a particular device or with a single support and now utilize new technologies, change their size, and redefine their functions. Products and services have been interchanged, and they now overlap within "digital platforms," which allow us to read, write, listen, see, receive, archive, and send.

This loss of traditional characteristics has led many scholars to speak of the end of individual media, and this is true above all for cinema, as the progressive abandonment of photographic film and the darkened theater has given rise to discussions of its death. *Chambre 666* is one of the first sources in which we see this preoccupation appear. In the mid-1990s, Susan Sontag sounded the alarm once again, arguing that the proliferation of screen condemns cinema to an inevitable and progressive decline.[2] In the following decade, this notion became a veritable leitmotif. The conviction arose that the digital image lacked that direct contact with reality that represented one of the constitutive elements of the cinema.[3] It was observed that the new ways of watching film on television or in one's DVD player overturned the traditional parameters of film consumption.[4] Finally, the suspicion grew that the multiplication of images would bring about their loss, both because the new supports that held them were impermanent and, even more importantly, because

their abundance brought with it a sense of indifference.[5] The death of cinema seems to be a given fact. Peter Greenaway, with his usual eccentricity, even assigns a date to its death: "September 31, 1983," the day on which the remote control made its debut in our homes and obliged us to transform spectatorship into an interactive relationship.[6]

Yet the cinema has certainly not died. Movie theaters, for example, not only continue to exist, but also are increasing in number. In 2012, theater screens multiplied by 5 percent worldwide, due to the double-digit growth in the Asia Pacific market, raising the total number to just under 130,000. In the same year, box office grosses rose by 6 percent, reaching $34.7 billion with the help of increasing attendance in countries such as China, Brazil, and Russia.[7] Going to the cinema seems to be a firmly entrenched habit.

Furthermore, we continue to call "cinema" what we watch at home, in our home theater, or while traveling, on our tablet, thanks to our ability to rent DVDs or download films online.[8] The equipment and the support change, as does the viewing environment, but habit seems to persist even in these new situations.

Finally, we consider many of the images that surround us to be cinematic, even if they are not films in the traditional sense of the term. I am thinking of the so-called cinéma d'exposition, widespread in contemporary art and intended for projection in galleries and museums.[9] I am also thinking of the many other formats that we encounter online but also screened in public spaces such as in squares and malls, and that have been, hardly by chance, placed within the category of an "extended cinema."[10] There also exist the kinds of installations, videos, Web projections, video games, and laboratory experiments that Jeffrey Shaw and Peter Weibel hosted in 2003 in a great exhibition in Karlsruhe with the title "Future Cinema" (and with an even more suggestive subtitle: "The Cinematic Imaginary After Film").[11] And lastly I am thinking of the works based on a re-materialization or a re-instantiation of the cinematic apparatus—something already familiar in the avant-garde, which Pavle Levi names "cinema by other means."[12] Luc Vancheri has proposed that this complex of noncanonical productions simply be called "contemporary cinemas" (plural).[13] Cinema is a brand that is also applied to new products.

Cinema thus survives and in many senses is expanding. This survival, of course, is intertwined with a series of major changes. For example,

most theaters are now digital, meaning that they no longer project film, and many of these are equipped for 3-D, which means that they promote a different (although not truly new) mode of viewing.[14] Furthermore, many projection sites are adopting facilities that make them rather similar to theme parks[15] or to domestic environments.[16] Television sets, computers, and tablets mark the abandonment of reflective screens: The projector is no longer an essential component of the cinematic complex. Spectators not only watch movies on different devices, but often also watch a film moving from one device to another, for example from their television set to their smartphone, using a multiplicity of screens. Finally, many new products, although inspired by cinema, take on forms that shift our traditional notions about film: think for example of the short clips on YouTube or Vimeo (fictional vignettes, travel diaries, or short improvised sketches) or on the contrary of the large images of IMAX—modern versions of the panorama and diorama.[17] There is a *persistence* of cinema, but it faces deep transformations at every step of the way.

This is not, however, an unprecedented dialectic: Throughout its history, cinema has often met with changes that seemed to push it beyond its technological, linguistic, and institutional boundaries, and at the same time it has always sought to remain itself, also negotiating or appropriating novelties. Today, the tension between persistence and transformation seems to be reaching its high point and thus takes on a particularly meaningful—and even dramatic—character.

THE CINEMATIC EXPERIENCE

In this book, I aim to analyze this tension by placing the spectator's experience at its center. *Experience* is a complex term: It refers at once to a subject's direct confrontation with the world (experience as "immediate sentient observation": we speak of "experiencing something"), to the capacity to rethink and make sense of what we encounter (experience as "acquisition of an insight or a wisdom": we speak of "gaining experience"), and finally to the ability to manage a situation on the basis of the knowledge acquired in previous cases (experience as "mediating between abstract concepts and concrete particulars": we say "to have experience").[18] Experience is thus not only a matter of

perception but also implies a reflexivity and a number of individual or social practices. It is a perceiving, a consideration of what is perceived and of ourselves, and a way of dealing with the context—all three of these levels, without any possibility to reduce one to another. In this sense, it is a cognitive act, but one that is always rooted in, and affects, a body (it is "embodied"), a culture (it is "embedded"), and a situation (it is "grounded").

Using the idea of experience will allow me to distance myself from an approach that places the technology of cinema at its center. There is an academic tradition, of which authors such as Marshall McLuhan and Friedrich Kittler are often considered major exponents, holding that the "material base" of the medium not only determines the way we perceive what it shows to us—and the world for which it acts as mediator—but also directly defines the nature of the medium itself. Following this line of thought, cinema would be reduced to a support and a device. If this were the case, every change in the technological complex would result in a change in the medium's nature, and those who preach the death of cinema would be correct, against all evidence to the contrary. Granting a central position to experience, meanwhile, means overturning this perspective: What constitutes the defining core of a medium is the way that it activates our senses, our reflexivity, and our practices. The way it does so is undoubtedly influenced by the technical complex, but it has also crystallized over time into a cultural form that is recognizable as such and which can also find different instantiations. Such an orientation does not imply a return to "the philistine's concept of 'art' . . . stranger to all technical considerations"—to use Benjamin's words.[19] It simply suggests that we deal with a more complex framework, in which technology does not play a causal role, especially in an epoch like ours, in which it is increasingly light and available for different purposes. In this context, what identifies a medium is first and foremost a mode of seeing, feeling, reflecting, and reacting, no longer necessarily tied to a single "machine," not even to the one with which it has been traditionally associated. It is the case of cinema: born as a technical invention, it soon came to be identified as a particular way of relating with the world through moving images, as well as of relating with these images. As a consequence, cinema will live on for as long as its way of engaging us does, whatever the "device" that it takes as its support might be.

There is, however, another reason that the concept of experience will be particularly useful here. Many scholars have noted how the advent of the digital functions less as a point of rupture than as an element of potential continuity; John Belton, for example, has spoken of a "false revolution."[20] In particular, Stephen Prince has noted how the digital image allows for a "perceptual realism" strongly analogous to what characterized the photographic image. While it is true that the digital image no longer functions as a direct "trace" of the real, the process through which we understand what it shows us as real is the same as the one set into motion by the photographic image.[21] Berys Gault has developed a parallel argument: The difference between a digital camera and a film camera is the support on which information is registered, not the way in which reality is captured. Therefore, even a digital image can be considered a photographic one; it is not by chance that we react to it in the same way that we react to traditional photographic images.[22] David Bordwell has retraced the transition to the digital in an e-book. There is no doubt that "films have become files."[23] Nevertheless, the enduring presence of the film industry provides a sense of continuity: We look at the digital movies as if they were film movies. In a text dedicated to cinema's specificity, Noël Carrol had earlier dismantled the idea that cinema possesses physical elements or constituents capable of defining its intrinsic nature, showing instead its wide variety of uses and styles; we can thus add that cinema may have many faces, some of which may emerge in another medium.[24]

I am sympathetic to these "anti-essentialist" approaches, and here I will seek to enrich this line of thought. If we assume that the continuity of a medium is determined by its endurance, or at least the endurance of a certain type of experience, and if we take the term *experience* broadly, as outlined earlier, we can delineate other elements that function as bridges, providing continuity: In addition to the particular way of seeing images offered by cinema, and certain recurring subjects, an important role is played by environmental factors (the fact of being in front of a screen), cultural factors (the memory of what cinema was), linguistic factors (the presence of a "cinematic language," whatever that term is taken to mean), and broadly psychological ones (the need for cinema, to use an old term coined by Edgar Morin).[25] It is on the basis of a multiplicity of elements that we recognize our experiences as "cinematic" and thereby give cinema another chance to live.[26]

This does not mean, however, that the "cinematic" experience is not often contested. At a remove from the projector-film-theater complex, what we experience and the ways we experience it tend to change. Small screens instead of large, fluorescent instead of reflective, in open spaces instead of closed spaces, accompanied by imperfect sound, are regarded as a threat to the pleasure of viewing. Many of the new devices and new environments imply forms of attention that are no more solely centered on a screen. The availability of a movie everywhere and at any time diminishes the sense of an event traditionally tied with film-going. More radically, on my DVD player, film may become a text, the chapters of which I can read individually, as if it were a book; projected in a museum or art gallery, it may become an exhibited object, as if it were a painting or a sculpture; on my tablet, it may become a private diversion, as if it were a video game; on a media façade, it may increase its value as spectacle, to the point that it becomes an environmental decoration, and so on. Placed in new devices and new contexts, cinema risks losing itself. It is this sentiment that leads David Lynch, in a parody commercial for the iPhone, to declare, "Now, if you are playing the movie on a telephone, you will never in a trillion years experience the film."[27]

Even so, it is also the case that many of these transformations, more than creating a rupture with the past, seem to bring with them an expansion of cinema's horizons. They allow it to conserve some of its fundamental characteristics, albeit in a compromised manner, as in the case of the home theater, which responds to a desire to re-create the movie theater in my living room. They also open up new, unprecedented opportunities, like that of reaching a mobile spectator who can nonetheless isolate himself from his context and concentrate on what he is seeing. They let cinema test and adjust itself while exploring new territories. Last, but not least, they allow for the recuperation of certain characteristics that cinema once had, earlier on in its history, but has now partially lost, like the ability to invade nonspecialized public spaces, work with multiple different types of screens, and mix together with other forms of spectacle.[28] What results from these changes is not so much an abandonment of the experience of cinema as its rearticulation: It takes on new forms that paint a more complex and varied picture of the whole.[29]

Cinema is thus confronted with changes to itself. Sometimes it risks giving in to these and transforms its own nature; in other instances it

attempts to resist, in order to remain itself. Most often, however, it weaves together these changes with a tradition, memory, and set of habits, and incorporates them. As a consequence, it unfolds an identity based not on the simple repetition of the same but on the acceptance of variations and differences—an ipse-identity, instead of an idem-identity, as Paul Ricoeur would say.[30] More than reaffirming the usual features, what is highlighted is the presence of a field of possibilities, even apparently discordant ones, that give us back a reality in its multiple aspects and moreover in its becoming. A self is an opening to the other. It is such an identity that in the past allowed cinema to remain itself even when it adopted new guises. It is such an identity that today allows cinema, threatened by more radical modifications, to continue on its path.

SEVEN KEY WORDS

I will consider this interweaving of persistence, change, and rearticulation by following seven major processes that are taking place, attending not so much to their concrete details as to their theoretical implications. Each one of these processes will be dealt with in a single chapter of the book and will be organized around a key word that gives each chapter its title.

The first chapter of the book engages with cinema's *relocation* to other devices and to other contexts. As I have suggested, what migrates is not a technical complex but rather a form of experience, which reestablishes itself in a new context. If cinema can now be transferred into my living room, as well as into city squares, public transportation, the Internet, my television, and my smartphone, while remaining itself in some sense, this is due to two reasons that bring us back to the film theories of the first decades of the twentieth century. On the one hand, cinema has been a medium expansively characterized by the type of experience it created: From its inception, it was presented not simply as a specific kind of "machine," but as a particular way of seeing the world and making the world visible through images in movement. On the other hand, its gaze has often seemed to emerge in other situations as well: As many commentators have emphasized from its beginnings, we sometimes feel as if we are at the cinema even when far from the darkened theater. These two aspects have made cinema both well defined and capable of going

beyond its borders: If today it relocates itself on a massive scale, this is due to these long-established tendencies. For cinema to remain itself, however, is not a simple enterprise. In relocating, cinema continually risks losing itself. It remains for us to recognize its presence in situations that are in many cases ambiguous and which can be understood in different ways. For the most part, we end up identifying our experience as "cinematic" because, due to habit or the strength of memory, we find in it the reemergence of several typical and already well-established elements. But oftentimes we identify our experience as such also because we imagine, wager, or decide that it is. In this case, we cause an identity to spring forth not on the basis of the repetition of the same, but rather from cinema's capacity for taking on different guises—not as sameness, but as selfhood. Cinema then unfolds itself, regardless of the mask it wears.

The second chapter revolves around two words: *relic* and *icon*. With respect to the darkened movie theater, new situations reduce the original experience by half. In some cases—for instance, when I watch a film while traveling, likely on my tablet, which is intended to deliver content in any possible situation—I recover the object of the cinematic experience, but not its environment. In other cases—as when I watch a television series on my home theater, which is designed to provide high-quality vision and sound—I retrieve the modalities of the cinematic experience, but I recover its object only indirectly. The situation that follows is in some ways curious: We can watch films in an un-cinematographic manner (a DVD while traveling, for example), and cinematic vision can also apply to other products (a television program on a home theater, for instance). For more than a century, *cinema* has denoted both a particular product and a particular form of use; these two aspects now risk being split apart. However, even when separated, these two situations remain "authentic" in their own way. A film on DVD is nonetheless a fragment of the whole of cinematic production, even when broken away from it and placed elsewhere. In this sense, it is as if it were a *relic*. It is precisely because of the fact that this fragment was a part of (or could have been a part of) the holy body of cinema that it puts me in contact with the latter. My home theater, meanwhile, attempts to reincarnate the darkened movie theater, even while it is a copy of it. In this sense, it constitutes an *icon*, which is to say, a substitute that reactivates the presence of the model, even as it simultaneously draws attention to the model's absence. Here,

it is the similarity it shares with the original—more than contact at a distance—that allows cinema to live again. Relocated cinema is precisely a relic or an icon, and it is because it takes on these identities (I repeat: on the one hand the fragment and contact, on the other hand similarity and reincarnation) that cinema conserves its "authenticity," as it were.

The third chapter discusses the new forms taken on by the technological complex and foregrounds the notion of *assemblage*. The point of departure here is the observation that in situations that might be called "imperfect" in contrast with the viewing of a film in a theater, the spectator often responds by "repairing" whatever falls short. For example, in cases in which one is exposed to an external environment—as often happens when using portable devices—spectators construct an existential bubble in which to seek refuge, and in doing so they recapture a sense of intimacy in regard what they are watching. In the same way, in many instances of individual viewing, spectators construct for themselves an imagined audience as, for example, when chatting online after watching a film—or even during a film—with other spectators who have been having the same experience. Such behaviors inevitably lead us to reconsider the role of the cinematic machine. Do the conditions in which we find ourselves, or, more specifically, the devices that we use, determine the modality of our viewing and our status as spectators, or are they modifiable factors? In the 1970s and 1980s, much of film theory considered the dispositive in terms of an apparatus, that is to say as a closed and binding structure; the spectator was what the "machine" wanted him to be. There is, however, another line of thought (for example, in the work of Gilles Deleuze)[31] that considers the dispositive in terms of an *assemblage*, in other words as an alterable complex of components that includes the spectator. The concept of assemblage is useful insofar as it allows us to see how the cinematic "machine" is made up of multiple elements that recompose themselves in response to the circumstances, and thus how its usage has variable and adjustable aspects. This does not mean, however, that the spectator can do whatever he wants: He continues to respond to the dispositive but can in turn intervene in it. This dialectic, which is particularly visible today, does not represent an entirely new element of cinema. If we look back on cinema's history, we see that it has always been a much more adaptable machine than we have often been led to believe. The cinema has always been prepared to change its own structures and to exceed its

own boundaries; at the same time, it has always sought to remain faithful to itself. It continues to do so today, but by way of a global transformation.

The fourth chapter examines the ongoing *expansion* of cinema. The idea of "expanded cinema" enjoyed a certain success in the 1960s and 1970s; it may be useful to revisit it today to uncover a tendency that has been incubating for a long time. Today, cinema's expansion is developing in several precise directions. First, there is the imposition of a transmedial logic, which requires that content be conceived of for multiple media—beyond cinema, to television, theme parks, video games, and so forth. Then, there is an expansion of modes of production and reception, with an always-greater space for so-called grassroots practices. There is also a growing tendency to include within the boundaries of the film what were once accompanying texts, such as the trailer, working journal, or critical comments, which can now be found on a film's DVD or Web site. Finally, there is an opening to new types of images, no longer linked to the analogical reproduction of reality. Of course, the risk of expansion is that cinema will end up being reabsorbed into a larger category—that of "screened images"—to the point that it loses its own identity. However, cinema in expansion seems to retain its own terrain of choice. It reaches this goal through two paths. On one hand, cinema continues and intensifies its traditional vocation of offering images in "high definition": The recent success of 3-D signals its desire to immerse the spectator even deeper into the represented world. On the other hand, cinema increasingly recuperates "poor" images, such as those produced by webcams, smartphones, or on the Web, in order to constitute a kind of critique of the way in which other media present a world often transformed into pure simulacra. In this case, the "high definition" pertains less to the perceptual level than to the level of our consciousness. We thus have three cinemas: first, one that while expanding risks its dispersion, then one that enhances its appeal to the senses to include the spectator in the depicted world better, and finally one that lowers its level of sensory appeal as a critical stance. These three cinemas—cinemas of dispersion, of adhesion, and of awareness—are not always at ease in establishing mutual connections. Nevertheless, they shape a common ground that defines what remains specific to cinema in an era of media convergence.

The fifth chapter analyzes the space that is created both in front of and around a screen and introduces the notion of *hypertopia*. Cinema's

migration toward new environments implies many new elements. While the darkened theater appeared to be a space mainly oriented to the film viewing, and was recognizable as such,[32] today sites of viewing—domestic spaces like my living room, or urban spaces like public squares of the hall of a train station, or exposition spaces like galleries and museums—take on a more complex status. In these sites, cinema is no longer an exclusive presence, but rather is placed alongside other points of interest; it is not a permanent presence, but often closely tied to specific occasions; it is thus not something that we can rely on finding consistently in the same place, but rather something that seems to "take place" from time to time. These changes overturn the traditional dimensions of cinema. If the darkened movie theater implied that I would literally go to the cinema, in these new environments it is as if the cinema comes to me. Moreover, if, in the movie theater, cinema allowed us to travel to other worlds, in these new environments it makes these worlds available wherever I happen to be, placing them in my hand, so to speak. This is particularly true when I download a film from the Internet: here the word *access* no longer implies that I must pass over a threshold and enter into a particular place; rather, it indicates that something arrives before my eyes at my command. We now need to have everything "here," as opposed to being obliged to move "elsewhere." We can summarize this new situation by saying that we find ourselves not before heterotopias—that is, as Michel Foucault has explained,[33] spaces with points of passage toward different dimensions—but rather before hypertopias, points that attract and absorb other ones into themselves. The early cinema, with its ability to strike the spectator viscerally rather than absorbing him into the narration, already experimented with the hypertopia. Today, relocated cinema can move more freely in this direction.

The sixth chapter deals with the evolution of the screen. The new devices into which cinema relocates—from computer to smartphone, from tablet to media façade—change the very nature of the screen. It is no longer the surface on which reality is represented with renewed strength and clarity (including the reality of dreams). In other words, the screen is no longer the site of *epiphany*, to take up a term used by the early film theorists. New devices have a screen that functions rather like a *display*, which is to say that it has become a place on which free-floating images stop for a moment, make themselves available to users, allow themselves

to be manipulated, and then take off again along new routes. Moving to these new devices, cinema too has ended up following the logic of the display: Its images appear more precarious, less limited by narration, and open to different meanings. The increasing success of films using images that come or purport to come from some preexisting archive symptomizes how filmic images too now seem to be part of a tornado of images that occasionally subsides and leaves a few behind. However, the point at which images "land" is never arrived at by chance. An image may make itself available to a crowd or to an individual, in a public space or in private, close in time to the events it represents or distant from them: In each of these cases, an image acquires different valences, both experiential and political. For a long time, cinema has been acting as a perfect public sphere and in this way has displayed the relevance of sharing images and sounds. Now, in a regime of intense and endless circulation, it is valuable to be reminded that images and sounds must be shared, even in the context of increasingly precarious audiences and situations.

The seventh chapter focuses on spectators, and their profile is changing as well. They no longer engage with a single film, but rather with an array of diverse discourses; they no longer attempt intense concentration, but rather assume a multifocused attention; they no longer immerse themselves in the story being told, but rather navigate its surface; they no longer reside in a closed space that circumscribes an audience, but rather inhabit a more open space that functions as the hub of an ideal network; and they do not confront an "other" world capable of speaking about the "real" world, but rather a "possible" world that can find its "realization" anywhere. As a result of these changes, the scopic regime has undergone a profound transformation. While traditional spectatorship was characterized as "attending" a spectacle, contemporary spectatorship is presented as a true "making": Spectators spring into action, constructing for themselves, with their own hands, the object and the mode of their seeing. To watch a movie has become a *performance*. This does not stop spectators from arriving at an experience as intense as in the past: Part of their action is aimed to create a vision close to the traditional one. It is not by chance that cinema is still tied to the dark theatre: It tends to go back to its motherland, even while retaining some of its new modalities to be approached. This return to the film theatre is the other side of the process of relocation.

The seven chapters lead to a conclusion. The cinema is moving to new places and to new devices, and in doing so, it seeks to remain itself. This migration, though, hides a small paradox. Many situations we meet are puzzling, and to recognize them as "cinematic" is not easy at all. If we do indeed recognize them, it is because we recall an "idea of cinema" and we apply it to what we find before us. In doing so, we often "force" the situation: We believe in a certain continuity, and we try to find it at any cost, hoping that cinema's relocation will be just another step in its history. In the name of continuity, however, we often readjust also our "idea of cinema." We want the medium to continue its journey—we want it to survive—and in order to guarantee its survival, we are also disposed to changing the model we refer to, in order to adapt it to what we encounter. In this way, we literally rewrite cinema's history. Sometimes we make room for lost pages; sometimes we simply reimagine the past, so that it may also include the present. Cinema remains with us: Its survival represents a real and genuine rebirth, which returns it to what it was or could have been. But its survival is also marked with the sense of death, if only as a reflection of the fear that it could indeed disappear.

QUESTIONS OF METHOD

As I have noted, each chapter of this book seeks to bring into relief a key word. The seven key words—relocation, relic/icon, assemblage, expansion, hypertopia, display, and performance—stand in opposition to many of the concepts with which the current situation is usually analyzed. These would be ideas such as canon, specificity, and apparatus, but also remediation and convergence. These are doubtless useful concepts, but they risk missing the contradictions that media now navigate. The seven key words, on the contrary, sketch out a framework of thought that can help us to grasp better the dialectic between permanence and change in the media landscape. They tease out what it is that cinema is trying to remain and what it is inevitably obligated to become. They thus allow us to see how permanence is often born of change and how change often pays tribute to the tradition. They help us to make our gaze flexible, as it must be in this case.

In this framework, the method of investigation needs to be purposefully heterogeneous. In examining the present, I will make abundant references

to the past, in particular, to the film theories of the first three decades of the twentieth century, which I read not as well-substantiated explanations, but—as they were—as practical attempts to define cinema's identity and to spread it through the public sphere;[34] and to the media theories and film experimentation of the 1960s and 1970s, which I consider to be the moment at which cinema began the transformation that is now coming to completion. Historical references will help me both to underline the novelty of many phenomena that are now unfolding and to uncover the roots of these new phenomena. Today, cinema faces many questions that it has already met along its way. To see how they resurface is enlightening.

In any case, I will also keep in mind that the past is often a construct that emerges from current needs. It is a source, but also a myth that is shaped retrospectively. Cinema continually rewrites its genealogy under the pressure of the situations that it is coping with. This will be true also for this book, which is keen to connect the possible end of cinema with its beginnings.

Similarly, I will read the present not as the development of a coherent and inevitable design, but as an open contest between different forces and exigencies. More than one single thing, cinema has always been a field of possibilities. That is true also at the present. Before the cinema lies not a single destiny, but many open trajectories. If it wants to survive, it should not necessarily adopt an obtuse fidelity to itself projected into the future; rather, it must call its history into question, even at the risk of losing it.

In observing the present, I will select my examples based on the questions that I will grapple with; however, I will do so in such a way that these same examples reformulate the questions under discussion. Hence, I have a preference for symptomatic details, controversial elements, junctions, and provocations. I will examine everyday life (keeping in mind the most prosaic ways in which media work) as well as specialized ambits (those of artistic and linguistic experimentation) and that great virtual world that is the Internet. My fields of observation will be living rooms, town squares, public transportation, art galleries, YouTube, Facebook, and other Web sites, as well as films themselves, particularly those that interrogate the cinema.

Although this book wants to be rich in references and seeks to reconstruct several precise genealogies, it does not offer a systematic history. Its objective, I repeat, is to sketch a theoretical framework that will allow us to consider the cinema of today in its expansion beyond its usual

confines, as well as its faithfulness to itself. The cinema is moving onto a terrain that is not its own, but wishes to maintain its own identity, even if this is based on difference. This book seeks to understand what words may be used to speak of this phenomenon.

THE LUMIÈRE GALAXY

Finally, I'd like to offer some words of explanation about this book's title. It purposefully echoes the title of Marshall McLuhan's famous volume, *The Gutenberg Galaxy*. This reference foregrounds an analogy: After the invention of movable type, the invention of cinema constitutes a further revolution in the field of writing. However, this evocation also points to a deep difference: If McLuhan was persuaded that media shape our experience, this book advances the notion that some consolidated forms of experience, such as that of cinema, can today be reenacted in different contexts, which are compelled to "adapt" themselves to the experience.

Beyond the evocation of McLuhan, I was interested in retrieving the idea of "galaxy." It synthesizes perfectly the image of an experience no longer localized in a single point, ready to assume different forms, at the crossroads with other kinds of experience, and yet still characterized by its own identity. Along the full arc of the twentieth century, cinema has been a brilliant and immediately recognizable star shining over our heads. This is no longer the case. A cosmic deflagration has taken place, and that star has exploded into a thousand suns, which in turn have attracted new celestial material and formed new systems: These new suns govern new planets. The stuff cinema is made of is still present in these heavenly spheres, but what we now face is a configuration of a vast and differentiated array of celestial bodies. There are fountains of light at the center of the spiral and at the borders of universe: some ultraviolet, others now almost fully spent. There are new constellations and new orbits. And there is a resplendent Milky Way that occupies our entire sky and which is not only visible on dark nights.

For us, residents of a new century—indeed, of a new millennium—cinema is exactly this: the Lumière Galaxy.

1. Relocation

TACITA

In October 2011, the British artist Tacita Dean presented *Film* at the Turbine Hall of the Tate Modern in London.[1] Dean's work is a film short, projected in a continuous loop onto a large screen in a dark space furnished with a bench for visitors. The written explanation at the entrance to the room draws attention to the presence of all these elements: "35mm colour and black & white portrait format anamorphic film with hand tinted sequences, mute, continuous loop, 11 minutes. Large front projection; projection booth; free standing screen; loop system; seating." In her article in the *Guardian*, Charlotte Higgins described *Film* as "pay[ing] homage to a dying medium,"[2] and *Film* is undoubtedly an act in defense of film stock—the same film stock that Kodak had announced, on June 22, 2009, it would cease to sell after 74 years of production because of a steep decline in sales. Beyond the preservation of a medium-support, *Film* also seems to invoke the preservation of a medium-device: in the Tate we find a projector, a reflective screen, a dark room, a bench—all things that the new forms of image consumption, on laptops or tablets, seem to renounce. In essence, Tacita Dean attempts to restore to us all the principal elements of the cinema, those that characterize its material basis. Paradoxically, she sets them before us as components of an artistic

installation: She gathers them together and reunites them for the purposes of a work intended for a gallery or museum. It is no accident then that the visitors to the Turbine Hall do not hold the same expectations or display the same behavior as they would if they found themselves at the British Film Institute Southbank (which, by the way, is located not far from the Tate) to see a Woody Allen retrospective in one of its small theaters or even to see *Mission: Impossible—Ghost Protocol* in its IMAX theater. This audience did not go to Turbine Hall to experience what is usually called *cinema*, that is to say, a set of images and sounds that provide a particular representation of the world and a particular relationship with a spectator. It went there for *art*. Immediately a question arises: Did Tacita Dean, in her attempt to preserve cinema, focus exclusively on its material elements while leaving aside or dispensing altogether with the social practices that it involves?

In an opposite movement, if we exit the Tate—or the British Film Institute, too easily identifiable as a "temple" in which canonical works are worshipped—we find many cases in which cinema, understood as a form of representation and spectatorship, not only continues to live but also expands beyond its traditional support and device. For example, at almost the same time as Tacita Dean's exhibit was being inaugurated, a group of Londoners reappropriated a space alongside a canal, under a highway overpass, and transformed it into a kind of outdoor movie theater where films were projected for the neighborhood residents.[3] In August of the same year, the gardens in front of Paris's Trocadero (the old site of the Cinémathèque) hosted the Moon Light Festival with open-air screenings.[4] Some months prior to this, Cairo's Tahir Square, a space that had already been active during the Arab Spring, was reanimated with a projector and a large screen on which videos of various kinds were shown.[5]

Indeed, the diffuse presence of cinema goes well beyond these examples. In 2011, it was still possible to rent a DVD in a Blockbuster shop, and already at a Redbox kiosk; spectators were able to choose a title from the catalogs of Netflix or Hulu and receive it in a streaming format on their television set or on their computers; a good number of films and clips were also available on YouTube. Similarly, movies were screened on airplanes, as well as in cafés and bars, although often mingled with sports and news. The film industry itself supported these new forms of

distribution,[6] moving a film from one channel of distribution to another with increasing velocity.[7] There was also an enormous profusion of images and sounds that used a cinematographic language other than that of the feature-film format: We found cinema in television series, documentaries, advertisements, musical clips, and didactic presentations. We encountered it, in disguise, in waiting rooms, stores, public squares, along streets, and on urban media façades. Finally, we found on the Internet a vast array of objects that still had something to do with cinema, from trailers to parodies, video diaries to travelogues. Today, this trend continues, but the picture has grown even larger. The enormous diffusion of screens in our daily life—including those of the latest generation, which are well integrated into domestic and urban environments, interactive and multifunctional, in the form of windows or tabletops[8]—brings with it a greater presence of cinema. This diffusion give movies new trajectories along which to circulate, new formats, new environments in which to be enjoyed. It allows cinema to continue to live—and not only to survive—as it adapts to a new landscape.

Therefore, we find ourselves before a minor paradox: on the one hand, we have an artist defending a traditional technology, even to the detriment of a mode of consumption; on the other hand, there is an evident tendency among industry, consumers, and fans to promote the permanence of a mode of consumption even while renouncing a technology. It is precisely this paradox that allows us to begin to think about the state of cinema today beyond the facile proclamations that announce its death or celebrate its triumphs. What is happening to cinema in an age in which it is losing essential components and gaining unprecedented opportunities? What is it becoming at a moment in which all media, due to the processes of convergence, seem to be spilling out beyond their usual routes and embarking along new paths? What is cinema, and moreover, where is it?[9]

I will begin to respond to these questions by analyzing four points in order to map out the terrain. First of all, a medium is not only a support or a device. A medium is also a cultural form: It is defined most of all by the way in which it puts us in relation with the world and with others, and therefore by the type of experience that it activates. By *experience*, I mean a confrontation with reality (to experience something), the re-elaboration of this reality into knowledge (to gain experience), and the

capacity to manage this and similar relations with reality (to have experience).[10] From its very beginnings, cinema has been based on the fact that it offers us moving images through which we may reconfigure both the reality around us and our own position within it. Cinema has always been a way of seeing and a way of living—a form of sensibility and a form of understanding, as a brief overview of the film theories of the early decades of the twentieth century will clearly demonstrate.

Second, the two faces of the medium, its status as a support or device on one hand, and its status as a cultural form on the other, are usually closely linked together: We experience reality in the ways that a technology allows us to. These two faces, however, are also distinct from one another, and it is therefore useful to use two different names for them: it is not by chance that Benjamin speaks of the *Apparat* and of the *Medium* of perception[11]; Rosalind Krauss of mediums and media[12]; W. J. T. Mitchell and Mark B. N. Hansen of technological forms and forms of mediation.[13] One is the material basis of a medium, while the other is the way in which this material basis organizes our experiences. The distinction is becoming particularly important today, at a moment in which the type of experience that characterizes a medium seems able to be reactivated even without the full presence of its traditional material basis. Indeed, we have just seen an example of this: The cinematic experience can arise even outside of the traditional darkened theater, thanks to other devices, and though it is certainly not the same, it still retains many of its characteristic traits. Once again in this case, an overview of the film theory of the 1920s and subsequent years will illuminate how cinema was long ago conceived of as a medium that could also emerge in other situations.

Third, what allows an experience to relocate itself in new physical and media environments? A new context brings transformations along with it. Even so, an experience—for example, the experience of cinema—remains in some way the same when the new situation in which we find ourselves conserves, if not the traditional individual elements, at least a "cinematic" profile or shape. In such cases, we "recognize" the presence of cinema even when it is no longer as it was, or where it was, before.

Fourth, to recognize a medium, and cinema above all, in a new environment that is not its own is a complex operation. In a sense, this recognition takes us backwards: If our recognition is based on memory and habit, we look for something that corresponds to a canonical model. But recognition

can also take on a progressive aspect: Before a situation that is necessarily imperfect, we literally imagine what cinema could be, and thus open ourselves to new possibilities. It is also in this sense, in suspension between past and future, between having being and potentially being, that cinema, relocating itself, can survive.

BACK TO THE EXPERIENCE

The cinema, from the moment of its birth, has been considered a particular form of experience. Obviously, it also involves a technical device; after all, it was born from a set of patents, and the earliest commentators and theoreticians were fascinated by the presence of a "machine." Jean Epstein's famous portrait of the movie camera comes to mind: "The Bell and Howell is a metal brain, standardized, manufactured, marketed in thousands of copies, which transforms the world outside it into art. . . . [A] subject that is an object without conscience—without hesitation and scruples, that is, devoid of venality, indulgence, or possible error, an entirely honest artist."[14] Then there is Antonello Gerbi's description of the projection: "From the back of the long room, seated up high behind the audience—like the drivers of old hackney cabs in London—the projectionist holds in his fist the taut reins of the projection that is taking place. The band of rays that keeps the images bridled on the screen gives unity to the three essential elements of the cinema: it holds the screen, the audience and the projection booth together in a collected and peaceful order."[15] It is no coincidence then that in Europe during the first three decades of the twentieth century, one of the most common epithets for the cinema was "the mechanical art"—a term that is found in the title of a book by Eugenio Giovannetti, a text filled with proto-Benjaminian ideas.[16]

Nevertheless, the "machine" is not valued for what it is, but for what it can do and for what it makes the spectator do. Béla Balázs, in one of the more crucial pages of *The Visible Man*, speaks of cinema as "a technology for the multiplication and the dissemination of the products of the human mind."[17] The printing press is a technology, too, but while it has "in time rendered men's faces illegible,"[18] cinema rehabilitates our visual abilities and restores our familiarity with the language of the body.

"Every night millions of people sit in the cinema and through their eyes live the experience of events, characters, sentiments and emotions of every kind, with no need of words."[19] The emphasis is placed on the way in which the device mobilizes our senses and places us in relation with reality—on the type of experience that it engenders.

This experience owes much to the "machine," but not everything. It relies on a technology, but it also finds sustenance elsewhere. For example, the exaltation of vision is undoubtedly linked to the fact that cinema works through screened images, and furthermore, it presents them to us in a darkened room, which augments our concentration. As Giovanni Papini recalls, "[cinema] occupies a single sense, the sight . . . and this unique focus is ensured even further, in an artificial manner by the dramatic Wagnerian darkening of the theatre, which prevents any distraction."[20] However, if we are compelled to watch, it is also a result of our curiosity and our obsessions. Jean Epstein notes, "We demand to see because of our experimental mentality, because of our desire for a more exact poetry, because of our analytic propensity, because we need to make new mistakes."[21] And Walter Serner, in an extreme and fascinating text, speaks of a "desire to watch," which has always pushed humankind to attend the most terrifying spectacles, and has kept us from backing away from blood, fire, and violence.[22]

The filmic image places us in contact with reality—or better, with life.[23] In one of the earliest descriptions of the Lumières' invention, André Gay connects "the striking impression of real movement and life" directly to the way that the device works.[24] A few years later, Ricciotto Canudo, in his celebrated manifesto "The Birth of a Sixth Art," while underlying cinema's ability to capture reality in its wholeness, speaks of a "scientific theatre built with precise calculations, a mechanical mode of expression."[25] And yet Canudo lists other instances that push cinema toward a perfect reproduction of life: the inclination of modern times toward objective documentation instead of fantasy, or Western civilization's predilection for action instead of contemplation. In one of his last contributions, Canudo will draw an even more general picture. He claims that cinema is essentially a new form of writing, and writing, he remarks, is born not only as "a stylization or schematization . . . of ordinary images which had struck the first men," but also as an attempt "to arrest the fleeting aspects of life—internal or emotional—images or

thoughts, so others could know them."[26] From this perspective, cinema meets man's enduring need to achieve "triumph over the ephemeral and over death."[27]

To capture the real also means to openly transform it into a wonder. Blaise Cendrars offers a touching description of a filmic séance: "Above the spectator's head, the bright cone of light wriggles like a dolphin. Characters stretch out of the screen to the lantern lens. They plunge, turn, pursue one another, crisscross, with a luminous, mathematical precision."[28] Cinema implies a state of astonishment.[29] This surprise, however, is not merely triggered by a technical marvel; rather, it is fed by a mix of friction and participation. In a paragraph bearing the extraordinary title "The Naturalism of Love," Béla Balázs reminds us that "In films with many close-ups you often gain the impression that these shots are the product not so much of a good eye as of a good heart."[30]

Cinema also activates our imagination, and it does so because the image on the screen lacks its own physicality. Georg Lukács observes that "the world of the 'cinema' is a life without a background and perspective, without difference of weights and of qualities," and therefore it is open to pure possibility.[31] However, the imagination is given free access only because cinema possesses a language, elaborated autonomously and through borrowings from other arts, that clears plenty of space for "fancy," as Victor Freeburg notices.[32]

Nevertheless, cinema offers us a knowledge of the world. This is because its mechanical eye captures the subtle logic that animates reality in a way that no human eye is able to do. Dziga Vertov praises "the use of the camera as a kino-eye, more perfect that the human eye, for the exploration of the chaos of visual phenomena that fills the space."[33] And yet, according Sergei Eisenstein, the decomposition and recomposition of visible phenomena, which form the basis of such knowledge, constitute a process that art and literature—as well as ideographic writing—have been practicing for a long time. Cinema brings this process to its climax.[34]

Finally, cinema makes us feel like members of a community. The sense of belonging that accompanies the watching of a film is born of the possibility of projecting the same film in the same moment in many places. As Louis Delluc affirms, "The semicircle in which the cinema spectators are brought together encompasses the entire world. The most separated and most diverse human beings attend the same film at the same time

throughout the hemispheres."[35] However, this sense of belonging is also tied to an ancestral desire to create a state of communion in which one can live out collective feelings and values, as Elie Faure imagines,[36] just as it is linked to the capacity of the modern crowd to share interests and foci of attention to the point of forming a true public opinion, as Victor O. Freeburg reminds us.[37]

Therefore, cinema is not only a "machine": it is also an experience in which other factors—cultural, social, aesthetic—play a role. It is one of the technical devices that, between the nineteenth and the twentieth centuries, changed our way of coping with the world.[38] However, it is also something that goes beyond a technology and involves anthropological needs, traditional forms of expression, the trends of the day, and the emergence of new languages. It is an apparatus, and yet it puts us in contact with a pristine world and with "the visible things in the fullness of their primeval force."[39]

The film theory and criticism of the first three decades of the twentieth century consistently developed this "experiential" approach. In the 1930s things changed a bit, and the "machine" took the upper hand. In his influential book, *Film*, Rudolf Arnheim observed that technical limitations, linked to the support and the device, are precisely what push cinema toward its own specific language; it is only by taking them into account that the best expressive solutions may be found.[40] But the "experiential" approach would remain present, making a deep impression in those same years in the thought of Walter Benjamin and Siegfried Kracauer,[41] to then reemerge with even more strength in successive decades in the work of André Bazin[42] and Edgar Morin,[43] as well as in the Filmology movement,[44] whose work was based on a retrieval of phenomenology, psychology, and anthropology.

The elements highlighted by this approach vary over time. For example, it is interesting to note how at the beginning of the twentieth century, many scholars stressed cinematic experience's resonance with modern experience (for a representative example, see Karel Teige's extraordinary essay "The Aesthetics of Film and Cinégraphie"),[45] while at midcentury, more weight was placed on its anthropological implications (as in Bazin and Morin). Nonetheless, a kind of central nucleus emerges: At the cinema, we face screened moving images; these images surprise us and take hold of us; they lead us directly to living reality, forcing us to see it

again in its fullness. Simultaneously, they feed our imagination, opening us up to the possible; they provide a knowledge and an awareness, and they make us live in unison with other spectators. These traits do not belong exclusively to the cinema, and they do not offer a definition of cinema in any narrow sense; nevertheless, as a whole they characterize a phenomenon. If cinema is experience, this is the form that it takes.

"THE HOME DELIVERY OF SENSORY REALITY"

A peculiar trait of this experience is that once it is experienced in the darkened movie theater, it can also emerge elsewhere, even far from the presence of a screen.

In his essay-novel *Shoot*, Luigi Pirandello has his protagonist say, "Already my eyes, and my ears, too, from force of habit, are beginning to see and hear everything in the guise of this rapid, quivering, ticking mechanical reproduction."[46] To confirm such a sensation, a few pages later Pirandello provides a description of a simple event—a motor car that passes a one-horse carriage—as if it were seen through point-of-view shots and shot/reverse shot editing. The description ends on an ironical note: "You have invented machines, have you? And now you enjoy these and similar sensations of stylish pace."[47]

Referring to the same years in which Pirandello wrote his novel, Jean-Paul Sartre recalls in his autobiography the intertwining of his childhood with the cinema and confesses finding the atmosphere of those first movie houses even on the most unexpected occasions: "We had the same mental age: I was seven and knew how to read; it was twelve and did not know how to talk.... I have not forgotten our common childhood: whenever a woman varnishes her nails near me, whenever I inhale a certain smell of disinfectant in the toilet of a provincial hotel, whenever I see the violet bulb on the ceiling of a night-train, my eyes, nostrils, and tongue recapture the lights and odors of those bygone halls."[48]

In a beautiful essay about his climbing of Mt. Etna, Jean Epstein recognizes something in the spectacle of the volcanic eruption that is typical of cinema: "To discover unexpectedly, as if for the first time, everything from a divine perspective, with its symbolic profile and vaster sense of analogy, suffused with an aura of personal identity—that is the

great joy of cinema."[49] Epstein also reminds us that the day before, while descending the mirrored staircase of a hotel in Catania, Sicily, he had experienced an analogous and opposite impression. His image reflected in a thousand profiles had offered him an unforgiving vision of himself, exactly as happens on the screen, on which we see things without the usual filters: "The camera lens . . . is an eye without prejudice, without morals, exempt from influences. It sees features in faces and human movements that we, burdened with sympathies and antipathies, habits and thoughts, don't know how to see."[50]

Finally, Michel de Certeau, years later, when the status of cinema was already changing, observed that watching a Jacques Tati film enables us to see Paris with different eyes, as if the city continued to live on a screen: "So, leaving the film theater, the spectator notices the humor of the streets, as if she shared Tati's gaze. Film made possible a humorous vision that could not have been elicited without it. The same goes for the reading of a poem, meeting somebody, the effervescence of a group. If the register of perception and comprehension changes, it is precisely because the event has made possible, and in a certain sense made real—it has permitted—this other kind of relation with the world."[51]

The cinema experience is thus contagious, reproducing itself even far from the darkened theater. An essay from the 1920s—which, not coincidentally, Walter Benjamin quoted in the epigraph to the third version of his "The Work of Art in the Age of Mechanical Reproduction"—explains how it is in fact characteristic of media to enable this reproduction of experiences. In "The Conquest of Ubiquity,"[52] Paul Valery, writing about music and the gramophone, notes that through the means of reproduction and transmission that are being created, "it will be possible to send anywhere or to re-create anywhere a system of sensations, or more precisely a system of stimuli, provoked by some object or event in any given place."[53] This means that we would be able to relive elsewhere emotions that seem confined to a particular terrain—including emotions apparently linked to specific fields, like music or literature. "Works of art will acquire a kind of ubiquity. We shall only have to summon them and there they will be, either in their actuality or restored from the past. They will not merely exist in themselves but will exist wherever someone with a certain apparatus happens to be."[54] The result would be a system that allows for the reactivation on command of all possible kinds

of experience. "Just as water, gas, and electricity are brought into our houses from far off to satisfy our needs in response to a minimal effort, so we shall be supplied with visual or auditory images, which will appear and disappear at a simple movement of the hand, hardly more than a sign."[55] And in this way would be born "a company engaged in the home delivery of Sensory Reality."[56]

The specificity of a medium, *qua* support or device, therefore lies in its ability to move experiences freely. If necessary, a medium may also lift experiences from another medium—as does the gramophone, when it borrows a sound from a musical instrument. This means that an expressive field (a medium, this time *qua* a cultural form) can find other instruments (other media) in order to venture beyond its own borders. The medium that intervenes does not represent a betrayal, but rather an opportunity: it gives the previous media the chance to survive elsewhere.

Cinema, with its vocation for existing in other contexts, possessed all the prerequisites for following this same route. Valery, however, never mentioned cinema in his essay. The reason resides in the fact that, when Valery was writing, there did not yet exist new extensions ready to deliver anywhere, outside the darkened theater, the characteristic "system of sensations" of a film.[57] It is true that, thanks to portable projectors, cinema was already able to migrate into domestic spaces, into schools, into the squares of little rural villages, but the basic device was almost the same, even if more flexible.[58] And it is also true that a few years later, in its golden age, the radio would offer many film adaptations, by a re-reading of their dialogues, their music, and comments providing further information,[59] but the experience—which is in many senses a filmic experience—would lack an essential component, the visual one. In the epoch in which Valery was writing, cinema had the capacity and the will to live again in countless other situations, but it was waiting for the means to do so fully.

The means would arrive later—when the great theories of the two first decades of the century had become a memory for many, and when "classic" cinema had finished its grand parabola. This moment would coincide with the arrival of television, VHS and then DVD, the personal computer, the tablet, home theaters, and so forth. It is a moment at whose climax we now find ourselves living.

THE RELOCATION OF CINEMA

Let us return to our original description of the increasing presence of cinema in our daily lives, often far from its traditional support and apparatus. I would like to use the term *relocation* to refer to the process by which the experience of a medium is reactivated and reproposed elsewhere than the place in which it was formed, with alternate devices and in new environments. I am thinking of the newspaper: No longer necessarily made of paper, I am now able to peruse its pages on the screen of my iPad, but even from this new site it continues to allow me to experience the world as an infinite stream of news. I am thinking of the radio: No longer a domestic appliance or transistor-powered device, but rather an extension of my television or tablet, it nonetheless continues to supply the soundtrack of my life. And, naturally, I am thinking of cinema: No longer only in a darkened theater and tied to rolls of film stock running through a projector, but now available on public screens, at home, on my cellphone and computer, it is still ready, in these new environments and with these new devices, to offer screened moving images through which we get a sense of proximity to the real, an access to fantasy, and an investment in what is represented. In all these cases, the "system of sensations" that traditionally accompanies each medium finds a fresh outlet. Thanks to a new medium—thanks to a new support or a new device—an experience is reborn elsewhere, and the life of the previous medium, in its fullness as a cultural form, continues. It is in this way that we can think of "being at the cinema" and "watching a film" even in bright light in front of a digital screen.[60]

The idea of relocation tends to stretch beyond what Bolter and Grusin call *remediation*. Remediation is the process through which "one medium is itself incorporated or represented in another medium."[61] It is a strategy advanced especially with regard to electronic media, and it can lead either to a reabsorption of the old medium in the new one (Bolter and Grusin mention the digitized family photo album on the PC, as well as some video games that conserve the characteristics and structures of the films on which they are based) or a remodeling of the old medium by the new one (here the example is the shift from a rock concert to a CD). In remediation, what matters is the presence of a device and the possibility of refiguring it. Relocation, meanwhile, involves other aspects,

which are in my opinion more decisive. On one hand, relocation emphasizes the role of experience. A given medium is defined by a specific type of watching, listening, attention, and sensibility. Therefore, it is not the permanence of its physical aspect, but the permanence of its way of seeing, hearing, and sensing, that ensures its continuity. A medium survives as long as the form of experience that characterizes it survives. On the other hand, relocation emphasizes the role of the surrounding environment. A given medium is also defined by the situation in which it operates or which it creates—an experience is always grounded. Therefore, it is not the mere reappearance of a device that counts, but rather the manner in which it literally takes place in the world. The concept of relocation makes clear that the migration of a medium outside its prior terrain involves a type of experience and a physical or technological space.

This attention to the displacement of an experience, as opposed to the simple replication of a device, leads us to confront two other problematic issues. The first is the relation between *flows* and *locality* that Arjun Appadurai references in his *Modernity at Large*.[62] What characterizes our era is the presence of a series of "cascades" that profoundly redesign the surrounding landscape: goods, money, people, ideas, and media are redistributed and rearranged continually within variable circuits. Their stop-off in a certain place not only involves new equilibria, but also tends literally to create new localities—it founds sites, just as temples and cities were once founded—within which we can locate the traces of a history. The concept of relocation serves to underscore the analogy between cinema's transformations and the processes of circulation that characterize today's world: Cinema's movement to new devices and new environments takes place against the backdrop of wider processes of migration that redraw the maps to which we are accustomed.[63]

The second problem is described by Gilles Deleuze and Felix Guattari with the terms *deterritorialization* and *reterritorialization*.[64] Capital, modes of production, power, and institutions often break away from a structured system, wander through a no-man's-land, and then perhaps take root in a new territory. In this movement, what counts is a twofold process: on one hand, the liberation from a bond (the untying of these entities from what anchors them); on the other hand, the form that the landscape assumes by these migrations (the environment of arrival is not necessarily as organized as the point of departure, but rather tends to

assume a rhizomatic form). The concept of relocation seeks to recuperate this sense of continual destructuring and restructuring, along with the idea of flexibility and dispersion that Deleuze and Guattari emphasize in their analysis.[65]

I have pointed out some of the threads to follow, and I have also managed to tangle them. The following pages will disentangle some of those that now may seem hopelessly knotted. We shall explore the notion of relocation in all its implications and consequences. Now I would like to confront the theme that it evokes more than any other—and which must be the first to be untangled.

ALMOST

Relocation acts in such a way that an experience is reborn almost the same as it was. Here the emphasis should be placed on "almost." And it can even mean "not at all." In fact, examined from a certain perspective, a relocated experience can resemble "not at all" the experience that it is trying to replicate.

Let's stick with cinema. In its migration, it encounters new types of screens, starting with the four that now dominate the landscape: digital television screens, computer and tablet screens, cellphone screens, and media façades. These screens offer visual conditions that are quite different from those of the traditional movie screen. For instance, the screens of mobile devices do not offer any sense of isolation from the surrounding environment, so that one easily loses concentration on what is being shown. There is also the size of the images, which on smartphones or tablets renders their spectacular nature hard to appreciate. On a computer, the icons work as instructions more than as depictions of a reality. The screens in public spaces host a plethora of products—from films to commercials, from documentaries to music videos—creating an effect of superimposition, which makes it difficult to isolate any strictly cinematographic properties. These conditions strongly affect the viewer's behavior. As empirical research directly or indirectly suggests,[66] spectators who watch a movie on new types of screens have the tendency, as media users, to activate a multitasking form of attention, which leads them to follow more than one object simultaneously; they work through a process of sampling rather

than trying to grasp everything that is presented to them; they mix images of reality with more abstract information; when possible, they interact with what they see; finally, they attempt to deal with different and contrasting situations. In other words, spectators tend to adopt tactics learned from television, the computer, the cellphone, and social networks. In this case, what they undergo is an *experience of cinema-beyond-cinema*.

But there is also another outcome that I would like to take into consideration here. Despite these new inflections, vision often remains "cinematographic." It triggers what we may call a *back-to-the-cinema experience*. Indeed, these same spectators succeed in isolating themselves in an environment, in recuperating the magnificence of images, in concentrating on a story, and in enjoying the reality that reappears on these new screens. They accomplish this because, on one hand, the situation is a flexible one, and in some ways adjustable (for example, while traveling one can put on headphones, move the tablet closer to one's eyes, and select a film to watch); and because on the other hand, it still presents a series of recognizable characteristics (there is a screen, a film, an attentiveness). These factors lead to the possibility of minimizing what seems incongruous and highlighting what recalls a more traditional form of usage.[67] Cinema returns to being cinema. This move sometimes also applies to something that is not cinema, but perhaps would like to be: Spectators can adopt the same attitude toward sports or video games, based on the fact that in sports and video games, just as in a film, the world is rendered into a high-intensity story and spectacle.

So, "almost" can mean "not at all," but it can also mean "nearly completely." The problem is that in the relocated experience, what counts is not so much its *material conditions* as its *configuration*. Material conditions make themselves felt: They constitute the concrete terrain on which the experience gains its footing, and they are what give a form its thickness. However, what makes itself felt above all is the way in which the components relate to one another. It is this configuration that tells us what this complex whole is or can be or in which direction it operates or can operate. In particular, it is this configuration that makes the situation appear cinematographic—and allows us to live it cinematographically. It is not necessarily an *a priori* model, but rather emerges from the situation such as it is, with all its imperfections. Compared with an ideal type, any situation is intrinsically imperfect.

It is always de-formed, from the moment at which it takes shape on the basis of contingent and particular conditions.[68] The configuration that emerges, however, brings this deformation back into a specific form: The situation in which we find ourselves acquires a recognizable shape, reveals its "how" and "why," and displays its guiding principles of construction and intelligibility. It is in this manner that the configuration reveals the presence of the "cinematographic" even where it seemed to be absent.

"Almost" thus means that what is essential is present, despite its apparent alteration.

PRACTICES OF RECOGNITION

But how can we make a cinematic configuration emerge from such ambiguous situations? How can we restructure such oftentimes vague elements into an arrangement that leads us to say "this is cinema"?

This question brings us to the mechanisms of *recognition*. To recognize something or someone means two things. First, it means to associate, even with difficulty, what we have before us with something that we have already encountered: such is the case when Ulysses' dog Argo recognizes him. It is thus a case of identifying a series of traits and seeing their correspondence with a reality that is in some way known or familiar. But recognition also means accepting the existence and legitimacy of something: such is the case when a government recognizes a new territorial entity or state. Here, we carry out a different sort of operation: We accept a reality, and we give it a certain status. Recognition is thus both of these things: It is an "agnition," by which something is identified, verified, and discerned, and it is a "ratification," by which something is validated, receives approval, and is constituted as such. I would add that both of these operations revolve around having an "idea of" what something is: In the first case, it is a matter of an idea that is recalled in order to carry out a correct identification, while in the second, the idea is constructed *a posteriori*, as the result of an acceptance. I would likewise add that neither of these operations are confined to the cognitive dimension; rather, they imply a concrete way of relating to what is recognized, and therefore a whole set of practices to be carried out.

Now let us return to relocated cinema. The distinction between an *experience of cinema-beyond-cinema* and a *back-to-the-cinema experience* lies in the way in which we recognize the situation. The situation presents itself as wholly ambiguous, a bit like the images that depict a duck and a rabbit at the same time. But just as with those images, recognition carries out a disambiguation: what we see is one thing or the other.[69] Of course, in such an ambiguous situation, we can also suspend recognition for a while, take things as they are, free of any pressure, or endlessly switch from one interpretation to another. The incertitude here remains alive. And yet, as a matter of fact, in the midst of this incertitude, we see either a "cinematic" or "non-cinematic" configuration of elements emerge. As large and persistent as a certain "gray zone" might be, we are pushed toward a solution. "It's cinema, in spite of everything"; or on the contrary, "it is, unfortunately, no longer cinema—but it is television, computer, portable telephone, and so on."

This is not only a decision made on a mental level: there are strong contextual elements that direct its outcome. There is, for example, the pressure of the market, which considers cinema "premium" content, or the desire to continue being spectators, even under difficult conditions: these help us lean toward a "cinematic" choice. But there is also the presence of technological devices, constantly being introduced, that push us in opposite directions. In any case, at a certain point we "read" the situation in one way or another, and we act accordingly.

I have mentioned how a recognition implies an "idea of." It is an "idea," indeed, that, on one hand, allows us to identify what we find before us, and that, on the other hand, we obtain at the moment we accept a given reality. From where do we derive the "idea of cinema" that allows us to recognize our experience? First of all, there is a "social image" of cinema that circulates in both specialized and nonspecialized discourses and thus serves as a reference point. Theories of cinema function largely in this sense.[70] We also extract an "idea of cinema" from our habits. Every time we go to the movies, we experience the same cardinal elements and engage in the same behaviors: this consolidated experience orients us. There is also our memory as spectators.[71] We remember what cinema was, and we use our idea of it in order to test the experience we are currently having. Memory of cinema is a question of generation; it could dissolve in the near future. Nevertheless, while fragile, memory is still in play. Additionally, the work of

the imagination comes into play: In front of an unforeseen situation—for instance a screen, the nature of which we don't immediately grasp, displaying images in motion—we hypothesize that it has something to do with cinema, and we try to interpret it in this key. In this case, we act on the basis of a conjecture. Regardless of the way in which we deduce this idea, it provides a fundamental means of orientation:[72] It helps us to understand whether we are dealing with a cinematic experience or not. Furthermore, it functions as a constitutive tool: It allows us to interpret our experience as cinematic, and thus makes it what it is.[73]

Nevertheless, it does not constitute a single, fixed model. The "idea of cinema" began to spring up in the very moment that cinema appeared; it has floated to the surface as cinema has advanced along its own path of development; it has readjusted and redefined itself according to the paths the cinema has embarked upon; it has become an individual and a collective patrimony; it has materialized to the point of becoming a reality in itself; and today it confronts new situations, showing their possible continuity—or possible variation—in respect to their precedents. But it also resurfaces in unexpected situations, taking as its starting point the differences that these put into place. The "idea of cinema" should be taken as plural.

An "idea of cinema" is eventually also an essential component of experience. Thanks to the emergence of an idea, we reconsider what we are experiencing, and we understand what sort of thing it is. The idea tells us that we are experiencing something, and what it is that we are experiencing; it allows our experience reflexively to acquire self-consciousness. Every experience, in order to really be one, must align bewilderment and knowledge. It is an experience not only because it surprises us and takes hold of us, but also because it makes us understand that it is an experience and a particular type of experience. Of course, this circuit is often interrupted, and we often experience things while unaware of experiencing them. We are often like the soldiers that Walter Benjamin wrote about, who returned mute from the front, incapable of communicating what they had seen, victims of a shock that made them lose the meaning of their existence.[74] Inexperience is always waiting in ambush, even and especially in more intense situations. The presence of an idea triggers this situation; it reunites a sensory richness with a path of re-elaboration, an *Erlebnis* with an *Erfahrung*.

AN IDEA OF CINEMA

Let's see how an *idea of cinema* works in borderline situations, as those that are born of relocation often are. What happens when it is measured against an *almost* that wants to seem like a *nearly completely*, even though it tends to be a *not at all*?

Here I will examine a series of social discourses that, although they are not part of the domain of criticism and theory, seek like the early film theories to understand the key elements of the cinema experience.

The blog allwomenstalk.com features a list of the best places to watch a film, in order of preference. In first place is "in bed," followed in second place by "at the theater," and then "at the drive-in," "in the train," "in the car," "in the arms of someone you love," and "in the park." These rankings might seem surprising at first, but if we read the reasoning behind them, we see an idea of cinema emerging that is not too far from the traditional one: in bed one can relax and concentrate on a film, even with another person. "Your bed is a really great place to watch movies. There's nothing like curling up and watching a good flick. You can curl up with your BFF, your partner, or even with a beloved pet. There's nothing wrong with cuddling up with yourself to watch your favorite movie, either. You're sure to be comfortable, and that will make you enjoy the movie even more."[75] I must add that in bed spectators rejoin the dreamer that film theories have always considered they are.[76]

The question of place also turns up in a short article in *Charleston City Paper*, an alternative weekly published in Charleston, South Carolina: "If you can't watch movies in Bill Murray's private home theater, the best place to watch one is on a lawn chair under the stars in Marion Square, sipping beer and eating tasty food from local vendors."[77] For the *Charleston City Paper*, then, cinema is above all a ritual and an atmosphere: From this perspective, not only fully equipped home theaters like Bill Murray's but also a public park like Marion Square can be seen as an ideal place for a projection.

There are numerous observations to be made concerning the home viewing of films. One ad suggests: "Home cinema is about recreating the ambience, atmosphere, tension and excitement of a true cinema auditorium, whilst adding a few home comforts—such as being able to pause and rewind the film, and not having to suffer interruptions from errant

Relocation 35

mobile phone owners, popcorn munchers or sweet wrapper rustlers!"[78] Cinema is foremost a way of viewing that is both intense and relaxed: home viewing is even better able to provide such an experience.

The same line of reasoning appears in a long article published on the Web site www.apartmenttherapy.com (the name says it all . . .).[79] The article gives advice on making home viewing as pleasurable as possible. It provides suggestions about the correct distance from the screen, how to ensure sound and image quality, choosing the right film, making "double bill" programs, scheduling an intermission, and lowering the lights. Clearly, these rules aim to reproduce the conditions of the movie theater. Once again, then, we see an idea emerge that takes account of the novelty of the new situation, but still connects it with tradition.

There are situations where such connections are more difficult to make. Such is the case, for example, with film viewing on mobile devices like the tablet or smartphone. The traditional cinematic experience called for a static spectator rather than a mobile one: How should we then think about this new condition? Another online comment offers a solution. A film has always been a form of company for the spectator, and watching one on a mobile device is legitimized if it serves this aim: "From emergency cases to encountering the most boring times while traveling or waiting in line, show reels and movies I actually placed in my mobile phone sometimes become my best buddy, colleague, or companion on the road or in a meeting."[80] Of course, if one is concerned with viewing quality, a big screen would be a better choice.[81] There are thus multiple ways to bring continuity to the experience of cinema, depending on the characteristics that one wishes to preserve.

Other situations are even more difficult to interpret. The online film forum mubi.com has hosted a debate over the course of two years about watching films on airplanes.[82] Some of the responses are quite revealing. One user writes, "I find the concept of watching movies on planes to be really interesting, because it's the place where you watch films that you wouldn't pick for yourself. This means that you watch some of the worst movies you've seen, but you also have a chance to watch something unexpectedly good." On an airplane, we don't choose the film, and this is in many senses an element that distinguishes it from a movie theater; even so, this condition allows us to widen our range of experiences. Of course, viewing conditions in an airplane may seem unfavorable, but

there is always a remedy. Another user says: "I can't see the films on those tiny airplane screens so I load a few on my iPad and watch away. It makes those coast-to-coast flights go a lot faster." This is not only a matter of increasing the screen size, but also of reproducing the quality and the concentration characteristic of traditional viewing. Furthermore, the iPad is promoted as the perfect cinema screen: "An iPad is a beautiful thing. The gorgeous Retina display and long battery life make the iPad a great tool for watching movies."[83]

The recognition of cinema in new situations becomes easier when intermediate steps exist between the new and the old. Still on the topic of watching films on airplanes, in the forum on mubi.com someone recalled the use of film projectors on flights in the 1960s: "I miss 16-mm projectors on planes. I'm getting old." Another responds, "I too remember real film being shown in planes; so wonderfully complicated and yet it worked (the 6000-ft reels I used for my features were, as I recall, designed for in-flight use, running horizontally in a compartment above the ceiling.)" In other cases, this intermediate step is re-created after the fact, in order to make the new situation more cinematic. Various groups of spectators organize collective viewings, in which each individual watches the film at home, but all at the same time, exchanging observations over Twitter. One participant, after a shared viewing of *Jurassic Park*, observed, "It makes me think back to that far-away afternoon of September 1993, when with a few friends and a pair of plastic dinosaurs, I entered into the little parish cinema to enjoy the most anticipated film of my young life, fluttering excitedly around the theater as though under the influence of fairy dust. A bit like Thursday night."[84] The idea of being part of a public helps to experience cinema as it was, even if one is now in fact alone.

Such an operation can also be extended to its limits. In responding to mubi.com's survey, one user recalls, "My best transportation/movie experience was hurtling along on a bus in Egypt where the DVD screen was showing an absolutely dismal-quality copy of a Jean-Claude Van Damme martial arts epic. Dubbed in Arabic. Now, that you don't get every day . . . (a fact for which I am grateful)." Here the idea of cinema is displaced, moving from a good-quality screening, in a good environment and with good company, to one characterized by surprise, strangeness, and provocation. And yet, if on the one hand there is a true redefinition of what

a cinematic experience is (we might add: in a globalized and multicultural world), on the other there is a reemergence of the characterizations of the filmic experience offered by early theorists. Their insistence on sensory excitement, or on the sense of uncanny inherent in every film, pointed in this direction. The user who describes his Egyptian experience is not so far from Blaise Cendrars and his attitude toward cinema in the 1910s.[85] The only difference is that the former, thanks to this attitude, finds something cinematic in an improbable situation.

Further examples could certainly be provided, but the mechanism at work is by this point quite clear. In these borderline situations, we evoke a certain idea of cinema that comes from habit and memory, but also from imagination. We do not forget the actual conditions in which we find ourselves; instead, these conditions push us to further analyze the situation. Even within things that appear anomalous, we find traits that are familiar, either because they remind us of a previous history or because they recur with increasing frequency. It is these familiar traits that allow cinema to reemerge even beyond its canonical contexts. In short, we carry out a recognition: We identify elements and define a situation.

Philippe Dubois, introducing a rich and controversial volume, refers to this process. For him, cinema is above all "an imaginary of the image, deep, powerful, solid, and persistent, that enters deeply into our minds and our thoughts, to the point of imposing itself upon other forms. It is an imaginary of the image that serves as the basis upon which we conceive of our relationship to all other types of modern images."[86] It is this capacity of an idea to impose itself upon many situations that leads Dubois to see cinema as an already-diffuse presence.

What Dubois perhaps omits to mention, however, is the complexity of this operation. To say, "oui, c'est du cinéma"—as he invites us to do,[87] even in situations the most foreign to the canonical—is never a self-evident act.

CINEMA IN SPITE OF ALL

Let us return to our examples. To recognize the presence of something cinematic in borderline situations implies, first of all, the acceptance of an imperfection. Relocated cinema is not 100 percent cinema. But it

is precisely what is missing that proves valuable: it not only leads us to questioning, but also offers us the possibility of bringing to light a configuration that, despite its difference, continues to be cinematographic. In other words, it is, thanks to the differences that we discover, an identity. It is thus not a resemblance, however vague or clear, that allows us recognition, but rather the dissimilar and the deformed. "Yes, it is cinema," because in some sense, it is not. In this light, we can also understand why many scholars consider relocated cinema nothing less than a form of "degraded" vision, as Raymond Bellour calls it[88]: when one looks for the identical, the simple return to a previous model, what is different can only be an obstacle. Cinema can only reemerge, though, if one begins from imperfection and makes a virtue of it.

Second, recognizing the presence of something cinematic even in odd situations entails a tendentious reading. I repeat: To recognize is not simply to delineate similarities, but rather to see the identical beneath the differences and declare it to be identical. In this sense, recognition is a highly creative act. We must know how to—and want to—see what is happening in front of us. "Yes, it is cinema," only because we know and want to see it as such. Following this logic, it may be useful to distinguish between an essentially retrospective gesture, which brings to light the presence of precedents in the new, and a projective gesture, which constructs an identity after the fact, adapting it to the object before us. In the first case, we find ourselves within a tradition, while in the second we reconstruct a tradition from our recognition. Relocation moves in the second direction, thereby stimulating imagination more than memory or habit, although it is hardly odd to find scholars who limit themselves to the first path. In the same volume from which Dubois' preface is drawn, Eric De Kuyper and Emile Poppe deny that a spectator in a gallery or a museum can be considered as such[89]: for them it is the apparent that prevails.

Third, the recognition of something cinematic brings along with it the fact that we know how to recuperate elements that were lost in the shadows. The idea of cinema has changed over the years, and an excavation into the past can help us to understand what parts of it have been lost. In a well-known text, Miriam Hansen points out how contemporary cinema, even though it seems to violate many of the rules established by Hollywood, in fact reactivates characteristics typical of its beginnings.[90] "Post-cinema" is not the end of a model, but rather the return of its

original characteristics. And more. The borderline situations that we find today also illuminate the paths that were intuited but never really taken. As an example, it suffices to consider Moholy-Nagy's dream of a cinema that would be projected not on a flat screen, but on a concave hemisphere,[91] and compare it with what we see happening today in installations. Post-cinema is also the realization of possibilities left unexplored. This is why Anne Friedberg reminds us not only to delve deeper into the genealogy of cinema, but also to discover alternative genealogies.[92] The idea of cinema must be ready to enrich itself with new characteristics.

So—a confrontation with imperfection, a penetrating reading, and an opening to the possible. To recognize the presence of cinema in new situations is a complex and risky task, but it is only through doing so that we can see the profound authenticity of this presence.

AUTHENTICITY, ORIGINS

Walter Benjamin can perhaps come to our aid here. In the "Epistemo-critical prologue" of his *The Origin of German Tragic Drama*,[93] he seeks to figure out how one can define a genre that is characterized by many very different works. For him, what is essential is to consider the *Trauerspiel* in terms of an idea, that is to say, as something that unifies a field of works in a much more effective way than the conception of a prototype followed by copies or an archetype that emerges through a series of iterations. In this context, authenticity is no longer conceived of as the direct correspondence to a canon, nor as the clear permanence of a series of traits. Something is authentic not in itself, because it corresponds exactly to a model, or because it comes to us intact from the past, but rather because we come to consider it as such, taking account of its history, the conditions in which it reappears, and the destiny toward which it is directed. "The authenticity—the hallmark of origin in phenomena—is the object of discovery, a discovery which is connected in a unique way with the process of recognition. And the act of discovery can reveal it in the most singular and eccentric of phenomena, in both the weakest and clumsiest experiments and in the overripe fruits of a period of decadence."[94] We are called to a recognition that also confronts what is seemingly unrecognizable—that literally constitutes an identity from the differences.

Benjamin further clarifies this fact, speaking precisely of the origin and the original. The origin is not a starting point that justifies what will happen later, but rather a "vortex" created around a constant becoming.[95] In this continuous passage, the central element of a phenomenon never makes itself visible as such: "That which is original is never revealed in the naked and manifest existence of the factual.... On the one hand it needs to be recognized as a process of restoration and re-establishment, but on the other hand, and precisely because of this, as something imperfect and incomplete."[96] When we carry out a recognition, our point of reference is something that is incomplete; we attempt to reconstitute it, but every reconstitution revolves around this incompleteness.

Benjamin adds: "There takes place in every original phenomenon a determination of the form in which an idea will constantly confront the historical world, until it is revealed fulfilled, in the totality of its history."[97] We can in all cases form an idea of an object or a phenomenon, but we can only do so by following along the entire historical journey of this object or phenomenon; we will know what is faithful to it or not only at the end of the journey. This means that we must take into account a temporal development, a "before" and an "after." Benjamin again: "Origin is not, therefore, discovered by the examination of the actual findings, but it is related to their history and their subsequent development."[98] We have a journey of the object or the phenomenon that unfolds earlier in the process, toward a prehistory, and subsequently, toward a posthistory. This brings about a reconsideration of defining traits: "This dialectic shows singularity and repetition to be conditioned by one another in all essentials."[99] In the journey of an object or phenomenon, what appears original and authentic and what appears derived or secondary are mutually bound together and always appear together.

It is by taking into account this picture—which is a matter of not a fact but a recognition, not a single point of the story but its entire journey, not an object but an idea that supports it—that we can easily say that the relocated experience speaks, at the same time, the language of authenticity and that of deformation. A relocated experience *is* its model, but in its becoming, in its being stretched between a prehistory and a posthistory, between what has been and what will be (or also between what could have been and what could be). This is why it is at once so faithful and so treacherous, to the point of containing forms of

experience that seem literally at the limits, or even further—forms of experience that seem to deny their own model. But in this way, and only in this way, is it a *cinema* experience.

⁂

Tacita Dean's *Film* thus acquires its exemplarity. It is not in fact a homage to a dying media through its restoration, but rather the assertion of how difficult, if not impossible, it is to bring a medium back to life without transforming it. What we have before us is indeed an installation—with a single bench, a vertical screen, and some of the artist's images. This installation is not cinema, but obliges us to think of cinema's history, full of searching and experimentation, and of its future, dominated by the presence of the digital. In this sense, more than a failed imitation of cinema, *Film* is the mise-en-scène of its inevitable deformation—of its inevitable becoming other in order to remain itself. At the Tate, we find the risk of cinema's nonbeing. But it is the very difficulty of recognition, a recognition that operates through its opposite, that makes the installation interesting. It is in not easily finding the cinema at the Tate that we understand perfectly what cinema means.

2. Relics/Icons

ALFREDO

The movie theater is already completely full, and a small crowd is pushing and shoving to gain entrance from outside. In the projection booth, Alfredo is working, as usual, with the assistance—or better, in the company—of his young companion, Totò. The projectionist strikes upon an idea: Using mirrors, he intercepts the beam of light coming from the projector that is destined for the screen, and directs it toward the façade of a building in the piazza opposite the theater, so that those who cannot fit inside can watch it too. This is how the film comes to life on the exterior wall of a large building, and the waiting crowd, spellbound, is now able to watch it. One of the building's residents protests, but then he too is captured by the spectacle. A habitué of the piazza tries to sell tickets with the excuse that this place belongs to him, but he is roundly dismissed. Everyone is fascinated by the new magic. Suddenly, however, a fire breaks out in the projection booth. The flames quickly spread to the reels of film, the posters hanging on the walls, and the furniture. Alfredo battles to put out the fire but is overcome by the flames and drops to the ground. Totò returns to the projection booth and drags the projectionist down the stairs all the way to the piazza, where, in the meantime, the crowd has dispersed. The fire continues to burn unabated, with no one

able to put it out. The movie theater is destroyed, and when it is rebuilt, a few years later, it will not be the same. Alfredo, whose face was struck by the flames, loses his sight.

Many readers will have recognized this scene—one of the most famous sequences in *Cinema Paradiso* (Giuseppe Tornatore, Italy, 1988). In a film overflowing with symbols, this excerpt offers at least three major metaphors. The first concerns cinema's desire to leave its traditional location—to emerge from the movie theater—in order to find new environments in which to bring its images and sounds alive. This is an age-old desire. Antonello Gerbi, in a remarkable article of 1926, imagines a radical experiment. He notes: "A projection made without a screen, onto an empty space, where will it end up? It will appear to vanish into the air; it will dissolve into a vague luminous nebulosity."[1] Nevertheless, adds Gerbi, "nothing gets lost in the universe"[2]: film characters, although out of their element, and in the form of ghosts, will continue to exist among us.[3]

The second metaphor, in contrast, concerns the risk of death cinema runs in leaving the movie theater. The beam of light is diverted from its natural destination, the screen, and that is why a fire sends the building up in smoke (the one and only temple in which the cult of viewing *should* be celebrated) and permanently blinds Alfredo (the officiant of this rite). It is therefore dangerous to look for new spaces, for this might release forces that no magician, no matter how expert, can control.

Finally, the third metaphor is one that foreshadows a potential revival of cinema. Totò, in rescuing the man who is his putative father from the fire and dragging him toward the piazza, is, in a way, reminiscent of Aeneas carrying Anchises on his shoulders, out of the burning Troy toward new shores. He is someone who saves (it is no coincidence that—although the short form of his name is Totò—his full name is Salvatore Di Vita, literally, "Savior of Life") and at the same time someone who guarantees a future (nor is it a coincidence that he will become a famous director). The cinema will continue to live. After the fire, the New Cinema Paradiso will be constructed on the site of the Cinema Paradiso, albeit with a new design. And, moreover, cinema will find new ways to develop: Totò will go to Rome (to Rome, from Troy . . .), and from the mid-1960s onward we can imagine that he will be confronted with new

kinds of films, new supports, and especially new venues—he will even contribute to them, as many "engaged" directors did at the time.

A little more than twenty years after Giuseppe Tornatore's film was made, and a little more than sixty years after the event related by the film, cinema's exit from its temple has been achieved. As Robert C. Allen recaps, we already deal with "an entire generation [which] has grown up with their earliest, most formative and most common experience of movies occurring in places that Hollywood dismissively referred to as 'non-theatrical' exhibition sites: bedrooms, living rooms, kitchens, automobiles."[4] The theater screen has moved toward a great many other screens, starting with those belonging to the four media that now dominate the landscape: the plasma or LCD television, the computer or tablet, the mobile phone, and the LED media façade. As a consequence, cinema is everywhere, even if dressed up in other clothes or mixing with other realities. It invades all aspects of our daily life and fills in its interstices.

So, which paths does this gigantic relocation of cinema follow? What casualties does it take with it? And to what extent does it represent the continuation of a history?

CINEMA OUTSIDE OF THE DARKENED THEATER

Let us began with some statistical data. First of all, it is important to take account of the fact that movie theaters still exist and that their number is increasing. In 2012, the number of screens worldwide grew by 5 percent, thanks mostly to a double-digit increase in Asia, Africa, and the Middle East, bringing the total number of theaters to 130,000. It bears noting, meanwhile, that two thirds of these screens are digital. In the same year, box office grosses grew 6 percent, reaching $34.7 billion. While Europe saw a slight decline (1 percent), there were substantial increases in countries such as the United States, Brazil, Russia, and, most of all, China (36 percent). In any case, the tendency toward increasing box office returns appears to be a constant over the past few years.[5] Still in 2012, admissions "were up in Australia (0.9%), China (13.4%), Germany (4.2%), Russia (5.8%) and the USA (4.0%) but decreased in France (−5.7%), Italy (−9.9%) and Spain (−7.3%)."[6] Over the long term, the number of

tickets sold, after having undergone a progressive decline during World War II that reached its low point in the 1970s and 1980s, has increased on the whole and today seems to remain at a constant level, oscillations and stagnations aside.[7]

Cinema is, however, also widely consumed outside of theaters. To get an idea of the scale of this tendency, we can refer to market research concerning the choices of American spectators during the first three months of 2012: Compared to the 44 percent who had watched a film in the theater, 59 percent had watched one on a purchased DVD or Blu-ray Disc, 58 percent on television, 36 percent recorded one on DVR or saw it with TiVo, 21 percent rented one from a kiosk, 20 percent watched one through free video on demand via cable or satellite, 19 percent through an on-demand subscription, and 13 percent through pay-to-view on-demand.[8] Spectators thus choose from a number of places in which they can view a film: it is no longer linked to one place alone and is most definitely not linked only to the movie theater.

In this context, the showing of films on television appears to be an area of major growth. *The Statistical Yearbook 2013*, prepared by the British Film Institute, offers an interesting cross section of this sector in the United Kingdom, which is the third or fourth largest market in the world. According to the yearbook "there were just under 3.9 billion viewings of feature film across all television formats (except pay-per-view) in 2012—over 22 times the number of film admissions." As for the number of broadcasted films, "there were 7,409 unique film titles on television in 2012, including 1,914 on terrestrial channels, 1,386 on Pay TV film channels, 4,109 on other channels"—a number that must be compared with the 647 films that were released for a week or more in theaters in the United Kingdom and Republic of Ireland.[9]

As for the other modes of viewing, we should note, returning to the United States, that in the first half of 2012, "rentals of physical DVDs and Blu-ray discs (BDs) from kiosks, brick-and-mortar retailers, and Netflix Movies by Mail accounted for 62 percent of movie rental orders; digital movie rentals—including subscription streaming, pay TV VOD, and Internet VOD—accounted for the other 38 percent." Anyway, "rentals of physical discs, while dominant, are becoming less so; in fact, year-over-year disc rentals from all sources declined by 17 percent, as digital movie rentals increased by 5 percent."[10] In other words, streaming is the form

of access to a movie that is increasing the most. Working in favor of video on demand is the fact that it is "available on a range of platforms including connected television, cable/satellite/Internet protocol television (IPTV), digital terrestrial television (DTT), mobile and online."[11] These devices free up viewing from the need for personal presence in a specific place and make it possible literally anywhere (or at least anywhere with an Internet connection). The transformation that began with DVD, which allowed mobile viewing thanks to portable players, thus comes to completion.

We should also recall that when it comes to streaming video, cinema can be pirated as well. According to the Web site torrentfreak.com, the most pirated films of 2012 were *Project X*, with 8,720,000 downloads, *Mission: Impossible—Ghost Protocol* (8,500,000), *The Dark Knight Rises* (8,230,000), *The Avengers* (8,110,000), *Sherlock Holmes: A Game of Shadows* (7,850,000), *21 Jump Street* (7,590,000), *The Girl With the Dragon Tattoo* (7,420,000), *The Dictator* (7,330,000), *Ice Age: Continental Drift* (6,960,000), and *The Twilight Saga Breaking Dawn Part 1* (6,740,000).[12] There does not seem to be any direct correlation between a film's success at the box office and number of downloads; rather, these seem to be parallel areas.[13] In any case, this area of consumption has seen substantial growth.

THE TWO PATHS OF RELOCATION

Keeping this landscape in mind, let's try to cast a more phenomenological look at cinema's shift beyond its old confines. Relocation seems to follow two main paths. At the center of the first path is the object: the film. Unable to re-create all the elements of the traditional theater experience, we secure the *what*, independently of the *how*. A good example occurs when I switch on my portable DVD player on a train. I could have passed the time in some other way: by reading the newspaper, telephoning someone, or chatting with the people next to me. I have decided instead to watch a title I missed a few months before and which I have rented in a kiosk. So I now take the disk, insert it in the machine, put on my headphones, and start watching. I might also have been able to locate this title on the Internet, in which case I would have had to power up my laptop or iPad, get connected, and download the file. In this case,

which as we have seen is becoming more and more common, I would have had access to the film without necessarily passing through a physical support, such as the one offered by the DVD. This means that on the Internet I am accessing images more directly, while with the DVD I need to have the object on hand in order to access the images. But putting aside this difference, important as it may be, in both cases I start with the *what* that I am seeing. It is because the object exists that I can experience it. And so I concentrate on what appears on the screen, I try to grasp the thread of the story, and I immerse myself in the world presented. In this way, in addition to being a traveler, I become a spectator—a bit like being at that movie theater that I did not manage to get to during the film's initial release.

Yet there is no auditorium: The film being screened exists, but the environment associated with the screening does not.[14] The place where I now find myself seems quite unlike the movie theater: With its noises, activities, and comings and goings, it seems to interfere with my attempt at being a spectator. Therefore, I must modify the environment in order to be able to watch a film. The acts I can perform are minimal, but useful: I stretch out on my seat, I draw closer to the screen so that it takes up a large part of my visual field, I raise the sound on my headphones so it is louder than the background noise, I minimize what is going on around me. The effect is the creation of a space all my own, in which there is only room for the film I am watching, and in which the flow of the external world seems suspended. However, it is an imaginary space: an *existential bubble* in which I take refuge because I choose to, not a ready-made physical place in which I take my seat, as is the case with the theater. If it is true, then, that even on the train I can find the opportunity to isolate myself from my surroundings and to concentrate on the images and sounds, it is also true that this happens because I coerce the situation and personalize it. Naturally, this personal construct proves to be fragile and temporary: all that is needed is for the conductor to ask me for my ticket, or the people next to me to raise their voices, or the train simply to arrive at my station for my bubble to dissolve. The experience, dependent on the film object and no longer supported by the environment, all of a sudden fades away: I am no longer able to feel that I am a spectator; I am once again just a traveler. I remove the disk from the DVD player, or I disconnect from my laptop or iPad. I also stop watching the film.

The second path is exactly the opposite. The cinema experience is reactivated far from its canonical locations, not so much because of the availability of an object as because of the existence of a suitable environment. Such is the case with my home theater, for example.[15] Here what matters is the fact of being in front of a wide screen, enjoying the images and sounds in the best way possible, surrounded by walls that shut out the outside, and being able to lower the lights and relax in a chair with food or drink at hand. Or rather, what matters is that these conditions have been given to me in real terms and that I do not have to reconstruct them through my imagination. Thanks to them I actually attain, without any effort, that isolation from the outside and that concentration on the images and sounds that make me feel like I do at the movie theater. Therefore, it is *how* I see, rather than *what* I see, that triggers the experience. It is the modality, rather than the object, that turns me into a film spectator.

It is no coincidence, then, that what I am watching can also change without altering the register of my experience. Let us suppose that from a film filled with special effects (it was to watch this type of film that I bought my home theater), I have now moved on to watching an episode of a television series or a match of my favorite team that is under way. Both objects, albeit to different degrees, are foreign to the cinematic world. And yet, if I watch them on my home theater, the environmental features that I mentioned earlier can lend a cinematic quality to them. The vastness of the screen, the soft lighting, and the suspension of what surrounds me see to it that I view the episode not as one usually watches a television program (in a distracted and discontinuous way) but as one watches a film (with concentration and attention).[16] But even the soccer match takes on features peculiar to the cinematic product—after all, is it not a spectacular representation of the world, with a large number of actors and extras, halfway between reality and fantasy, with a story that unfolds and suspense that keeps it going? So then, while the first journey of relocation returns an object to me and at the same time requires me to do something to the environment, here I find an environment for myself, and I can reshape the object. Naturally, my work of adapting the object to the situation does not always hold up. If, for example, my enthusiasm for my team is reawakened and, instead of staying relaxed in my chair, I begin to behave like I would in a stadium, the cinematic dimensions of

the experience begin to fade; dependent only on environmental aspects, it begins to subside. I am now on my feet, waving my scarf and singing my team's anthem; I have stopped being a film spectator and am now happy just being a fan.

DELIVERY, SETTING

So it seems that two paths have opened up before us. Cinema is relocated, making what I want to watch available somewhere else or re-creating somewhere else the best conditions for watching. In the first case, I am engaged with a film object that is presented to me wherever I find myself now; in the second, I am engaged with a viewing environment that is reproduced where it is possible to do so. On the one hand, a conveyance occurs, a *delivery*; on the other, a reorganization of the space, a *setting*.

Each of these two paths has a history behind it. The processes for delivery began in the 1960s, when television first offered us the opportunity to watch films on the small screen, thanks to some popular programs, the first and the most famous of which was *NBC Saturday Night at the Movies* in the United States.[17] This broadcast was self-serving on the part of television, directed more toward augmenting its number of viewers than increasing cinema-going. The format, furthermore, was not always ideal: The presentation of the film was interrupted by commercials, it was squeezed into a set time slot, with cuts made to the film if necessary, and often it was spread over two weekly programs, with the film sometimes divided in half. Nevertheless, this was also the first step in the migration of cinema to a new medium. This migration intensified in the mid-1970s with the advent of cable television and its specialized channels. The first company in operation was HBO, and it is no coincidence that its most valuable pay-television programming was sports and cinema. HBO was followed in 1976 by Showtime and in 1977 by Ted Turner's superstation WTCG-TV (later WTBS); in 1983, the former merged with The Movie Channel, while the latter bought the rights to the MGM library in 1986 and to a substantial portion of the RKO library in 1987. HBO, in turn, created Cinemax in 1980, a channel dedicated entirely to cinema, which also promoted new productions. At this point, film had found a home on the television screen. In the same year that cable television and

satellite entered forcefully onto the scene, another delivery tool attained widespread public success: 1975 was also the year of the VCR, with its two standards in competition with each other, namely JVC's VHS and Sony's Betamax. The VCR originated as a device to tape-record television transmissions so they could be saved for future viewing, but it quickly proved its worth as a tool for reproducing prerecorded works[18]: This led to a widespread trade in films on videocassette, which could be purchased or rented from specialized shops and then taken home to watch whenever one wanted. It also provided viewers with the option to select particular scenes, to speed up or slow down the tape, to reverse, or to advance frame by frame. So once again, cinema had to strike a bargain and pay the price: The VCR forced it to get rid of the strict temporality that is imposed by the movie theater, where spectators are obliged to follow a film's continuity and progression.[19] In exchange, the VCR offered it further circulation opportunities. This trajectory was completed by the introduction of DVD in the 1990s and then, most importantly, by the possibility of downloading a movie from the Internet in the first decade of the new millennium. As Chuck Tryon has extensively analyzed,[20] viewing will acquire further and more complex features, but films—now readable on a disk or accessible from the Internet at any moment and in any place on mobile devices like tablets and smartphones—will become increasingly accessible.

 The arrangement of environments that recall the cinema also has a history behind it. For example, beginning in the 1960s, museums—especially museums of natural history—started with increasing frequency to use screens with moving images in place of traditional display cabinets or dioramas. They did this because they wanted to modernize the forms of presentation of the objects (a need that had already emerged at the turn of the twentieth century).[21] In doing so, however, they drew frequent accusations of abandoning science for the sake of spectacle, or pedagogy for the sake of entertainment.[22] Retailers followed a similar route: Shops and department stores presented film clips with the merchandise they were selling on in-store monitors; in this way they made the objects more desirable, but also further increased the customers' enjoyment of the mise-en-scène tied to commerce. However, as the end of the twentieth century drew near, it was the city itself that was increasingly transforming into an exhibition space: large billboards gave

up their places to gigantic moving images; road signage often adopted an animated form; transit stations, waiting rooms, and streets filled up with screens; and walls became media façades (a transformation of the future depicted in *Blade Runner* [Ridley Scott, USA, 1982]). Finally, in this same period, an analogous transformation was invading the home: not only was there an increase in the number of appliances that liberated people from their domestic chores, but also, more importantly, there was a domestication of communication and entertainment tools: stereos, fax machines, printers, video-game consoles, video displays measuring more than thirty inches, and, finally, the home theater, in a sense the ultimate point of culmination for these gadgets. The home had become a smart house, and in this smart house, more and more weight was given to the consumption of spectacle.

This retrospective glance reveals how the operations of both *delivery* and *setting* have accompanied the cinema for a good part of its recent life: film was widely accessible for a long time, and suitable spaces for viewing outside the theater were available. However, it was not until the new millennium that the two paths at the core of cinema's relocation broadened and became more visible. This occurred and was made possible through the introduction of two types of media.

On the one hand, we have a series of devices aimed specifically at *transporting* content: there is no longer just the DVD player, desktop, or laptop, but also the notebook, tablet, and smartphone. Thanks to them, consumers have access to texts, images, and sounds of any type, anywhere, and at any moment. This means these media are extremely flexible, ready to adapt to the demands of the user, whoever that may be. Moreover, they are relatively neutral, capable of hosting material without shaping it into their own parameters. Finally, they are interchangeable, meaning they can also be used in place of other devices. In this respect, they leave behind even the recent past, when the consumer had to adapt to the tools (the film spectator submitted to the screening requirements), media and their contents were intertwined (every text in the newspaper became a news item), and every medium possessed intrinsic worth (radio and television were not only two appliances but, in a sense, two different worlds as well). Faced with a dramatic increase in material and situations, these media aim to deliver what is most needed, in the most direct and, at the same time, most focused method possible. What they lead to, then, is a

"personalized media delivery system"[23] thanks to which we can basically have access to everything in every situation.

On the other hand, we have a series of devices that work according to an opposite movement. More than just being transporters of content, they set up environments that the consumer can enter. I am thinking here of video games, which draw me into an imaginary universe, but also of augmented reality, which redesigns the real-world territory I am traversing. In both cases, a world that I can immerse myself in and interact with takes shape. These are true *experiential environments*, in the sense that they offer an *environment* and literally *let us experience it*. The system that animates them is not too distant from that of theme parks, in which the visitor plunges into a new reality; the simulation here reaches its apex with Nintendo Wii, for example, which transforms my room into a tennis court one moment and into a boxing ring the next.

These two types of media, media delivery and media environment, occasionally overlap. Microsoft Office, installed on my computer, provides me both with the opportunity to retrieve material from the archives of the Internet and from my folders, and with the possibility of entering a virtual space that is modeled on my everyday work space. However, these two types of media also reveal two different systems, which have at their center, respectively, the content and the environment: In one case, everything revolves around the texts, images, and sounds that I want to get hold of; in the other, everything depends on a context straight out of the real world that I want to access. The expansion of media makes use of either one system or the other, with distinct strategies and effects. The relocation of cinema today operates in the same way. It is also following two paths—in fact, it clearly distinguishes between them. It offers me either an object to view, leaving to me the task of imaginatively completing the environment in which I see it, or a viewing environment, allowing me the option of selecting the object.

THE SCHISM OF THE EXPERIENCE OF CINEMA

This double choice allows cinema to capture a larger territory. It can make films go anywhere and at the same time re-create elsewhere the typical way of enjoying them. The relocation of cinema can proceed in

all directions. There is, however, a counterpart to this expansion, and it is not insignificant. Transformations of this sort are not the only things toward which the cinema experience is inevitably heading: On the television screen, on the DVD player, in the home theater, on the computer or on tablets, we are losing the linearity and progressiveness of viewing, we are erasing the boundaries between film and other types of products, and we are losing the pleasure of associating a film with its habitual location. This is something more radical: With relocation, a traditionally unitary experience has been split in two. The cinema has long been both something to watch and a way of watching something. It has been a body of films and an apparatus (projector, screen, theater). The fact that, one moment, we are directed at the object, leaving the environment incomplete, and, the next, we are directed at the environment, leaving the object undefined, introduces a profound breach between the *what* and the *how*. Cinema becomes either the film object or a modality of watching films. Two things—no longer just one.

It is quite true that there has been tension in the past between the object and the modality of the cinema experience. In the 1920s, when the luxurious and elaborately decorated movie palaces were flourishing and the atmospheric theaters—with vast skies painted on their ceilings and landscapes often depicted on the walls—became fashionable,[24] it was the viewing site rather than the film being screened that was exalted. It is an environment that tells us, first of all, what the cinema is: the ability of the world to turn itself into a spectacle. Siegfried Kracauer, in a 1927 essay devoted to Berlin's large movie theaters, brings to light the meaning of this spectacle: Through the theaters' architecture and furnishings, we understand that the more a representation of the world communicates an idea of superficiality and externality, the more truthful it is, as superficiality and externality are characteristic of the new ways of living.[25]

By contrast, when between October 28 and December 30, 1934, Iris Barry presented a film series entitled *The Motion Picture, 1914–1934*, at the Wadsworth Atheneum in Hartford, Connecticut, and, to an even greater degree, when she repeated and extended the program about a year later at the Museum of Modern Art (MoMA) in New York,[26] what was highlighted was the object of the filmic experience.[27] Iris Barry was aware of the importance of the modality of a film's presentation, so much

so that in the first run of the program at the MoMA, in introducing *The Execution of Mary Queen of Scots*, she mentioned that the film had originally been intended for the Kinetoscope and was only later projected on the screen. But for her the cinema was above all a collection of works that gained their intrinsic value from the way in which they were shot, narrated, and performed. This value is established independently of the manner and the place in which the works are enjoyed; hence her decision to present simple fragments[28] and, more significantly, to present film in an improper setting such as an art museum. In fact, in this seemingly unsuitable space, the artistic completeness of the films was made to stand out even more.

Even in its classical period, then, cinema was identified one moment with a modality of viewing (which seems to exalt the superficiality of the world become spectacle) and the next with an object of viewing (which often appears, instead, as endowed with an intrinsic depth): two distinct poles. And yet, we can't imagine that one could exist without the other. It is no coincidence that critics in the interwar period often slipped from one aspect to the other. Louis Delluc, who carried out a methodical battle for quality films at the turn of the 1920s in France, also provided us with detailed analyses of the various Parisian movie theaters, each with its own characteristics and its own audience.[29] And Robert Desnos, who was among the finest critics of the 1920s, did not refrain from describing what happened to him while he was watching a film as part of an audience.[30]

Relocation splits this unity. Today, the identification of the cinema with either something to watch or a viewing experience bound above all to the environment is starting to become exclusive. At the top of former Blockbuster's home page,[31] a window alternates information about the films currently showing in theaters, information about the availability of films to rent, and information about the modality of buying films "on demand"; lower down on the same page we have four horizontal bands with rows of posters, devoted respectively to "DVD Spotlights," the films still screening in theaters, the "New Releases," and finally the films soon to be released ("Coming Soon"). All the titles offered can be rented or purchased as DVDs or Blu-ray Discs, but they can also be downloaded from the Internet for a fee. Here, cinema is reduced to an archive of works that we can access—it does not matter how and where we then watch them.

On the opposing front, on the home page of a California company that specializes in the installation of home theaters, Elite Home Theater Architects,[32] a caption reads, "We duplicate the exhilaration of attending a live concert and of going to the movies, in the comfort of your home." In the pages that follow, we are shown various models of the home theaters that are available, with very generic references to the films that can be screened there. Here, cinema is a viewing modality, indifferent to what we then actually choose to watch.

The home page of Family Leisure,[33] a chain of stores that sells "pool tables, tanning beds, spas, above ground pools, patio furniture, game tables, gas grills, fireplaces, bars, games, poker tables, and more," goes even further: We see a carefully arranged row of lounge chairs, with all the comforts of cinema seating, but almost without the screen (barely visible, an object evidently not for sale), and with a tagline that reads, "Stay Home for the Movies." Here, the films have literally disappeared, and the cinema has become nothing more than a place in which to be comfortable.

There is no lack of occasions in which the two fronts—delivery and setting—draw close to one another. For example, the opening image on the Netflix home page[34] shows a family at home in front of a screen, while the copy advertises the immediacy and ease of gaining possession of the films you want to see: "Streaming instantly over the Internet to your computer & TV," and "Watch as often as you want, anytime you want." On the face of it we have both an environment and a product, but of course the films can be downloaded wherever and whenever we want, and therefore that domestic space fitted out like a theater is only one of the possible environments in which the viewing can occur. I would add that the representation offered by Netflix also signals a nostalgia for a traditional form of consumption, to which we may be able to return; however, it is now one among many, and not necessarily the only one.

So now there is the sense of a rift: The cinema is either an object[35] or it is a modality. The consequence is undoubtedly serious: The cinematic experience is heading toward an unavoidable bifurcation. It will be either a *filmic experience*, if it leads to the *what*, or a *cinematographic experience*, if it leads to the *how*. Two types of encounter; two modes of doing; two forms of gratifying desires. Roland Barthes had already forecast this rift in one of his finest essays: "Whenever I hear the word

cinema, I can't help thinking *hall*, rather than *film*."[36] Barthes may have been breaking up a word in order to isolate the two meanings, yet he was also choosing one of the two to the detriment of the other. His love went to the auditorium, inside of which he could literally "décoller" (take off), rather than to the film on the screen, to which he had to "s'encoller" (glue himself).

Barthes was anticipating the moment at which the cinema would be facing two paths. As for us, we are already in divided territory. To be precise: the filmic or the cinematographic.

OTHER SCHISMS

This is not the only rift that cleaves the cinema when it is relocated elsewhere. Take cinema's migration on one hand toward the small screens of portable devices, which generally function as media-delivery systems, and on the other, toward the large IMAX screen, which functions above all as an environment. Haidee Wasson, in an excellent comparative analysis of films intended for the two types of screen and their modes of consumption, has shown how "little Web films enact the logic of the private, of the domestic, of the possession"; conversely, "the gigantic functions as a container, offering its grand vision only to capture us in its labyrinthine tracks."[37] In one case, then, an experience centered on intimacy emerges, while in the other we find one focused on spectacularity. Wasson describes the precedents of both forms of experience; I would add that cinema has traditionally held them together, whereas now it divides them.[38]

Often, bifurcations occur within the context of a single situation. Let us consider urban screens, for example, both the large-format ones mounted in the public squares of many cities and the more moderately sized ones found in shops, transit stations, and along roads. Their presence offers passers-by a dual choice. On the one hand, they can stop to look at what the screens are displaying and, seduced by the images—especially if they are large scale—try to immerse themselves in them. In order to do this, they not only have to bring their own journey to a halt, but they must also isolate themselves from the surrounding environment, let themselves enter into what they see, and abandon their activities for a

moment. In short, they can stop being passers-by and try to be spectators. On the other hand, they can continue along their way, just casting a glance at the screens in the same way we look around us to monitor the environment in which we move. In this case, they will not immerse themselves in the images; they will instead give them a cursory glance focused simultaneously on many spots. They will not be spectators, but accidental observers. Now, the presence of these two opposing choices has the effect of bringing to a halt the coexistence of two forms of attention that the cinema knew how to hold together: In the theater, I could let myself fall into an attentive gaze, and at the same time I could relax to the point of distraction. By contrast, the passer-by is at a crossroads and when faced with the screen must choose between two opposing forms of experience.

Let us now consider domestic screens. The home theater demands not only concentration from us—after all, this is what we ask it to do—but also a series of acts that help us to connect with what we are watching. We have set aside the time devoted to our viewing, we try to take a break from our commitments, we enter the room, we lower the lights, and we let ourselves relax into the chair: in short, we follow the steps of a little ritual. The screen of the television in the kitchen works differently: We watch it while we do our domestic tasks, while we eat, or while we converse with the rest of the family. It does not demand a ritual from us; it leaves us to our everyday lives. The consequence is a rift in what the cinema was holding together. In the theater, rituality and everyday life are intertwined; at home, the two aspects are separated and presented as opposing experiential poles.

I am moving forward too quickly, but I want to give an idea of how these bifurcations proceed. So let us also consider mobile screens, meaning my smartphone or my tablet. I use them to access a series of images, of texts, of sounds; at the center of my relationship with them lies a process of appropriation. But these screens are also instruments of control, both active and passive. I use them to follow events around me, to stay in contact with other people, to take photographs, or to find out where I am: in short, to monitor the surrounding world. And by using them, I myself am held under surveillance: someone can track me, or rather, someone *is* tracking me. The consequence, again, is a schism between what the cinema was holding together. While the cinema gave me the

sensation of being able both to explore the world and appropriate the world, now I must choose: either to navigate toward the discovery of new territories or to pay careful attention to my own, trying to not lose sight of it (and perhaps trying to be lost to sight myself).

FRAGMENTS AND SUBSTITUTES

This series of schisms signals a profound transformation in the cinematic experience. Much more than the loss of a place (that is, the theater) or of a support (that is, the film) or of a community (that is, the audience), it is the profound disarticulation of a viewing regime that seems to threaten the continuation of cinema's journey. *Cinema Paradiso* expresses it well: After the fire destroys the town's cinema and Alfredo has lost his sight, nothing will ever be the same again. A new hall will be built, new projectionists will do the work, new films will be screened, but that conjunction of collective interest and personal involvement, that ritual dimension that spread out into daily life, that desire to be surprised associated with a kind of social control exercised in this case by the priest (who excises scenes of kissing from the films), all these aspects will no longer be able to embed themselves in each other so as to form a seemingly contradictory, but in reality very solid whole. The cinema will become a composite object, the singular sides of which will at times refract very different realities.

Does this mean that cinema, in being relocated, is somehow heading toward its death? *Cinema Paradiso* also hints at a continuity. Totò, now a famous film director, returns to the village of his childhood for Alfredo's funeral years later. The villagers recognize him: not only was he a minor hero in the past, he is now a prominent figure. At the end of the funeral he receives a package that Alfredo had kept for him. Inside are the film clips that the priest had wanted expurgated because the scenes, in his opinion, were too risqué, but that the projectionist had religiously preserved. At home, Totò watches the clips; they bring him back to his past, and moreover rekindle his passion for filmic images and his desire to be a filmmaker. So, cinema is still a crucial presence. It is a legacy—the film clips. And it is a vocation—the need to deal with images that represent reality and feed the imagination. There will

always be films to watch, and films that bind us to cinema. There will always be someone ready to offer us a special gaze on the world, a gaze that has been peculiar to cinema.

This leads us back once again to the two paths of relocation. Let's examine their mechanisms further and try to understand how, while, on the one hand, they break the cinema in two almost to the point of killing it, on the other, they actually ensure its survival.

In the processes based on delivery, the film that I am watching appears as a sort of fragment of the cinema. The film is a component of a much larger whole, indeed, an essential component. On the one hand, it is what I go to see when I go to a movie theater, where I also find other stimuli: an audience, an atmosphere, high-quality image reproduction. On the other hand, it is one work among the many that an industry has produced through the years, and hence a single component of film history. I gain a cinema experience because I gain the experience of one of its *little pieces*—a little piece of what it regularly offers to its spectators, as well as a little piece of what it has been and is. This means that in this case, relocation functions in a certain sense through *metonymy*: It offers me a part that stands for the whole, or a part that puts me in contact with the whole (*pars pro toto*).

Naturally, this operation will acquire much more value the better the part provided to me can bring the whole with it. More specifically, my cinema experience (even though limited to the film—so, more correctly, my filmic experience) will be more intense and complete the more that the film I am watching, for example, on my DVD player, makes me re-experience the pleasures I felt watching it in the theater, or makes me understand the story better, or explains to me through the bonus material the role that the film has played in the history of cinema, or carries with it the success it attained at the box office, or tells me about the current trends in production. This is why a film on DVD benefits from having had a life on the theatrical circuit (and not only for mere advertising reasons): It is thus a fragment that knows better how to testify and can better report to me on the whole to which it belongs.

In the processes based on a setting, what is offered to me instead is a substitute for what is found in cinema. In fact, these processes aim to create environments of viewing that resemble as closely as possible those of the movie theater, even though they are *not* movie theaters.

My home theater allows me to lower the lights, to concentrate on the film, and to enjoy high-quality images. While on the one hand, it's true that I remain at home, on the other hand, I can experience this house as a movie theater. This means that in the case of the *setting*, we are not dealing with a part that puts me in contact with the whole (as with *delivery*), but rather with a situation into which certain elements belonging to another situation are transferred. Consequently, the underlying logic is no longer that of metonymy, but rather that of *metaphor*. With *setting* we literally attribute the modalities of cinematic vision to a new environment, and we expect to enjoy in it possibilities that seemingly do not belong to it. We call *theater* that which is not a theater, but which could be.

Naturally, the more convincing the transfer process appears, the more efficacious it will be. An extreme example would be the home theaters built by the architect Theo Kalomirakis, who draws on the large movie palaces of the 1920s and 1930s: we can recognize the design—or at least many of the details—of Hollywood's Chinese Theatre, Los Angeles' Pantages Theater, New York's Radio City Music Hall, and some large cinemas of San Francisco and Brooklyn.[39] The resemblance is aimed not simply at creating an imitation of the past, but literally at reviving the atmosphere and spirit of those temples of the cinema—creating the conditions for a perfect spectatorial experience, as the architect himself stresses again and again.[40] This is an experience centered above all on the environment and viewing conditions, rather than on the object being viewed (and, in this sense, it is fundamentally a cinematic rather than a filmic experience). But to the extent that it imitates the experience of going to the classical cinema, it will seem quite full and satisfying.

CINEMA AS RELIC, CINEMA AS ICON

Fragment and copy, metonymy and metaphor. These are not only two different strategies through which to relocate the filmic experience, but also two different modes of referencing the cinema, of recalling its essential traits, and thus of guaranteeing to the relocated experience its own completeness—we could also say: its own authenticity. Let us then take a step further in this direction in our analysis.

In the processes of *delivery*, I retrieve the canonical cinematic experience because I hold in my hands something that has been, or is, a part of it. The film I watch on my DVD player is a fragment of a larger corpus (produced films) and of a larger situation (the experience of the movie theater). It can also be considered a mere residue with respect to that corpus and situation: in essence it is all that remains of them. However, even as a mere residue, this film is capable of putting me back in contact with cinema: in watching it, I reconnect with the history and the modalities of cinematic presentation. In this sense, the film that I watch functions as a *relic*: It is like a piece of the body of a saint or an object that belonged to one or that was near one, which, thanks to this ownership or proximity, prolongs the living existence of the saint. Relics can also multiply: An object that touches a relic becomes a relic in turn. This causes an open metonymic chain to form: What has been near the saint, even if not immediately, puts me in contact with the saint. What is important in this chain is that even a fragment—mere remains—can reestablish the fullness of a presence, even while mourning a loss.

The clips of *Cinema Paradiso* that Alfredo preserved with care in order to leave to Totò, who now looks at them with nostalgia for a time gone by, function precisely like relics: They are fragments belonging to an entity that has now been dispersed, but nevertheless they are able to make cinema present—they are able to convey its sanctity, if you will, and to inform with this sanctity the work that Totò is performing. At the same level as these film clips, all the films that pass through media delivery function like relics: They are fragments of the holy body of cinema to which I can draw near, even if I find myself far from its temple.

In the case of *setting* processes, the viewing environment brings me back to the canonical cinematic experience through a resemblance as opposed to through contact. The home theater is a copy of the movie theater, and it works precisely because it shares many traits with its model. Therefore, we are dealing with a thing that stands for something else, but which in substituting it, recuperates its essence. In this light, *setting* processes follow the logic of the *icon* rather than that of the *relic*. An icon is a representation that possesses an intrinsic likeness with what is represented. In seventh-century Byzantine thought, such a likeness was conceived as a participation: the icon owned the same nature as its prototype; the latter emanated its essence on the copy, and in this way it kept living in

it. Even when after the Second Council of Nicaea (A.D. 787) a non-essentialist approach emerged, and the idea of participation was replaced by the idea of relation, the icon continued to reference its model in a full and direct manner. The representation was considered an impression of the represented: the subject literally molded its depiction. Therefore, an intrinsic link between copy and prototype continued to exist, not because they shared the same substance, but because they shared the same form.[41] Beyond these two positions, the idea that the icon concretely reactivates the presence of its model has remained. It brings this presence fully among us—even though in doing so, the icon marks an actual absence.[42]

The processes of preparing a viewing environment seem to follow this same path. It is not only a question of nostalgia for a certain way of watching a film; rather, it is also a matter of recognizing a model and giving it the possibility of being transferred into a copy. Let's think of the extreme accuracy with which many home theaters are set up to look like a film theater: This suggests a desire for the "spirit" of the latter to emanate into the former, as the prototype does with the icon. In this sense, cinematic relocation—even when it affects only one aspect, such as the viewing environment—attempts to give us the fullness of an experience. I would add that in *Cinema Paradiso,* it is Totò himself who becomes an icon: he reincarnates the roles, passions, and dreams of a pure cinephile and at the same time tries to reincarnate the great story of the cinema in the work he does.

THE AUTHENTICITY OF RELOCATED CINEMA

Of course, the idea of juxtaposing relocated cinema with a relic one moment and an icon the next may seem risky. It helps us to understand, however, upon what relocated cinema's sense of authenticity is based. This is confirmed by two other aspects tightly linked to the theme we have been discussing, which lead in the same direction.

First of all, to speak of relics and icons helps us to recall that the cinema has often been considered a cult object. In the first decades of twentieth century, theory often invested cinema with a religious valence. It is sufficient to remember this passage of the famous "manifesto" on the cinema as the sixth art by Ricciotto Canudo: "When [cinematographic

theater] becomes truly aesthetic, complemented with a worthy musical score played by a good orchestra, even if only representing life, real life, momentarily fixed by the photographic lens, we shall be able to feel then our first *sacred* emotion, we shall have a glimpse of the spirits, moving towards a vision of the temple, where Theater and Museum will once more be restored for a new religious communion of the spectacle and Aesthetics."[43] In this same vein we find writers like Vachel Lindsay, who speaks of the director as a prophet, or Antonello Gerbi, who speaks of the screen as an altarpiece.[44] After World War II, this cult gave way in France to a full-blown cinephilia, marked by an almost maniacal attention to films and ways of viewing them and characterized by a "pantheon" of films that rise to the level of sacred texts and rigorous spectatorial behaviors.[45]

Today, we are witnessing a return of cinephilia, as though the transformations of cinema led on one hand to a greater admiration for what is at risk of vanishing, and on the other a greater openness to what is being imposed. In 2011, the Web site mubi.com launched a large project entitled "New Cinephilia," curated by Damon Smith and Kate Taylor. The project consisted of a collection of classic texts on the theme, a series of essays on new forms of cinephilia, a forum, and a day-long symposium at the 2011 Edinburgh International Film Festival.[46] Nico Baumbach, speaking on this topic, observed that "Cinephilia today might mean one of two things: a response to scarcity or a response to abundance."[47] In the first case it would be "a way of loving a disappearing object—celluloid film (whether 16, 35, or 70mm) projected in large dark theaters—and therefore takes the form of nostalgia for the conditions that produced the first great wave of cinephilia (which could be extended to roughly a quarter century from the late Forties up through the early Seventies), the period of the economic boom, the self-conscious discovery of the American cinema as an art, and the emerging waves of postwar European cinema from Italian neorealism up to New Hollywood." In the second case, meanwhile, cinephilia is "a response to the sense of a new kind of digital utopia either emergent or already at our fingertips, in which virtually everything is virtually available—an inclusive cinephilia that incorporates everything and everyone." I find Baumbach's analysis perfect: I would only add that in the first case, cinephilia develops as a cult of relics, and in the second as a

cult of icons. As far as relics are considered, we might think for example of the enthusiasm surrounding the projection of restored films (remains, we might say, that one tries to bring back to life), but also the increasingly common collections of film memorabilia. In the case of icons, we might think about how the new objects of veneration, including video games, are seen as the reflection of certain traditional cinematic qualities, such as intensity of perception, the possibility of immersion, and so forth. The new cinephilia has a cult dimension as well, then: treating its own objects of veneration as "sacred remains" or as "true copies," it gives them a dimension of absolute authenticity.

The second path that icons and relics allow us to take originates with one of the greatest film theorists. Writing about the photographic image and its intrinsic rapport with reality, André Bazin used arguments not dissimilar to the ones we have mentioned here. On one hand, the image preserves the presence of the world thanks to the existential contact that it had with reality: "Photography enjoys a certain advantage in virtue of its transference of reality from the thing to its reproduction."[48] Not by chance, the footnote that is added to this sentence directly refers to relics.[49] On the other hand, the photographic image offers us reality anew, bringing it to new life in itself, thanks to a process of resemblance: "The existence of the photographed object participates in the existence of the model like a finger print."[50] In either situation, reality is "extended" in the image, and the latter allows the former to represent itself integrally. It is such a process that gives to the photographic image its authenticity.

These two openings, toward cinephilia and the theory of the photographic image, deserve longer discussion. I will, however, break off my analysis here. To conceive of relocated cinema as relic or icon is not simply a whim. Rather, it is a way to bring together a series of ideas that have been raised concerning cinema (its cult dimension, the nature of the photographic image) and have raised questions concerning its authenticity. Now, at a moment when cinema seems to be losing itself, it is essential to pose the same question once again. The relic and the icon, with their underlying logics, offer a response. It is either the contact with what cinema has been or the emanation or the molding of cinema on its replica that makes our experience to continue to be a cinematic one. We do not have only a fragment or an imitation: we have the permanence of

what has been. No matter how fuzzy, distorted, or discolored (here I am paraphrasing Bazin), this experience is not only the memory of a model: "it *is* the model."[51]

* * *

In 1915, Vachel Lindsay in his seminal book *The Art of the Moving Picture* devoted great attention to the movies as a new form of hieroglyph—and moreover as a way to retrieve the "primeval force" of things, as older forms of civilization were able to do. To him, cinema was Egyptian. Today, relocation transforms cinema into a relic of a "holy body" and an icon of the "prototype." Are movies, then, to become Byzantine?

3. Assemblage

PAUL AND MADELEINE

Paris, 1966. Paul and Madeleine go to the movies with their friends Catherine and Elisabeth. The choice of seats takes time—Elisabeth wedges herself into Paul's seat, forcing him out—but eventually the four settle down. On the screen appears a title card reading: "4X ein sensitiv und rapid film." It is a foreign film, and Madeleine comments: "Oh, it's in the original language." Paul gets up and goes to the restroom, inside of which he finds two men kissing. Before returning to the theater, Paul writes on the door of the toilet, "À bas la république des lâches" ("Down with the republic of cowards"). Madeline changes her seat to stay close to Paul; Elisabeth and Catherine exchange comments. A spectator behind them complains, and Paul openly insults him. The ratio of the image on the screen is wrong, and Paul runs to the projection booth, where he gives the projectionist a lesson on ratios and the necessity of respecting them. While returning again to the theater, Paul spray-paints a slogan against President de Gaulle on a wall, then stops and stares at a man and woman locked in an embrace in a corner of the alley behind the theater. Back inside, Paul asks: "Well, what's happened?" Catherine replies: Uh . . . It's about a man and a woman in a strange city. They . . . " On the screen, a violent love affair is developing between the couple. Paul

feels uneasy and wants to leave: "Let's go, it's stupid." Catherine: "Oh, no, no, I want to see it." Elisabeth: "Come on, let's go, eroticism disgusts me." Madeleine: "Speak for yourself." Paul asks Madeleine if she wants to stay. "Yes, I am staying": Madeleine is attracted by the movie, but also troubled. Paul's voice-over comments: "We went to the movies often. The screen lit up, and we trembled, but more often than not Madeleine and I were usually disappointed. The pictures were dated, they flickered. And Marilyn Monroe had aged terribly. It made us sad. It wasn't the film we have dreamed. It wasn't that total film we carried inside ourselves. That film we would have liked to make, or, more secretly, no doubt, the film we wanted to live."

What I described above is the eleventh chapter of *Masculin Féminin. 15 faits précis*, a film by Jean Luc Godard (*Masculine Feminine: In 15 Acts*, France, 1966). This is not only one of the most enjoyable episodes of the film, but also, as often happens in Godard, an open reflection on the nature of cinema. We follow a couple that enters a theater with two friends, not simply to see a film, but also to experience it, and we witness all the difficulties that interfere with this desire. The choice of the seats is not easy, and the characters constantly shift places. The film's audience is undisciplined, commenting on the movie loudly, quarreling, and that implies a permanent distraction. Paul misses part of the film, and Catherine must tell him the story. The projection is faulty, and the image is not what the director of *4x ein sensitiv und rapid film* would have liked. The plot of the film is unsatisfying, not because it embarrasses Paul (and attracts Madeleine), but because it does not correspond to the expectations of the two spectators. Furthermore, what is going on in the restroom and in the back alley is much more intriguing than what is being represented on the screen, and Paul is almost more attracted by these scenes. In short, Paul and Madeleine would like to experience cinema, but they are blocked by the conditions in which they find themselves. Theater, screen, audience, and film do not mesh. It is as if the cinematic "machine" has broken down.

But what is this cinematic "machine"? And what does it mean for it to break down? These two questions take on a high degree of relevance today, at the moment in which cinema's relocation to other devices and other environments brings not only a state of nonalignment between the viewing site, the object of vision, and viewing practices, as in *Masculin*

Féminin, but also radical changes in each one of these individual elements. The theater is no longer the only site in which to view a film: It can be consumed at home, or on a train, while traveling. Film in the traditional sense, furthermore, is no longer the sole object of vision: The category of "cinema" also contains other types of audiovisual materials. Viewing practices, finally, seem to take on ever-more personalized and contingent factors. In this framework, what in fact is an appropriate cinematic "machine"? Better still, what is a proper cinematic *dispositive*?[1]

Cinema has been considered—and largely still is considered—a stable and unified complex of consistent and distinctive components. According to this view, in order to have a true cinematic experience, it is necessary to be in a darkened room, sitting in front of a large screen on which a strip of film is projected. Any change to any one of these elements leads to a different type of experience. The new conditions of cinema's existence, as well as larger transformations around us and some theoretical developments, push us to correct this somewhat rigid concept. Technology is increasingly distant from the nineteenth-twentieth century model, based on integrated and monofunctional entities: It has become a diffuse element, open to new combinations and new uses. At the same time, our modes of living are no longer tied to a unique context: Environments—also because they are less and less "natural"— become largely adaptable. Consequently, what is now gaining acceptance is the idea that cinema consists of—and has always consisted of—a collection of heterogeneous elements (some of which derive from other dispositives, and many of which are permutable), which coalesce based on circumstance. Cinema assumes its configuration from time to time, through conjuncture, when motivated by an opportunity, a need, or a memory. And the experience of cinema takes advantage of any situation to revive.

The change in perspective is quite profound. The cinematic dispositive no longer appears to be a predetermined, closed, and binding structure, but rather an open and flexible set of elements; it is no longer an *apparatus*, but rather an *assemblage*. And it is not the "machine" that determines the cinematic experience; rather, it is the cinematic experience that finds—or even configures—the "machine." Such a reconsideration opens up a new horizon. Even in imperfect and contradictory situations, cinema can reconstruct its basic conditions so that the experience that

distinguishes it can continue. Even in new environments and on new devices, it can truly be reborn as cinema, ready to furnish new occasions for re-enchantment.

STRATEGIES OF REPAIR

Let's perform a mental exercise. Let's imagine Paul and Madeleine, the protagonists of *Masculin Féminin*, living in the Paris of 2013. The city is still extraordinarily rich in cinematic offerings, and there is no doubt that Paul and Madeleine would go to the movie theaters to enjoy films, even though they would find the same troubles as forty-seven years before. But there is also no doubt that they would practice other forms of cinematic consumption. They might watch a film in their home theater or download another onto their tablet and take it with them somewhere. They would miss the presence of other spectators, because their experience of vision would be limited to the two of them, if not to just one of them, each one to himself or herself, on his or her own device. The format of the image would inevitably be automatically transformed in order to adapt itself to the domestic or portable screen. The film would be accompanied by some commercials, and probably offered together with television series, music videos, or sports programming. Finally, their viewing experience would be much more discontinuous: On the home television, it would be interrupted by the continual insertion of other material, while on DVD it could be voluntarily suspended and picked up later, partially watched again, paused on a single frame, or skipped ahead to the end. Paul and Madeleine would no longer have anything to do with a broken cinematic "machine," rather they would be engaged in diverse situations, in which this "machine" seems, at least on the surface, to have disappeared. Nevertheless, they would not give up; they would try, as in 1966, to create the conditions for a satisfying cinematic experience. In a bit more laborious and complex way, they would seek to put in place *strategies of repair*, just as so many of today's spectators do.

Of what do such *strategies of repair* consist? How can a spectator minimize the differences with respect to an ideal model, constructing for himself the most "cinematic" experience possible? Let's consider, to take

the most extreme case possible, the situation of a spectator who has a mobile device.[2]

The individual and mobile mode of vision would seem to be the exact opposite of the collective and immobile mode that cinema adopted from the time of its birth. The rise of cinema at the end of the nineteenth century in fact created a clear-cut opposition between, on the one hand, spectacles based on images fixed in place and spectators free to move in space according to personal itineraries, as in the case of the panorama and the museum and, on the other hand, spectacles based on mobile images (or at least quasi-mobile) and fixed spectators, gathered together in an audience in front of the screen, as in the theater or the magic lantern show.[3] Cinema's inclusion in the latter group inevitably led to the characterization of the first group as non-cinematic.

Nevertheless, today in the field of new media, three possibilities seem to emerge that render this opposition less radical.[4] The first regards the space in which spectators are located. Viewers using a mobile device to watch cinematic or video material often find themselves in potentially distracting environments: a commuter on a train watching a film on a laptop, a pedestrian glancing at a video on a smartphone, or an employee watching some material on a tablet in the break room. In these cases, vision is subjected to inevitable outside intrusions. This does not, however, impede spectators' ability to detach themselves from the surrounding context and better immerse themselves in what they are watching. Viewers may find it helpful if the device is furnished with a relatively large screen, or if it offers high-definition images, or if it is compatible with earphones. However, the truly decisive element is for the user to succeed in constructing a *bubble* in which to seek refuge and to find a personal space in which to maneuver.[5] The walls of this bubble are very fragile and are subject to rupture at any moment. The privacy that they provide is quite precarious, as users remain exposed to the gazes of whoever passes near them. Nevertheless, this bubble offers a sort of shelter. When I nestle into it, I abolish my surroundings, and I re-create a sense of intimacy.[6] Thanks to this, I can construct a "mobile home,"[7] a "home away from home,"[8] which I can bring with me and in which I can recover a sense of familiarity even while inhabiting a strange and inhospitable space.[9] This "mobile home" resembles in some ways not only the den in which I have installed my home theater, but also the

darkened movie theater itself. I repeat: It does not have physical walls, but rather imaginary ones; it is not a true shelter, but rather a temporary refuge. However, it takes me in, and in this way it helps me to accomplish what I want to do—including viewing a video or film. Metaphorically, it allows me to pause, to sit, and to gather myself. Moreover, I often feel the need to construct a bubble even in the darkened theater. There too I am often surrounded by elements that could potentially disturb me: loud neighbors or the penetrating smell of popcorn. The seat in which I am nestled, and above all the dark, help me to isolate myself from my surroundings and project myself into what I am watching. However, I often have to make an extra effort to reach this level of concentration.[10] The bubble I construct for myself in open environments, despite its utter precariousness, and despite its reliance on a sustained mental effort, reproduces the same processes that are activated in more secure environments. It is thanks to the bubble that I am able to position myself face to face with the object of my vision.

The second possibility that new media offer us regards the state of the spectator. Users of a mobile device may find a certain intimacy with what they are watching, but they seem to have greater difficulty merging with an audience. The bubble in which they seek refuge can be shared with someone sitting alongside them who participates in the viewing,[11] but it cannot be enlarged beyond a certain limit. However, there are other tools that can help individual vision to assume a more collective character. They are related to the fact that new devices function as media platforms, which is to say, as instruments that aggregate multiple functions and services. From this derives the possibility of watching a film or video, but also of establishing contact with other individuals who are doing the same things. I am thinking in particular of my laptop: At the same time as I watch a streaming video, I can log into a social network and discuss that object. I watch and I discuss what I am watching with someone, who therefore virtually becomes my couch-mate. A Web site such as Constellation TV,[12] active for a bit more than a year between 2010 and 2012, aimed to offer a service of exactly this type. Its model was that of the cineclub or cineforum: Users paid a fee in order to watch a good film scheduled at a precise date and time. During the "projection," users could ask questions of an expert, usually a director, critic, or film professor, and when the movie was over, they could engage in dialogue

with other viewers who had seen the film. Despite its short run, this experiment is symptomatic of the necessity of offering spectators not only an object to experience but also a human context in which to do so. Cinema has always been associated with an audience: The new media context allows for the construction of *imagined audiences*, even when spectators find themselves alone in front of a computer or tablet screen.

The third possibility regards the object of vision. We navigate an environment saturated with images of all types, and we use instruments that allow us to capture these images without any distinction between them. It could be said that film spectators have always been in contact with composite programs: From the nickelodeon to the movie theater of the 1950s, the fiction feature film was always associated with a documentary, a newsreel, advertisements, and so on. And yet, the contemporary situation presents us with a more radical element: Cinema is only a small part of the continuous flow of images and sounds that reaches us from the many screens to which we are daily exposed, and these screens only rarely present themselves to us as cinematic screens. How then can we be sure we are watching cinema, when we are no longer occupying the darkened theater? The answer lies in the unique route certain images travel to arrive at the new distribution points, including mobile devices. I can receive everything on my cell phone, but if I open Netflix or Hulu, or if I go in search of videos on Web sites such as Comingsoon, or if I purchase content through an online store such as iTunes, or even if I select what I want to see through YouTube, then the material I receive is guaranteed, so to speak, to belong the universe of cinema. Cinema comes to me through the mediation of something else; however, it arrives to me with its identity intact. The route it travels is longer than that of theater distribution: it entails two steps rather than just one. But it is an officially sanctioned route, one that assures me that what reaches me is indeed cinema.

Therefore, while it is true that the new contexts of vision are distant from the classic cinematic experience, it is also true that we can "repair" the situation. Even mobile vision can approach the canonical model. The three possibilities briefly outlined above play a fundamental role: Thanks to the construction of an *existential bubble*, we have the sensation of inhabiting a protected space, even if we are out in the open; thanks to the presence of an *imagined public*, we can once again merge with a community, even if we are engaged in individual viewing; and thanks to

a *two-step route*, we can continue to enjoy the large worlds that cinema knows how to construct, even while immersed in the chaos of all the newly available content.

Of course, differences remain, and they are not to be discounted. The open environment increases the possibility of distraction, leading toward forms of consumption, such as epidermal and multitask consumption—which have been analyzed thoroughly by Mariagrazia Fanchi[13]—in which spectators are always ready to abandon what they are watching in favor of something else. The absence of a real audience and the indeterminacy of available material engender, as Lucilla Albano has emphasized,[14] a "hypertrophy of narcissism" and an "instability of desire" that place spectators at a dead end: They no longer know what they want, and so they end up wanting everything. Finally, mixed in with other material, cinema tends to lend itself to other uses—in a certain sense it becomes *de-cinematized*. However, as long as these differences exist and push us toward an alternative experience, we try to place ourselves in the condition of the classic spectator.

Cinema confronts new environments and faces new conditions, but it does not abandon us. In short, thanks to us, it is *relocated*.

THE QUESTION OF THE DISPOSITIVE

This permanence of cinema leads us to ask a crucial question. How is it possible to emend the situation to the point of bringing it back to what it no longer is? How is it possible to gain a cinematic experience even where it cannot take root?

We tend to think that our experiences depend on the conditions in which we find ourselves. This is particularly true for media: Ever since McLuhan, the reigning opinion has been that various means of communication favor various forms of perception and thought, according to the technology they use. Each means activates a particular form, and each means asks us to put ourselves on its terrain.[15] This implies that we cannot have a cinematic experience outside of the darkened theater furnished with projector, film, and screen. End of story. The strategies of repair seem instead to suggest the opposite. A consolidated form of experience—such as the cinematic experience—would be able to act

upon a set of circumstances to the point of affirming itself even if the circumstances are not all favorable. Cinema would remain among us, not in its complete form, of course, but not in a degraded form either. Now the story is open-ended.

These two positions clearly reflect two different ways of considering the role of the basic elements of cinema—the role of the cinematic *dispositive*. François Albera and Maria Tortajada have brought to light how the idea of the dispositive is historically associated with at least five elements: the presence of a series of technical components, the presence of a machine that holds these components together, the fact that this machine can include, within a single configuration, its user, the fact that this machine assigns a precise role to this user, and the fact that the machine subjects the user to a well-defined and ordered series of behaviors.[16] If, in considering these elements, we assume that a dispositive's components constitute a compact and stable ensemble, if we imagine that this ensemble produces one, and only one, form of experience, which is not possible without it, and if we think that the subject has no room to maneuver, then we must draw one and only one conclusion: We experience what the machine wants us to experience, and we need this machine to experience it. The idea of the dispositive as *apparatus*, which has strongly influenced film studies since the 1970s, assumes this position. If instead we consider a media's material base in terms of a heterogeneous collection of elements, which can be reintegrated, rearranged, and put to different functions—and if, at the same time, we conceive of the subject as something that is undoubtedly determined by the mechanism, but that can, in turn, intervene in the game, if for no other reason than that it is part of this mechanism—then the situation becomes much more flexible, and we can imagine cinema re-creating itself in other contexts and in other circumstances. Here the experience will still be influenced by basic conditions, but these conditions are neither permanent nor inflexible. Moreover, they can be restructured according to the type of experience that is put forward as the reference model. Technological determinism thus yields the floor to multidirectional influences.

In recent years—thanks to the technical transformations and the new theoretical frameworks related to cinema—there has arisen the idea of a more flexible and open dispositive. I will analyze this change in direction more closely, but only after a short flashback.

THE DISPOSITIVE AS APPARATUS

Let's restart from the idea of dispositive as apparatus, and let's reexamine the two texts that in the 1970s gave birth to this theoretical trend, "Cinéma: effets idéologiques produits par l'appareil de base"[17] and "Le Dispositif,"[18] both penned by Jean-Louis Baudry. According Baudry, on one hand the complex of camera and projector, and on the other that of the projector, the screen, and the dark room give rise to a mechanism[19] characterized above all by the ability to create a series of "ideological effects." The first of these consists in the concealment of the work performed by the movie camera and the projector. If it is true that the camera transcribes reality into a series of photograms lacking light and movement, and if it is true that the projector, in reintroducing light and movement, translates these same photograms into an image on the screen that has the same appearance as reality, then it is also true that spectators are not conscious of this double transformation: they simply enjoy this restitution of the world, victims of a hallucination that leads them to mistake a simple representation for the direct perception of reality. The second ideological effect consists in the creation of a transcendental subject with which spectators can identify themselves. The movie camera retrieves the model of the fifteenth-century *camera obscura* and therefore proposes a space that assumes the presence of the observer at the point of convergence of the perspectival lines. Moreover, the camera seems disembodied, ready to move anywhere, and it therefore gives a sense of omnipotence to the observer. In the same vein, the camera imbues with meaning whatever it frames and therefore makes the observer into an interpreter. Spectators identify themselves with the eye of the camera, acquiring consciousness of themselves and of what they see, but they also fool themselves into thinking they are the source of this process. The third effect consists in a regression toward prior states. In the darkened theater, in front of the screen, the spectator is immobile, all eyes, a bit like the baby in front of Lacan's mirror or the prisoner in Plato's cave. This leads them to relive, like the baby, the itinerary that leads to the formation of the self, and like the prisoner, they travel a path of knowledge that claims to be immediate but is in fact is mediated.

This is an extremely synthesized version of Baudry's ideas. Essentially, he links the technical components of cinema together in an extremely

homogeneous and closed whole, so that they directly determine what the spectator experiences, and so that the form of the experience is identified with the dispositive's structure. The "apparatus theory"[20] was then supported by these bases—at least until in the 1990s David Bordwell and Noël Carrol attempted to discard it with all of its problematic aspects, thus throwing out the baby with the bathwater.[21]

During the more than two decades when "apparatus theory" reigned, there was no lack of critical voices attempting to integrate the picture or to correct its rigidity. Among the integrations, relevant are those suggested by Christian Metz. In *The Imaginary Signifier*,[22] Metz analyzes the major drives that lie behind the activity of spectatorship—specular identification, voyeurism, and fetishism—and places them in parallel with the characteristics of the cinematic image, namely its presentation of itself as the mirror of reality, its separation from the observer, and its fragmentary character. This parallelism would seem further to solidify the apparatus; in reality, however, the superimposition of a "psychic machine" and a "technological machine" opens the way to a more complex configuration, in which none of the components has complete primacy. The apparatus, in addition to being a site where the pieces fit together, can also be a site of confrontation and negotiation.

As for corrections to apparatus theory, two voices are particularly worthy of attention.[23] The first, from the early 1990s, is that of Jonathan Crary. In *Techniques of the Observer*,[24] he notes that the cinematic "machine" is a point toward which converge not only scientific discoveries, but also social discourses and practices. These elements form a very wide network, in which they can take on a range of different orientations. Cinema resides at the intersection of two roads: the tradition of perspectival vision, which places emphasis on the observer as both receiver and organizer of the representation, and stereoscopic vision, which presupposes an observer not in front of the scene, but rather immersed in it. The latter road comes to prominence especially during the first decades of the nineteenth century, and it is closely tied to other aspects that develop over the course of that century, such as research in the field of physiology. It is the road of stereoscopic vision that leads to an idea of modern vision and of the modern spectator. The fact that cinema, despite its connection to the *camera obscura*, is related to stereoscopic vision, demonstrates how a technology is not assessable in and of itself, but rather depends on the

context in which it operates and on the history into which it is inserted, with all their complexities and conflicts.

The second voice dates from the end of the 1990s. Rosalind Krauss, in her *Voyage on the North Sea: Art in the Age of the Post-Medium Condition*,[25] shows how cinema, as opposed to painting, has at its foundation not a simple support, but a complex machine consisting of various components and open to various equilibria. It is a recursive and self-regulated structure, rather than a device predisposed toward a predetermined goal, something that is constructed bit by bit, rather than something given. "The filmic apparatus [. . .] is aggregative, a matter of interlocking supports and layered conventions."[26] It is no surprise then that artists increasingly use (or at least are inspired by) cinema and video: It is one way to measure themselves against a tool that neither forces them in only one direction nor limits them to only one dimension.

Crary and Krauss do not abandon the idea of the apparatus; instead they give it a new twist. The cinematic device is seen as deeply historical and is characterized by multiple genealogies and variable structures; subjects are caught up in the dispositive, but they also find in it the space to maneuver. Rigidity and unidirectionality make way for great complexity and flexibility.

FROM APPARATUS TO ASSEMBLAGE

I believe it is time to take this issue in a more radical direction: to renounce the very notion of the apparatus and replace it with the concept of the *assemblage*, which can restore to the dispositive its proper boundaries.

Two texts of a more philosophical nature may help us on our journey. The first is Giorgio Agamben's essay, originally entitled "Che cos'è un dispositivo?"[27] In this text, Agamben re-reads Michel Foucault, for whom the concept of "dispositif" plays a central role, and at the same time looks to the etymological root of the word. *Dispositio* is the Latin translation of the Greek *oikonomia*, which, in the theological writings of the second through sixth centuries, indicates the manner in which God "administrates" the world according to His plan of salvation: It describes God's *doing* rather than His *being*. From this perspective, it is easy to see how a dispositive is an operative instrument: It may be defined as "a set

of practices, bodies of knowledge, measures, and institutions that aim to manage, govern, control, and orient—in a way that purports to be useful—the behaviors, gestures, and thoughts of human beings."[28]

These tasks become explicit in large part through processes of subjectivation: When we enter within the field of a dispositive, we are assigned a precise profile—an identity, a self—which inevitably categorizes us, but which also opens to us a field of action. All dispositives—including systems of production, state apparatuses, and scientific disciplines, as well as types of media such as computers and cell phones—always lead to the construction of a subjectivity that defines individuals and constitutes the point of departure for all of their actions and experiences. Contemporary devices accentuate this operation: As they become increasingly numerous, they offer more and more subjectivities to the individuals who pass from one to another, effectively pushing "to the extreme the masquerade that has always accompanied every personal identity."[29] However, contemporary devices—and media in particular—are also characterized by an opposite operation: "What defines [them] is that they no longer act as much through the production of a subject, as through the processes of what can be called desubjectification."[30] When we use them we lose our selves, as in the case of the telephone user who risks becoming a mere number through which to be monitored. Is it possible to escape such a trap? Agamben proposes doing so through a *profanation*. To *profane* means to return a thing to its common usage after it has been placed in a separate sphere through *consecration*. In the case of dispositives, a profanation is that which allows for the liberation of what devices had captured and held apart, in order to render it ours once again.

This allows for the opening of an interesting scenario. It is surely true that subjects cannot move freely—they remain what the dispositive makes them.[31] However, it is also true that there exist maneuvers through which they can find emancipation. The practices of profanation—which Agamben explores in greater depth in another essay[32] and which include activities such as play—allow subjects, despite the extent to which they are determined by the situation in which they find themselves, to break through the circumstances and regain control of the terrain in which they move.

This sense of an opening also emerges in a work by Gilles Deleuze, written ten years before Agamben's, which, curiously, shares the same

title.³³ In his re-reading of Foucault, Deleuze redefines the dispositive as "a skein, a multilinear whole [. . .] composed of lines of different natures." These lines "do not encircle or surround systems that are each homogeneous in themselves, the object, the subject, language, etc., but follow directions, trace processes that are always out of balance, that sometimes move closer together and sometimes farther away."³⁴ The dispositive, then, is a collection formed by disparate elements, characterized by a continuous transformation, a continuous becoming. In this context, "lines of subjectivation seem particularly apt to trace paths of creation, which are constantly aborted but also taken up again and modified until the old apparatus breaks."³⁵ Therefore, while it is true that a subjectivity is never given, but rather is a construct, it is also true that it is always open to change. "We belong to these apparatuses and act in them." However, "in every apparatus, we have to distinguish between what we are (what we already no longer are) and what we are becoming: the part of history, the part of currentness."³⁶ The dispositive changes together with, and thanks to, its subject.

Deleuze, however, adds a second important element. While it is true that a dispositive is formed by a collection of heterogeneous elements and is never in perfect equilibrium, it is also true that it is always capable of holding together all the various lines in a single design, which, in turn, changes under the pressure of the dynamics at work. "Apparatuses are therefore composed of lines of visibility, utterance, lines of force, lines of subjectivation, lines of cracking, breaking and ruptures that all intertwine and mix together and where some augment the others or elicit others through variations and even mutation of assemblage."³⁷ What we have here are disparate components, their continuous and reciprocal interference, and the presence of crisis points, but also a kind of comprehensive structure to which all these things make reference—despite the fact that the structure itself is mutable.

The notion of assemblage, which ends the quote above, is essential to this point. It indicates the state in which the various elements reassemble themselves in a kind of amalgam. The term is also at the center of another of Deleuze's works—*A Thousand Plateaus*, written with Felix Guattari—where it means "first and foremost what keeps very heterogeneous elements together: e.g. a sound, a gesture, a position, etc."³⁸ In this sense, an assemblage is what transforms an assortment into a whole. The original

term used by Deleuze and Guattari is *agencement*, a word that carries the sense of "arrangement," "fitting," or "fixing." The English translation is adequate: The term "assemblage" refers both to a connection between different elements and to the new unity that is thus created. In the 1950s and 1960s, the term was applied to an artistic practice that involved making three-dimensional compositions by putting together found objects. Hence, the term carries the sense of a collection of items that are detached from a previous context and are recombined in a new unity. In Deleuze and Guattari, an assemblage is precisely that: heterogeneous elements that are stripped from former combinations, that enter into a new relation with one another, and that form a new general profile.

Conceiving of the dispositive as an assemblage is extremely useful. It allows us to avoid the dead end toward which the concept of the apparatus steers us. We no longer have to deal with a "machine" that is prearranged once and for all, but rather with something that is repeatedly re-formed under the pressures of circumstance, and the elements of which are free to recombine. And we no longer have to deal with a "machine" that captures whoever enters into its field of action, but rather with one that creates tension between its single components and their complex whole. The assemblage is coherent and solid without being inflexible; it determines its components without being a trap from which nobody and nothing can escape. It is a "machine," but also a meeting point, as Roberto De Gaetano has emphasized,[39] in which different elements are arranged.

THE ASSEMBLAGE-CINEMA

Let's try to redefine the cinema in terms of assemblage. François Albera and Maria Tortajada have made a similar attempt for the early cinema.[40] I will mobilize a more synthetic approach that will keep cinema's present condition in mind,[41] while also highlighting not only the different components at play, but also the reasons and the ways in which they find a mutual arrangement.

The first element of the assemblage is undoubtedly constituted by the presence of a series of images and sounds, grouped together in a more or less intentional and coherent manner, which we usually call a *film*. A film is characterized by multiple aspects—its duration, its format, its support,

its function—but what I would like to emphasize here is that it refers to at least three realities. First, there is an ensemble of products that constitutes the corpus of cinema, and which is identified with the most evident parts of its history. Then, there is a set of rules for constructing these products on a narrative, stylistic, or grammatical level, which, despite its change over time, represents a reference point for the production process. Finally, there is a form of production that follows, and sometimes challenges, these basic rules. The film lies at the intersection of these three realities: It is part of an imaginary archive, it enacts a language, and is the result of a process of production.

Second, there are the *practices of consumption* of films. These are gestures, even quite basic ones, such as buying a ticket, entering the theater, and sitting in one's seat, but also turning devices on and off, focusing one's attention, entering a possible world, and feeling oneself part of an audience. In this category, we find perceptual practices, cognitive practices, operative practices, and relational practices. They bring into play our body, our mind, our relationships with others, and our "transactions" with reality. In this sense, their extent is larger than cinema. And yet, they do so with respect to a precise act: the following of images and sounds for a determined length of time. Cinema is an experience that implicates sight and hearing within a circumscribed situation.

The third component is the *environment*. Our experience, beyond being *embodied* (connected to the body) and *embedded* (connected to a culture), is also always *grounded*, which is to say that it takes place in precise, physical spaces. This includes the media experience, which is by no means de-territorialized; rather, if anything, it is constantly re-territorialized. We always belong to a space, and this space determines us. Therefore, I am thinking not only of the darkened theater, but also of the living room, of city squares or streets that contain screens, of the Web sites we access with our computers, and of our personal bubbles: These are all spaces that are characterized by the fact that they offer a surface on which images can be projected, and by the fact that they constitute a sort of small shelter—an ideal one perhaps—in which to seek refuge for a while. We continue to inhabit a place, even when we immerse ourselves in the World Wide Web.

Finally, there is a series of important *symbolic needs*. I am thinking, for example, of our need to encounter the real, to imagine the possible, to

define the situation, to follow a story, to interpret the world, to attain control over things, and so on. These needs reside on a plane that is in some ways in opposition to the above-mentioned elements: Just as those constituted resources at our disposal, these represent necessities that require an answer. The former are tactical components, in the sense that they represent what I confront; the latter are strategic components, in the sense that they orient my action. The former constitute my everyday existence; the latter define an anthropology. In this framework, perhaps more than *needs*, I should speak of *instances*. They are something that literally presses us, in the double sense of pushing and of seeking urgently; but they are also something that engages us profoundly as human beings. Cinema, as André Bazin[42] would say, addresses above all our need to preserve the real through its appearances; but it addresses also, as Edgar Morin[43] would say, the need to lend a real guise to our imagination.

We will see in a moment how two additional elements, a technology and a spectator, are added to these first four basic ones. These four primary elements, however, provide us with the defining core of the cinema-assemblage: there is an ensemble of moving images and sounds, offered for our consumption, in a given place, and in response to a series of individual, cultural, and anthropological needs. Now, what is it that brings together these four basic elements? In and of themselves they are independent, and they live suspended between different poles of attraction: Images and sounds can also give rise to other types of products, practices of consumption can be activated in other contexts, places used for cinema can host other types of activities, and needs can manifest themselves in other forms. What is it, then, that allows these four elements, unstable in themselves, to re-territorialize—to use yet another Deleuzian term—in a sphere that keeps them united?[44] There are a least two aspects that seem relevant here.

The first is the presence of a *negotiation*. A negotiation occurs when heterogeneous elements seek to adapt reciprocally to one another for their mutual advantage. Cinema is a machine based on adaptation[45]: It feeds fantasy through images that reproduce the real, it puts spectators into contact with the world by secluding them from everyday life, it favors a social encounter thanks to a collective hallucination, and so forth. Seemingly heterogeneous elements confront each other, readjust themselves, and interlock. The four key components I have noted here are

Assemblage 83

no exception, and their accord, furthermore, is advantageous to each of them. In particular, symbolic instances acquire a certain concreteness as they are placed into an everyday context, while practices, environments, and discourses lose their contingency when they project themselves on a wider horizon. An undetermined need becomes a "need for cinema," as Edgar Morin pointed out so well in the 1950s,[46] and environments, images, and behaviors that have been open to different purposes up to this point place themselves at the service of what appears to be a true social institution.

I would add three brief observations. First of all, we should note how the processes of adaptation apply to single elements as well: In a film, the moving images adapt to the sounds and vice versa; in practices of consumption, individual behaviors adapt to collective ones; in environments, spaces adapt to viewing activity; as far as needs are concerned, individual instances adapt to social forms. Negotiation operates at all levels.

Second, the accord between different elements is often sanctioned—or at least fixed—by a particular instance that in this way "sutures" the whole. The Grand Theory highlighted the presence of a "suture" at the level of images and sounds: A film provides a play of gazes that implies an "absent subject" in the position of addressee; this "absent subject" is not only what keeps these images and sounds together, but also what holds together the flow of the film and the flow of attention and desire, thereby joining the discursive, the technical, and the psychological.[47] I want to suggest other elements that at different levels provide further kinds of "suture," that is, the possibility to stitch together a variety of components that are ready to converge. Lumière's invention found its unifying element in a screen, lit for the time of a projection, and able to receive a beam of light, to display a world in full view, and to collect a number of viewing subjects all implicated in the same space. The screen continues to play this role as "suturing element" also now, even without a proper beam and a proper public. More controversial, and yet still relevant, is the darkness of the space of vision, which cinema has, nevertheless, often sought to overcome: It is this darkness that allowed, and still allows, an environment to adapt itself to viewing a film and an image to take on the character of reality.[48] The list of "suturing elements" could be longer: There is always an element that "closes" the negotiation.

Finally, while the accord between elements ensures advantages, it also brings losses: Once they have been channeled into a fixed form, these four elements lose a part of their potential. Indeed, they are re-territorialized in what we call cinema, and they become a film (and not just images and sounds), practices of consumption (and not just a free behavior), a space for vision (and not just a simple place), the need for life and imagination (and not just a flowing desire). In exchange, once found their form, the four elements can become a true ensemble.

It is at this point that emerges the other crucial aspect: The presence of a *recursivity*. When consolidated, the elements can return and remain in the same positions—or, if one of them does not return, it is the same configuration or "formula" that return. This leads to the creation of a stable field of action, within which components arrange themselves according to consolidated modalities; or, within which, when one component is substituted by another, the total mechanism continues to perform an identical function nonetheless. Beyond the stability of the whole, recursivity allows for a certain automatism: As Stanley Cavell[49] reminds us, when elements return regularly, it is not necessary to think in terms of intention. This is precisely what happens when a narrative form, a style, or a figuration intervenes: A film continues on its own along the usual tracks. However, this is also what happens when a habit intervenes: This time it is the behaviors that continue on their own, based on already internalized gestures. Cavell adds that automatism renders things "natural": If something is always done in a certain way, then it is obvious that this is how it should be done. I would add that recursivity also helps to render the whole recognizable: The fact that elements return allows me to identify them immediately, and it tells me immediately what I am dealing with. This recognition is then confirmed in a series of discourses—reviews, authoritative opinions, regulations, theories—that outline what cinema is or could be. These bring to light a "social image" of the cinema that discursively endorses its presence. This is the point at which the dispositive finds its definition—and its identity.[50]

We have not yet mentioned two essential components of cinema: technology and spectators. The space in which these emerge is precisely the space marked by negotiation and recursivity.

Let's first take *technology*. This would seem to constitute not only the heart of the "machine," but also what guarantees it its maximum stability.

Indeed, it is hardly incidental that we still tend both to identify cinema with its traditional technology and to think of this complex as fixed (so much so that in order to signify the act of filming, we still make the gesture of turning a crank . . .). In this sense, technology is closely linked to automatism: It is the site of a function considered both self-evident and constant. The instruction manual of a device—whether it be a 35-mm film projector, a DVD player, a tablet, and so forth—exemplifies the presence of functional norms. This remains true even when the technological component is no longer a machine in the traditional sense, but rather an application, as is the case today. A software program also runs according to pre-established rules—perhaps in a more flexible way and perhaps with an autocorrective function, but it nevertheless runs along predetermined tracks.

If technology does this, it is because it has succeeded in coordinating a set of components into a single complex. It has, in short, carried out a successful negotiation. What appears self-evident and fixed is therefore the result of continuous processes that only at the end reach a standardization: At the basis of technology is not only an automatism, but also a progressive adjustment. The "pieces" of the mechanism must continue to fit together—and fit with the other elements in play. Only thus can the ensemble function on a regular and consistent basis. Today, the adjustment of technical components appears more urgent than in the past: We no longer deal with prearranged and uniform devices, but rather equipment that lends itself to multiple uses and needs to be reorganized from time to time. As we have seen, the experience of cinema can arise from a large LCD screen, a darkened room, and a DVD, but also from a laptop, a downloading program, and the possibility of extricating oneself from the surrounding environment. There are many interlocking pieces, and many configurations, and only after these have taken shape can the system begin to function. In this sense, technology now offers more space for negotiation. Of course, once a compromise has been reached, it can become literally automatic.

Now let's turn to the *spectators*. They, too, display a certain automatism. In fact, media activate a series of largely fixed perceptual processes: Whatever the content they offer at a given time, and whatever the concrete situation in which they do so, each medium "hits" us with largely regular rhythms, modalities, and orientations. In this way, media

organize a sensorium that works automatically and which constitutes part of the dispositive's positioning of the subject. However, spectators also constitute a dynamic element, suspended between a being (no longer) and a becoming (other), as Deleuze has written. They tend to be one of the "lines of breaking" of the assemblage. In this sense, they not so much sanction a point of compromise in the processes of negotiation between the various components as they hold the process open, endlessly relaunching it. Located at the intersection of discourses, practices, places, and needs, spectators intervene in the equilibrium between elements: They revitalize it when everything is working as usual, they restore it when it faces a threat, and they shift it when the occasion presents itself. From this is born a continual movement: forward, backward, and, paradoxically, in place.

I do not mean that spectators are the exclusive or privileged elements of transformation; following Bruno Latour, we know that they are just among the many "actors" in the "network"—some of them non-human, as the technological components are.[51] Neither do I mean that spectators are "free" in their action: Against a widespread neoliberal approach, which has sometimes been adopted by the left as well,[52] they must be considered as a component of the dispositive, behaving "inside" and not "upon" it.[53] And yet, because of their liminal position, spectators also constantly verify—and constantly keep open—the horizon of possibility, assuming in this way a dynamic role.

PROFANATIONS AND RE-ENCHANTMENTS

The description of cinema that I have sketched above attempts to furnish an idea of something that is capable of continual self-readjustment with no loss of identity. It is important to maintain a model that is both sufficiently distinguishable and flexible. Cinema's migration increasingly gives rise to opposing positions. In a volume of great interest, *La Querelle des dispositifs*, Raymond Bellour takes a step back with respect to his previous positions and suggests that the only experience worthy of the name "cinema" is what takes place in the darkened theater. Outside of the film theater, according to Bellour, there exist only two possibilities: either a "degraded vision of cinematic films" or a new territory encompassing

films and installations intended for galleries and museums.[54] At the other pole are scholars such as Philippe Dubois, who push not only for a limitless multiplication of the presence of cinema, but also for its dissolution within the great flow of images in movement to which we are daily exposed.[55] The model that I have proposed attempts to understand how cinema can live beyond the traditional conditions of its existence and also how cinema is nevertheless tied to a series of traits that identify it as such. Cinema is a dynamic reality that is always on the point of going beyond its borders and yet is also always ready to reaffirm its basic characteristics.

We can easily see this play of ruptures and readjustments, in which the identity of cinema seems perpetually on the verge of losing itself in order to reconstitute itself, in so-called grassroots practices. These are those bottom-up practices through which media users—film fanatics among them—experiment with new ways of using both devices and content. These practices include, for instance, the retooling of technology in order to produce unforeseen effects, such as a new kind of cinematography or a new kind of sound; marginal forms of film production and distribution, including the ones promoted by hackers; remakes put together by fans, with an intention somewhere between affectionate and ironic, many of which we can see on YouTube. Other examples are those film projections at which the spectators can intervene and interfere with what they are watching, such as the *Rocky Horror Picture Show*; or reworkings of a film or a trailer that are either edited in a different way (retakes) or are combined with the images and sounds of another product (mashups) in order to bring alternative meanings to the surface.[56] It is hardly difficult to see how these practices aim to call into question both the single elements of cinema and their reciprocal relations. Subjects who are formed by the dispositive nonetheless challenge its way of working: They intervene on one component or another and aim at the same time to reorganize the whole; they push its limits in order to render it more their own, so to speak. In this sense, it is not far-fetched to place these practices alongside Agamben's practices of profanation.[57]

Like the practices of profanation, the grassroots processes often take the form of a ludic behavior—a behavior that, as Agamben reminds us, simulates a situation, making it function in vain, and therefore neutralizing its effects.[58] This is what *Star Wars* and *Star Trek* fans do: They re-edit the sequences of the original movies or television episodes; they remake

well-known scenes with Legos; they dress up as their heroes; they organize conventions that function as a kind of live cinema; and so on. Fans in these cases intervene mostly at the level of the textual component, of film: They destroy the initial text, through a re-editing or a remake, and at the same time destroy the idea of a text itself, through a reenactment of the story in their own lives. They do so, however, joyfully, on one hand as form of paradoxical respect, and on the other in order to free themselves of any sense of subjection.

However, spectators can also arrive at the same point by making use of the "masquerade" that opens up before them—to stay with Agamben's terms—which is to say by trying out the assorted identities that media offer them, to the point of perverting their action. This is what happens with retakes and mash-ups: In these cases, ultra-competent spectators also become authors of new products, identifying themselves with filmmakers, but also signing their products on YouTube with different nicknames. Here it is the process of production, with its fixed roles, which is called into question. There are, of course, other elements placed under stress by grassroots practices as well. I have in mind here those collective viewings at a distance, in which spectators remain alone, but all watch the same film at the same time, an experience that changes one's sense of the viewing environment. Then there are also those often anomalous techniques used in retakes, which change our ideas about automatism. The entire dispositive is called to task.

We must not assume that grassroots practices are always aimed at undermining the dispositive. They are also directed toward reactivating widely traveled paths. It is no coincidence that they have produced types of results that are already in some way consecrated: retakes, mash-ups, viral behaviors, and so forth. Here what were formerly counteractions become part of the system. But the grassroots practices go also beyond. Opposed to profanation while still being intimately linked with it, operations of foundation or re-foundation of the dispositive come to light. In these cases, it is as if subjects work to allow the assemblage that defines them to work better; not to liberate themselves, but to make of their own inclusion—their own slavery, if you will—a situation that is desired rather than imposed upon them.

It is here that we find what we have called *strategies of repair*. The cinephiles who organize their own home theaters with all the most advanced

devices by combining them so as to enhance their performance as much as possible, or who download everything available for enriching their viewing experience, or who try to concentrate on the film playing on their computers with a diligence worthy of a Tibetan monk, reconstruct the cinema machine through practices that another believer could use, in reverse, to destroy it. Profanation and re-consecration are two sides of the same coin.

It is precisely this re-consecration that somehow pushes forward strategies of repair. They aim at restoring cinema—regenerating it, reinstating its profile—even if they do so by raising spectators from the status of mere believers to that of officiants. Cinema returns to being cinema. It could have died, whether from having been absorbed by other devices or from having lost necessary components. Instead, it returns among us, thanks to our action, thanks to a challenge and to a reappropriation. Cinema reinserts us within its horizon as effective spectators in order to enchant us again, thanks to our complicity.

Only an idea of the device as assemblage—that is, as a collection of heterogeneous elements that are ceaselessly combined and recombined, with a subject who remains suspended between no-longer-being and trying-to-be-something-else—allows us to understand how profanation and re-enchantment are subtly complementary. Cinema, no-longer-cinema, and once-again-cinema are configurations that go hand in hand.

AN UNSTABLE MACHINE?

Cinema, furthermore, has always been a medium that has tried to explore new paths through work on its individual components, through their reconfiguration, or through the introduction of new elements. This has at times taken it beyond its own terrain but in general has served to provide a better understanding of its nature and to reinforce its contours.

For example, beginning in the 1960s, we find quite a few artists associated with movements like Fluxus or performance art, who work with and on cinema, radically interrogating its basic elements. Outcomes are often extreme. There is a renunciation of the image: in *Zen for Film* (1962–1964), Nam June Paik uses a roll of clear leader that, when projected, turns the screen into a white surface.[59] (Guy Debord's *Hurlements en faveur de Sade*

[1952], even earlier, was constructed exclusively from white segments with voice-over and black segments that corresponded to silent pauses). There are works that mobilize a plurality of screens, from two up to seven (for example, Kenneth Anger and Paul Sharits), sometimes with the same film projected at different speeds (Malcolm LeGrice). Then there are completely new spaces for viewing, like Stan VanDerBeek's Video-Drome, in which a series of unsynchronized projects operate at the same time, creating a casual and variable spectacle (in some ways the opposite of the environments designed by the Eames brothers during the same period, in which multiple projectors created a rigorous and enveloping one). There are mobile screens, screens not lined up with the projector, horizontal screens, convex screens. There are performances that become films, and films that are part of performances, as well as cinema projections that are "disturbed" by the artist's presence (as in the case of Valie Export's legendary performance, *Genital Panic*).[60] There are multimedia experiences that bring projections together with live sounds and actions (as in Andy Warhol's Exploding Plastic Inevitable events).[61] There are projectors running with no film, projecting only a ray of light (Anthony McCall), as well as film with no projector (Roland Sabatier, Paul Sharits); and films that are not projected at all, so that the spectators are asked to imagine them (Maurice Lemaître).

These operations often aim to broach questions of politics or gender, or more broadly aesthetic ones. However, as Valie Export sums up in respect to her own work, dealing with cinema inevitably means calling the dispositive into question, to understand its possibilities better: "In Expanded Cinema, the film phenomenon is initially split up into its formal components, and then put back together again in a new way. The operations of the collective union which is film, such as the screen, the cinema theatre, the projector, light and celluloid, are partially replaced by reality in order to install new signs of the real." And furthermore: "The formal arrangement of the elements of film, whereby elements are exchanged or replaced by others—for example, electric light by fire, celluloid by reality, a beam of light by rockets—had an effect which was artistically liberating and yield a wealth of new possibilities, such as film installations and the film-environment."[62] The artist's work thus necessarily leads to a destruction and reconstruction of the dispositive, either to master it better or to point out new possibilities. This happens to such

a degree that some of the results (installation films or film-environments) can become widespread practices.

In this sense, the artists of the 1960s and 1970s were engaged in grassroots practices before the term even existed. Their ideological orientation was doubtlessly a different one: They functioned in a strongly critical dimension and were well aware that the subject is inscribed within the dispositive, while today's media users often adopt a playful attitude and presume that their action develops freely, on the basis of their own desire. In both cases, however, we find a destruction and reconstruction of the dispositive that brings about its reconfiguration. I would add that this act of destruction and reconstruction constitutes a kind of bricolage:[63] Both the artist of the 1960s and 1970s and the new media user of today rearrange a set of elements that they find in their hands, replacing or adding components, and giving rise to new objects. They attest to the fact that the cinematic dispositive is an unstable reality that can be continually reorganized.

Once again, it is the cinema-machine's nature as assemblage that makes this action conceivable and realizable.

THE PERIMETERS OF CINEMA

I have focused on the artistic work of the 1960s and 1970s and connected it, a bit provocatively, to grassroots practices. But this work on the dispositive is in fact a constant in the history of the cinema. We can detect it today in many of the museum and gallery installations that reference cinema explicitly, and which often dismantle and manipulate the components of the darkened theater one by one.[64] But we can retrace this work also in the experimental tendencies that dotted the golden era of cinema.

Let's consider the numerous utopias that flourished in the 1920s. At mid-decade, László Moholy-Nagy, in his book *Painting, Photography, Film,* explored a space of vision with a radically innovative structure and role: He spoke of a screen "in the shape of a segment of sphere," on which "more than one film would be played . . . and they would not, indeed, be projected on a fixed spot but would range continually from left to right or from right to left, up and down, down and up, etc."[65] In the same volume, he also imagined the complete abolition of the screen, thanks to

a "kinetic, projected composition, probably even with interpenetrating beams and masses of light floating freely in the room without a direct plane of projection."[66] Within the Bauhaus school there were other projects aimed at creating new conditions for vision, including Walter Gropius's *Total Theater* and Andor Weininger's *Spherical Theater*, in which spectators were surrounded by the spectacle, which could take place at any point in the room.[67] These projects also included other public spaces: In a work from a few years later, László Moholy-Nagy imagines projections onto the walls of houses or even onto clouds or artificial fog banks created expressly for this purpose, and he conceives of the city as an enormous expressive space in which the artist can intervene as a "painter with light" or a "light composer" (*Lichtgestalter*).[68] The idea of the city as a gigantic movie theater is also seized upon by Futurists and Russian Constructivists: in his story-essay "The Radio of the Future," Velimir Khlebnikov imagines screen-buildings featuring alternating news reports, art reproductions, scientific updates, and entertainment spectacles.[69]

Returning to the screen, Sergei Eisenstein held a famous conference in Hollywood in 1930.[70] At a moment in which the movie industry was beginning to think about the panoramic format, he proposed the adoption of a square screen that could contain two axes along which images would run and could alternate: the vertical ("a masculine, strong, virile, active composition") and the horizontal (linked to the "nostalgia of 'big trails' and 'fighting caravans'"). In the same period in Hollywood, Eisenstein sketched out the plans for *The Glass House*, a film that would require projection onto a screen of immense proportions, large enough to completely alter spectators' sense of the darkened theater and their modalities of vision.[71] What's more, twelve years before Eisenstein, the Italian critic Enrico Toddi proposed a screen of variable format and dimensions, capable of being adapted to the reality represented on it, to the point of creating completely differentiated forms of spectatorial involvement.[72]

There are many more examples that could be listed. What is surprising in any case is the fact that the large majority of these experiments, in making reference to cinema, claim to develop inside its boundaries or at least within its extended horizons. Although the dispositive is put under pressure, there is no desire to destroy it, but rather to explore the possibilities it affords or even to uncover its true nature. Naturally, certain

variations imply new types of texts, environments, and needs, and in this sense they seem to open up a new horizon. However, even when the models of reference move away from the habitual, they still tend to be perceived as a outgrowth of the old trunk, rather than as a new species. I will try to explain with an example that may be marginal, but which I believe is indicative. In 1922 the Pathé Baby, a projector for small-gauge film (9.5 mm) designed for domestic use, was introduced. Although its modifications to the cinematic device may seem minimal, the Pathé Baby implies, at least potentially, spaces, forms, and objects of vision that differ from those of the darkened theater. The Czech critic Karel Teige, in a beautiful essay in which he points out the "cinematicity" of many phenomena, also underlines the Pathé Baby's complementarity with respect to the dominant model. "In the meantime, the Pathé Baby device enables the introduction of the *home cinema*. Chamber music. [. . .] It is entirely proper to make a distinction between public art (posters, frescoes, street music, etc.) and private art, lyrical poetry, and intimate, lyrical films."[73] Cinema would be the epitome of the two domains, not of just one.

Returning to the more recent past, Roger Odin has observed that once the definition of cinema encompasses all of the elements that we tacitly accept—such as the inclusion of nonphotographic images or projection in nontheater spaces—even the most radical experimentation can be incorporated into the category of cinema without much difficulty. If anything, it may be useful to articulate various subterritories of cinema and to recognize those zones that exist parallel to mainstream production, such as research cinema or pedagogic cinema. As a result, we can identify the differences between them while also keeping them within a unified horizon.[74]

Raymond Bellour, who is an attentive observer of contemporary experimentation in cinema, video, and installation art,[75] made an even more radical gesture before assuming the one mentioned above.[76] He affirms that the cinema that is blossoming around and outside the movie theater is indubitably an "other cinema," and yet, it is not difficult to see how the categories that have traditionally characterized cinema continue to play a central role, even in this new reality. In fact, even installations inspired by cinema involve walls, reflective surfaces, succession, and projection: simply put, these elements are no longer taken for granted, but rather they have come to constitute question marks. We

often find them in another guise (as when a film's linearity is broken and various bits are projected simultaneously on a set of different screens, rather than being projected one after the other on a single screen); however, the ideal reference appears all the same, sometimes paradoxically. Indeed, the very same preoccupations have emerged in directors engaged in the field of art cinema, such as Godard, Ackerman, and Varda. Consequently, it is possible to perceive within experimental and avant-garde works the very same nucleus found at the center of traditional cinema. We can also identify in these works that dialogue with contemporary art a middle zone[77]: an *entre-deux*, in which cinema transgresses its own borders, entering into an apparent no-man's-land, where in reality it finds its own roots. If much contemporary cinema is an "other cinema" (starting with those works created for art galleries and museums), this does not mean that is no longer "cinema": it is, in the substance it exhibits and in the possibilities it opens up.[78]

CINEMA, NO-LONGER-CINEMA, ONCE-AGAIN-CINEMA

What can we deduce from the panorama I have sketched out above? First of all, it confirms the fact that cinema has always been a very flexible "machine," open to innovation and attentive to its own equilibria. Its entire history is marked by the desire to challenge the dispositive, to introduce new variations, and to experiment with new possibilities. Its history is also characterized by a kind of constant loyalty to the idea of cinema, almost as if venturing beyond its dispositive were a way of strengthening it. Its entire life is full of attempted profanations and recurring consecrations.

In this sense, while it is true that cinema now finds itself in front of a decisive challenge that is pushing it toward new territories and new forms of existence, it is also true that cinema has long been preparing itself for this challenge. Cinema has gotten a lot of practice being *no-longer-cinema*, almost as if it had wanted to adapt itself prophylactically for the possibility of a catastrophe. However, a second proposition is equally valid: While it is true that cinema has always tried to stretch beyond itself—in Eisenstein's formulation—it is also true that it has constantly maintained a bond to its own nature. Its prophylactic adaptation has always been

countered by a kind of inertia. When it could have renounced its identity, cinema has preferred to absorb the differences or at least localize them in an "other" cinema, which, however, continued to be "cinema."

Now if this was allowed to happen, if rupture and canonicity always go hand in hand, then it is precisely because the dispositive has functioned as an assemblage more than as an apparatus. Cinema has always constructed its "machine" by bringing together various pieces, creating permutations, stretching some components, and including new elements, but always in the end finding a configuration compatible with the habitual one. And cinema has always placed spectators in the role of having an experience that was beyond their expectations, but still within legitimate perimeters. In essence, cinema could always have been something else but has always preferred to remain itself. It has not negated transformations, rather it has responded to them with continuity. It has not sought to hide rupture points; instead, it has often preferred to cast them as part of an expansive design, rather than boldly using them as the beginnings of radically different paths.

It is in light of this history that today, faced with the great digital challenge, cinema paradoxically knows how to be itself even as it changes—and it knows how to change in areas of permanence. While mourning the loss of the darkened theater, of the film reel, of the photographic image, the *no-longer-cinema* and the *once-again-cinema* come face to face: they remain cinema nonetheless.

* * *

At the 2012 Whitney Museum Biennial, Werner Herzog presented an installation entitled *Hearsay of the Soul*. It consisted of five screens, three lined up along the back wall and two along the side walls. On the screens, sometimes in perfect synchrony, other times in alternation, two types of images appeared: the seventeenth-century landscape etchings of the Flemish artist Hercules Segers and a music group playing a work by the contemporary composer Ernst Reijseger. The installation references an earlier film by Herzog, *Ode to the Dawn of Man*, of which it used some material. In its layout, it recalled both the seventeenth- and eighteenth-century panorama, as well as screen formats such as the CinemaScope and Circorama. Moreover, Segers' etchings, which represent the invention of the modern landscape according to Herzog, recalled what was

considered cinema's primary vocation by early film theorists, that is, the restitution of nature—a restitution that Herzog pursues in all his films. Finally, the reference to etchings corresponded well to the use of filmic images, which constitute the culmination of mechanical reproduction. In essence, *Hearsay of the Soul* positioned itself at the intersection of many roads—modernity, mechanical reproduction, the landscape, the exhibition space, the integration of image and sound, and so forth—which all have cinema in common. In a certain sense, the installation exhibited all the components of the filmic device, laying bare the roots and possible outcomes. But there is, above all, one element that completes the picture. *Hearsay of the Soul* required projection in the dark. It is this dark—the warm dark of the film theater—that allowed Herzog's many threads to find a mutual link, an arrangement. There were at the Whitney Biennial other works based on screened moving images. *Hearsay of the Soul* was the only gallery installation that we may call cinema for sure.

4. Expansion

LUKE SKYWALKER

In 2010, a work entitled *Star Wars Uncut* began circulating online with increasing popularity. The title is willfully ironic. It is not in fact the original film by George Lucas integrated with cut scenes, but rather a remake based on a fragmentation of the movie. The original *Star Wars* film was subdivided into fifteen-second segments, and users were asked to reshoot whichever segment they chose, using any possible modality— live actors, cartoon animation, puppets, superimposition of comic-strip thought-bubbles over the photographic image, actors in costume, actors in contemporary street clothes, found footage, parody, literal reenactment, and so on. The new segments were collected via the Internet and then spliced together in the same order and with the same duration as the original. The final product used the original soundtrack, but without necessarily respecting the original dialogue. The result is a seemingly bizarre work, in which completely different styles, expressive registers, and aesthetic intentions coexist; homage to a cult classic is mixed with the pleasure of iconoclasm; and the possibility of following the story line is accompanied by the surprise of discovering how each segment will be presented. The selected segments, reedited in sequence, were then uploaded onto the film's Web site (www.starwarsuncut.com/) under the

(again, sarcastic) heading "Director's cut,"[1] where it can be viewed. On this Web site one can also find material that did not make it into the final version, along with new fragments that continue to be submitted to the organizers, a selection of the "Top 50 scenes," the explanation of the project, announcements of theatrical screenings, and even the original scenes from Lucas's film.

The promoter of the *Star Wars Uncut* project is Casey Pugh, an audiovisual project developer who works primarily on the Web, and who won a Primetime Emmy Award for this endeavor in 2010. However, a large number of protagonists are involved in the operation of the project: the fan community, anxious to move from spectatorship to production; a cult film, which is caught up in a logic that goes beyond mere remake; and finally the presence of the Internet, which functions as the site of mobilization and dialogue, as well as a collection point for audiovisual material placed at the disposition of all. All these elements render *Star Wars Uncut* much more than a delightful movie; they render it a symptomatic film capable of telling us several things about the state of contemporary cinema.

First of all, *Star War Uncut* owes a debt to Lucas's film, while at the same time exhibiting a creativity largely independent of its model. This is evidence of the diffuse vocation of contemporary cinema for taking up preexisting narrations in order to dress them up differently, or to illustrate previously hidden aspects, or to fill in unexplored gaps, or to uncover new ways of reading; but also to construct stories that parallel or enter into dialogue with those narrated by other media (television episodes and video games, for example).

Second, *Star Wars Uncut* is made by fans at home. It is accessible on the Web to whoever connects to it; however, it is also considered a full-fledged industrial product (it won an Emmy, is included on the Internet Movie Database, and is projected in mainstream movie theaters). In this sense, the film demonstrates the presence of new models of production, distribution, and consumption, which are added to, and often overlap with, traditional ones. We have moved beyond the traditional distinction between studio cinema and auteur cinema. Today there is a kind of creativity that wells up from below, associated with semiprofessional figures, new modalities of collaboration, and nonindustrial forms of circulation.

Third, *Star Wars Uncut* is not only a series of sequences edited in succession and running for 126 minutes: it is also a project, the explanation of which we can read on the film's Web site; it is the continuous intervention of fans; it is an archive of fragments that could enter into the finished work; it is a dialogue between participants; and it is the epitome of product promotion. In this sense, *Star Wars Uncut* demonstrates how it is that a large mass of heterogeneous material is now gathered under the heading of "cinema." The life of the film is continued in the "Making of," in spectator comments, in parodies and re-edits, in possible new editions—in other words, in a network of products and discourses capable of coming together to form one body.

Finally, *Star Wars Uncut* brings into alignment the most diverse types of images: comic book graphics, security camera footage, digital elaborations, diagrams, smartphone messages, found footage from various provenances, and so forth. It is a demonstration of contemporary cinema's urge to go beyond the photographic images that have traditionally characterized the medium. The advent of the digital has opened up many new possibilities, but it is the very idea of the "filmic image" that has now been placed under discussion. Cinema no longer has its own characterization, as vague as it may have been; now it is an open terrain, hospitable to the most wide-ranging forms of iconicity.

Thus far we have described a series of phenomena: a narration that takes up and rearranges other narrations, new modes of production and consumption added to the institutionalized ones, a text that aggregates within itself other texts, and images that go beyond their usual form. *Star Wars Uncut* carries out a curious operation: It takes what is undoubtedly a monument in cinema history, but in celebrating it, bypasses its stylistic, productive, and institutional boundaries. It does not exalt and preserve a *canon*; rather, it works on the *expansion* of film's preexisting modalities and dimensions. Contemporary cinema often presents itself as carrying out an expansion: It appears ready to adopt new solutions, to copy what other media do, and to go beyond its typical models. In doing so, however, it also exposes itself to risks. As soon as cinema abandons the individuality of a work, the centrality of film, the homogeneity of an industry, and the uniqueness of a language, it may also lose itself in the great sea of audiovisual products—indeed, in the great sea of images and signs. To what degree does film succeed in remaining itself? What can

give it, if not a full-fledged identity, then at least the vestige of one? To what extent is expansion also a form of persistence?

I will attempt to respond to these questions along a zigzagging trajectory, which will allow us to examine better some current trends and to reinterpret cinema through a re-reading—perhaps a tendentious one—of some theoretical contributions of the past.

EXPANDED CINEMA—CIRCA 1970

Cinema's expansionist vocation is not new. It can even be perceived in cinema's early days. From its very beginnings, cinema has found inspiration in literature, theater, music halls, comic strips, journalism, family photos, picture postcards, and so on. Its ability to bring to the screen whatever was of interest to the public can be interpreted not only as a desire to define its own terrain, but also as a desire to work on the terrain of others. However, there was a key moment in cinema's expansion that can be precisely located at a particular point in time: 1970. It was in this year that the American scholar Gene Youngblood published a successful book entitled *Expanded Cinema*.[2] This label circulated widely in the 1960s, especially in the underground cinema, and designated one of its particularly advanced currents, as the critic Sheldon Renan has discussed.[3] Youngblood takes up the term and explores all of its implications.

His starting point is the idea that an epochal shift is taking place: Humanity is entering into a new era—the Paleocybernetic Age—which is characterized by the evident deterioration of old concepts and the emergence of new forms of sensitivity.[4] The most significant cause of this transformation is the fact that we live in an environment that has become profoundly *mediatized*: We are immersed in a network formed by television, newspapers, radio, books, illustrated magazines, computers, and the like. Cinema constitutes part of this intermedial network, which leads to its systematic confrontation with all the means of communication that operate in the context of our lives, and not only with the ones that are most similar to it. Consequentially, there is a push toward the radical renovation of cinema's expressive instruments and, even more so, a push to expand beyond itself, to enlarge its own range of action decisively. As Youngblood explains, the tight connection that is created

between cinema and the media system "carries with it the potential of finally liberating cinema from its umbilical to literature and theater" and "forces the movies to expand into ever more complex areas of language and experience."[5]

How is this need for expansion expressed? Toward which territories and along which paths is cinema moving? Based on the experiments conducted in the 1960s by a series of filmmakers, video artists, and scientists, Youngblood points out some broad tendencies that lead cinema beyond its traditional boundaries.

The first tendency is tied to the medium as such. Cinema acquires a growing consciousness of its own means: on the one hand, it attempts to exploit better those that it already has at its disposition, aiming at new results; on the other hand, it attempts to add new ones, which expand cinema's expressive possibilities. Youngblood writes openly about a "fusion of aesthetic sensibility and technological innovation," offering as examples the work of Stan Brakhage, Michael Snow, Jordan Belson, and others. These filmmakers work toward a *synaesthetic cinema* that is capable of deeply involving all our senses. Youngblood writes that this cinema, precisely because it is so rich in solutions, "is the only aesthetic language suited to the post-industrial, post-literate, man-made environment with its multidimensional simulsensory network of information sources."[6]

The second tendency regards the emergence of a diffuse creativity. This is made possible by the presence of easily accessible technologies and by the advent of a new culture no longer tied to the idea of the masses. "For the first time in history every human now has the ability to capture, preserve, and interpret those aspects of the living present that are meaningful to him."[7] This leads to the presence of cinema in many moments of daily life and to its more individualized use.

The third tendency is connected to the possibility of creating feedback between the film and spectators. These spectators are not mere consumers: they are interlocutors who enrich communication as they respond to what they are watching. "If the information [...] reveals some previously unrecognized aspect of the viewer's relation with the circumambient universe—or provides language with which to conceptualize old realities more effectively—the viewer re-creates that discovery along with the artist, thus feeding back into the environment the existence of more creative potential, which may in turn be used by the artist for

messages of still greater eloquence or perception."[8] We live in a context that is no longer monodirectional, but rather is characterized by an uninterrupted circulation of information in all directions.

The fourth tendency is linked to the growing interconnection between cinema and other media. "To explore new dimensions of awareness requires new technological extensions. Just as the term 'man' is coming to mean man/plant/machine, so the definition of cinema must be expanded to include videotronics, computer science, atomic light."[9] This leads to a rich range of current and future marriages. One of these marriages is with theater: Cinema can become an essential component of live spectacles, to the point of engendering what Youngblood calls *intermedia theater*, examples of which we can find in the work of Carolee Schneeman and John Cage. Another confluence is with television. Youngblood is thinking of experiments pointing toward the aesthetic potential of magnetic tape, which make possible what he calls *synaesthetic videotapes*. He is also thinking of the first installations that made use of multiple video screens in order to create *teledynamic environments*; these installations follow the same logic as the staging of environments characterized by multiple projections and are capable of producing actual concerts of images. He is even thinking of commercial television, not for its intrinsic qualities, but for its ability to remind us that an artist is also a communicator who must know how to address an audience.

The newest and most productive convergence is with the computer: a machine that, according to Youngblood, will be able to "erase the division between what we feel and what we see" to the point of becoming "a parapsychological instrument for the direct projection of thoughts and emotion."[10] Thanks to this marriage, cinema can shift from representing phenomenal reality to directly representing human consciousness (twenty-five years later, Kathryn Bigelow's *Strange Days* will imagine a digital dispositive, the Squid, capable of recording a person's neural impulses and allowing another person to relive them by putting it on: this is precisely the machine conceptualized by Youngblood). There would be a number of intermediate steps before arriving at such a machine. Youngblood talks about *cybernetic cinema*, in which plotters design figures without the input of a designer. He also refers to *computer films*, in which figures come to life on a cathode screen, outside of all the traditional filmmaking processes, simply generated by a program. He describes

videographic cinema, which is born of the meeting of television with its fluorescent screen and cinema with its reflective screen. Finally, he imagines *holographic movies*, which reach beyond the flatness of the image to recuperate figures' three-dimensionality. At the time Youngblood writes, the forms he has in mind are all experiments, but he sees in these the most productive path toward the future of cinema. Expansion is an inevitable process: It responds to the expansion of our minds, which allows us to enter into a new era. "We are making a new world by making a new language. [. . .] Through the art and technology of the expanded cinema we shall create heaven right here on earth."[11]

NEW EXPANSIONS—CIRCA 2013

Forty years after its publication, Youngblood's volume shows a few wrinkles, due both to its chaotic pace and inclination toward utopic visions; however, it also maintains much of its freshness. It captures well a turning point regarding the now decisive role of media in our daily lives, it intuits the importance of nascent electronic technologies, it records the desire for the new in a decade of experimentation and research, and it suggests that cinema can conserve its identity only if it figures out how to find new paths. Cinema will either expand or risk obsolescence. The years after publication proved Youngblood right: in fact, reality became even more radical than his predictions. Cinema's ability to move beyond its traditional boundaries would become ever more evident and would surface not only in artistic experimentation but also in mainstream production. Cinema would expand much more consistently than could have been foreseen.

It may be useful to observe some aspect of our current landscape in light of the predictions Youngblood made in 1970, not to evaluate the accuracy of his analysis, but in order to capture the sense of an evolution.[12] If cinema today adopts expressive modalities taken from video games and the Internet, if it develops its technology in order to match the effects that can be found in theme parks, or if it creeps onto television or smartphone screens, it is because forty years ago, in the Paleocybernetic Age, cinema became fully aware of being a part of an intermedial network and, at the risk of losing itself, threw itself radically into question.

The first nucleus of the current expansion recalls Youngblood's observations about the technological implementation of the medium. In recent years, cinema has been enriched by numerous new technologies, both aural (for example, through the Dolby system) and visual (with the introduction of IMAX or the forceful return of 3-D, for example). These new technologies all aim at intensifying the level of the cinematographic experience through greater involvement of our senses. First of all, our vision is engaged more deeply through higher-definition images, better stability, and greater breadth. Simultaneously, our other senses are also engaged: not only hearing, through the creation of highly complex sound environments, but also touch, through stereoscopic images that almost allow us to grasp them. Thus, cinema is rendered no longer only, or specifically, optical; rather, it becomes a bit stereo, a bit media façade, and even a bit natural environment. We might even say that cinema approaches the theme park—the epitome of a space in which our entire body is engaged. As a result, cinema's field of action is extended.

The second nucleus of expansion is tied to the growing presence of grassroots production. Youngblood already noted the growth of a mass creativity: Today, this creativity has assumed even larger dimensions because of the ready availability of economical technologies for shooting and editing, as well as the presence of new possibilities for circulating material. Aside and beyond the film industry, there is a "light cinema" that is increasingly widespread and relevant.[13]

Much of this grassroots creativity comes from fans. As Henry Jenkins documented at the end of the 1990s,[14] today's fans are not only intense consumers, but also producers. They double the object of their love through remakes made on their smartphones, or through re-editing that brings to light new perspectives (recuts), or through superimposition of images and sounds from other films (mash-ups). These are products that circulate on the Internet in abundance—thanks above all to YouTube and Vimeo—and that also achieve official recognition, to the point of being included in exhibitions and festivals or placed alongside industrial productions. The film we started with, *Star Wars Uncut*, is a perfect example of this type of expansion.

Chuck Tryon has commented on a large number of these products, which are based in great part on the practices of retake and remix. These range from fake trailers that promote well-known films, offering a plot

completely different from the original (one of the classics is *The Shining*, reinterpreted in 2004 by Robert Ryang as a family film with a happy ending), or that promote nonexistent films, as if they were already in distribution (there are entire Web sites dedicated to this genre[15]), to compilation videos that gather together a selection of scenes from a film in order of preference, often with parodic intent. Tyron recognizes in these products a real cultural form[16] and foresees in them a way for cinema to project itself into a scenario like the current one, which is strongly marked by desires for self-expression, for intervention in the processes of production, for establishing social connections, and for instantaneous access to products at the click of the mouse.

Jonathan Gray has also dedicated attention to grassroots production. His idea is that these consist substantially of paratexts; that is, texts that accompany other texts in order to offer new interpretations of them. These paratexts seem to take a polemical stance with respect to the films they reference, especially when they adopt the mode of parody. In reality, according to Gray, their objective is primarily to "intensify certain textual experiences, less working against the industry's version of the text than cutting a personalized path through it."[17]

John Caldwell has offered an extensive analysis of this bottom-up production. He insists on the fact that the grassroots practices are not in opposition, but in accord, with the film and entertainment industry. The latter increasingly absorbs suggestions and experiments of the former. Hollywood has become an industry that practices poaching, functions as an open source, and operates through a gift economy, in the same way fans do.[18]

This reference to industry leads us to the third nucleus of contemporary cinematic expansion, which is linked to the growing number of adaptations, remakes, sequels, prequels, reboots, and so forth. It is as if contemporary cinema were always in the process of doubling. This is nothing new: Cinema has always stolen when the opportunity presented itself—from novels, plays, photos, and countless other sources. If anything, what is new is the number and the quality of the products now coming out. On the one hand, the number of media to confront has grown: today cinema dialogues with the graphic novel, computer games, home videos, security-camera footage, and more. On the other hand, more than stealing, we should now speak in terms of partitioning: a narration begun

by one medium is continued by another and advanced in parallel by yet another, reinterpreted by another, and so on.

Henry Jenkins accurately describes the strategies of what he calls *transmedia storytelling*: "Integral elements of a fiction get dispersed systematically across multiple delivery channels for the purpose of creating a unified and coordinated entertainment experience."[19] A film is born of a theme park, continued in a video game, generates a certain number of consumer products (clothing, food, toys), becomes a television series, returns to being a film, gives life to a comic book or a novel, and so on. This is what happened, for example, with *Pirates of the Caribbean*: It is no longer a simple cinematic work with annexes and connections, but a franchise that can be purchased in various products and formats.[20] A transmedia story is "a narrative so large that it cannot be contained within a single medium."[21] We can therefore enter into such a narration by many doors and explore it in many directions: It is, as Jenkins suggests, spread out along a series of channels of distribution.[22]

The fourth nucleus of cinematic expansion refers back to Youngblood's observations concerning feedback. Today, the audience's response has grown in influence: rather than punctuating the life of a film, it constitutes an integral part of it. I am thinking in particular of the role played by blogs, forums, and specialized Web sites: They are not merely spaces for expressions of cinephile culture, or outlets for unwitting propaganda for movies already in circulation, or places in which critics have retreated after being expelled from newspapers; these are also spaces for the accumulation of discourses that now form part of the films they discuss.

Chuck Tryon has analyzed a considerable number of examples of Internet interventions, including the discussions made during or directly after the viewing of a film in the theater or on television.[23] However, in order to appreciate the functions that blogging and networked film criticism cover, it is enough to go to a Web site such as Comingsoon.net. What can we find here? First, there is a section dedicated entirely to information. Under the menu item "Movies," we find a film database, release dates, production stills, and box office returns for the week and the weekend. Under "Trailers" we find material updated daily: behind-the-scenes clips, interviews, television commercials, trailers, and even partial sneak previews of trailers about to be released. Under "TV" we find the schedules of film offerings on television and related news.

Under "DVD" there is a list of the DVDs available on the market and related news. Under the menu item "News," there is a dense collection of daily news regarding film production and distribution. There is also a series of pages dedicated to spectators and open to their voices. Indeed, these are in some sense the true heart of the Web site. "Reviews" hosts film reviews written by visitors to the site to which other visitors can add their comments. "Most Popular" contains a series of rankings rated on the basis of user choices, in particular the "Most Craved Movies," "Most Craved Articles," and "Most Craved Searches." The "Forum" gives access to a community for which users can sign up. One can even connect to the Web site and its contents through Twitter.

At least since the 1920s, films have been systematically accompanied by a series of social discourses, which draw on them, comment on them, and assess them. Christian Metz, in referring to criticism and theory, speaks of a "third machine"—a discursive machine—that exists alongside the industrial machine of production and the psychological machine of vision.[24] The function of this "third machine" is to make cinema an object acceptable to and accepted by society—a "good object" in all the sense of the term. Today, the discourses around cinema continue to carry out this function of "valorization" or "ratification," but they are no more an accompaniment to films, rather something that becomes one with what it discusses. They occupy the same physical space as film, participate in its existence, and help it to develop and present itself on the social scene. They are within, not alongside, cinema. Comingsoon.net, with its ability to integrate access to films and the voices of users, is a clear example of this phenomenon.

The fifth nucleus of contemporary cinematic expansion is tied closely to the computer. Youngblood intuited how the marriage with this new dispositive would develop. In fact, the computer offers to cinema the possibility of going beyond the type of image that it has always used—the photographic image—to adopt instead a new type of signifier, the digital image. This step should not be underestimated. Cinema is not necessarily a mold of the world: It can now directly "create" reality on the basis of a logarithm.

Numerous scholars have interpreted the advent of computer-generated imagery (CGI) as a break with tradition.[25] While the photographic image presupposed the effective existence of what it represents, the digital image

can constitute a simple invention; therefore, film ceases to be the direct witness of something that really happened. David Rodowick takes this tack. According to Rodowick, cinematic narration continues to function as a model, even for stories offered by new media; however, the shift to digital inaugurates a new mode of representation. The image on the screen is no longer a true portrait of reality, but rather a "map" that guides our gaze. From this emerges the presence of an "interface" that acts as a filter between us and the represented world.[26] Lev Manovich is even more radical: The advent of the digital marks the end of cinema as a specific sphere. It returns to being what it often seemed to be: a simple region within the wide field of figurative arts. Its task among the figurative arts is to represent all of reality—internal and external—through the eyes of the artist, not to ensure a close connection with the world.[27] Therefore, it makes no difference what type of image cinema employs.

Nonetheless, we cannot reduce all of cinema to a pixelated landscape. As Tom Gunning emphasizes in his response to Rodowick, the indexicality of cinema—that is, its intimate connection with reality—does not rely exclusively on the photographic image: A film puts us in direct contact with the world by other means as well, including, for example, the ability to restore movement to things.[28] In another vein, Stephen Prince notes also that it is true that the digital image no longer functions as a direct "trace" of the real; nevertheless, the process through which we understand what it shows us as real is the same as the one set into motion by the photographic image.[29] This means that cinema can continue to be itself even when it uses digital images; in fact, digital images allow cinema to stay on its path, while expanding the field of possibilities and increasing the number of additional routes.

Naturally, there is also a spatial expansion. Cinema has come to occupy new environments. It has left the darkened theater and entered into the streets and houses of cities. It has emigrated, founded new colonies, and linked them back to the motherland.[30]

FROM CINEMATIC TO KINETIC (AND SCREENIC)

The rapid description offered in the preceding pages attempts to sketch out an idea of what cinema is today. It is a visual experience that also

attempts to involve our other senses. It is a myriad of products, from industrial to amateur. It is a series of stories that take up other stories and give life to new ones. It is a distribution platform for content that connects to and extends into other media platforms. It is an amalgam of discourses that derive from films and then become part of them. It is an expressive form at the crossroads of various traditions, such as painting and photography. It is a dispositive that seeks to appropriate images that originate in other dispositives. It is a medium that spreads far and wide, continually occupying new places. Cinema today is an expanding reality; or rather, expansion is the reality that best defines cinema today.

One could easily object by saying that cinema has never occupied a homogeneous territory, or that it has never really occupied a territory that was exclusively its own. It has witnessed the cohabitation of different practices of production and consumption: Alongside mainstream cinema, there has always existed avant-garde cinema, didactic cinema, family cinema, and propaganda cinema. It has held together a variety of discourses: trailers, film press, reviews, specialized magazines, cineclubs, collections of photographs and other merchandise, correspondence with stars, and so forth. Finally, cinema has never limited itself to "filmic" images: It has always aggregated material from other fields, from theater, painting, illustrated magazines, comic books, and the magic lantern. Cinema has always been broader than itself.

However, the presence of an easily identifiable basic technology (the movie camera, film stock, projector, screen) had always provided cinema with a common denominator, just as the centrality of film allowed it to organize that which surrounded it. And the presence of a "filtering" action allowed it to digest what it had adopted from the outside. Cinema has always had centers of gravity. Today, these certainties seem to have been compromised. From this comes the apparent ease of cinema's expansion: There is no longer anything to hold it in place.

This movement that leads cinema beyond its productive, narrative, media, and linguistic borders contains a paradox. On one hand it represents a great opportunity: Cinema can develop its internal potentials, can include new components, and can move toward new territories. On the other, such a movement brings dangers with it: As we have seen in the case of digital images, it can lead to a change in nature; or, as in the case of transmedia storytelling, it can mean wandering into a terrain that is not

strictly one's own. Cinema has acquired new possibilities and established new relationships, but it is no longer sure what or where it is.

From this perspective, it becomes clear why it is now difficult to use adjectives like *cinematographic*, *filmic*, or even *cinematic*. We face a realm so large and comprehensive that it loses any specification. What defines this domain is simply the generic presence of moving images displayed on a screen. Hence, the only adjectives we may use are *kinetic* and *screenic*: indeed, these foreground a character that, shared in common by so many different devices, from computers to smartphones, or from video games to *son et lumiére* spectacles, is hardly a defining one; better, they designate a quality without any real determination. Serge Daney, in describing this domain marked by indistinctness, chooses the term *visual* as opposed to the term *image*.[31] *Kinetic* and *screenic*, in contrast with *cinematographic* and *filmic*, move in the same direction.

Expanded cinema now resides within this wide and indefinite horizon. What qualifies it risks not being so different from what qualifies other media. As a consequence, cinema no longer appears to be a given reality. It is something that must prove its own existence and prove that it is being itself. It must emerge from the expansive and generic territory of the *kinetic* and *screenic* and affirm its own existence. It must rise up from anonymity and demonstrate its own specificity. Cinema today finds itself having to "return" to being cinema.

REMAIN-CINEMA, BECOME-CINEMA

There exist several recurrent practices that allow cinema to reaffirm itself as cinema. Some are defensive in nature: Cinema tries to "remain" what it is by pretending that the expansion it is moving toward does not have destructive or disorienting effects. Others are more open: A series of products "becomes" cinema after having crossed the great sea of screenic images. Some of these practices also touch upon the social life of films: They are activated the moment a series of products is presented to spectators. Others, instead, concern these products directly, the ways in which they are conceived, the forms they assume, and so forth.

Let's begin by addressing, albeit very briefly, the social strategies. I am thinking, for example, of the numerous ceremonies at which cinema

celebrates itself and, in so doing, affirms that it is still alive and is still itself. Lifetime achievement awards, film tributes in honor of celebrities, but also the red carpet more generally, all belong in this category. Festivals often associate the ceremonial with the idea of discovery: They further the notion that cinema is still alive, and one must simply know how to look for it. The statement of purpose of the Venice Film Festival in 2013 exemplifies this attitude: "The aim of the Festival is to raise awareness and promote the various aspects of international cinema in all its forms: as art, entertainment and as an industry, in a spirit of freedom and dialogue. The Festival also organizes retrospectives and tributes to major figures as a contribution towards a better understanding of the history of cinema."[32]

The archive and the museum remind us that cinema continues to live among us. These *promemoria* are especially good at emphasizing the presence of a glorious history, as is the case with the self-presentation of the Cinémathèque Française: "How was the cinema invented? What were the first movies like? How did we go from 'magic lantern to Hollywood'? We will discover the answers to these questions together through the observation of wonderful optical instruments with strange names, outstanding costumes, film posters and unique set decoration drawings, as well as many movie extracts."[33] However, the reference to history is often also connected to the challenges cinema finds itself facing today. This is expressed in an Academy of Motion Picture Arts and Sciences brochure announcing the creation of its own museum, with a declaration that is a perfect mélange of an evocation of tradition and an acceptance of change: "The significance of the movies has always been a constant, but the industry itself is undergoing dramatic change. Digital technologies are rapidly becoming the standard, along with new crafts and techniques. While motion pictures and visual storytelling will endure and thrive, documenting and curating the art, craft and science of the movies is now more important than ever."[34] In other cases, the diffusion of cinema over a vast terrain is accepted, but this does not mean that cinema cannot be made the central region of this territory. This is how the New Zealand Film Archive presents itself: "The Film Archive is the home of New Zealand's moving image history with over 150,000 titles spanning feature films, documentaries, short films, home movies, newsreels, TV programmes and advertisements."[35]

Even DVD editions function as witnesses to cinema's continued existence, as well as proof of the extension of its borders, as exemplified by the Criterion Collection's self-presentation: "The Criterion Collection is dedicated to gathering the greatest films from around the world and publishing them in editions of the highest technical quality, with supplemental features that enhance the appreciation of the art of film."[36]

Finally, some Web sites that track current productions play a crucial role as well. The most well known as well as the most representative of these Web sites is undoubtedly IMDB.[37] It contains a database of all produced films, and it furnishes continuous updates. In addition to being an extraordinary reference, the site functions as a kind of "authority" that defines what enters into the field of cinema and what is excluded. It is interesting to note that these borders are considered flexible: While traditional cinematic productions continue to occupy center stage (the numerous rubrics dedicated to "box office," "coming soon," "openings," the "100 Best Directors," and so forth, remain within the perimeter of *cinema-cinema*), the list of products tends to widen and now includes television series and video games, but not YouTube postings.

HOT MEDIA

There are also strategies of self-assertion that directly concern films, the ways in which they are conceived, and the forms they assume.

Let's first take a small step back. In the same years in which Youngblood published his contribution, Marshall McLuhan, in his influential volume *Understanding Media*,[38] advanced a distinction between hot and cold media. *Hot media* are those that grant their users such a great wealth of perceptual intensity that no form of completion is required, while *cool media* are those that propose low-definition messages, which must in some way be completed by users, on both a perceptual and an interpretive level. "Hot media are, therefore, low in participation, and cool media are high in participation or completion by the audience."[39]

Cinema is a decidedly hot media. "Film has the power to store and convey a great deal of information."[40] This wealth of information associates it with the book. Like the book, film proceeds by a tight succession of blocks—no longer typographical characters and sentences, but frames and

shots. Like the book, film nurtures spectators' imaginations and literally manifests it before their eyes.[41] Like the book, film appeals to our sense of sight; that is, the sense *par excellence* that lies at the center of the Westernization of the world.[42] But in comparison with the written word, film is able to illustrate a situation or represent an event in an even richer way. It leads us immediately to the heart of the action; it lets us see things in their own environment; it offers us perfect reconstructions of the present and the past. It is capable of mobilizing additional senses, thanks to the presence of music, dialogue, and color. Films involve our entire body. Film is able to associate the mechanical reproduction of reality with the capacity to produce dreams. Essentially, "in terms of media study it is clear that the power of film to store information in accessible form is unrivaled."[43] Consequently, spectators feel absorbed and almost dominated by images and sounds, to the point of falling into a kind of hypnotic trance. To open our eyes wide is also to begin to lose ourselves in what we are seeing.

Such a characterization of cinema has a long tradition behind it. McLuhan was likely not fully aware of it, but other scholars before him had thought of cinema in terms of sensory intensity, the ability to grasp the world, amazement, and abandon. Jean Epstein, in his extraordinary text "Magnification," describes the impact of film on the spectator as follows: "A head suddenly appears on screen and drama, now face to face, seems to address me personally and swells with an extraordinary intensity. I am hypnotized."[44] Béla Balázs reaffirms this combination of intensity and proximity: "Close-ups are a kind of naturalism. They amount to the sharp observation of detail. However, such observation contains an element of tenderness, and I should like to call it the naturalism of love."[45] A few years earlier, Giovanni Papini had underlined the particular strength of filmic images: "These are only images—small luminous two-dimensional images—but they give the impression of reality far better than the scenery and backdrop of any of the best live theatres."[46] And Ricciotto Canudo, in his famous manifesto, "The Birth of a Sixth Art," pointed out that cinema "represents the whole of life in action."[47] Cinema has always found its specificity in hotness.

One of the strategies cinema now uses in order to *remain* or *become* cinema consists in championing "high definition," and various maneuvers are involved. It is interesting to note, for example, that cinema, in its continuous exchanges with other media, often reserves the most

spectacular and aggressive content for itself. It is cinema that presents the most engaging scenes of a story that continues in a theme park or video game, leaving to the theme park the pleasure of an openly exhibited fiction and to the video game the pleasure of intervening in the narration. To this semantic dimension there can often be added a syntactic one: Cinema presents more cogent narrations. Its stories unfold at an unrelenting pace, to the point of literally taking our breath away. Cinema doesn't give us the chance to take a break, whereas while visiting a theme park I can—or rather, I must—stop for a moment to have a Coca-Cola. Furthermore, the events narrated by a film are characterized by extreme compactness: They are not a mere list of situations, but rather they construct something that hurtles toward a conclusion. A closed text in which everything appears necessary is plainly hotter than an open range of possibilities. Finally, there is an iconographic dimension to this strategy: Cinema reserves for itself the densest images. I am thinking in particular of the successful adoption of the IMAX, the increasing diffusion of larger screens,[48] and the recent reemergence of 3-D. This return of the stereoscopic image merits some consideration.

The first 3-D explosion (circa 1952–1954) was advertised and experienced in the key of high definition. Three-dimensionality promised an image endowed with an unusual perceptual intensity: Reality was apparently rendered in all of its depth, to the point that objects seemed to emerge from the screen, and the spectator had the impression of finding himself within the narrated world. In an essay written shortly before his death, Sergei Eisenstein fully seized upon this characteristic: "Stereoscopic cinema gives a complete illusion of the three-dimensional character of the represented object."[49] He added: "That which we have been accustomed to see as an image on the flat screen suddenly 'swallows' us into a formerly invisible distance beyond the screen, or 'pierces' into us, with a drive never before so powerfully experienced."[50] This second movement in particular was crucial to Eisenstein, who considered it "the most devastating effect"[51] of 3-D. In Hollywood, films such as *House of Wax* (André De Toth, 1953) and *The Creature from the Black Lagoon* (Jack Arnold, 1954) exhibited this capacity for "piercing" a spectator to capture her better, and at the same time they positioned themselves in opposition to other media, in particular television, which is characterized by a weaker appeal to the senses, and consequently by the impossibility to

create a strong sense of reality. Three-dimensionality, as Miriam Ross reminds us, was creating a vision so intense that it trespassed into the domain of touch.[52]

The relaunch of 3-D, this time in a digital version (D3D), began with *Avatar* (James Cameron, 2009) and reaffirms cinema's vocation of working with the "high definition," but robs this propensity of its polemical function. Stereoscopic vision, in fact, continues to appear as a distinguishing trait of cinema, but also functions as a bridge toward other media. As Thomas Elsaesser has underlined, such a bridge provides cinema with links to its past, but it is also intended to work in the future.[53] On the one hand, the new 3-D cinema does not hide its affinities with older optic devices like the phantasmagoria or the panorama, in which the spectator did not simply face the depicted scene, but could in some way move through it, in all of its depth and expansiveness. Eisenstein, furthermore, in the essay cited above, had already observed that stereoscopic cinema is a close relative of all of the previous attempts to break the threshold between representation and observer, demonstrating this through a series of examples ranging from painting to theater.[54] On the other hand, it is no coincidence that not long after *Avatar*'s release, stereoscopic images began to become available in other media, first on television, then on smartphones. This technology did not have the hoped-for success, but it demonstrates how cinema is still conceived of as a trailblazer, experimenting with something that is intrinsically its own, and then passing it on to other media.

So, the rediscovery of a genealogy, and the hope of a large diffusion. It is precisely in this sense that the reemergence of 3-D is exemplary of cinema's contemporary need to reaffirm its identity through "high definition," but it is also indicative of the fact that while it wants to *remain* or *become* cinema, it also continues to want to maintain an open dialogue with the territory in which it operates. In essence, cinema does not want to fade into anonymity, but it also is not renouncing expansion.

HIGH AND LOW DEFINITION

One could nevertheless object that contemporary cinema does not move only in the direction of "high definition"; it also increasingly works with "low definition" images. This approach is followed by movies that use

images created with webcams, cell phones, and security cameras, retrieve old archival images that have lost their former quality, or employ images taken from the large quantity of material circulating online. In all these cases, we face "poor images" that lack the quality we are used to finding on a cinematic screen. The artist and theorist Hito Steyerl writes about these "poor images" as a kind of *Lumpenproletariat* in the present-day iconosphere: "it is a ghost of an image, a preview, a thumbnail, an errant idea, an itinerant image distributed for free, squeezed through slow digital connections, compressed, reproduced, ripped, remixed, as well as copied and pasted into other channels of distribution."[55] Cinema gives an increasing amount of space to these images and literally makes them its own.

Why is this happening? And in what sense does this propensity not contradict the one we highlighted above?

Let's return once again to McLuhan. The distinction between *hot* and *cool* allows him not only to divide media into two large categories: on the one hand, the hot media (alphabetic writing, the printed book, photography, recorded music, radio, and cinema); on the other hand, cool media (the spoken word, the manuscript, the telephone, comic books, mystery novels, cool jazz, and television). McLuhan's distinction between *hot* and *cool* also helps him to distinguish different epochs within the history of media, emphasizing transitions in particular: from the coolness of orality to the hotness of the written alphabet; from the coolness of medieval culture founded on the transcription and commentary of manuscripts to the hotness of culture transformed by the diffusion of the Gutenberg movable-type press; from the hotness of the mechanical era to the coolness of the electronic era.

The first reason that cinema migrates toward poor images is the fact that it is now functioning in a *cool age*. The lowering of temperature had already begun in the 1950 with the advent of television,[56] and cinema reacted with films such as *Marty* (Delbert Mann, 1955) and *Room at the Top* (Jack Clayton, 1959), all characterized by "low definition or low-intensity visual realism, perfectly in tune with the new temper created by the cool TV image."[57] Today, in the Internet age, the temperature has dropped even lower, and cinema, by adopting "poor images," acts accordingly.

However, there is also a second reason: The adoption of poor images allows for the opening of a different space in which to maneuver.

McLuhan foresaw that media can change their internal temperature: Along the course of their lives they can either heat up or cool down, and may even incorporate forms that are seemingly contrary to those of their origins.[58] In these cases, they end up interfering with other media, to the point of extending into their sphere of action. For example, "radio changed the form of the news stories as much as it altered the film image in the talkies."[59] This media confluence, which can lead to the collapse of one into another, has as its effect the liberation of hybrid energies. "The crossings or hybridizations of the media release great new force and energy as by fission or fusion."[60] These hybrid energies serve to expose what is often hidden. In particular, if it is true that superstimulation leads to a state of numbness,[61] then hybrid energies serve to reactivate consciousness of a situation. "The hybrid or the meeting of two media is a moment of truth and revelation from which new form is born. For the parallel between two media holds us on the frontier between forms that snap us out of the Narcissus-narcosis. The moment of the meeting of media is a moment of freedom and release from the ordinary trance and numbness imposed by them on our senses."[62]

This is a fundamental observation. The second reason that expanded cinema accepts working with poor images is that by doing so, it can recuperate consciousness of itself and of the field in which it operates. If the recourse to high definition—and in particular to 3-D—permitted cinema to give spectators the world represented in such a way that they could literally feel it at their fingertips, then this embrace of low definition—with images taken from security systems, hand-held cameras, smartphones, the Internet, and the like—serves to wake up these same spectators, to alert them, to make them reflect on what it means to represent the world today. In this sense, the merging of a hot medium and low definition allows for the launching of a "critique of the political economy of signs"; that is, the launching of a line of thought that attempts to uncover reflexively what media are and do today.

This process is brought to the fore in the work of a director like Harun Farocki. Appropriation of the most commonly circulated images translates into a reflection on the very status of the contemporary image: In films and video installations such as *Eye/Machine* (2003), *I Thought I Was Seeing Convicts, Counter-Music* (2004), and *Deep Play* (2009), Farocki develops a critical reflection on the immense quantity of anonymous

and "operative" images that contribute to the disciplined and efficient functioning of contemporary society, by collecting and reworking material gleaned from sporting events, security and control devices, television programs, and so forth. Here, cinema becomes the privileged terrain on which to develop a greater consciousness of the landscape that surrounds us.[63]

We can also find elements of the "critique of the political economy of the sign" in mainstream cinema. The clearest example is that of *Redacted* (Brian De Palma, 2007). This film mixes multiple different types of images: those filmed by the soldier Salazar with his handycam for his video diary; those of a French director's documentary on Samarra; those of the military camp's surveillance cameras; those of the news broadcasts from Iraq or from local television; those of the webcam through which the soldiers communicate with their relatives; those nocturnal images filmed by the microcameras on the soldiers' helmets; those filmed by the Iraqi insurgents and posted online.[64] In this seeming jumble of images, "poor" ones inevitably run up against "rich" ones: The latter reveal the rhetoric that lies behind them, as in the case of the French documentary, but "poor" images show their limitations as well, both when they aim to capture events on the spot (as with the film's embedded journalist) and when they aspire to reach a professional level (as with Salazar's video diary). Anyone who thinks that filming the reality of war is simple or that they can have a privileged point of view on this reality is destined to failure.

In other cases, self-reflexity divides films in two. I am thinking in particular of Kathryn Bigelow's controversial *Zero Dark Thirty* (USA, 2012). In the last section of the film, which depicts the Navy Seals' mission to capture Osama Bin Laden, there is a large use of pixelated and blurred images, identical to those taken by the infrared viewers or by microcameras installed on the soldiers' helmets. This choice doubtlessly serves to satisfy the spectator's voyeuristic urges, but it also retrospectively brings out the highly spectacular nature of the first part of the film, which uses traditional images. These "perfect" images allowed us to see things quite well, in their full appearances. The poor images of the last section of the film do not allow us to see things as well, but they have a greater ambition: They seek to depict an event from inside, in its development, and as it is experienced by somebody who takes part in it. They remind

us of what Jean Epstein said about the camera's eye: "This eye, remember, sees waves invisible to us, and the screen's creative passion contains what no other has ever had before: its proper share of ultraviolet."[65] This contrast between "high" and "low" images creates a break that splits the film, and perhaps all of contemporary cinema: on one hand there is the *reality effect*,[66] thanks to which we grasp the world in its full visibility; on the other there is the *truth effect*, through which we gather the world in all of its processes and intrinsic meanings. The full images provide the former, and poor images deliver the latter. Reality and truth are no longer a single thing, as they have been in cinema's past. We need two different regimes of sensibility to describe the world.

It is a matter of fact that today the poor image tends to be taken as synonymous with authenticity, sincerity, and even truth. Many films use them precisely to suggest these values. In this vein, it is worth remembering that Georges Didi Huberman, analyzing four photographs of Auschwitz secretly taken by a prisoner, has masterfully shown how it is a certain invisibility that allows an image to speak.[67] Only if they are "images in spite of all" can they bear full witness. The presence of a contrast in temperature (hot and cool) attests to this link between invisibility and truth, but also helps us to relativize it. This truth effect can be little more than a stylistic tic, as in *The Blair Witch Project* (Eduardo Sanchez and Daniel Myrick, 1999) and in the many films inspired by it.[68] Or it can be something that images deceptively imply, sometimes to justify a further action, as Farocki constantly points out about war documents. Poor images can be false, and rich ones may become true, as for example when they conserve their value as trace. What really matters is a dialectic between the two poles: This is what allows a "critique of the political economy of signs" to emerge, and thus permits the rise of a full awareness of how they function and what value they carry.

This brings us to a somewhat paradoxical conclusion. If, on the one hand, the adoption of "low definition" leads cinema far from what seems to be its primary vocation, on the other hand it allows it to remain in its chosen space. Poor images force cinema to renounce "high definition" on the level of perception, but they help it to gain "high definition" on the level of cognition. They elicit a reflection on the circulation of signs and their truth value. The senses cool down, but thought heats up. An "illusion machine" also manages to acquire an "intelligence."

ONE, AND THREEFOLD

At this point, we can better discern the portrait we have been sketching. First of all, there is a major movement that is leading cinema beyond its traditional borders toward new forms of production, new products, a new idea of text, and new types of images. Cinema extends its range of action, implementing its own internal possibilities, associating other media with itself, and shifting itself onto the more expansive terrain of moving images. It becomes expanded cinema.

Such expansion brings the risk of a loss of identity. Cinema attempts to neutralize this danger by reasserting its ties to a tradition that claims a strong appeal to the senses. This leads to a pursuit of particularly rich images, tight plotlines, extreme situations, and engaging sound environments. In this framework, the adoption of 3-D seems particularly meaningful: cinema reaffirms its ability to absorb the spectator in the represented world more quickly and effectively than any other media.

However, cinema concurrently pursues an opposing strategy as well: It increasingly uses "poor images," shot with camcorders or cell phones, or taken from surveillance cameras, or appropriated from the Internet. Here, cinema does not attempt to absorb the spectator in the represented world, but rather to cultivate a critical consciousness that investigates the state of media and their responsibilities in the processes of knowledge. If these poor images are "low definition," the consciousness they raise is "high definition." They too work on intensification—but that of the intellect, rather than the senses.

An expanded cinema that preaches dispersion; a willfully "hot" cinema that seeks adhesion; a "cooler" cinema that pursues self-consciousness. It is not the first time that cinema has been deeply split, yet now the relationship between the different parts looks more complicated and less well defined. There no longer exists an ideal point of convergence as there did during the golden age of the seventh art, when various forms of cinema tended to draw inspiration from the same model. Nor is there any longer an open conflict, like the one that began in the 1950s when Hollywood cinema, *cinéma d'auteur*, and the cinema of the emerging countries of the so-called Third World were proposing different models, but were all moving in a common universe. Instead, there are now three coexisting hypotheses that face each other in the attempt at remaining

or becoming cinema, three coexisting hypotheses that in a certain sense defend territories that are not always permeable: put simply, the Internet (the typical space of dispersion), the blockbuster (more and more tied with the perceptual intensity), and experimentation (traditionally the cradle of self-consciousness).

Of course, there are bridges that ensure transit from one sphere to another. I am thinking, for example, of grassroots practices that recuperate intense images from successful films and re-edit them ironically, which "cools" them and adjust them to the Internet. I have already cited various examples along these lines: for instance, so-called honest trailers, which are fake advertisements for famous films that highlight their defects. *Avatar* (James Cameron, 2009), for example, is summed up with a series of images and commentary that pass by so fast that viewers understand nothing of what they have seen or heard, and with a list of other films with similar plots, which nullifies any claim of originality.[69] The same game of subversion is played with *Prometheus* (Ridley Scott, 2012), even more ferociously.[70]

On the opposing front, I am thinking of the insertion of poor images into "high definition" films destined for the commercial circuit. One of the first uses of this practice was made in *The Bourne Identity* (Doug Liman, 2002): The heads of the CIA at Langley attempt to locate the wayward Jason Bourne by reconstructing his presence inside the American Consulate in Zurich through security camera images. These images are captured, isolated, enlarged, and filled in, so as to render decipherable the license plate number on Bourne's car. What we have is essentially a brief "low definition" film within a "high definition" film, in which the former furnishes a truth that the latter—perhaps being too wrapped up in sensorial engagement—cannot manage to reach.

These bridges exist, but there are also some difficult crossings. In the third episode of the *Bourne* series, *The Bourne Ultimatum* (Paul Greengrass, 2007), there is a sequence that seems similar to the one mentioned above: Through a series of surveillance cameras, the CIA attempts to follow a journalist and Bourne through Waterloo Station, where an assassin awaits to kill them. However, in this case the images are live rather than recorded, just as the gaze, rather than searching for the truth, now serves to coordinate an action—in this case, the assassination of Bourne and the journalist. This means that inside the "high definition" film there is no

longer another small film, restoring to the former a greater consciousness of what an image is today. Instead, we find something that belongs more to the worlds of television (the live image) and of surveillance (the functional image). Here, cinema stops wanting to explore other ways of being, and instead seems to be attracted to what it is not.

Indeed, cinema today is one and threefold. The presence of a multifaceted profile is precisely what underpins the dialectics on which the remaining or the becoming cinema rest, but this profile also reveals in the background a "geography of media" that makes the sense of unity difficult and precarious.

THE DISTRIBUTION OF THE SENSIBLE

The emergence of the three cinemas I described above—cinema of dispersion, cinema of adhesion, and cinema of consciousness—foregrounds not only a "geography of media," but also a "political geography" with which film equally must come to terms.

Let's focus again on the sensorial dimension, this time not with the help of Marshall McLuhan, but with that of the philosopher Jacques Rancière and his concept of distribution of the sensible.[71] The concept defines the way in which a given society makes accessible to the senses that which is present within it; for example, the way in which a word is offered to the ear or an image to the eye. There is always something in common to all the members of a society, but it is made available in different ways: We can have a specific address or a free circulation, the transmission of information or the concealing of a secret, the creation of a hierarchy or a sense of equality. To make a word or an image accessible to the senses means to outline roles and positions, which in turn can change according the channel that is activated and the way in which it is used. The arts constitute locations *par excellence* in which this distribution of the sensible takes place: they define which sense must be operated, by whom, with what kind of personal implication, in which kind of framework, and so forth. However, this distribution of the sensible also influences modes of participation in social life. The modalities of citizenship and the networks of power are defined by various levels of participation: access, or lack of it, to a word or image, being a direct addressee or a mute

witness, being part of a large conversation or having to keep one's mouth and eyes shut. In this sense, politics has an aesthetic basis: The organization of the senses reveals and establishes the organization of a society.

Rancière's suggestion is an important one: It examines regimes of sensibility, but rather than differentiating between them according to intensity, as McLuhan does, distinguishes them on the basis of the way in which they assign roles or functions, thus constructing social models. In this sense, it allows us to grasp their deeper implications.

Let's return to cinema. From its inception, it has always exemplified an aesthetic regime characterized by an egalitarian distribution of the senses—a characteristic that Rancière attributes to modernity and that he sees emerging above all from the nineteenth-century novel like Flaubert's, and from artistic movements like Arts and Crafts. Not by chance the first theorists presented cinema as the exemplary "democratic" art: It admits all social classes to partake in vision[72] and offers to everyone the chance to see in the same way.[73] Expanded cinema goes to extremes: It opens itself to all kinds of images and media. It does not propose differences; rather, it promotes inclusivity. In this sense, it embodies the emergence of what Rancière calls the "great parataxis": The loss of a "common term of measurement" pushes the arts not toward the search for "some term of measurement that would be peculiar to each of them, but on the contrary where any such 'peculiarity' collapses"—toward a "great chaotic juxtaposition, a great indifferent mélange of significations and materialities."[74] In this vein, we can say that expanded cinema, with its openness toward what is unlike itself, also in some way "causes the image to pass into the word, the word into the brush-stoke, the brush-stoke into the vibration of light or motion."[75] It practices both transference and accumulation.

To take a further step on the path indicated by Rancière, this attempt to host within itself new pieces of territory, accompanied by the inevitable slippage beyond its own borders, seems to me typical not only of a democratic will, but also of the processes of globalization that characterize our world. The aggregation of new modes of production, new forms of consumption and new languages, and, conversely, the ability to contaminate with its own presence new social environments, new instruments of entertainment and new forms of expression, reflect the presence of a comprehensive network that is increasingly thick and open

to relationships and exchanges. In a globalized world, everything can shift from one sphere to another, everything can become accessible, can merge with another context. In this sense, expanded cinema can be understood as a symbol of a *circulation* of the sensible, more than of its distribution: The visible and the audible—and also, through synesthesia, the tactile—move incessantly from one sphere to another, even while running the risk of ending up in a no-man's-land.

To return to Rancière, he notes that the "great parataxis" carries two risks within itself. On one side it draws close to the "great schizophrenic explosion where the sentence sinks into the scream," while on the other it is almost isomorphic with "the great equality of market and language."[76] These are two risks that the expanded cinema runs as well: on one hand, that of a sensoriality that is no longer connected to meaning, and on the other, that of a dispersion that leads to a loss of identity. As we have seen, cinema reacts to these dangers through two strategies that maintain and even develop its identity: on one hand it adopts high-definition, sensorially engaging images that reconnect movies to their history; on the other it hosts poor images, endowed with a strong critical power. This return of intensity—both sensory and cognitive—has the effect of "marking" the images: It exalts their presence, underscores their documentary or ludic value, and makes them enter into tension with other signs present in social space.[77] Moreover, this return of intensity creates zones of "condensation" in opposition to zones of "rarefaction," which allow expanded cinema to move out of the homogeneity into which it risks falling. The sensible returns to redistribute itself: Rather than circulating in a random way, images find precise destinations along with precise effects. In particular, they try to identify on one hand those who want to adhere and be absorbed in the represented world, on the other those who look for a critical consciousness that creates distance between us and the situation in which we find ourselves.

Once again, it seems to me that this twofold response echoes the processes of globalization and more precisely the efforts to escape them. Against the idea of an "indistinct society," on the one side there is the search for a mythical "fusion" with a primordial community; on the other, there is an attempt to control the proliferation of sensory data in the name of an often instrumental reason. In its attempt to avoid the dispersion—and to *remain* cinema—expanded cinema seems to follow

these two routes: It calls out to spectators to rejoin a community of dreamers or to reacquire a consciousness of the world in hopes of once again getting a handle on it. It does so softly, without the drama that these two responses embody in politics, but it does so effectively, making us see clearly the risks and opportunities that lie along each of the routes that it seems to follow—the routes of dispersion, of absorption, and of self-consciousness.

Here let me interrupt my thoughts on the political value of the three choices that expanded cinema brings into play. The fact that I have constructed a kind of relay between McLuhan and Rancière may give rise to perplexity, but it strikes me that both authors are extremely attentive to the way that cinema acts upon our sensory and mental faculties and equally determined to connect this action to larger dynamics, both symbolic and social. There is, paradoxically, more than an affinity between them.[78] Their common voice tells us that whatever path cinema is taking, it reveals—in the way it engages our senses and our intelligence—the web of relationships in which we are situated. The expansion of cinema becomes thus clearer: In choosing either the dispersion, or the adhesion, or the consciousness, it shapes also different spaces in which cinema operates. Cinema today is the dream of an undifferentiated circulation of signs in a global world, an impulse to find new centers of gravity for believers, and an attempt to give rise to a critical awareness for self-reliant subjects. Three different options, even though strongly connected. In their mutual confrontation it is not only the destiny of images that comes in full view: it is also our own destiny, as members of a society.

* * *

In the Valley of Elah (Paul Haggis, 2007) recounts the dramatic journey of a father, an ex-military policeman, in search of what led to the murder of his son, a soldier newly returned from Iraq. The father continually analyzes images recorded by a cell phone that the son had sent from the front. They are jumpy low-quality images, with uncertain colors and contours. They show glimpses of a reality of violence and abuse perpetrated by the soldiers on the local community, but the actual situations they record are unclear. At the moment that the truth is uncovered, the images suddenly stabilize themselves, and the film fully documents the traumatic event at the origin of the drama. This represents the conversion

of "low definition" to "high definition," both on a sensory level (we see what really happened) and on a critical level (we are pushed to reconsider the value of the images of war with which the media deluge us). A cinema that was contaminated with other types of images takes its revenge and proves that it, too, knows how to represent the world.

Forty-three years earlier, another film, Alain Renais' *Muriel* (1963), recounted the trauma of war and violence on prisoners, and it did so through its own (presumptively) internal amateur images.[79] At the end of the movie, however, Bernard, the veteran of the Algerian War, throws away his 8-mm camera and burns the little studio where he had tried to make his film. This outcome is the opposite of the previous one: *Muriel* hosts poor images but does not manage to re-elaborate them and make them its own. We will never see the perpetrators or the victims—nor will we need to see them in order to understand the tragedy.

My impression is that in 1963, at the beginning of the process of expansion, and with a public still strongly homogeneous, cinema was still sure of itself to the point of mastering other images—images fixed on the same support, film, after all—without fear of losing its identity. In 2007, cinema in full expansion must demonstrate its strength, and reconquer its own identity, also on behalf of a public that is losing the sense of a cinematic identity. Hence the emerging of a traditional filmic image in *In the Valley of Elah*—the face of the son, the only time we see it in close-up, and the body of the child victim, finally identifiable. This move is in some way presumptuous.[80] The poor images depicting the war and circulating on the Internet tell us that even something that is not clearly visible is capable of disclosing the truth. Nevertheless, the desire expressed by *In the Valley of Elah* to give us both clear vision and consciousness, precisely through the transition of poor images into a full one, is evidence of how much cinema still wants to play a part today.

5. Hypertopia

PIAZZA DUOMO

On December 19, 2007, an enormous screen was installed in Milan's Piazza Duomo, billed as the "largest media façade in Europe." Across its surface appeared without interruption advertisements, live events, film clips, documentaries, and cinematic images. The installation of this mega-screen responded to a specific pragmatic need: It concealed the construction work taking place in the Museo del Novecento (Museum of the Twentieth Century), housed in one of the buildings facing the square. Its presence, however, created a sort of competition with other realities situated in the same locality—a conflict at once spatial and symbolic.

First of all, the screen's large surface contrasted with the façade of the building that lends its name to the piazza, the Duomo of Milan. It constituted a strong, new focal point to the right of the famous cathedral, so much so that the set of steps that leads up to the church—the starting point of a small ascesis for the faithful—was effectively transformed into bleachers on which the mega-screen's spectators could sit and watch what was projected on the screen, turning their backs to the house of God.

The screen also contrasted with the Palazzo Reale, long the seat of municipal government, and still one of the city's major symbols. In fact,

the mega-screen blocked one of the thoroughfares leading to this building, in addition to offering a form of entertainment that constitutes the opposite of the cultured gaze that the Palazzo Reale demands, having become in recent years the site of large art exhibitions.

The screen also contrasted with the equestrian statue of Vittorio Emanuele II, the king who oversaw the unification of Italy, and therefore a national symbol. Located in the center of the piazza, the statue suddenly seemed shoved to the margins, having lost its previous pride of place. Furthermore, the small groups of people that often gathered near its base to discuss politics were now often displaced by the crowds that gathered to watch the screen.

There was also a contrast with the famous Galleria that opens to the left of the piazza. The mega-screen makes a perfect companion piece to the gallery, a major emblem of nineteenth-century capitalism; unlike the latter's rows of display windows, however, the screen did not exhibit goods to contemplate, touch, and acquire, but rather only images—free images—of worlds to which we do not have immediate access.

Finally there was a contrast, less pronounced but relevant nonetheless, with the small display screens of the mobile devices that many passers-by carry and use as they cross the piazza to take a picture, send a message, or make a call. The mega-screen's vast expanse towered above them, completely overshadowing them.

A new presence, a new organization of space, a new hierarchy of symbols—the mega-screen redesigned the geography of the piazza: It created a new center of gravity, shifted points of stasis and passage, and altered relations between preexisting elements. However, it also affected the meanings that characterize the space: It introduced a new protagonist, the Great Image in Movement. It made of this larger-than-life figure an emblem of the world as Spectacle, and it inevitably competed with old symbols—God, the City, the Nation, the Market, Art, and the Personal Sphere of the passer-by.[1]

The mega-screen was dismantled in autumn 2010 upon completion of the construction on the Museo del Novecento. Its demise seemingly restored the old equilibrium to the Piazza del Duomo, but the memory of the conflict somehow remains inscribed in the place.[2]

What can we learn from this small example? First of all, that space counts. A well-known argument states that media increasingly ignore

a sense of place. Television made us feel as if we were in two places at once—at home and wherever the events occurred.[3] Now, mobile devices allow us to be in contact with everyone—and everything—from everywhere. In reality, if we approach this on the level of experience, we see that the "where" continues to be important. Experience is always *grounded* in a physical context, in addition to being *embodied* in a subject and *embedded* in a culture. It takes place, and it shapes a place. This is true of the screen: Every screen occupies a space and also gives life to a visual environment.

Second, space is also a site of contrapositions. The new visual environments to which a screen gives life are almost never peaceful: old functions attempt to hang on and new functions fight to establish themselves. Even spaces that seem totally dedicated to vision (from my living room with its home theater to Times Square with its media façades) are always shot through with tensions.

Third, in these new spaces cinema no longer represents a fixed presence as it did inside the darkened theater. It is no longer something that "is there"; it is, if anything, something that "intervenes," "complements," or even "intrudes." Cinema's approach toward the spectator has profoundly transformed the filmic experience. If the traditional theater was a place that we entered in order to experience a world different from our everyday world—leaving a "here" in order to take ourselves to an "elsewhere"—then in these new environments of vision, cinema brings an "elsewhere" to our "here," by reaching us where we already are. This spells the end of the heterotopic nature of the traditional movie theater: The new places of vision are characterized by a *hypertopia*, that is to say, by the fact that an "other" world is made available to us, responds to our summons, and comes to us—as I said, it fills our "here" with all possible "elsewheres."

But maybe cinema has always been the site of this centripetal movement. Spectators sitting in the theater in front of the screen felt projected into the heart of the action and at the same time experienced the touch of images and sounds. Cinema carried its spectators elsewhere, but also restituted that which the movie camera had captured. So, even though cinema is a heterotopic art *par excellence*, it has also constantly been tempted by *hypertopia*. Today, it may perhaps rediscover this more secret vocation in the process of relocation.

THE SPACE OF VISION

We should keep in mind that the space we inhabit is a constructed space: It is the result of a series of physical and mental actions that we apply to it, in order to render it into our environment. From Henri Lefebvre[4] to Arjun Appadurai,[5] via Michel de Certeau,[6] numerous scholars have shed light on the complex of practices capable of transforming a *place*, considered as simple container, into a *space*, a living environment.[7] There are direct interventions (such as constructing a house, redesigning a landscape, and transforming the configuration of architectonic elements), processes of appropriation (such as walking through a city to get to know it or narrating it to explain how it is lived), and rites of foundation (for example, giving a name to a place, passing regulations, or opening public areas). From this point of view, it is not inappropriate to think of the screen as a presence that produces space. The screen does not simply occupy a place; rather, it constitutes space. This is especially true for the new environments that it affects: here, its role is openly active, on at least three levels.

First, the presence of the screen "defines" or "redefines" its context: What was at first a space of transit like a street, or a space of anticipation like a waiting room, or an exhibition space like a store window, now become a space for the enjoyment of images and sounds. The environment opens itself up to a new function; it acquires a new meaning. This function and meaning can seemingly emerge from nothing; for example, from a screen erected on a beach, which transforms the shoreline into a temporary outdoor cinema. But this function and meaning can also overlap with a preceding situation, perhaps without erasing it altogether: An example might be the projection of a film in an art gallery or in an airplane, which gives new connotations to these spaces without changing the intimate natures of the gallery or the mode of transport. In either case, the presence of a screen leads to a "determination" and "qualification" of the place in which it is inserted. In short, it gives it an *identity*.

Second, the presence of a screen "rearticulates" the space: It brings out certain focal points, emphasizes some elements at the expense of others, and establishes new borders. The configuration of the environment changes, and a new layout is defined. Let's take for example a television set in a waiting room: It literally generates a new center of gravity

(coincident with its placement) and a possible spatial hierarchy (corresponding to the seats that offer better views with respect to obstructed ones). We could call what comes into play here a "cartographic" operation. In short, what emerges is a *map* of the place.

Third, the presence of a screen introduces a series of "rules of behavior." If for no other reason than to be able to see "well," observers are drawn to perform certain acts, which lead to the assumption of a certain mental attitude, a certain physical posture, a certain ideological position, and so forth. Let's take for instance the installation of a home theater in a domestic living room. It brings out a cinephilic attitude, marked by the demand for a more concentrated form of attention, the abandonment of collateral activities, and the desire to obtain the best possible quality of vision from the device The place assumes a certain *workability*.

It is through these steps—an identity, a map, and a workability—that a screen intervenes in a place, and it is as a result of these steps that a screen turns a place into a *space of vision*. These three steps directly involve a semantic dimension (definition of a place), a syntactic dimension (articulation of a place), and a pragmatic dimension (activation of a place). In this light we could say, a bit metaphorically, that the screen dictates its language to what surrounds it. To put it another way, we might say that a screen functions as a spatial enunciator, in the sense that it appropriates the space in which it finds itself, recategorizes it from its own point of view, and invests it in its own direct or indirect action.[8]

In any case, the screen creates a space of vision. A space links up to an eye and an ear and is transformed from a mere container into an environment to be lived.

THE CINEMA AND ITS ENVIRONMENTS

How does cinema enter these new spaces? Which environments does it encounter? What situations does it create?

First of all, the presence of cinema is characterized by a certain *ambiguity*. If on the one hand cinema pushes these new spaces toward its customary domain, on the other hand it creates situations that are more difficult to decrypt and whose cinematicity is deeply questioned.

Let's consider the new environment's mimicry of the traditional darkened movie theater. There is no doubt that a space of vision becomes a cinematic space the more it draws upon a tradition. Nevertheless, this connection can have various meanings. For example, the home theater—characterized by a large-format screen, high-definition sound, seating arranged toward the screen, and adjustable lighting—is reminiscent of a public projection space. Although it is located within a private house or apartment, and consequently not open to strangers, it can function as a substitute for the movie theater. As Ben Singer[9] and Barbara Klinger[10] remind us, since its very beginning, cinema has always considered itself capable of operating within the domestic setting. Likewise, ever since the second half of the nineteenth century, the home has been conceived of as a place open to hosting communication and entertainment technology. In this coming together, an essential role has been played by technologies like the Edison Home Projecting Kinetoscope, introduced in 1912 (and whose career Ben Singer has exhaustively retraced), and moreover by the Pathé Baby, a 9.5-mm film projector, launched in 1922 with great success. Digital technologies—the plasma screen, the DVD, Dolby, and so on—simply reinforce the intersection that had already taken place.

In the case of cinematic relocation within exposition spaces, imitation of the darkened movie theater can produce a more blurred effect. Maeve Connolly has examined installations that replicate the traditional cinematic environment.[11] There is, for instance, *12 Angry Films* (2010) by Jesse Jones, which reconstructs a drive-in theater in a derelict area near the port of Dublin, in which spectators sit in their cars to watch a program of socially conscious films. *Auto Kino* (2010) is another replica of a drive-in, this time in Berlin, which offers projections of films by Fritz Lang, Douglas Sirk, and others. Tobias Putrih's *Venetian, Atmospheric* (2007) is an ideal reconstruction of the atmospheric theaters of the 1920s and 1930s that offers a program of avant-garde movies; and *Sunset Cinema* (2007) by Apolonija Šušteršič and Bik van der Pol is a true art theater constructed in the middle of a town square in Luxembourg that shows films after sunset. So, "although these projects clearly draw upon images, memories and experiences of cinema as a cultural form with a long history, they do not necessarily constitute a nostalgic evocation of a lost and idealised sociality."[12] On the contrary, these projects profoundly question the types of social ties that cinema has managed to create. They

emphasize certain ones, such as proximity to strangers; they explore contrasts between public and private dimensions or between the intimate and the collective; they attempt to align this sociality with the rhythms and routes of urban life; and, finally, they rethink and refound the sense of "being together" that cinema has primarily shaped.

These examples tell us that mimicry can be useful for restoring a cinematic space, but it can also have a more subtle function, in which memory opens up to a future, and yet discontinuities with the past are not hidden by the revival of a tradition.

Second, the presence of cinema in new environments is often characterized by a certain *bifurcation*. In some cases it raises certain traits, in other cases traits that are the opposite.

Let's consider, for example, the scale of the screen. There are screens that we can literally hold in our hands, like those of computer tablets or smartphones, and there are screens that occupy a significant portion of an available space, like media façades. In the former case, the represented world assumes a modest weight and allows observers the possibility of mastering what they have in front of their eyes; in the latter case, the representation assumes maximum dimensions, imposing itself on the surrounding environment and practically annihilating the observer. This difference in scale brings us back to the origins of cinema, and in particular to the evolution from the little figures of the Phenakistoscope and the Kinetoscope to the life-size (or even larger) images of Edison's Vitascope and the Lumières' Cinématographe. As Mary Ann Doane reminds us, "the viewer, who could dominate, manipulate the optical toy or kinetoscope, controlling the speed and timing of its production of movement, became dominated, overwhelmed and dispossessed in relation to an image that seemed to be liberated from the obligation of dimension."[13] Moreover, the later innovation of the close-up, in which small details assume gigantic dimensions, introduced an air of menace and bewilderment.

In reality, outside of cinema, the entire iconographic culture of the nineteenth century was based on the opposing poles of the minuscule and the gigantic. Erkki Huhtamo[14] explains how this conflict became particularly evident at midcentury with the diffusion of photographic business cards (which included a miniature portrait) as opposed to the large-scale billboards posted on the walls of cities (which greatly amplified proportions), and with spectators' domestication of the landscape thanks

to portable viewers as opposed to their feeling lost in the great circular panoramas.

The present-day diffusion of screens favors this process of "Gulliverization," as Huhtamo terms it[15]: we increasingly confront someone or something that is far larger or smaller than we are. In essence, we come up against elves one moment and cyclopes the next. Consequently, two divergent situations emerge. On the one hand, small screens and miniature figures give rise to a *space of control*, in which we glance at the news that arrives to us, recuperate the data we need, and enter into contact with others (within a more private dimension, from which even those people situated most closely to us tend to be excluded). On the other hand, mega-screens and gigantic figures give rise to a *space of spectacle*, in which we enjoy the grandiosity of that which is larger than life (and we enjoy it collectively: a mega-screen is available to a plurality of spectators, who can participate simultaneously in the same event). Cinema-cinema would seem to pertain to the second case, but let us not forget that it has always nurtured inclinations aimed at keeping the world under control[16]: The Lumières' *La sortie des usines* (1895) offers both the spectacle of an efficient factory and the gaze of a surveillance camera.

Third, the presence of cinema in new environments often creates *resonances*. Despite the degree to which a screen assigns new functions, a new articulation, and a new practicability to a place, the environment always conserves a memory of what it was, and what in some cases it continues to be. My living room can become a small movie theater, but it also continues to be a domestic space. A kind of echo continues to resonate, creating curious superimpositions.

Let's stick with the home theater. The eruption of cinema into the domestic environment, which is always ready to return to the foreground, brings with it a kind of "aestheticization" of the home. Technological devices are put on display, not only as a boastful sign of status, but also because of the fascination inspired by their design as objects. They are often chosen to match other domestic technologies, so as to create a uniform style. Sometimes this aestheticization also involves other elements: Barbara Klinger observes that audiovisual magazines suggest that users coordinate food choices with the kind of film they plan to watch in their home theaters, in order to create a so-called integrated experience. "The result is a unified vision of the 'good life' that perpetuates existing

images of class while also continuing to characterize refined class sensibilities as the most desirable."[17]

On the other extreme there is a "domestication" of movie theaters. In fact, in order to achieve a maximum level of comfort, theaters now often utilize seats that amount to easy chairs: by giving more room to spectators, they make them feel more at home.[18]

Forms of superimposition also exist in public spaces. Watching a film on an airplane brings with it a strong "privatization" of a collective space: passengers immerse themselves in vision, seek refuge within their seats, and flee from the very idea of traveling (I am, by the way, writing these lines in an airport between flights). Conversely, a media façade implies a "monumentalization" of public space: The screen functions as a large totem pole, which inscribes a territory as if it were a landmark, rather than offering a window on the world to curious spectators. Whoever passes in front of these screens is often more attracted by the installation itself than by what is being shown on the screen. Times Square is a perfect example of such an attitude.

Ambiguity, bifurcation, resonances: As cinema enters new spaces of vision, it unfolds resistances and negotiations. In particular, it creates environments that are defined by a logic of "both/and": multiple spaces, which give rise to many different possibilities at the same time; but also unstable spaces, which lean sometimes toward one pole, sometimes toward the other. Cinema is not a closed presence: it brings with itself tensions and compromises, in a dynamic and open play.

NEW SPECTATORSHIPS

This cinematic space criss-crossed by a plurality of accents inevitably gives rise to new forms of *spectatorship*. What emerge are attitudes and behaviors that are more complex, less structured, and more casual than those of the past.

The mega-screens of urban environments offer a good example. They usually feature sports and commercials, but also show film clips, trailers, documentaries, video clips, and so forth. These are materials that generate a certain amount of interest, but they do not always succeed in attracting stable attention. Many people who find themselves crossing these urban

spaces continue unhindered along their routes, limiting themselves to launching at most a glance at what is appearing on the screen. Consequently, these passers-by only rarely constitute an audience in the classic sense of the term; what forms instead is what I would like to call a *semi-audience*, halfway between the casual aggregate formed by passers-by and the potential community of spectators.[19]

Conversely, there is undoubtedly a general tendency toward widening the scope of forms of individual consumption. When I watch something on my tablet, laptop, or smartphone, I do not necessarily share it with anyone else: I "privatize" my vision, including my filmic vision. Nevertheless, it is also true that we can find groups of people, sharing the same space and watching the same thing, each on his or her own portable device; and someone, shifting toward a neighbor, perhaps glances at the screen in the neighbor's hand.[20] This form of vision is not completely private: there is the spark of a public dimension, without it fully catching. We are within a *semi-private* regime.

When I watch a DVD at home I can concentrate on my vision, but I can also break it off, reorganize it, or finish it later. This is a much different kind of temporality with respect to the mode of consumption typical of the movie theater: in effect, I free myself from the duration forced upon me by the film.[21] However as Laura Mulvey reminds us, a film remains a film, even on DVD; indeed, the possibility of viewing it in pieces, slowed down, in reverse, and of postponing the completion of my vision, allows me to notice aspects that were always there, but which a typical gaze would not have revealed.[22] As in the case of Sigmund Freud's concept of "deferred action," it is only in retrospect that I discover the explanation for certain things. This means that the DVD did not completely abolish the continuity of vision; if anything, it complicated it through fragmentation and delay. We could describe the regime that consequently arises as *semi-continuous*.

Let's return to small-scale screens. They grant spectators a freedom of mobility during viewing. Such a condition can also seem to contradict the classic model of filmic vision, in which an immobile audience sits in front of moving images. However, Boris Groys has noted a real incongruence in this model: The active life that moving images celebrate on the screen is denied to spectators, who are fixed in their seats.[23] From this point of view, mobile vision can also be conceived of as a way out of this

incongruence: Spectators, thanks to the tablet and smartphone, regain an active dimension, and realign themselves with what they are watching. They are able truly to experience the world in transformation, rather than being limited to contemplating it. In essence, spectators can really become those flaneurs that cinema has always asked them to become,[24] but had kept them from becoming. In this way, mobile vision is not in fact cinematic, as it overturns the tradition, but it is cinematic in substance, as it satisfies a long unfulfilled promise. We can call, therefore, this mobile vision *semi-cinematic*: it changes a habit, but reaffirms a vocation.

HETEROGENEITY AND CONTINGENCE

Let's pause for a moment. We have just encountered forms of spectatorship modified by a *semi-* (semi-public, semi-private, semi-continuous, semi-cinematic), and before that we had encountered environments of vision characterized by a *but also* (mimetic but also critical, dedicated to spectacle but also to surveillance, endowed with an identity but also permeated by the identities of others). Outside of the darkened movie theater, cinema moves on very complicated terrain. So what does such a situation imply?

If it is true that a screen tends to construct a space of vision, this space is not necessarily exclusive or permanent. In the past, there was always and only cinema in the movie theater. The emigration of the screen out of the theater does not guarantee the same result: The multiplication of screens and their coexistence with other elements lead cinema to become a presence that is at once both noticeable and more uncertain and vague.

Better put: The new spaces of vision are not, nor can they any longer be, *dedicated spaces*. They open themselves to cinema, but only from time to time, and never completely. It depends on the circumstances, for it is they that determine the level of an environment's *cinematicity*. And it depends on the moment's equilibria, for it is they that decide if cinema can cohabit with other elements. When I sit in my living room in front of my home theater, it is the familiar context that helps me to become a spectator (or hinders me from becoming a spectator). When I cross a city square and glance momentarily at a mega-screen, it is my list of errands, in addition to my curiosity, that dictates if my gaze will really capture

what is appearing on that surface. While traveling, it is the discomfort of the situation that keeps me tied to my tablet. A screen contributes to the construction of points of vision, but my eyes do not necessarily always find reward or satisfaction in these points.

This contingent dimension may seem to be a condemnation. In relocating, cinema expands its field of action, but also seems to enter onto a terrain not its own. It gains space, but loses its environment.[25] However, this dimension opens up an interesting scenario. When cinema's presence can no longer be taken for granted it becomes something we run into, something we stumble upon. The intensity of the surprise can be greater in a public space, such as a bar for example, into which we enter not knowing what we will find, while it may be less intense in a private space such as our living room, in which we sit down and choose what to watch. But even in the latter case, cinema is an element that intervenes, forcing the situation, and imposing itself on other possible presences. From this point of view, after having been an institution, cinema increasingly presents itself—or returns to being, as it was at its origin—an *occurrence*.[26] Cinema takes place, it happens; therefore, it is a reality that we encounter. Better yet, it is a reality that comes out to meet us.

Victor Burgin, in a passionate and sensitive analysis of what cinema has become today, underlines its constant attempt to meet us. "The experience of film was once localized in space and time, in the finite unreeling of a narrative in a particular theatre on a particular day. But with time a film became no longer simply something to be 'visited' in the way one might attend a live theatrical performance or visit a painting in a museum."[27] On the contrary, film now is something that reaches us, in many ways and in many circumstances, also through fragments, memories, recollections. "A 'film' may be encountered trough posters, 'blurbs,' and other advertisements, such as trailers and television clips; it may be encountered through newspaper reviews, reference works, synopses and theoretical articles (with their 'film-strip' assemblages of still images); through production photographs, frame enlargements, memorabilia, and so on."[28] Films urge us to be taken in—at the point that they risk to take on a sort of phantasmic identity.[29]

So, in the public and private spaces into which cinema has relocated, it is as if it presents itself to its spectators, approaches them up close, and attempts to reach out to them; in essence, it is as if cinema surprises them

and consigns itself to them, into their hands and eyes. Spectators no longer go to the cinema; if anything, they find it along the way.

A brief glance back at the classic cinematic situation can help us to clarify this reversal of course.

GOING TO THE MOVIES

Erich Feldmann's "Thoughts on the Film Spectator's Situation,"[30] written in 1956, offers an accurate and intelligent description of what it means to go to the movies and can be fruitfully compared to texts such as Antonello Gerbi's "Initiation to the Delights of Cinema" from thirty years earlier and Roland Barthes' "Leaving the Movie Theater," written nineteen years later.[31]

Feldmann posits that the classic filmic experience consists of three phrases. The first phase involves spectators buying a ticket and directing themselves toward the theater.[32] This phase has more to do with the filmgoer as consumer than as a true spectator: It is constituted by a financial transaction in exchange for the satisfaction of a desire (or a need). Nevertheless, this monetary operation is closely tied to the wish to leave daily life in order to gain access to a new space: a specialized space, dedicated to spectacle, and different from those of the outside world. In this sense, the ticket purchase functions as the crossing of a threshold.

The second phase involves the spectators entering the theater and selecting a place to sit. The choice of a seat is not insignificant: Spectators can accommodate themselves next to others, maintaining personal contact, and thus emphasizing the fact that in this phase they are more accurately members of an audience than film spectators; or they can choose to isolate themselves, thus predisposing themselves to vision, even if "the world around [them] remains real and alive, until their attention is distracted and captured by the film."[33] In both cases, this is an intermediate stage: Spectators are no longer in the same condition as they were before entering the theater; their tie to the outside has weakened. They have already entered into the space in which the film projection will take place, but their eyes are not yet focused on the screen.

The third phase begins as the lights go down and the projection begins. A sharp break with everyday reality sets in, together with a reorientation

of attention: "With the darkening of the theater, [spectators] lose visual contact with the real world that surrounds them, they concentrate on sensible impressions, and dispose themselves to experiencing that which acts on them."[34] It is at this point that spectators truly become *spectators*: when they dedicate themselves fully to the film.[35] As a result of their availability, they adhere closely to what is being represented: The world on the screen is taken as real and is lived by spectators as if they were part of it. As the film continues this situation is consolidated: "as the film advances, which is nothing more than a succession of images in movement, the illusion of an objective event and of subjective participation is born."[36] Spectators "enter" into the represented reality.

This entrance into the represented world on the screen is never realized completely. Feldmann concludes his essay by saying that the filmic narrative presents a series of vicissitudes in which it is impossible to intervene. "The stronger the images offered by the film, the more intensely spectators imagine that the dramatic action of the film must be accepted as a predetermined destiny and that the situations must be left to play themselves out."[37] No matter how strongly spectators project themselves into and identify themselves with the fictional universe of the film, there remains a subtle barrier that keeps them separated from it.[38] Spectators, sitting in the theater, ultimately always stay attached to the real world.

Feldmann offers an accurate portrait of the cinematic experience. He brings it back to a path that leads us to abandon the everyday, to enter into a room furnished with a screen, and to attempt to penetrate into the universe that is born on that screen. Going to the movies means above all leaving a customary territory and confronting an "other" world. In this sense, we experience a *heterotopia*, which is to say, the existence of a particular place, which, although located "here," opens up on an "elsewhere."

FROM HETEROTOPIA TO HYPERTOPIA

The notion of *heterotopia* was advanced by Michel Foucault in a 1967 conference, though it was only published in 1984.[39] The term refers to the existence of spaces that put the world we inhabit into communication with situations that exceed everyday reality, such as sickness, death, dreams, unusual sites, and so on. Examples of heterotopia are places such

as hospitals, cemeteries, trains, gardens, hotel rooms, mental institutions, prisons, and theaters. In each of these sites, an "other" dimension presents itself within our world—it remains separate, but is also made accessible. So, while utopias represent an "elsewhere" that lacks a "where," heterotopias represent a concrete space that allows us to arrive at an "elsewhere" by setting out from a "here."

All cultures have elaborated heterotopias, even though in different ways and with different functions.[40] And all heterotopias are characterized by a recurring structure.

For example, "heterotopias always presuppose a system of opening and closing that both isolates them and makes them penetrable."[41] These are spaces marked by a series of thresholds that we are called to challenge and cross.

Additionally, "The heterotopia is capable of juxtaposing in a single real place several spaces, several sites that are in themselves incompatible."[42] It therefore has a variegated design, made up of diverse pieces in coexistence. Theaters and gardens (and, according to Foucault, also the cinema, which incorporates a theater, a flat screen, and a seemingly three-dimensional narrated world) exemplify this heterogeneous composition.

Heterotopias are also spaces that suspend in some way the flow of everyday time: "The heterotopia begins to function at full capacity when men arrive at a sort of absolute break with their traditional time."[43] Cemeteries, which both confirm the end of life and establish a quasi-eternity, constitute good examples of what Foucault calls *heterochrony*.

Finally, heterotopias serve a double function. "Either their role is to create a space of illusion that exposes every real space, all the sites inside of which human life is partitioned, as still more illusory [...]"—Foucault mentions brothels—"Or else, on the contrary, their role is to create a space that is other, another real space, as perfect, as meticulous, as well arranged as ours is messy, ill constructed, and jumbled."[44] This second case describes not heterotopias of illusion, but rather heterotopias of compensation, of which colonies—especially the ones established by Jesuits in Paraguay during the eighteenth century—represent a prime example.

These are the principal traits of the heterotopia. They make it a true counter-site "in which the real sites, all the other real sites that can be found within the culture, are simultaneously represented, contested, and

inverted."[45] The classic movie theater fits in easily among these heterotopias. Its triple threshold—economic, physical, and symbolic—its drawing together of different spaces—social and representational—its ability to suspend quotidian time and reemit it in an alternative flow, and its dual nature as both outer limit and mirror of society, all correspond perfectly to the characteristics described by Foucault. Indeed, he mentions cinema in his list, even if it is only cursorily.

But can we say the same of the new environments into which cinema has relocated? Do they too constitute heterotopias? For example, it is worth noting that in these sites of vision, the presence of a threshold is sharply diminished. Urban spaces, such as a town square, remain perfectly passable, while personal spaces, such as the one I construct by holding my tablet, exhibit the fragile borders of an existential bubble. Furthermore, their internal composition is variable more than variegated. Like my living room, which transforms into a small movie theater and back again in a flash, these sites of vision change structure each time they are used. These sites cause different temporalities to flow in parallel, rather than bringing them into confrontation. Along a street, in front of a screen, some people stop to take a break and some hurry by without pause: both ways of organizing one's time coexist without intersecting. Finally, these sites of vision are not true counter-sites. They insert themselves seamlessly into the geography of our everyday world, taking part in it fully, rather than reconquering and twist it.

The consequence of this is a reversal of the previous situation. New environments of vision no longer constitute destinations, but rather places that one happens upon along the way. Similarly, representations on the screen no longer constitute worlds toward which we reach out, but rather worlds that appear before us, offer themselves to our gaze, and place themselves at our disposal. In short, in these new environments, there is no longer the opening of a "here" toward an "elsewhere," but rather an "elsewhere" that arrives "here" and dissolves itself in it.

I call this new spatial structure *hypertopia*, in order to underline the fact that rather than taking off toward an "other" place, there are many "other" places that land here, to the point of saturating my world. Relocated cinema leaves the terrain of the heterotopia and adopts this new spatial structure: It no longer asks me to go to it; it comes to me, reaching me wherever I am.

ACCESS

The most evident counterpart to the transformation from heterotopia to hypertopia can be found in the development of the word *access*. Traditionally, *to access* means "to approach or enter (a place)."[46] The word therefore implies movement, the crossing of a threshold, entrance into a new space and the sharing of it with whoever was already occupying it. In the field of media, Jurgen Habermas uses *access* to indicate the possibility of social subjects entering into the arena of collective debate, and therefore participating in the public sphere,[47] while Stuart Hall uses *access* to indicate the way in which the use of the media also brings with it an adherence to the rules shared by a community.[48] Entrance into a movie theater represents a form of access: Spectators arrive at a site, enter it, and become part of an audience.

The computer and the Web have transformed the meaning of the word: *to access* has become synonymous with *to obtain* and *to retrieve* (as in computer data or a file).[49] The central element becomes the possibility of consulting a series of sites—my mailbox, a social network, a home page, or a discussion form, for example. With a click of the mouse or a tap of the finger, I can put myself in contact with a myriad of other points. I do not, however, move from the place in which I find myself; rather, the information comes to me.

There is no doubt that when I navigate the Internet, I do put myself in motion in some ideal way. Lev Manovich has exhumed two classic metaphors that describe cybernauts: on the one hand they are Baudelaire's flaneurs, ready to enter indifferently into a series of situations; on the other hand they are the explorers of the great novels of James Fenimore Cooper and Mark Twain, ready to set out beyond charted territory, in search of a new world.[50] In particular, video games are constructed on the idea of a progressive advancement from one environment to another, via a series of thresholds: "*Doom* and *Myst* present the user with a space to be traversed, to be mapped out by moving through it."[51] However, this movement is of course metaphorical: In reality, the space designed by programmers does not have the characteristics of an organic site, in which objects are structurally incorporated. Rather, it consists of a collection of elements to be grasped one by one: "Virtual spaces are most often not true spaces but collections

of separate objects."[52] As Manovich himself emphasizes, "The space of the Web, in principle, cannot be thought of as a coherent totality: it is, rather, a collection of numerous files, hyperlinked but without any overall perspective to unite them."[53] In short, "there is no space in cyberspace."[54]

Furthermore, cybernauts do not aim to find a new world to inhabit, as was the case with classic cinema spectators, whose dream it was to immerse themselves in the coherent, compact universe represented on the screen. Instead, cybernauts aspire simply to acquire. It is no coincidence that the activity by which they are most often measured is *downloading*: a term that refers to a transport that has already arrived at its destination, and to a destination that coincides with the "here" in which navigators find themselves together with their computers, wherever that may be. It is not a matter of reaching a certain place; rather, it is now a question of how to make oneself reachable. And it is no longer a matter of entering and taking part in a territory or a community; rather, it is now a question of how to collect and accumulate data. The meaning of *access* has truly changed.

Returning to cinema, there is no doubt that it incarnates a traditional idea of access: Spectators enter a place—the theater—from which they can face toward a world ready to welcome them. However, the context in which cinema now operates, and in particular the fact that its presence increasingly conforms to contingency, make cinema appear more disposed to reach out to us than to ask us to move toward it.

The act of watching a downloaded film on a computer illustrates this change in direction. Spectators do not move from their seats: They explore their possibilities online, activate a link, and have their selection arrive on their screens. Urban screens propose a similar situation. When I cross a city square and my eye happens upon a display showing a film trailer, a documentary, or anything connected in some way with the world of cinema, that thing seems simply to appear before me: It captures my attention and reaches me. Ultimately, I find myself in the same situation as when I play a DVD from my small collection at home: That DVD is already here with me, it has already reached me. Therefore, spectators no longer approach the cinema: The cinema approaches them, when it is not already with them.

"PANTHERS AND PUMAS LEAP OUT OF THE SCREEN"

This situation is further strengthened when we consider the new modes of filmic representation. I am thinking in particular of the reemergence of 3-D. Three-dimensionality offers a representation that literally extends itself toward us, as if it wanted to invade our space. Sergei Eisenstein already understood this in the 1940s: In an essay on early experiments in stereoscopy, he noted that the image "pours out of the screen into the auditorium." The effect, he added, is that "panthers and pumas leap out of the screen into the arms of the spectators."[55] The diegetic universe attempts to reach us.

Such an extension of objects toward us changes the meaning of the entire dispositive. As Philip Sander has underlined, perspectival vision, to which classical cinema owed much, offered an illusory immersion into the depicted world. In particular, it constructed an implicit observer, who overlapped with and concealed the real beholder, and who was swallowed by the representation itself. Three-dimensionality reverses such a situation. First of all, 3-D calls for a concrete observer, able to re-create a stereoscopic image. Second, 3-D emphasizes the existence of the theater: "Because objects project off the screen, the space in front of the screen is no longer arbitrary."[56] Hence, there is a peculiar relationship with the spectator: "When an object extends off the delineated space of the screen and into the theatre, the object attains a real presence and is in an actual relationship with the apex of the vision, which, instead of being an arbitrary point, is now the actual viewer's eyes."[57] The subtle "delineation between the necessarily structured space of the image and the variable space of the viewer"[58] is broken. The world on the screen not only leans toward spectators but also literally fills the environment surrounding them.

The trailer for the original *The House of Wax* (André De Toth, 1953) promised the audience that "every astounding scene in the story comes as close as the person next to you." The trailer for *The Creature from the Black Lagoon* (Jack Arnold, 1954) announced that "up from the depth of the mighty Amazon comes the Creature." In *Avatar* (James Cameron, 2009), we are brought to Pandora, but once we have arrived there, Na'vi join us.

Hypertopia

The recent adoption of stereoscopy by a dispositive such as television also emphasizes this direction. It is no coincidence that a 2012 television commercial for 3-D Blu-ray Discs proclaims: "3-D brings the action to you!" Another commercial for DirectTV further clarifies the concept: "You've experienced it at the theater—a picture so realistic and immersive that you feel like you can touch the people and objects you're watching. DirectTV now brings the 3-D experience to your living room."[59] Of course, this may also result in a deeper participation to the story. But what matters is that the world on the screen is now capable of erupting into my own home.

In short, we no longer move for film; it is now something we acquire, we meet by chance, or we pick out from a range of available products; it is something that offers up a world ready to extend itself everywhere. Cinema, too, is becoming a hypertopic art.

THE ROOTS OF HYPERTOPIA

Does this forward extension of cinema and of the world it represents constitute a true innovation for film? And, more importantly, is this movement of "elsewhere" toward "here" only a recent phenomenon? The latter question inevitably leads us to "The Work of Art in the Age of Mechanical Reproduction," and thus to the 1930s. At the end of his essay, Walter Benjamin contrasts *concentration*, to which the work of art that is still tied to aura invites us, and *distraction*, which characterizes the behavior of the masses: "A person who concentrates before a work of art is absorbed by it: he enters into the work, just as, according to legend, a Chinese painter entered his completed painting while beholding it. By contrast, the distracted masses absorb the work of art into themselves. Their waves lap around it; they encompass it with their tide."[60] Therefore, there are two directions of movement: that which leads subjects to immerse themselves in the work of art, and that which leads the work of art to extend out of itself and to deliver itself into the hands of the subjects. The more the sense of a "cult" tied to a work is diminished in favor of its vocation of exposing itself to the gaze, the more the first direction—the immersive direction—cedes the field to the second, which we, together with Benjamin, can call *percussive*.[61] The world of art's

self-consignment into the hands of consumers satisfies the desire of the masses to take possession of things, to make them their own[62]; and at the same time it exists in perfect syntony with a mode of perception dominated by shock (external events seem to assail the subject), by tactility (things increasingly become objects of use), and by challenge (subjects are constantly put to the test, subjected to a training that trains them for the times they live in).

Let's return to cinema, to which Benjamin makes constant reference in his essay. The idea that film reaches out to spectators, beyond merely calling out to them, emerges quite early. In 1907, Giovanni Papini described the great success that this new art form was enjoying: "These theaters with their invasive lighting, their grandiose triple-color posters updated every day, the raucous arias ringing out from their phonographs, the weary announcements by red-uniformed boys, are now invading the main streets, closing down the cafés, opening up to replace the halls of well-known restaurants or billiard rooms, they join forces with bars, with a sweep of their arc lamps they have the effrontery to shine their beams into the mysterious old piazzas, and are even threatening to expel the live theaters, just as the tramways have replaced public carriages, newspapers have replaced books, and bars have taken the place of our cafés."[63] In Papini's words, cinema appears as a reality that is occupying the city and is impossible to avoid. In short, cinema comes out to meet its spectators, to the point of imposing itself on them, in order to be included in their world. There is something utterly new that is taking root in the "here."

The idea of invasion applies to the theater but also to the represented world. Some twenty years after Papini, at a time when cinema was already widely institutionalized, another Italian scholar, Antonello Gerbi, extolled the virtues of going to the cinema. His description, as I have suggested, can be placed alongside that of Eric Feldmann and constitutes a perfect portrait of a journey toward an "elsewhere." However, at a certain point, Gerbi opens up a completely different scenario: He imagines what would happen if the projectionist pointed his lens toward the audience: "The nighttime-reveling phantasms would come down from the screen and would attach themselves, deformed, contorted, grimacing, to the bodies of the spectators, to the bare walls, to the skin of the ladies, to the backs of the chairs, to people's heads, to their collars, to the newspapers."[64] For Gerbi, the idea that the characters of the screen could invade the

theater "is not a joke. It is a frightening possibility." It corresponds to the hypothesis that these characters, liberated from the story in which they are forced to live, could visit us at any moment: "If you were to find them close to you, so thin and silent, one night while you're returning home, there would be quite a bit to be afraid of."[65]

This idea that cinema not only abducts us and spirits us far away, but also that it looms toward us, invading the space in which we find ourselves, can be found in a pair of Italian short stories, written in the same period as Gerbi's text. Camillio Mariani dell'Anguillara (who a few years later will be one of the writers of *Scipione l'Africano*) recounts in "A Cinematic Adventure" the experience of a spectator watching a group of riders on horseback approach him on the screen, when, suddenly, they spill out of the screen and into the theater, racing along the cone of light produced by the projector.[66] The spectator is forced to follow the riders on an adventure that turns out to be nothing like the one originally advertised by the film he had gone to see. Massimo Bontempelli, a much more solid writer than Mariani dell'Anguillara, narrates in "My Public Death"[67] the story of an actor forced to relive the film in which he appears in perfect simultaneity with every projection. No matter how far he is from the movie theater, the film literally reaches him and overcomes him. The only solution is to acquire every copy of the film and destroy them all.

These examples are somewhat extreme[68]; however, the idea that cinema not only welcomes spectators but also imposes itself on them and invades their space is quite common in its early days—in fact, it constitutes a constant motif. As Tom Gunning has brought to light, early cinema was essentially a "cinema of attractions," that is to say, "a cinema that displays its visibility, willing to rupture a self-enclosed fictional world for a chance to solicit the attention of the spectator."[69] Its objective is to offer provocations on a perceptive and cognitive level, more than to narrate a story with which spectators can identify. Similarly, it is engaged in constructing a direct addressee for its images, more than an invisible participant in its events. From this view point, the "cinema of attractions" manifests a logic that is not distant from that of a hypertopia: Its images do not invite spectators to enter into another world, but rather surprise them, overwhelm them with a constant excess, inundate their senses and minds. Spectators are not called upon to go elsewhere; rather, they are engulfed by stimuli wherever they already find themselves.

EVERYWHERE HERE

This little flashback in search of the roots of hypertopia helps us to understand something: If it is true that the attempt to reach the user or spectator is a typical gesture of the current moment, it is also true that it has been with us for a while. Perhaps it no longer expresses the values that Benjamin recognized in it—shock is now disconnected from the necessity of training, and appropriation no longer has a collective dimension—however, the direction of the movement is the same. Indeed, we may say that the gesture has fully matured: In a now-globalized world, it allows us to think of the space we inhabit as a "here" where all possible "elsewheres" throng, and thus offers a (perhaps illusory) center to an otherwise scattered subject.

Cinema occupies an interesting position in this plot. There is no doubt that in its classic moment, cinema constituted an excellent example of heterotopia: I repeat, the cinematic experience was in large part an experience of a place in which one looked out upon an "elsewhere." Nevertheless, especially at its origin, it also explored the opposite model. In addition to the possibility of living in an "other" world, it also prompted us to seize it and make it ours. In addition to soliciting every mechanism of self-projection and identification, it also provoked us and assaulted us with its images. It is precisely this twofold story that allows cinema to claim a precedent (hypertopia is not unknown to it), and also to bring to light certain aspects of its current condition that might otherwise be lost.

In particular, cinema reminds us that the tension between "here" and "elsewhere" persists. Consequently, if "here" is nowadays filled up with "elsewheres," it does not mean that "here" becomes a self-sufficient and a self-evident space. It is not merely what it contains, including what I can download because I need it. On the contrary, it is a space capable of bringing into dialogue different planes of reality and capable of conserving an element of openness to the possible. On the one hand, the throng of "elsewheres" transforms the "here" into a sort of prism in which various components of the world we inhabit can come face to face and interact. My living room, the train car I'm traveling in, the town square I am crossing—each one with its respective screens becomes an unstable but eminently representative concentrate of the whole reality that surrounds me. On the other hand, the "elsewheres" that arrive "here"

continue to construct protrusions with respect to the place in which I find myself; they bring with them a *difference* that is not easily assimilated. Consequently, the screen in front of me, even though it gives me all I can get, also marks a horizon that challenges and provokes me.

In other words, hypertopia does not necessarily make an absolute of the "here." On the contrary, thanks to a sense of articulation and alterity that it brings with it, it can emphasize how this "here" is a space ready to open itself, to transform itself, to renew itself—no matter how full it already is. Wherever I am, I am able to summon up the world, but the world that arrives before me presents itself in all its complexity, tensions, and potentialities. "Here" can explode, in a certain sense—and in exploding, it can call me to task, appealing to my responsibility.

Cinema is still with us to guarantee this dimension of multiplicity and openness. Precisely in its present status as an occurrence—something that happens *to me*, rather than an institution that can be taken for granted—it again offers me a taste of surprise, curiosity, and transformation. And in doing so it reveals in depth just how mutable and unpredictable the space in which I find myself is. Cinema renders my "here" dense and promising, even outside the theater. This is the fruit of the double bind—heterotopia and hypertopia—that cinema embodies.

* * *

In *Non-Indifferent Nature*, Sergei Eisenstein thinks back to *Battleship Potemkin*, made twenty years earlier. He reveals that for the first projection of the film, he had had in mind a spectacular finale: At the moment when the ship is heading toward freedom, after having left Odessa and passing the fleet that was waiting to block her, the screen in the theater would rip open, and the sailors of the *Potemkin*—the actual, flesh-and-bone survivors of the revolt—would spill into the theater . . . a stupendous idea.[70] The sailors would return not only because the October Revolution brought with it freedom, but because it is right to have here and now the object of one's desire. Spectators are not forced to project themselves elsewhere: the elsewhere—the *Potemkin*, Odessa, the revolt—can come to them. Concretely. Pure hypertopia.

There is a price to pay, however. The sailors that enter into the theater also spell the end of cinema: The screen would be destroyed, the projection would stop—with the arrival of reality there is no need of images.

Cinema ceases to function as usual: It renounces its traditional framework and moves on to another regime of representation—it becomes performance, installation, maybe life as such.

To have everything here, where we are; and to no longer have cinema, but rather something else. Eisenstein has granted us a great lesson. He brings to light a double paradox. First of all, the sailors that enter the theater constitute a kind of living challenge to the possibility of summoning an "elsewhere" "here," but at the same time they prove that when this does happen, the "where" in which we find ourselves often changes nature: it explodes, opens up, transforms. Second, the sailors shed light on the ability of a heterotopic art, such as cinema, to also activate the opposite procedure, delivering to spectators what is beyond their horizon—and moreover actually, in real life—but it also reminds us that this gesture can lead to deep and potentially fatal self-redefinition. In a fully developed Internet culture like the one in which we now all live, it is useful, perhaps necessary, to remember Eisenstein: He makes that click of the mouse or tap of a finger with which we download all the world's information just a little more problematic.

6. Display

ORDINARY PEOPLE

Mike Figgis' film *Timecode* (2000) recounts ninety-three minutes in the life of a group of people living in Los Angeles. The duration of the movie and of the events it relates coincide: The story is captured in one long take without intervals or cuts. Most surprising is the possibility of following more than one situation simultaneously: The film was shot with four different digital cameras, and all four takes are presented simultaneously, on one screen divided into four sections. Sometimes the plotlines of the various characters intersect with one another more or less haphazardly, and when this happens the camera that has been following one of the characters may shift to another character and follow him or her instead. At other points, the plotlines converge, and we retrospectively discover the correlations. More often, however, the events proceed in parallel, without intersecting, but also without excluding the possibility of eventually crossing paths. We watch the stories on the four adjacent sections of the split screen, jumping from one to another, attempting to establish connections, selecting what seems to be the center point, at the mercy of the flow of images.

This is not the first time that cinema has experimented with the split screen.[1] However, there is something new in Figgis' film: something

quite different from the traditional desire to enlarge visible space or to juxtapose contemporaneous events that take place in separate spaces. His screen, divided into four, evokes the new kinds of screens that already constituted a familiar presence at the beginning of this millennium. It reminds us of the mosaic structure of the television screen, inside of which many conduits of communication coexist.[2] It also suggests the computer screen, with all the available applications in view, or monitors placed one next to the other, displaying images from surveillance cameras in the security centers of office buildings and malls. It also reminds us of the conglomeration of screens in the great media façades of many cities, such as New York's Times Square. Through these references, *Timecode* suggests that the movie screen no longer stands by itself; on the contrary, because of outside influences, its very nature is changing. We can no longer observe it as we did before, nor can we expect it to offer us the same kind of images as it used to.

I shall attempt here to think about how the proliferation of screens has led to a general transformation of their nature. They are no longer surfaces on which reality is relived, so to speak. Rather, they have become transit hubs for the images that circulate in our social space. They serve to capture these images, to make them momentarily available for somebody somewhere—perhaps even in order to rework them—before they embark again on their journey. Therefore, screens function as the junctions of a complex circuit, characterized both by a continuous flow and by localized processes of configuration or reconfiguration of circulating images.

This transformation of the screen is in fact the symptom of a more general media transformation. The advent of the network and of digital technology has led us out of an era in which media operated as instruments for exploring the world and for facilitating dialogue between people; that is, as instruments of mediation vis-à-vis reality and other people. Media have now become devices for the "interception" of information that saturates social and virtual spaces: They have become "lightning rods," if you will, onto which the electricity in the air is discharged. In this context, cinema has also found itself questioning its own identity, discovering perhaps a new destiny, but also a deep continuity between past and present.

THE CINEMATIC SCREEN

What exactly was the screen? The term has an intriguing history: In the fourteenth century, the Italian word *schermo* denoted something that protected against outside agents, and that therefore presented an obstacle to direct sight.[3] Along these same lines, the term also indicated someone who serves to mask the interests of another person, as in the Dantean formulation *donna schermo*, or "screen woman."[4] The English term *screen* also referred to a protective surface in the sixteenth and seventeenth centuries, especially against fire or air.[5] However, *screen* (or *skren*) also indicated smaller devices used to hide oneself from others' glances, such as fans or partitions of a mostly decorative nature.[6] At the beginning of the nineteenth century, the term began to enter into the sphere of entertainment: In the phantasmagoria, *screen*, *schermo*, and *écran* designated the semi-transparent surface onto the back of which a series of images was projected, so that the screen now served to open our gaze onto something hidden. This association with the instruments of spectacle was strengthened with the introduction of the shadow play (which the West had already imported from the East in the seventeenth century), and moreover with the magic lantern show, in which the projection is cast from in front of the screen rather than from behind it. Contemporaneously, the term *screen*, at least in English, acquired yet another aspect: During the Victorian age, it referred to those surfaces on which figures and cut-outs were pasted, forming both a private collection of images and a small public exposition.[7] It is from this rich background that the term arrives, in various languages, at the turn of the twentieth century, to indicate all the surfaces, and especially the white curtain onto which filmic images are projected,[8] finding its most widespread meaning in its connection to the cinema.

The route traveled by this word is instructive.[9] It demonstrates a slippage of meaning: from a surface that covers and protects, to one that allows us to glimpse images projected from behind, to one that gathers representations of new worlds, to one that can contain figures that reflect our personality. The major metaphors used by classical film theories for the cinematic screen encapsulate this entire history.

The first metaphor is that of the *window*: The screen is a breach in the barrier that keeps us separated from reality, thanks to which we

reestablish contact with the world. The obstacle between us and the outside is represented primarily by the walls of the movie theater; however, the most powerful impediments are the cultural filters that do not allow us to look directly at reality. Among these filters are our habits and prejudices, as Jean Epstein underlined in 1921,[10] and the massive presence of the writing and the press, which make man readable but not visible, as Béla Balázs states in 1924.[11] Therefore, the screen should be understood as a laceration that allows us to see reality directly, again and anew. The metaphor emerges quite soon in film debates: It appears, for example, in an Italian text of 1908 by Tullio Panteo.[12] However, it will find particularly fertile ground later, in the realist theories of cinema[13]: in fact, these theories are all characterized by a desire to reactivate a direct gaze on things and by the knowledge that in order to do so, one must overcome resistance, obstacles, and impediments. In this light, cinema literally offers to the world the possibility of a redemption.[14]

The second major metaphor is that of the *frame*: The screen is a surface within which appear figures capable of depicting *the*, or at least *a*, world. Here we are no longer dealing with a direct gaze on things, but rather with a representation of them. This leads to the emergence of new aspects; in particular, the content of the image, rather than a simple datum, becomes a construct at the root of which is a work of mise-en-scène. Nevertheless, a representation does not cease to speak to us about reality; every time an understanding of the laws of nature is applied to a representation (something that true artists always do eventually), it also ends up revealing to us the dynamics and composition of reality. This explains why the metaphor was utilized most of all by formalist theorists of cinema. We find it in the early debates (for example, in Victor O. Freeburg, not by chance in connection with his strong attention toward pictorial composition).[15] But we encounter this metaphor quite regularly in tandem with the awareness that the filmic image is based on a visual configuration, and that such a configuration is capable of fully restoring to us the sense of the world in which we live.[16]

The third major metaphor is that of the *mirror*: The screen is a device that restores to us a reflection of the world, including a reflection of ourselves. The mirror metaphor, too, had already emerged in earlier cinematic theories: a good example is Giovanni Papini's essay of 1907.[17] However, it will find its most fully developed elaboration in the

psychoanalytic approach, which asserts that spectators may identify with the film's protagonists and with the gaze (of the director? of the camera? of a transcendental subject? of the gaze as such?) that captures them on the set. A film's spectators see a world to which they yield themselves, but they also see a point of view on this world with which they associate themselves. In this sense, they see themselves seeing. I should add that the mirror reunites what the two preceding metaphors held apart: The former underlined the possibility of perceiving things directly, while the latter highlighted the necessity of passing through their representation. This third metaphor posits a reflection that allows us to see things as they are, and ultimately offers up only an image of them[18]—an image, I repeat, which also references directly the observer.

These three major metaphors are not the only ones that film criticism and theory use to talk about the screen.[19] Although less frequently, it is also seen as a *door*, through which one enters and exits, as illustrated in the last sequence of René Clair's *Entr'Acte* (1924). It is also associated with *skin*, as suggested by Jean Epstein's famous phrase concerning the close-up: "I look, I sniff at things, I touch."[20] (In 1966, the marvelous opening sequence of Ingmar Bergman's *Persona* would confirm this image.) But the screen can also be considered simply as a support, as Elie Faure attests to when he speaks of it as a mere environmental element.[21] The three metaphors of the window, the frame, and the mirror, however, aside from being the most widespread, bring us most closely to the heart of the problem. They all identify the screen as the place in which reality offers itself to spectators—in all its immediacy, consistency, and availability. At the cinema, we have access to the world; through its cinematic representation, we may sense its structure and its possibilities, and thanks to the process of identification, we can make the world ours.

It should not be surprising then that the first theories of cinema often speak of an "epiphany": On the screen, reality reveals itself in all its density to eyes ready to witness it. Antonello Gerbi writes: "Submerged by the sounds, we are ready to receive the new Epiphany. Are we buried in the deep or hovering among the stars? I don't know: certainly we are very close to the heart of the cinema."[22] These references to epiphany sometimes lead early film theories to adopt a sort of religious inflection, in which the screen is assigned an even greater role as a component of a rite. To quote Gerbi again, "This piece of crude canvas [. . .] is reborn

as an altarpiece for the liturgies of the new times."[23] These suggestions do not foreclose a more secular approach: The three metaphors mentioned above also allow us to glimpse an idea of the cinema as medium. If it is true, as Marshall McLuhan suggests, that media form the nervous system of a society,[24] the movie screen is essentially a terminus from which we gather data from outside (window), as well as an organ with which we re-elaborate data (frame), and a device for self-regulation and self-recognition (mirror). The cinema owes much, if not everything, to the screen.

BEYOND CINEMA

The television screen differs from the movie screen: It is small rather than large; it is made from glass as opposed to canvas; it is fluorescent rather than reflective; and the world it hosts is live rather than recorded. However, in its early years, this screen recalled the same major metaphors mentioned above: It was a window, even if the walls it faced were those of the home instead of a public space; it was a frame, even if its components were arranged differently; and it was a mirror, even though it was more reflective of a society than of an individual.[25] In its initial stages, notwithstanding its increasing role in the media landscape, television apparently did not alter a well-consolidated system of concepts.[26]

Nevertheless, there arose a new metaphor that came to join the others, and which in some ways signaled a new direction. Television, it was often said, was like a hearth in front of which the family gathers. This metaphor not only emphasizes the continuity of consolidated habits (today we would say the processes of domestication of a medium); it also indicates that this screen brings the outside world into the domestic space—radiating it like firelight, and endowing it with the continuity of a warmth that permeates the home. Indeed, the epiphany becomes the everyday: it persists within reach, so to speak. This radical availability of the world, and its transformation into a flow of images onto which viewers can continually graft themselves, would eventually come to be a decisive characteristic of new screens.

A greater sense of novelty comes on the scene in the 1960s with the appearance of multiscreen installations. One type of installation consists

of the simultaneous projection of a film onto multiple surfaces. The New York World's Fair of 1964–1965 provided more than one example of this: There was, for example, Charles and Ray Eames' spectacle, which involved fourteen projectors and nine different screens.[27] This structure was then immediately reinterpreted in an experimental key by Andy Warhol, in particular in his *Chelsea Girls* (1966), in which the arrangement and synchronization of at least two screens was much freer.[28] Another form of installation—the video wall—was created by stacking up a series of video devices. The video wall, too, took its first steps in the 1960s, offering spectators greater immersion in its images. Nam June Paik provided an almost immediate artistic reinterpretation of it with his *TV Cello* (1964), a series of television sets stacked on top of one another in the form of a cello.

With the introduction of the multiscreen installation, the traditional screen seemed to signal openly that it felt constrained within its traditional confines. The time had come for it to grow, to multiply, to spread out, and this moment arrived in the 1980s and 1990s. It was precisely during these years that a series of extensions became common and, moreover, the screen began to constitute an essential part of new media, following a trajectory that would continue into the next decades. Among the expansions, we find the connection of the television set to the VCR and to the video-game console[29]; or the amalgamation of a video screen and the telephone provided by the French Minitel.[30] Examples of new screens are the computer[31] and the cell phone,[32] which in these years became an increasing presence in daily life. In the same vein, the introduction of the portable DVD player allowed for the personal consumption of videos outside the walls of the domestic space.[33] Electronic organizers began to replace paper diaries.[34] Tablets started developing along a path that would lead to incredibly successful products such as the Kindle and iPad.[35] Finally, media façades started taking their place as a characteristic feature of many urban spaces, before acquiring the capability, as they now have, of interacting with passers-by. Indeed, all media have become media screens.

This screen explosion—which is still affecting us today—has led us to a true turning point. We find ourselves surrounded by unprecedented technological innovations: surfaces made of liquid crystals, of plasma, and of LEDs, as flexible as a piece of paper, interconnected, reacting to my

touch and my voice, and so forth. This turning point, however, represents a conceptual transformation as much as it does a technological fact: it is the very idea of a screen that is changing, as Lev Manovich has already suggested.[36] There are three aspects that I consider crucial. First, the great diffusion of screens allows media content to multiply the occasions and the ways in which it may present itself (a book may be read also on a Kindle or on a tablet; on a computer, we can have different editions of the same book on the same surface; we can add images or edit it in a different form; we can keep a copy with our notes, and so forth). Second, the fact that these screens are often connected allows for a sort of "bouncing" of the content from one point to another—a rebound that shares this content on a large scale, but that also ultimately transforms it (the book I am reading, and the notes I am writing, can be read also by someone else at a distance, who can add further notes). Finally, and more radically, the ubiquity of these screens makes possible the living or reliving of media experience in new environments and on new devices (we can feel like readers, even if we do not have a bundle of paper in our hands). In short, this screen explosion has resulted in a diffusion of content on many platforms (*spreadability*), an interconnection of reception points (*networking*), and a reactivation of experiences in many situations (*relocation*).

This new situation, which seems to have now arrived at a maturation point, has literally led the screen to assume a new nature. Embedded into new media, the screen no longer exclusively represents the site of an epiphany of the real; rather, it tends to appear as a surface across which the images circulate as they travel through social space. The information that surrounds us condenses on the screen, lingers for a moment, interacts with the surrounding environment, and then takes off for other points in a kind of continual movement.

NEW METAPHORS FOR THE SCREEN

To understand this new situation better, let's attempt once again an exercise in terminological recognition by asking: What are the key words that communicate what a screen is today? There is no doubt that the old metaphors no longer work, so we must discover which other terms have supplanted them.

The first term is undoubtedly *monitor*. The screen increasingly serves to inspect the world around us, to analyze and verify it—in essence, to keep it under control. The window that once restored our contact with the world has become a peephole through which to scrutinize reality, on the likely chance that it may be hiding something dangerous.

The screen as monitor is first of all what we find in large surveillance centers and in the security offices of apartment buildings and commercial complexes. A series of screens form a kind of wall, which allows for the constant surveillance of every room and corridor, and, above all, every entrance/exit and every point of the external perimeter. Who is it that performs this surveillance? In some cases, members of the security staff view the monitors. However, in many 24-hour, closed-circuit systems, the images gathered by the cameras are simply recorded; there is no one watching, unless the footage is reviewed later, but only "after" something has happened—in this case they are also often largely publicized, and every citizen can look at them, and consequently become a detective.

Such a situation takes us inevitably back to Bentham's Panopticon, which Foucault discussed in *Discipline and Punish*.[37] While the Panopticon was designed so that only one individual was required in order to keep an eye on the entire building, in the case of security cameras everything is observed, but there are no longer any observers. Put another way, no one is looking, as the end goal is not to watch (or to make known that one is being watched), but simply to gather data to be mined in case the need arises. This is symptomatic of the passage from a disciplinary society to a society of control,[38] like the one in which we now live. And yet it is still noteworthy that the security monitor implies a gaze, but not necessary a viewer.[39]

This same contradiction may be found in an even more paradoxical form in the other example of the screen as monitor: the GPS. The Global Positioning System is also an instrument used to keep territory under observation, in order to avoid possible inconveniences and in order to take advantage of possible opportunities. We use it to stay on track and to arrive quickly at our destination, to avoid running out of gas and to locate the nearest service station, to avoid dying of hunger and to find a decent restaurant in the vicinity. The GPS may seem to represent the return of the observer; after all, its small screen is always in front of the driver's eyes. However, the gaze elicited by the GPS differs significantly from the one

traditionally linked to a screen. It is an intermittent gaze, activated only—and most often—in moments of need. It is also a gaze with multiple focal points, aimed both at the maps supplied by the kit and at the surrounding reality, which continues to be visible through the windshield and windows of the vehicle (these actual windows do still exist!). In short, it is a gaze that is largely independent from the device. In this light, GPS confirms the fact that although monitors are in constant need of new information, they do not always require an eye to scrutinize and observe them.

The second term that defines contemporary screens—replacing the metaphor of the frame, which nowadays exhibits clear limitations—is *bulletin board*, or even *blackboard*.[40] In fact, on the screens that surround us, we encounter less and less frequently representations capable of restoring the texture of the world, and more and more frequently figures that function as *promemoria*, as signposts, and, above all, as instructions for behavior.

Let us consider screens found in waiting rooms, in stations, and in modes of public transport. Various messages pass across these surfaces: film and video clips, advertisements, tourism documentaries, and so on. Their objective is not to offer an external reality or to alleviate the sense of oppression brought on by the closed environment in which we find ourselves confined. Rather, these communications are intended to help us pass the time and to prepare us for future actions: They inform us of the approach of a train (to the station), of whose turn it is (in the waiting room), of the weather at a destination (in an airport), of the beauty of tourist destinations (in a ticket office), or of exercises to do in order to avoid discomfort (on an airplane). More than fragments of the world, these are instructions for behavior.

The same may be said for the videos in shops and malls, which display the goods for sale on the counters and shelves. Again, what is important is not what these videos depict: The merchandise is right next to them, in plain sight. What really counts is the information that accompanies the depiction of the merchandise: We see how it is used, how much it costs, where it comes from, why it is convenient, and which lifestyle it matches. It is according to this information—often evocative and emotional—that we adjust our behavior, deciding whether to purchase or not purchase the merchandise. The presence of these videos acts as a sort of veil over reality: We have ceased to look at things via their representation, and now we look instead at a set of directives aimed at us.

Even in places where we might expect a contrast, such as many homepages of institutional Web sites, images function in a similar manner. I am thinking, for example, of school or university homepages. These describe academic life with a profusion of attractive images: They reveal a whole world to the eyes of the reader. However, these illustrations act as bridges to boxes or links that offer detailed information aimed toward the various users of the site: students, professors, families, or administrators. A possible life experience is transformed into a series of announcements.

Video games offer perhaps the clearest example of the screen as bulletin board or blackboard. The image that they present consists essentially of a group of figures of variable value upon which the player must act. Their value is defined by a score that appears in an accompanying box or that flashes near the figure. The player chooses his moves based on these values, deciding whether to confront the figure, to move to another portion of the landscape, or to acquire new abilities. His move will determine a change in value, either of a specific character or of the total gains or losses; this score in turn will determine new moves. Therefore, the essence of the game does not lie in recognizing figures that appear on the screen: Attention is concentrated above all on a set of values and on a menu of possible lines of action. The player does not find pleasure in contemplating a representation; rather he moves within a forest of instructions. I would add that in many of these games—those called "shoot 'em all"—the essence of the action consists in destroying what appears before the player. This means not only that the world represented is completely abstract, reduced as it is to numeric values, but also that this world is essentially destined for decomposition. What a perfect example of the tendency of the bulletin board to disassociate itself from reality in order to create space for a flow of information!

This does not mean that such a flow does not constitute "a" reality: it will not be, however, a mere physical reality in the empirical sense, but rather an overlapping of actual facts, possible actions, comments, and values. Let's take what is called today "augmented reality": When I point my cell phone in front of me, I see on the screen a piece of urban landscape made up of actual buildings, supplemented by indications that help me to move within the city, as well as information on edifices belonging to the past that have since disappeared, and projects for future constructions. I see a city, and a "true" city, that nevertheless is not just a reflection

of an empirically existing entity, but rather a complex made up of many different types of data.

The third way to describe better a contemporary screen—moving away from the traditional metaphor of the mirror—is to think of it as a *scrapbook* or a *wall* on which excerpts, quotations, pictures, and so on, are posted. Spectators now struggle to identify with a character or story; they prefer instead to construct images of themselves in the first person, assembling photos, texts, and comments often lifted from elsewhere and entrusting these heterogeneous materials to a blog or putting them in circulation on a social network. Therefore, more than identifying with someone or something else, they cut, paste, compose, and send.

I mentioned blogs: The personal homepage is the primary example of the screen as scrapbook. Blogs are literally mosaics of texts and figures, which accumulate day after day, narrating the life of the blogger. This is a particular kind of self-presentation; the materials that form it are only partly self-produced. Often they are recuperated from elsewhere, and once they are posted on the Internet, they become available for other users to narrate their lives. As a consequence, the portrait that we meet may be considered true to life, but in its dismantling and reassembling, it could also apply to anyone. The flow of data, news, and quotations becomes more important than the representation of subjectivity: the "I" is almost exclusively born of the personal use of whatever materials the user finds.

In the social networks typical of Web 2.0, such as Tumblr, this condition returns in an even more radical way. Thanks to the presence of a feed reader, the page is loaded with content lifted from elsewhere, until it forms a kind of newspaper that contains content that the user reads or is interested in. The posts of other bloggers appear on the user's dashboard, and she may sometimes—though not always—add comments or corrections. This results in an enormous accumulation of citations, references, and sources, with a relative paucity of the user's own interventions. The user's personality continues to manifest itself within this accumulation, but this manifestation comes about as a result of the links to which she connects herself, much more so than as the result of what she says directly. Precisely because of this, her voice is ultimately nothing more than a montage of others' voices—almost as if to radicalize the fundamentally hybrid and composite nature of our discourse, highlighted by Bakhtin eighty years ago.[41]

Even when this voice is made direct, the situation is not much altered. Twitter and Facebook (which includes, not by chance, a page called a "wall") represent interesting examples. There is more space here for an exchange of opinions; however, any personal intervention is restricted to a few possibilities (in Facebook: "like," "comment," and "share"). Furthermore, this intervention is limited in space and therefore often devoid of much meaning (it is difficult to imagine that a click on the "like button" can really reveal a personality). The user's intervention depends on the material that is continually posted on her wall (a confirmation of the fact that one's own discourse is always an echo of the discourse of others). Finally, it reflects thoughts and opinions that are strictly dependent on the subject touched upon in a discussion: Once the subject changes, nothing hinders the emergence of other orientations, except a kind of loyalty to the objects that are "collected" and that lead each "friend" obsessively to offer what is expected of him or her.

These social networks are therefore typified by a kind of self-presentation that is based on a mosaic of material, often borrowed from others, and linked closely to contingency—or simply guided by obsession. The same mosaic may also be reassembled in order to represent other personalities (perhaps of the same individual: there is no shortage of people who live a plurality of virtual lives under different nicknames). If it evolves, it may follow a course of personal transformation ("today I am not who I was yesterday"). But often, at least it seems to me, it simply follows the progression of circumstances ("I am who I am depending on the day"). These characteristics highlight the limits of these self-presentations: Their value lies in how they are displayed, not in what they say, and while they have value for an individual, it is neither exclusive nor permanent. In light of this, we could say that in the very moment in which the social network participant presents a self-portrait, he opens the door to his own dissolution. In reality, what is lost is the traditional process of projection-identification, as described by psychologists and, for film, by Edgar Morin[42]: social network participants no longer find completed stories in which to recognize themselves. Rather, they live in the midst of a continual flow of data, available to them for every eventuality; they collect the material that is more meaningful and akin to them; they edit this material in a composite whole; and they make of their lives a *combination*.

FROM THE SCREEN TO THE DISPLAY

Monitor, bulletin board, and scrapbook or wall: These new key words indicate just how distant the new screens are from the old. While it is true that we continue to deal with a rectangular surface on which figures in movement appear, it is also true that this surface no longer implies a reality to which an observer can relate, nor one in which an observer can recognize herself in what she sees. This new screen is linked to a permanent flow of data, but it is not necessarily coupled to an attentive gaze, to a world that asks to be witnessed, or to a subject that is reflected in what she sees. There is a connection and a disconnection: A set of figures becomes perpetually available here where we are, but it does not necessarily lead us to a stable reference, an ensured addressee, and a full identification.

The concept of a *display* may help to render an idea of this new entity better.[43] The display shows, but only in the sense that it places at our disposition or makes accessible. It exhibits, but does not uncover; it offers, but does not commit. In other words, a display does not involve its images in the dialectic between visible and invisible (like a window used to do), between surfaces and structure (like a frame), or between appropriation and dispossession (like a mirror). The display simply "makes present" images. It places them in front of us, in case we may want to make use of them. It hands them to us, if you will.

The display is fully realized in the form of the touch screen. Here the eye is connected to the fingers, and it is they that signal if the observer is paying attention and, if so, what kind. Touch solicits the arrival of images, but even more so, it guides their flow: it associates them, it downloads them, and it often deletes them. It enlarges them, moves them around, and stacks them. While it is the eye that supervises the operations, it is the hand that guides them. It is the hand that calls to the images and seizes them.[44]

We are beyond the old situation in which spectators were immersed in a world that surprised them and held their attention from the screen. Now, spectators surprise and grab hold of the images that scurry before them: images that are not necessarily capable of restituting an empirical reality; rather, they are oriented toward supplying data and information. They are not even addressed directly to anyone in particular: It is

their flow, more than their capture, that defines them. Finally, they are tied more closely to the hand than to the eye: It is only when they are "touched" that they find their place and define their value. The display screen makes these images present. It is here that they exit the flow and come to a halt. It is here that they become simultaneously available and practicable. We literally extract them from the screen, according to a logic that mixes push and pull.[45]

In short, we cannot look out of a display screen, nor can we fill our eyes with it, nor can we lean out of it. Instead, we ask something of it, as at an information window. We work on it, as at a table. We wait by it, as at a bus stop. And we find ourselves in front of something that stays with us for just as long as is necessary.

Naturally, not all the screens that surround us enter fully under the rubric of the display screen. There are still moments in which the reality around us is represented to an interested and engaged observer. This may happen on the very same devices that normally seem to negate the possibility of an epiphany. Google Earth, though it offers me maps and not territories, can lead me to rediscover the pleasure of taking a walk; Photoshop, though it offers me an image of how I would like to be, may obligate me to face myself again; a video game, though it gives me the opportunity to abandon the world, may also give me the scripts and the characters to construct another one. Computers, cell phones, or tablets are still widely used for diffusing documents and investigations, for fostering public discussions, and for constructing effective communities.[46] Indeed, there is still room for direct testimony that reconnects us to an exploration and to a dialogue.

Although the contemporary media landscape is multifaceted, current tendencies are moving toward the display: a surface on which we find—when we find it—a reality that goes beyond empirical data, from the moment in which samples, information, and elements of possibility are mixed together; and a surface on which a gaze is trained—when there is one—that goes beyond the traditional poles of contemplation and analysis, from the moment in which it is accompanied by the manipulation of that which is being observed.

The epoch of the window, the frame, and the mirror is largely coming to an end.

A NEW SCENARIO?

This transformation of the screen is symptomatic of a larger transformation, which involves media in their totality. Media have long been conceived of as means of mediation between us and the world and between us and others: They serve to supply information and share it among subjects. In this sense they appeared as instruments of transmission and dialogue. This kind of idea prevails in models such as that proposed by Harold Lasswell in the 1940s,[47] but it persists in the subtext of Marshall McLuhan's reformulations of the 1960s[48] and Raymond Williams's of the 1970s,[49] in which the emphasis is placed, respectively, on media's abilities to extend our senses and on their abilities to elaborate cultural models. We have now entered into a new dimension. Let us take for example GPS or Wii, or even tablets and smartphones: These are primarily devices that serve to access information and services. Thanks to them we "recuperate" a series of data—perhaps without meaning to, but anytime and anywhere. Put another way, we "intercept" elements that are present in social (and virtual) space, and we utilize them in the situation in which we find ourselves, whatever it may be, only to store them away. In essence, we capture, modify, and release.

This characteristic is recognizable in all contemporary media. They invite us to "capture" something that is "available," and which is made available again after we have used it, perhaps transformed by our intervention. We are no longer in the sphere of a proper communicative exchange; there are no hand-offs or confrontations, transitions, or transactions. There is a *circulation* of information in which we must immerse ourselves; media are the essential components of this circulation. They function as nexuses of interconnected circuits. They store data so that we may avail ourselves of them. They permit us to modify the situation in which we find ourselves, and they help us to construct new situations with data. They allow us to adapt what we find. And finally, they relaunch these same data, after they have been used and adapted, within these various circuits. In short, media are places in which information in unremitting movement is downloaded and then uploaded to continue on its trajectory.

Such an orientation may be confirmed in the growing success of applications such as feed readers: These are programs aimed both at

supplying users with a continual stream of fresh data and at aggregating these data among themselves. Another confirmation may be found in practices such as Web harvesting: research in the forest of data that arrive or that may arrive, in order to comb through them, keep them in view, and eventually stow them away. In both cases, the objective is to acquire, assemble, and archive the information that is circulating—in order to then make it available to whoever might be connected.

I do not know if we may call this "communication" precisely. I repeat: We are no longer primarily dealing with messages addressed to specific individuals or encounters between people. Of course, there still exists the space for announcements and dialogues; but above all, there is an enormous mass of data that circulates through the air, so to speak, and that occasionally halts and then takes off again.[50] Media are the instruments of a slackening of speed—as well as of an acceleration—of this perpetual motion. Thanks to them, we may "block" something here in front of us, to then "relaunch" it—which is to say, we download it and then upload it. In so doing, we place ourselves at a transit point, rendering our experience that of an ephemeral place.

The same goes—and above all—for visual media. Contrary to a long tradition of "realism," the image is no longer engendered by facts; rather, it is born of an amalgamation of elements that are concretized according to the circumstances. And even when the image is the product of a live recording, it remains part of an information flow that makes it available for new combinations and new circumstances. The image is an aggregate of provisory data and an entity in continual movement, responsive to momentary needs, ongoing discourses, and up-to-the-minute rhetoric. It is not important from whence the image comes, but rather that it circulates and that it can pause somewhere to then take off again.

Vilém Flusser has offered an effective portrait of this situation: Written ahead of its time, and in a somewhat prophetic tone, it is proving to be consistent with what is currently happening. He begins with the observation that the reality that surrounds us has crumbled into fragments: "The world in which [people] find themselves can no longer be counted and explained: it has disintegrated into particles—photons, quanta, electromagnetic particles. [. . .] Even their own consciousness, their thought, desires, values, have disintegrated into particles, into bits of information, a mass that can be calculated."[51] This state does not

impede us from forming an image of the world; however, this image can no longer be based on a depiction capable of tracing the contours of things (an *Imagination* in German). Rather, it must emerge from a calculated montage of fragments, from an *envision* (an *Einbildungskraft*, in German). "The whirling particles around us and in us must be gathered onto surfaces; they must be envisioned."[52] This is what constitutes media: They block the whirlwind of data and they recompose them into new figures. They accomplish this mechanically, following preprogrammed automatisms, from which it is difficult to depart. And they do so blindly, offering up various combinations, some of which are completely unpredictable. This is another reason why the images they supply (which Flusser calls *technical images*, to distinguish them from traditional ones)[53] no longer constitute evidence strictly speaking. Nevertheless, that which media present to us continues to concern reality: It is not, however, an already formed world, but rather it is a world in formation. And it does not contain exclusively factual elements, rather it also—and above all—contains elements of possibility.[54] In light of this, technical images, although they cannot be considered either true or false,[55] bring us closer to things. They allow us to emerge from the abstraction into which the world is flung; they return to us some meaning; they lend themselves to some project.[56] They continue to speak to us, but from inside a continual and unstable wandering.

I would add that the effectiveness of these images depends on how and where they appear. Above all, the situation is decisive—a situation that the images find and simultaneously shape. It is one thing if images materialize on my computer, only for me, in an interstice of my daily life; it is quite another if they are displayed on a public screen in front of a crowd gathered for an event. Similarly, it is one thing if images reference distant events, which I follow, perhaps even with great concentration, but disinterestedly; it is quite another if they refer to my surroundings, in which I can, or perhaps must, intervene. And finally, it is one thing if images remain trapped in a schema or formula on a screen, while it is quite another if theirs is simply a temporary stopover open to ulterior developments. I am thinking, for instance, of the images of the Arab Spring: It makes quite a bit of difference whether they reappeared on the screens of Times Square for the benefit of curious passers-by or on the smartphones of the crowd gathered in Tahrir Square. In essence, if it

is true that the destiny of these images is to be permanently in transit, it is also of essential importance when and where they land. Their force, meaning, and even their political value are determined in great part by their location.[57]

We no longer find ourselves faced with an exchange, but a circulation; no longer in front of a merely factual reality, but a reality born of a recombination of information packets. We are dealing with a whirlwind of data, which occasionally pauses only to reconstitute itself and set off again; but also with presences that manifest themselves here before us, and therefore can still communicate to us about the world. This is precisely the media landscape that we must now confront—and the display screen is its perfect emblem.

THE CINEMA, AGAIN: A CONTRADICTORY PRESENCE

Is there still space for cinema in this new landscape? Can it find real hospitality on the display screen? And can it, in turn, teach us something?

Cinema undoubtedly represents a point of resistance with respect to the process that I have attempted to describe in the preceding pages, for at least three good reasons. First of all, cinema is still largely the prisoner of a tradition that sees it as the closest art to reality. Cinema continues to be, both in the collective imaginary and in the intentions of its authors, a trace of the world: Its images, even when they serve to narrate fiction, continue to possess a strong documentary value. Second, cinema still carries with it the dream of an organic unity. The stories that it offers are aimed at constructing structured worlds that are dense and coherent: for as much as a film makes space for randomness, what it shows us always reveals a strong consistency. Third, cinema is still based on a system of distribution. Films are spread along pre-established routes and arrive at predetermined points. It is true that it is becoming increasingly easy to find films everywhere—and recuperate them through legal and illegal practices—but there is not yet a "whirlwind" of images, as has happened online for other types of products.

The weight of a tradition of realism, the strength of narration, and the directionality of distribution: Cinema seems to channel images and conduct them—toward a reference, toward a text, toward a well-established

addressee—in an era inclined to leave the circulation of data open. However, this characteristic does not confine cinema to the margins of the great media transformation currently under way. On the contrary, it proves useful by demonstrating some contradictions in the contemporary panorama.

First, even if we do not trust images as we did in the past, there still exists a need for truth. It emerges from many small, personal artifacts posted on YouTube, whether they be the documentation of a childish prank or the cell-phone camera footage of some historical event. The same need has inspired such strange Web sites as photoshopdisasters.com, motivated by the desire to point out the distortions perpetrated by Photoshop users, mostly in advertisements. The persistent success of movies inspired by "true stories" (ever more opposed to the trend toward fantasy), and the increasing role played now by the documentary (in its different forms, by a Werner Herzog, a Michael Moore, or an Errol Morris), bears witness to how film directly touches upon one of the most problematic contrasts in contemporary media.

Second, even if there is an increasing presence of "short forms," from clips to advertisements, the need for stories is still vital. We see evidence of this in the flourishing genre of neo-epics in the mold of Tolkien and Marvel superheroes, in which the vicissitudes of the characters wind along seemingly infinite paths. And we also see it in video games, both those fantastical in nature (the parameters of which are basically "realistic") and those inspired by history (in which a past verdict may be reversed, as long as the new narration remains consistent). Cinema, with its strong and everlasting vocation for storytelling, serves as a testament to the resistance against the death of the great narratives.[58]

Third, even if circuits are always open, there still exists the need for an actual, concrete reception. This need is evidenced in the desire to feel involved in what one watches that emerges from some particularly politically engaged areas of social networks, or from the systematic count of viewers and their comments that accompany the videos posted on YouTube, or from the conversion of virtual contacts into actual encounters, often stubbornly hoped for and celebrated on Facebook. Cinema, again, through the request of strong attention to images, and through the presence of specific venues where it can be enjoyed, attests to the need for effective experiences.

FROM TEMPLE TO PORTAL

If it is true that cinema echoes and enhances the contradictions that mark the epoch of technical images, it is equally true that it participates fully in the era in which we live. It too is now permeated by the logic of the display. It is no coincidence that the worlds represented on the screen are increasingly fluid, or that the stories are increasingly inconsequential, or that the settings are often unstable and the scenes are increasingly composed of collages and mosaics. Nor is it a coincidence that cinema now regularly lifts narratives and figures from other media, while simultaneously offering to other media its own stories and figures, in a kind of continual exchange—something it has always done, but which now reaches an unusual intensity. Finally, it is no coincidence that cinema itself is in constant search of new environments and devices onto which to transfer itself, from city squares to my smartphone. Cinema increasingly lives through forms and situations that are unsteady, provisional, and contingent,[59] and which reconfigure themselves for a moment and then take off again along new trajectories.

Here, cinema drops its claim to "channeling" images; instead, it limits itself to "localizing" them, supplying them with some modalities of stylistic or narrative reorganization, and especially with a place in which to offer them to someone's gaze. In other words, it gives the images a definite—but not definitive—"how" and "where": a "how" and "where" that delineate the situation within which the images can operate, while also allowing them to conserve all their mobility and potential. Localization does exactly this: It arrests circulating images for a moment; it makes them converse with a context that they, in pausing, create around themselves; and it gives them meaning through this conversation, without, however, eradicating other possibilities for meaning.

Cinema's capacity to supply images with a stopover—as opposed to a final destination—gives it a new and enhanced role with respect to other sites of viewing. On the one hand, cinema reminds us that images can still materialize in concrete environments, in front of an audience, or in precise circumstances, even now when viewing is mostly individual, often casual, and tends to take place in a neutral space and time. On the other hand, cinema teaches us that images are not easily imprisoned: Their appearance is necessary if we want them to speak to us, but it is

Display 175

also always temporary. Therefore, places of vision are now conceived of as unstably structured environments, characterized by temporary gatherings and fleeting images. This is true of spaces where films are screened, and also, by extension, of all the spaces in which the presence of a screen leads to the formation of a community of spectators—and perhaps, even of all the public spaces in which images are in play. We increasingly find more sites that allow circulating data to acquire a weight and a value, thanks to its link to a territory. These sites, however, are formed and dismantled according to the circulation of data. Though they are real spaces, they tend to function like a kind of portal in which images in flux are made to converge, and thanks to which one may make contact with the data whirling through the air.

If cinema today does want to function as an example, this is the only lesson that it can give us. We still need public spaces in which to welcome and experience images. However, these spaces can no longer exist as temples dedicated to a well-established rite, as Ricciotto Canudo described movie theaters at the beginning of the past century.[60] Nor can they continue to host a docile audience, ready to abandon itself to what it sees, as successive theories often described.[61] They can only be meeting points between images and spectators, both of which are in transit,[62] display places, if you will.

Naturally, examples of spaces dedicated to both gathering and transit can also be found outside of cinema. Eight years before the release of the film with which we began this study, *Timecode*, the stage of U2's *ZooTV Tour* was decked out with four mega-screens along with thirty-six monitors continually criss-crossed by images, some of which were gathered from local television channels. The music came forth in parallel, open to possible intersections with the images. The audience of fans, gathered to see their favorite band, found itself in front of a largely unpredictable event. However, if cinema does not hold a monopoly on display places at which transient images and transient spectators meet, it continues to function as an emblem of them. It is therefore fitting to conclude these pages with three very successful titles that have left their mark on the first decade of the twenty-first century: *The Matrix* trilogy (Andy and Larry Wachowski, 1999; 2003; 2003); *Minority Report* (Steven Spielberg, 2002); and *Inception* (Christopher Nolan, 2010). It is not surprising that all these films represent attempts at intercepting images, understanding them in

relation to a situation, and defining to whom they are addressed. I am thinking specifically of the scenes in *The Matrix* in which the resisters control the environment through a monitor that turns out to be merely the product of an illusion; of the moment in *Minority Report* in which John Anderton summons up images of the future on an interactive screen in order to understand what is taking place around him, but also in order to stage a sort of spectacle for his companions; and of Cobb's continuous attempts in *Inception* at aggregating projections and memories in order to sketch out possibilities. These films do a fine job of demonstrating what it now means for transitory spectators to localize transitory images. Indeed, the films themselves are in transit, ready to transfer onto television or computer screens, to become video games, and to create a social imaginary. They are emblems of what it now means to see in our contemporary era of display. In this sense, they are portraits of the current media condition and portraits of what cinema, in this context, can still say and teach.

* * *

What would a world without screens look like? *Goodbye, Dragon Inn*, a 2003 Taiwanese film directed by Tsai Ming-liang, depicts the last screening in a Taipei cinema before it closes for good. The film being shown is *Dragon Inn*, a martial arts classic from the 1960s. The spectators are now few, some in search of sexual encounters in the cinema's bathrooms. The cashier staggers around the hallways, limping. The projectionist is no longer in the projection booth. One man claims that the building is cursed. Two old men converse, with tears in their eyes: They were actors in *Dragon Inn*. The screening ends.

I find Tsai Ming-liang's film to be a work of science fiction, a bit like *Paris qui dort* or *Metropolis*. Unlike the earlier films, however, it inquires not as to what happens when a new invention takes over our lives, but rather what happens when an old media no longer lives among us. How will we live without screens—and without cinema screens? In short, there will no longer be a place where images can appear and pause for a moment, nor one where spectators in perpetual motion can sit down and try to catch them. Images will remain virtualities, in the air, or take on the character of memories that can no longer be obtained. Unrealized potentialities or forgotten realizations. They will certainly continue

Display 177

to exist, wrapping us in a warm blanket—that blanket that Benjamin associated with boredom. They will be images that are produced or reproduced almost by chance, like those of the millions of surveillance cameras scattered around the world, or those taken by tourists who will never see again what they never saw to begin with, or those that double and triple in automatically exchanged links. A giant archive with no end, the universe of images will fold in upon itself. And because of this, we need cinema. Still.

7. Performance

ANNA, NANA, NICOLE

Anna and Nicole make arrangements to meet each other at the movies. Unexpectedly, they end up at different theaters: Anna to watch *Vivre sa vie* (1962) by Jean Luc Godard, and Nicole to watch *The Adjuster* (1991) by Atom Egoyan. Anna contacts Nicole with an SMS from her mobile phone, and Nicole receives the text and responds. In the Godard film that Anna is watching, the protagonist, Nana, has just entered a cinema where Carl Dreyer's *La passion de Jeanne d'Arc* (1928) is being shown. Another spectator sits next to Nana, more interested in her than in the movie. At the same moment, in the film that Nicole is watching, the protagonist, Hera, is in a film theater and is approached by a man. Nana continues to watch *La passion de Jeanne d'Arc*: A monk played by Antonin Artaud aggressively interrogates Jeanne, who replies; Nana is moved to tears. Anna, instead, who sees these same images within Godard's film, is struck by the beauty of Artaud: She records the scene with the camera on her mobile phone and sends it to Nicole, who then finds herself following a second film, in addition to the one she paid to see. As the word *mort* is pronounced in the film that Nicole is watching on her mobile, the scene of a great bonfire from *The Adjuster* flashes across the screen.

Artaud Double Bill,[1] by Atom Egoyan, is a film that in three minutes creates a neat construction of interlinking elements. There are two present-day spectators, Anna and Nicole, who are sitting in two separate theaters but who participate in each other's film-going experience. They watch two films, *Vivre sa vie* and *The Adjuster*, which belong to two different phases of cinema history, but which both make reference to what is happening in front of a screen. The clip of *La passion de Jeanne d'Arc* included in *Vivre sa vie* is seen by two spectators at different times, Nana in the 1960s and Anna in the early 2000s, with different reactions. In the films that Anna and Nicole watch separately, there are events, such as the sexual aggression or the bonfire, which transit from one to the other. Moreover, we see a mobile phone screen that extends the cinematic screen by capturing and transmitting it. And there are the words, in the text message, which describe what the two friends are watching.[2] These interlinking elements—underlined by a set of explicitly related names, Anna, Nana, Jeanne, each one echoing the other as in an anagram or in a portmanteau word[3]—create a sensation of dizziness: The world seems to vacillate, and we risk becoming lost in it. But from the series of situations that reflect each other reciprocally, there emerge some precise indications of what it might mean to see a film in a movie theater nowadays.

TO WATCH A FILM

Let us follow the triangle composed of Anna, Nana, and Nicole, attentive to the divergences that seem to establish themselves between Anna and Nana, spectators of the same film though on different levels and in different epochs, and to the convergences that seem to occur between Anna and Nicole, spectators of different films, but anxious to establish common ground.

The first trait that strikes us is that if Nana, in Godard's film, watches Dreyer's film only, Anna, in Egoyan's film, finds herself in front of a more complex object. She sees Godard's film, and inside of that, Dreyer's: She is the spectator of a double set of images. She sees *La passion de Jeanne d'Arc* by Dreyer, but she also sees Nana who is watching the same images: She is the spectator of an act of vision. Furthermore, she sees something in Godard's film—Nana approached by another spectator—which also takes

place in the film being watched by her friend, and is perhaps experienced by her friend, as well: She is the spectator of a story that has an ulterior development. Finally, Anna watches a movie and simultaneously sends and reads messages on her mobile phone: She is spectator as well as writer and reader. Nicole, her alter ego, finds herself in an analogous position: She too sees her film and the clip of Dreyer's that Anna sends to her; she too sees things seen by others and things that complete others (the bonfire that overlaps Jeanne's death sentence); and she too sees, writes, and reads.

The fact is that Nana, on the one hand, and Anna and Nicole, on the other, measure themselves by two different objects. The word *film* does not mean the same thing to them. For Nana, it is a single and well-defined work: it is this film, and not another, to be enjoyed directly and on its own. For Anna and Nicole, instead, film is a discourse that hosts other discourses, that collaborates with other discourses, and that generates other discourses. It is this film, but it could also be a different one, which is to be encountered, perhaps thanks to someone else's mediation. It is a series of images that pushes one to write a text message reflecting what one is watching. It is also a set of events that is taken up again or is completed in other films, or perhaps, in life. And it is a catalog of generic situations (the orgy, the bonfire) easily made into a completely personal album of images (in Anna's case the close-up of Artaud). In essence, if Nana, the traditional spectator, still confronts a *text*, then the two modern spectators confront a *hypertext*[4] with its various components, its links and its expansions. Better still, what Anna and Nicole face is a *network of social discourses*, which aligns and embeds different occurrences, genres, regimes, and within which the film, in the strict sense of the word, can play a relevant but certainly not exclusive role.[5]

The second trait involves not the object of the spectator's vision but its modality. Nana directs her interest completely toward the film she is seeing: She is all eyes. Anna, instead, displays a multiple attitude: She follows the film, but in the meantime she concerns herself with finding out where her friend ended up; she writes what she feels as she watches *Vivre sa vie*; she isolates a detail of the film; she captures it on her mobile phone; she displays her passion for the cinema, and so on. In essence, while Nana centralizes her sight, Anna decentralizes it.

This *decentralization* has something in common with the distracted perception that Benjamin attributes to the cinema, and which, after

Benjamin, was attributed to television.[6] Here we are at the opposite extreme from that contemplation that the old work of art seemed to demand, and we are closer to a more casual, less involved engagement, which contemporary media ask us to develop. In this sense, using the respective terms of John Ellis and Stanley Cavell, we can say that Anna and Nicole do not reserve for the cinema a gaze in the strict sense, but rather glances[7]; and they do not commit themselves to a viewing, but rather to a kind of monitoring.[8] In doing so, however, the two women do not withhold their attention; rather, they direct it toward a plurality of objects and practices. They follow the story but they abandon some of the details; they pay attention to the film but also to their mobile phones; they react to the images but also to what is around them. Therefore, truth be told, they are not distracted, they simply multiply their centers of attention; they pass from one source to another; and they modulate their gazes. Put simply, they activate a multitasking form of attention.[9] In doing so, they stop short of re-sacralizing the film in front of them (which is what Nana does, rousing herself to contemplate that world that opens up before her eyes). They look at it just as they would look at any one of many objects they come across in their lifeworld, something to pick up now and put down later.

As for the third trait, Nana not only concentrates on the film she is watching but also immerses herself in it. Through an explicit play of identifications and projections, the protagonist of *Vivre sa vie* penetrates the story recounted by Dreyer to the point of feeling a part of it. The consequence of this is catharsis. We see it in the tears that streak down her face as she reads the intertitle *mort*: Nana sees her own destiny in that of Joan of Arc; she cries for herself as she cries for *la pucelle*. Anna, instead, remains on the surface of what she sees: She grasps the details that interest her, isolating the rest, and she sends them to her friend. Far from immersing herself in the film, she slides over it, wave after wave, engaging in a sort of surfing.[10] Any kind of catharsis is therefore avoided: Anna neither identifies with nor projects herself onto Jeanne or Nana; she remains herself, distant and distinct from the characters in front of her.[11] If anything, she experiences an aesthetic realization: She is struck by the beauty of Antonin Artaud. However, this is an epidermic reaction, in the sense that it causes a sensation, not meaning. Therefore, it keeps at a distance a true identification with

what is shown. In essence, Anna watches, but what she sees does not pertain to her.

In this regard, following Roland Barthes, we can say that Anna is a spectator who does not succeed in gluing herself to the screen.[12] She does not enter into the diegetic world of the film; at most, she crosses it. She does not take part in the story; at most she takes a part of it. The circumstances do not help her: Her friend's absence is weighing on her mind, and the need to contact her is distracting. This concern also alienates Anna from the environment. The urgency to call the friend detaches her both from what happens on the screen and from what happens in front of it: The life in the movie theater does not appeal to her. To continue using Barthes' terms, Anna neither "glues" herself to the represented world nor "takes off" from it in order to add the charm of the theater to the charm of the movie: She remains unstuck from both. The consequence is a loss of the rituality of vision: The latter is now occasional, provisional, and irregular. To watch a film becomes an adventure without a firm foundation.

The fourth trait concerns the movie theater. Nana seeks a kind of refuge in the cinema: She enters it in order to isolate herself from the external world, to escape from her daily routine. In doing so, she falls into a trap: By watching Dreyer's film, she discovers that she too is destined to die. However, this illumination is allowed her exactly because she momentarily distanced herself from her universe: only a completely other character, such as Jeanne, can make her understand what awaits her. Anna, on the other hand, entered the theater in order to spend some time with her friend: Cinema is not an alternative to, but a continuation of, her daily world. Therefore, when she realizes that her friend has not joined her, she immediately puts herself in contact with Nicole: Precisely because the movie theater is a prolongation of the outside world, it is also a locale from which one can get in touch with others. It is not surprising, then, that what appears on the screen can migrate elsewhere: In fact, the close-up of Artaud, captured by Anna, ends up on Nicole's mobile phone; the sexual aggression alluded to in *Vivre sa vie* also takes place in *The Adjuster*; and the fire to which Jeanne is condemned spreads in the film seen by Nicole. However, none of these correspondences turns out to be decisive. While Jeanne's death sentence reveals to Nana the meaning of her life, these echoes appear to Anna and Nicole as mere cues to

consider. They are splinters of an imaginary at everyone's disposal, linked to one another by a chain that is more random than mysterious.

In other words, Nana's movie theater is a site marked by a separation from the universe we live in; in it we encounter a reality that clearly lies beyond the usual one. This reality, however, reveals itself to be an ideal version of the one we are living in. It is thus a fenced-in space, offering a catwalk toward another world, from which we can draw resources for *our* world. The theater of Anna and Nicole, meanwhile, plays out differently: It lacks a true fence, being a space that belongs to the everyday world; even though there are openings to universes different from the one we live in, we are never called upon to cross any true thresholds beyond which we could discover ourselves; the elements with which we confront ourselves represent possible events, not interpretations of our condition; and finally these elements are accessible to many other spectators, no matter the film they are watching. In essence, Nana's theater circumscribes an audience that rediscovers on the screen the essence of its own life, thanks to a representation that seems far-removed from reality. Anna's and Nicole's theater holds together a dispersed audience, more similar to a television audience or to the participants in a social network—an audience that engages with images that do not necessarily function as revelations, but which can be accessed even at a distance, and whose significance may be gathered at any point along the network of spectators.

Let me summarize these initial findings. If we focus on Nana on the one hand, and on Anna and Nicole on the other, we discover two different ideas of film-going—and two different idea of cinema. What was a text gives way to a hypertext or to a network of social discourses; a centralized gaze switches to a decentralized glance; the possibility of immersing oneself in the story is replaced by the necessity of remaining on the surface; a closed space that circumscribes a public becomes a more open space, which functions like a junction of an ideal network; the representation of a world fully other, which, however, speaks to the real world, is supplanted by the representation of a possible world, which can locate its realization anywhere. *Artaud Double Bill*, triangulating Nana, Anna, and Nicole, reminds us what it was to watch a film in the past, and what it has become in the present. So what full lesson can we draw from the portrait offered to us by Egoyan?

FROM ATTENDANCE TO PERFORMANCE

Looking at what is happening in cinema—and *to* cinema—it is clear that we have reached the end of a model that has been dominant for a long time: the model that conceived of the spectator as attending a film. To attend means to place ourselves in front of something that does not necessarily depend on us, but of which we find ourselves to be the witnesses. What is important is to be present at an event, and to open our eyes to it, both in order to be able to accept it, as with a gift, and to be able to acquire it, as with a conquest.[13] Today, this model is no longer very relevant. Watching a film increasingly involves a series of preparatory acts, actions of maintenance, and choices between different alternatives or parallel movements. Spectators can—and often must—intervene upon the object of their vision, the environment in which they move, and even their very selves, as if it they had the responsibility to manage or even to direct the situation.

Let us consider the case of a screening in a movie theater: Spectators still pay for a ticket, sit down, and wait for the film, but increasingly they must also find the venue, book a seat, sometimes go to a neighboring town, and be on time—in addition to all that Anna had to do. Moreover, let us consider the use of new devices like the home theater, the laptop, the DVD player, the tablet, and even the smartphone: Each device implies a set of specific actions, like tuning into to a particular channel, buying a DVD, subscribing to premium channels, grabbing some apps, downloading a movie from the Internet, and so forth. On these new devices, spectators may also modulate the times and places of viewing; in particular, on a DVD player, a movie may be watched in its entirety, but also in fragments, either delaying its conclusion or jumping to the main scenes. If in the former case one can abandon herself to a sort of passive viewing, in the latter one continually has to manipulate the device, regulating the flow of the film in accordance with what she wishes to see. Spectators can also fulfill different goals: A film can serve to satisfy a desire for spectacle, but it can also simply kill time during a trip or capture the curiosity of a Web surfer. Especially in the latter cases, viewing is deeply affected by what happens around the viewer, and it can take different paths according to the circumstances. Lastly, a film can be an object of vision, but also a collectible, a cult object,[14] or something to be

Performance 185

manipulated or exchanged through file-sharing programs. Each of these cases mobilizes further kinds of actions.

The presence of options where once there was standard practice, the necessity of establishing the rules of the game where once they were implicit, the strong connection with one's own world where once there was a separation, the widening of perspective where once the field was bounded—these are all elements that testify to how much the framework has changed.[15] If traditional spectators once modeled themselves on films, spectators now model films, or remodel them onto themselves, thanks to a combination of precise practices that affect the object, the modalities, and the conditions of vision. The effect is that the spectators become the active protagonists of the game, even if they continue to be its pawns. They are no longer asked to be present at a projection with eyes wide open, just reacting to the film or to the environment; instead, they must act to make their own viewing possible. *Attendance* has ceded the field to *performance*.[16]

PRACTICES OF VISION

Among the current practices involved in watching a film, some might seem traditional if they were not also angled in a new direction; some others are quite new, even if sometimes they bring us back to early cinema and pre-cinema.

For example, we continue to engage in a *cognitive doing*, which allows us to interpret what we see; this interpretation, however, no longer follows the film step by step, but takes its own independent paths. In particular, especially when spectators watch an episode of a franchise, they try to reconstruct a "map" of the main characters, to move at ease on the field of the game. In this case, they adopt a sort of "explorative" attitude. Inversely, especially when watching a DVD, spectators look ahead, mentally storing up elements for future film viewing. In this case, the attitude is "selective." In both situations, more than following a movie step by step, spectators "test" what they find in front of them in order to best orient themselves. This interpretation in the form of a test can also affect the viewing environment or situation: The spectator often asks himself how and why to watch a certain film, and the response informs his subsequent action.

The same goes for the *emotional doing*. Films have always touched their spectators.[17] Today, however, affective components connected to the watching of a film seem to acquire an abnormal weight. Cinema is characterized by a greater "force of attraction" than other media; we expect it to strongly engage its spectator. The growing use of special effects, as well as the increasingly frequent construction of parallel worlds offered by superhero films or epics like *The Lord of the Rings*, seem to meet this demand. When a film is then enjoyed on another device, it often seems to absorb some of the emotions associated with that device as well: the pleasure of liveness particular to television or the pleasure of navigation particular to the Web.

In other cases, performance broadens the range of action of traditional practices, rather than transforming them. Take for example *relational doing*: The spectator has always been a social being who interacts with other spectators. Today, especially outside of the cinema, when he is seemingly alone, the spectator pushes his relation action further: a group with whom his own experience can be shared is constructed, through a system of contacts that accompany or follow viewing, whether over the telephone or through Twitter messages.[18]

However, the performance also and most importantly involves new levels of *doing*. For example, there is a *technological doing*, where access to the film is not direct, as it is in a movie theater, but instead mediated by a device that the spectator must activate (such is the case with home theater, DVD player, tablet, or computer) or by a channel or an app thanks to which the spectator chooses what to watch and how to watch it (VOD, Hulu, Netflix, MySky, and so on). In either case, a specific competence is required in order to complete a series of operations on the device. I will not describe these technological practices here, which include subscribing to a contract, buying an app, setting up a device, coordinating different devices, moving from a device to another to watch the same movie, and even manipulating the parameters of an image: It suffices to look at a blog like *AskJack* hosted by the newspaper the *Guardian* (www.theguardian.com/technology/askjack) or google "how to watch a movie on my iPad/on airplane/on my DVD player," and so forth, to have an idea of how rich and complex this field is.[19] I would simply note that the modern spectator is required far less to have a cinematic competence than a media competence.

We might also note an *expressive doing*: While the experience of watching certain cult films, such as *The Rocky Horror Picture Show* or *Star Wars*, has often been accompanied by dressing in costume, today self-display is also celebrated via a spectator's blog post or a message on a social network, in which one recounts one's personal reactions to what one is seeing or has seen.[20]

There is a *textual doing*, determined by the fact that spectators increasingly enjoy the possibility of manipulating a film, not only in the sense of adjusting it to one's own vision (as when one maintains or changes the video format of a display, choosing to watch a film in high or low definition, for example), but also in the sense of deliberate intervention[21] (as happens with the re-edited and dubbed film clips that populate YouTube; and yet it is worth remembering that the practice of versioning was usual during the classical age of cinema).[22]

Finally, performance implies a new *sensory doing*. In addition to sight and hearing, we increasingly find ourselves involving our other senses,[23] especially touch: In order to watch a movie on a DVD player or a computer, one must intervene with one's own hand. The action of the hands is particularly interesting. To schematize things a bit, we could say that we have a first moment, that of the VCR or DVD player, in which the spectator is required to push buttons that allow him to begin his viewing or to modify its flow through leaps backwards and forwards, pauses, slowing down, and so forth. On the computer these buttons become a keyboard, which is even more integrated with the screen. The computer is constructed to align hand and eye: I command with the first, and verify the success of my action with the second. The mouse adds another step to this integration: The paths of the cursor on the screen, which I follow with my eye, are just like the ones that I trace on my desk, moving the device with my hand. The touch screen represents a further step forward, incorporating the keyboard into the screen: I directly touch the surface from which what I want to see emerges. I no longer even need the mouse: My finger directly creates the paths of the cursor, and thereby serves as a substitute for it. The final step is one in which I can directly manipulate the shapes on the screen without any sort of keyboard whatsoever; I touch them, and they generate information, as in augmented reality. The world that was once offered up to my eyes is now offered to my hands as well. Tactility, which cinema evoked,[24] and which in some

sense brings us back to pre-cinema, when spectators needed to rotate the praxinoscope or flip through the pages of a flip book in order to have a moving image, here finds its full realization.

PERFORMER AND BRICOLEUR

The presence of this wide spectrum of practices makes the spectator a true *performer*: someone who constructs his own viewing conditions, bringing himself to bear directly upon them. The traditional model of attendance already implied an active spectator. As Richard C. Allen reminds us, "We tend to talk of films being 'screened' as if the only thing going on in a movie theatre were light being bounced off a reflective surface. Obviously, at a number of levels there is much more going on during a film viewing situation than that."[25] The new model of performance implies something more: an activity aimed at building the very possibility of the experience of cinema. This experience is no longer linked to a prearranged "machine"; rather, it emerges in a range of very different contexts, which call for intervention to be put in working order. It is the spectator who carries out this intervention, through a series of actions that are now entrusted to him. He must create the experience that he wants to have.

In this intervention, beyond mobilizing his own competencies, the spectator must also take account of the resources available to him. Where can he find the film that he wants to see? Does he have free time or does he need to use the intervals between one activity and another? What devices can he use? How can they be implemented? How can he bring his viewing activity into agreement with other imperatives that he must fulfill? While it was sufficient for the traditional spectator to go into a cinema to find everything he needed, now he literally has to put together the pieces of different components for his viewing. In this sense, he is not only a performer, but also a *bricoleur*: someone who constructs what he needs by taking advantage of a series of opportunities and materials, combining them together and finding the best arrangement.

The reference to bricolage was used (and criticized) in media theory during the 1980s,[26] and later, in the first decade of the new millennium, it was replaced by concepts such as Pro-Am or "produsage."[27] To go back to the bricoleur could look like an out-fashioned move. And yet if we

look at the practices of many present-day spectators, we cannot avoid recalling Lévi-Strauss's pages on this topic. "The 'bricoleur' is adept at performing a large number of diverse tasks: but, unlike the engineer, he does not subordinate each of them to the availability of the raw materials and tools conceived and procured for the purpose of the project."[28] The bricoleur does not wait to have everything that he needs; rather, he takes his resources from whatever situation he finds himself in. In this sense he is still, we might say, an "occasional" subject. But he is also a creative one: "He has to turn back to an already existent set made up of tools and materials, to consider or reconsider what it contains and, finally and above all, to engage in a sort of dialogue with it, and, before choosing between them, to index the possible answers which the whole set can offer to his problem."[29] The bricoleur does not have ready-made solutions; he invents them in the moment. Finally, his actions are a direct sign of his personality: "The bricoleur also, and indeed principally, derives his poetry from the fact that he does not confine himself to accomplishment and execution: he speaks not only with things, but also through the medium of the things; giving an account of his personality and life by the choices he makes between the limited possibilities."[30]

The new spectator is equally occasional, creative, and personal. He too puts together the pieces that a situation offers to him, looks to identify a solution based on what is available to him, and at the same time develops a behavior that he can consider his own. He is Lévi-Strauss's bricoleur (and sometimes, when he more openly defies the customary rules, a bit like de Certeau's poacher).[31]

Of course, very often the liberty and creativity of the contemporary spectators are more apparent than real. The industry is perfectly willing to furnish them in the easiest way possible with the resources they need, just as it is prepared to standardize even the most experimental paths that they take. Furthermore, their action often reveals itself as a simple function of a "do-it-yourself" type of marketing: The products they acquire already foresee their doings. Finally, alongside the activism of the few stands a mass of spectators who still like to watch films in the most simple and relaxed way possible. The bricoleur, then, is at times only the avant-garde of mass consumption. The fact remains, though, that the contemporary spectator is one who systematically "makes do" with what he has. And it is with him that we now must reckon.

THE MEDIATIZED SPECTATOR

In this brief description of the new spectator, we have inevitably slid away from the movie theater and into other spaces, encountering other devices and surpassing the very confines of vision. To see a film is no longer a localized activity, and it is no longer just a scopic activity. It is a *doing* that leaps beyond the presence of a big screen and which goes beyond the mere opening of one's eyes.[32] It is interesting to note how the most innovative aspects of the new spectatorship seem to arise from practices developed outside the theater and outside the strict confines of vision and are instead closer to the new screens that dominate the media landscape: digital television, computer, tablet, mobile phone, and media façade.

Let us take, for example, the act of exploration, which responds more to a need for orientation than a need for comprehension. There is no doubt that it arises from contact with the multichannel television that we browse with our remote control, searching for what we want. Let us also consider the act of storing, which leads us to put in reserve particularly interesting portions of films. Its origin is undoubtedly to be found in certain fan practices: Thanks to image-capturing devices, such as the video recorder, fans can construct and exchange highly personalized image albums.[33] Let us also consider emotional doing, which revolves around a strong intensification of feeling. Its background may be found in the presence of an enormous quantity of stimuli both in the world of media and in the urban environment. These are stimuli that ask us to refine our tuning, and yet also force us into a kind of isolation from the world, with the effect in both cases of definitively forcing us out of the traditional dimension of the sublime.

As for the ability to choose what one wants to see, this takes us back, for example, to the public's growing capacity to move strategically online, in search of more salient content and information, while the diffusion of mobile platforms, which allow for watching anywhere and anytime, strengthens the public's ability to liberate itself from the obligations imposed by programming.[34] The act of manipulation, which allows spectators to intervene in the means of their own vision, is born from the use of devices like the home theater, which require continuous regulation and maintenance. Relational doing, which involves spectators'

construction of their own groups, is born instead from the progressive growth of social networks. These social networks also feed into the act of expression, which leads to the construction and exposition of oneself: It is on YouTube that social subjects have experienced in depth the pleasure of the self-narration and the possibility of marketing themselves. Finally, textual doing is undoubtedly nourished by the possibility of capturing what one sees and relocating it to one's own computer thanks to low-cost applications.

In essence, today's filmic spectators find their gym and their school outside of the movie theater. It is far from the cinema and its canonical spaces that these new spectators now seem to be formed

THE SPECTATOR: NO LONGER EXISTING AND STILL EXISTING

Even so, we are still dealing with a filmic spectator. His focus continues to be the cinema, or at least what he still experiences as cinema. Laura Mulvey has devoted a fine analysis to forms of viewing linked to DVD and video, which allow us to view the film in order and as a whole, but also accelerated, in slow motion, forwards and backwards, or on pause. This is a delicate issue: Jacques Aumont claims, with some reason, that one of the characters that define the experience of cinema is an uninterrupted and completed vision. Film is something to be watched in its succession and in its integrity.[35] Mulvey provides another answer: Her analysis highlights how the spectator tends to take on new profiles, while still remaining indebted to the classical model. As for the new profiles, Mulvey identifies two emerging types. The first is that of a "possessive spectator," who through the slowing, halting, and reorganization of the film's flow has the illusion of dominating the film he is watching: "As the film is delayed and thus fragmented from linear narrative into favourite moments or scenes, the spectator is able to hold on to, to possess, the previously elusive image."[36] The second type is one that Mulvey, following Bellour, calls the "pensive spectator."[37] In this case, the disturbance of the film's flow provokes a kind of self-reflexive movement, which allows the spectator to understand better the nature of the film and the way that it brings together the camera's gaze, that of the characters, and that of the

film's addressee: "This pause for the spectator, usually 'hurried' by the movement both of film and narrative, opens a space for consciousness of the still frame within the moving image."[38] Mulvey notes how these two types represent a break with traditional viewing: narration tends to disappear, single frames take on an autonomous life, and the body of the star takes on an unusual density. Even so, the new sorts of fascination offered by film have their roots in older ones: We continue to deal with voyeurism, fetishism, a will to dominate, and so forth. In fact, the new modalities of spectatorial experience seem first and foremost to aid the film in making its meanings emerge: "By slowing down, freezing or repeating images, key moments and meanings become visible that could not have been perceived when hidden under the narrative flow and the movement of the film."[39] Furthermore, these images bring to light the mechanisms through which cinema has always functioned, and albeit in a somewhat perverse way, reveal its nature. In this sense, the new spectator is not "against" cinema, but rather prolongs its history: "Out of a pause or delay in normal cinematic time, the body of narrative film can find new modes of spectatorship."[40]

It is quite clear that the oscillation between no longer being and still being a film spectator largely depends on cinema's intermingling with other media. As we have seen, the new spectator faces a large set of options: Differently from the past, when the institution of cinema largely predetermined contents, modes, and spaces of a vision, the new spectator can choose the device and the modality through which she watches a film, taking advantage of different possibilities, and often working on them (her viewing—which is something that involves much more than a visual activity—depends on her). In this sense, the new spectator is primarily a media user, capable of distractedly moving between different devices and prepared to defy their normal functioning in search of new possibilities for action. I would add that, like the media user, the new cinematic spectator can have the illusion of a total freedom of action—even though the reality of media is one of always preregulated action, to which anomalous behaviors quickly become supplemental options, like those filters in Photoshop that allow one to make "ugly" or faulty images. Yet despite the extent to which the new spectator is indebted to the media user (Tara McPherson has illustrated several new "ways of being" that come about on the Web),[41] she continues to be a film spectator.

What happens is not only that the object of her experiences remains a film, even though sometimes in a new format; instead, the principal elements driving her experience are largely borrowed from traditional ones. Despite its being transformed and mixed with other demands, we still find the pleasure of encountering reality, of following a story, of giving concreteness to our fantasy, and of being able to transform an individual experience into a collective one.

Anna is a media user: not only because she distractedly uses her telephone, but also because of the environment that she, like all of us, operates in. But she is also a film spectator, however different from Nana. She has all of the same competencies and emotions. And, what's more, she still goes to the cinema.

RELOCATION AND RE-RELOCATION

Let us pause for a moment over this aspect of *Artaud Double Bill*, which we seem to have set aside. Atom Egoyan gives us two modern-day spectators who watch a film in a seemingly anomalous way, bring behaviors more closely related to those generated by other media to their viewing, but nonetheless watch the film in a movie theater. What *Artaud Double Bill* celebrates, then, is not only the affirmation of new ways of enjoying movies, but also a kind of return to the motherland.

If it is true that cinema is no more exclusively identified with the darkened theater, theaters still exist, and even flourish. The new practices of vision, whose birthplace is to be found in other environments and in proximity to other media, are quick to flow into the traditional home of the movies, and consequently contaminate and reconfigure the traditional forms of the filmic experience.

Just imagine the groups of spectators that meet up at the cinema after an intense exchange of e-mails or telephone calls, worthy of a social network; or the vibrating of numerous mobile phones in silent mode during the movie, maintaining contact with the outside world; or the increasingly frequent distribution upon entering the theater of reviews and commentaries, almost as part of an effort to create a multimedia product. Or consider the continuation of the movie in the form of post-film discussions, as one appends one's commentary on a blog; or the

purchase of a DVD of a movie that one has just seen, to be watched repeatedly at home. The extra-filmic and extra-theatrical practices that are emerging are ready to be reinserted within the context of the theater, thus renewing the traits of the filmic experience. Consequently, watching a film becomes a *performance* even within the temple of *attendance*.

I will use the term *re-relocation* for this return to the motherland of a cinema that has already migrated to new environments and to new devices, and now takes a step back. In leaving the movie theater, cinema gave film experience the chance to keep on living, albeit in a new way; coming back to the movie theater, cinema contaminates the previous model of experience with the new characteristics that it has acquired elsewhere. Re-relocation signifies precisely a double movement: the departure from the movie theater in search of new territory (relocation); and the return to the theater enriched by a new patrimony (the "re-" added to the relocation).

This double movement, back and forth, highlights the emergence of a complex game board. There are indeed film theaters that not only host new viewing practices but also develop them. I am thinking of the film theaters that increasingly offer operas broadcasted from opera houses such as the Metropolitan or sports events also broadcasted live. These offerings—the former "sanctifies" the environment, while the latter "popularizes" it—transform the theater into a sort of "platform" on which we can find different contents to be enjoyed through different rituals.[42] The movie theater becomes a bit less cinematic than it was before—and it is for this reason that it is prepared to welcome a cinema that, in the meantime, has mixed itself with other media. And yet there are also traditional theaters that wish to remain such and refuse the introduction of new forms of viewing, in the name of a rite that cannot be changed. This is what happens particularly during ceremonial situations, such as a festival, a debut, or a film series aimed at true cinephiles, during which the spectator is invited to attend a film and nothing else. In parallel, there are the new environments toward which the cinema converges, to reach a new stage in its history, even if in a different mood; this is the migration extensively explored in these pages. Even if physically different from film theaters, these new environments sometimes try to look like them: This is the case with the home theater, in which spectators watch a film seated on a couch, with the lights dimmed and silence enforced,

punctiliously re-creating the most traditional viewing experience. Finally, there are also new environments into which cinema transfers itself, but that end up imposing themselves upon it, so that it ceases to be cinema; this is the realm of the media user who no longer succeeds at being a filmic spectator.

The return to the motherland illuminates a very rich and interesting topography of cinema. The four cardinal points of this topography are the relocated cinema, which colonizes new spaces; the re-relocated cinema, which turns to its most characteristic venue, while contaminating it with new modes of viewing; the non-relocated cinema, which remains stubbornly attached to the theater and to traditional viewing practices; and finally, the radically dislocated cinema—a no-longer-cinema—which leaves its home to lose itself in the vast sea of media. Our experience of cinema now unfolds within these coordinates, in each instance choosing the position that suits it best.[43]

THE RETURN TO THE MOTHERLAND

Why return to the motherland, with new acquisitions in tow? It seems to me that there are at least four good reasons at the heart of re-relocation, which respond to some profound exigencies.

The first reason concerns a *need for territoriality*. To see a film has always involved— and continues to involve—a question of place: a where to see, in addition to a what to see. These new modes of vision only offer the spectator an existential bubble in which to burrow (I am thinking of the train passengers who watch films on a portable device, isolating themselves from their immediate context by putting on headphones and ignoring all that is going on around them). It is a fragile and precarious bubble, easily broken by the least disturbance (a conductor who asks for the ticket or the arrival of the train at a station). The movie theater, meanwhile, provides a more solid territory, better defined and protected. In particular, the theater continues to be associated with the idea of a living space: a space in which to dwell together with others (a roof for the community); a space in which one finds oneself immersed in a communal imaginary (in Heidegger's terms, the language that hosts us). A place both physical and symbolic,

the movie theater is that abode that cinema and its spectators continue to search out.[44]

The second reason highlights a *need for domestication*. Relocation undoubtedly introduces some changes into an experience that has largely been shaped by the movie theater: sometimes these are minimal, as in the case of home theater, at other times greater, as in the case of a viewing carried out on multiple platforms. In both cases, a challenge is created to traditional modes, which risk not so much extinction as loss of recognition as integral elements of filmic vision. The re-relocation into the movie theater serves to ensure that such novelties are literally incorporated into an experience that explicitly maintains its roots. Flowing back into a typical space, these novelties appear both acceptable and familiar, practicable and customary. Thus, vision as performance—as distant as it may seem from tradition—receives full recognition, in both senses of the word: It is acknowledged as an appropriate mode to watch a film (recognition as legitimization), and it is held up as an example that anyone can follow (recognition as identification). This recognition looks even easier when we think that theaters always hosted a "dynamic" crowd. Among the many testimonies to this fact, I am thinking of the beautiful description of the audience provided by Louis Delluc in his early 1920s essay, "La foule devant l'écran"[45]: In reviewing several theaters, as well as the films that were projected in them, Delluc highlighted how different strata of the population, from the Parisian elite to the working classes of the suburbs and the provinces, reacted and responded to the screen in different ways, ranging from total self-composure to the greatest enthusiasm, but always showing an active attitude. Theaters have always been the site of an intense activity, which however they were able to keep under control. This is also why relocated cinema, returning to the motherland, succeeds in domesticating the activism connected with performance.

Third, the return to the motherland highlights a *need for institution*. Watching a film on new devices like the computer and in new environments like an urban space brings our vision closer to other activities hosted by the same apparatus, such as listening to the radio, surfing the Internet, or downloading files. It also brings the film closer to other products hosted on the same screen: touristic documentaries, advertising, YouTube clips, re-dubbed and re-edited films in file-sharing networks,

and so on. We inevitably slip away from the realm of cinema and onto the terrain of media in general, and from the field of film to the terrain of audiovisual products. This twofold passage is the consequence of *convergence*[46]: Old apparatuses (including the cinematic apparatus, tied to screen/projector/film) are disintegrated in favor of multifunctional platforms (among them the three new screens, television, computer, and smartphone); and old products tied to a single medium (including the fictional feature film) are disintegrated in favor of a rich array of multi-platform and crossover products (the film that is seen in the theater, the director's cut that is purchased, the clip that is downloaded onto a tablet). Now, in the age of convergence, it can seem like a desperate enterprise to hold in place the confines of the cinema and the profile of a film—and in part it is indeed a desperate enterprise, as cinema today is intrinsically expanded. Re-relocation assures us that the medium we have long enjoyed with affection continues to possess its space and its identity. It not only gives back to the majority of films the place and the modes for which they have been created; it also tells us that whatever may happen, the cinema will continue to exist, and exist as cinema.

Finally, the return to the motherland highlights a *need for experience*. This is the most delicate of the four points, but also the most decisive. Migration toward new environments and devices presents a double risk. On the one hand, as mentioned above, this migration dissolves the filmic experience into a more general media experience. On the other hand, it forces this experience onto mandatory tracks, which impose themselves especially in the case of strongly predetermined technologies, either because of the way in which a certain device functions or because of the way in which the user utilizes it.[47] In the first case, film watching loses its uniqueness, and with it its strength; in the second, it loses its unpredictability, and therefore its freedom. Re-relocation supplies a remedy to this situation. It offers environmental conditions that strengthen vision: The big screen, which dominates the spectators, interrogates them, instead of docilely obeying their commands like the display on a mobile phone or computer. It requires an attitude that restores freedom to vision: The need to change place in order to see a film, instead of receiving it on a display (this is *re*-relocation), requires spectators to make more precise and exacting choices. The cinematic experience thus recovers a precise and personal sense.

We can think even more radically: A bit of *attendance* can substantiate an experience that *performance* often promises but cannot deliver. When the watching of a film is intertwined with a *doing*, it seems to place spectators at the center of the game, but this centrality and this game risk proving illusory. On the one hand, this *doing* takes spectators back to everyday practices and may therefore be tinged with indifference: We might think for instance of the computer, which can offer up a film just as it can anything else. On the other hand, this *doing* absorbs the spectators to such an extent that they no longer have space to face what they find before them and therefore to see what they are confronting: Think for example of file sharing, the end of which sometimes seems to be limited to the mere exchange of material, or remixing, which often serves only to demonstrate one's virtuosity. In these situations, what can really surprise or grab hold of spectators? And how do they reacquire consciousness of themselves and of what they find in front of them? Do they really undergo an experience—an experience that in order to be worthy of the name requires amazement and recognition? With *attendance*, spectators still measured themselves against a world—on the screen and around the screen—capable of both interrogation and the formulation of answers. From *attendance* results the sense of an unforeseen encounter and, simultaneously, the possibility of mastering what is encountered. On the new devices, however, amazement is replaced by self-satisfaction and recognition of skill. There is no surprise, rather there is self-congratulation; there is no awareness, rather there is virtuosity. Spectators *do*, but their *doing* often appears to be an end in itself. The return to the motherland, as much as it brings with it new ways of watching, seems to restitute the conditions necessary for amazement and recognition to once again take effect. In the theater, a film continues to seem like an *event*[48] against which one can measure oneself, and from which one can rediscover one's surroundings. Think of how there, more than elsewhere, a film is not reduced to something ordinary or habitual—it conserves a certain noteworthiness with respect to the everyday. Or think of how it obligates one to take steps in order to meet it—leave the house, buy a ticket, mix with the crowd—which give importance to what one is doing. Or how it makes one share it with others, as a sort of small privilege. Or how it both imposes a rhythm and lets us take part in a rite.[49] In the theater, more than elsewhere, a film is an event; in this sense it

becomes a small enigma that provokes the spectators, as it restitutes a consciousness of self and of one's surroundings. The result is that, no matter how much one's vision is intertwined with a *doing*—and is therefore now far from a simple confrontation with an object—it can recuperate the sense of an experience. Something returns to surprise and take hold of the spectators, and they, in turn, make space for an awareness. In this sense, we may well say that, thanks to re-relocation, *attendance* has left us a legacy—I spoke before of gift and conquest—which fills the lacunae left by *performance*. To see a film does not risk becoming either a narcissistic exercise or an indifferent task.

Indeed, it is still an event, with the persistence of a surprise and of a recognition and the resistance of narcissism and indifference. Re-relocation—superimposing *attendance* and *performance*, intertwining tradition and innovation—opens itself better than any other gesture to an experiential dimension. This dimension of experience is really what is at stake, and as long as cinema is able to maintain this, it will survive.

* * *

In the Mouth of Madness (John Carpenter, 1995) tells the story of a private investigator, John Trent, who is hired to find a successful writer, Sutter Cane, who has seemingly disappeared. His search quickly transforms into a nightmare: Trent finds himself increasingly thrown into a world in which fantasy and reality are indistinguishable and discovers that it is in fact the reading of Cane's books that brings about the most absurd events. Very soon, Trent becomes convinced that the writer is an instrument through which evil seeks to dominate the world and whose latest novel thus needs to be prevented from reaching the shelves. No one believes him, however, and he is committed to a psychiatric hospital. Now, violence and horror are ubiquitous: Trent escapes from the psychiatric hospital and makes his way to a ghost town. Here he goes into a cinema and sees projected on the screen the story that he himself has been living, with himself as protagonist.

Using the framework of a genre film, *In the Mouth of Madness* offers us a possible metaphor. To carry out his investigation, Trent navigates a complex and heterogeneous world (a World Wide Web?). Through successive links, he moves from the big city to a provincial city, then into the imaginary world of a writer, and finally, to what may be Hell itself. In his travel,

he uses all of the means available to him (all of the media). He becomes aware that there are "viral" messages circulating and infecting the population. Then, he returns to the cinema and finds on the screen that very world through which he has been moving up to this point. Now, he is repositioned as a spectator: Perhaps what he experienced was only a film. Perhaps. Trent's final laugh may be one of liberation, but it is also the sign of his madness, for the reality that emerges inside the darkened theater often reveals itself to be more true than truth itself.

8. The Persistence of Cinema in a Post-Cinematic Age

THE DISAPPEARANCE OF THE DARK

"Initiation to the Delights of the Cinema" is an extraordinary text written by Antonello Gerbi in 1926.[1] Gerbi describes the cinematic experience in all its aspects, complete with erudite references and great irony. Among the topics under discussion is darkness. We encounter it in the first lines of the essay, as Gerbi follows the cinemagoer who buys a ticket, crosses the foyer, and approaches the velvet curtain draped across the entrance to the darkened theater: "Discreet and alert, [the attendant] opens the jaws of the shadows immediately upon arrival; and he opens them just slightly—I don't know if it is out of fear that the outside light would disturb or wound the sacred darkness, or that the darkness collected in the room, having found some small opening, would spread out into the lobby, would hinder a careful checking of tickets, would pour out into the street and would shortly flood the entire city."[2] The "sacred darkness" described here constitutes neither the erasure of day nor the absence of natural light. On the contrary, it is a state that positively characterizes the movie theater; it is the constitutive attribute of an environment in opposition—black against white—to the universe that we usually inhabit.

The dark returns a bit further on in Gerbi's text, when he describes the audience gathered before the screen: "The spectators—subdued by the

darkness, dull, wan and weighty without light inside, lacking any space around them or a bright background behind them—sit there silent and well-behaved, one next to the other, one just like the other."[3] Darkness creates a condition of suspension: The environment loses its consistency and becomes an indistinct container; individuals lose all conception of themselves and enter into a kind of hypnotic state. It is precisely this state of suspension that allows the spectators to consolidate into a single body to the point of forming a small community, as well as to become one with what they are watching, immersing themselves in the events recounted on the screen.

Finally, Gerbi evokes the dark with regard to the world that comes to life on the screen. This world possesses a luminosity that seems to come from the theater: "The light, quickly drained away from the hall where it first spread out, and immediately cast with the rhythm of swift waves from the small window of the projectionist booth to the great window constituted by the canvas, transforms itself into the light of apotheosis."[4] Therefore, there exists a sort of circularity between the theater and the screen: If the former is dark, it is because it literally bestows that bit of feeble light it possesses to the latter; in exchange, the screen allows a new reality to burst forth in all its splendor.

Gerbi brings us this far. However, we also come across the theme of darkness in numerous other writings on cinema from its earliest days. Jules Romains associates the dark with the dream state typical of the movie spectator.[5] Giovanni Papini speaks of "the theater's Wagnerian darkness," which prevents distractions and intensifies vision.[6] Walter Serner writes of the "sweetness" of the dark, in contrast with the ferocity of what is often represented on the screen (and with our very desire to see that horror).[7] Emilio Scaglione suggests that the dark permits spectators' bodies to approach each other and remain in close proximity, transforming the theater into a space of intimacy.[8] It is along these same lines that Roland Barthes, in a text written when cinema had already begun to confront the radical transformations that characterize it today, would discuss the erotic quality of the theater's darkness, the particular atmosphere it creates, and the pleasure of immersing oneself in it, which mirrors the pleasure of projecting oneself ideally onto the screen.[9] Hollis Frampton would voice a similar sentiment in 1968 when he opened one

of his lectures saying, "Please turn out the light. As long as we are going to talk about films, we might as well do it in the dark."[10]

Darkness seems to be an essential element of the cinematic experience. At times, however, some have sought to lessen it. In the first decade of the 1900s, some Italian cinephile clerics proposed projecting films in churches. In order to prevent the spectators from being too powerfully struck by the cinema, not to mention being in a state of potential promiscuity, they tried to figure out how to keep the space illuminated, attempting to adopt more powerful projectors and more reflective screens.[11] They were not the only ones to try and exorcise the darkness[12]: If such efforts prove unsuccessful, however, it is not because technology forbids them, but because the darkness constitutes an integral part of the cinema. It emphasizes the separation and the allure of the site of projection, it permits a group of individuals to be converted into spectators and into an audience, and it nurtures the possibility that the projected image may become its own true world.

If there is one element of the relocation of cinema toward new environments and devices that is particularly striking, it is precisely the absence of the dark.[13] Vision occurs ever more frequently in broad daylight, on modes of transportation, in city squares, and even at home; when we prepare ourselves to follow moving images (and sounds) on our computers, tablets, or televisions, we often do not require that the environment be dark.

We should consider this a significant symptom of the contemporary situation and not a mere detail to be dismissed. In fact, the loss of darkness highlights the cinema's progressive rejection of the three fundamental pillars discussed above. We are no longer tied to an enclosed environment; on the contrary, places of vision are often open, exposed, and lacking a defined threshold. Filmic images no longer aspire to world creation; rather, the material that arrives on our screens is often uncertain, composite, made up of constituent parts of diverse natures, and intended for various destinations. Finally, an audience immersed in viewing can no longer be taken for granted; on the contrary, the act of following a film is an increasingly solitary and superficial action. Exaggerating just a bit, we could say that the disappearance of the dark may signal the dissolution of the cinematic experience itself.

THE FAINTING OF THE MEDIUM

Nevertheless, cinema is still alive. Its end, as Raymond Bellour reminds us, is "an end that never stops ending."[14] Not only do there still exist darkened theaters, audiences that gather to watch movies, and worlds that come to life on the big screen; there are also cinematic experiences that are re-created, perhaps with some difficulty, in my living room, in a museum or art gallery in the form of an installation, or in a city square, thanks to devices such as DVDs, tablets, or media façades. Cinema survives also in broad daylight—or, better, in *regimes of light* that differ from its own.

In the preceding pages, we have inquired at length into the persistence of cinema and the way that it is affected by the changes occurring in the media universe more broadly. These changes point to a new and different terrain toward which we are inevitably moving; nevertheless, they frequently offer new opportunities to a model of cinematic experience that has its roots in the past and that through incorporating the new may continue to maintain its own identity. Thus, while it is true that we find ourselves before a no-longer-cinema, it is also true that in the process of change we often see a still-cinema or a cinema-once-again emerge. The seven chapters of this book have sought to follow the different processes that allow cinema to maintain its identity even in transformation, and the key words that serve as their basis have sought to sketch out the conceptual paradigm that allows us to understand this phenomenon better.

What does let this persistence in difference occur? We have already analyzed the main crucial elements: for example, the fact that experiences are not only repeatable, but also relocatable; the fact that the cinematic machine is no longer an apparatus, but an assemblage; the fact that cinema is no more defined by a canon, but by an expansion; and so on. Beneath these elements, there are at least two factors that allow cinema to continue to be itself, not in repeating itself in an identical way, but as part of and as a result of the differences. Both make explicit reference to the history of cinema, constructing a bridge between past and present; neither, however, conceives of the present as a simple return of the same, but rather as a distancing that, by its very nature, unites. We will call these two factors the *fainting of the medium* and the *paradox of recognition*.

Let us begin with the first element. In a fragment written in 1920, Walter Benjamin argues, "The medium through which works of art continue to influence later ages is always different from the one in which they affect their own age. Moreover, in those later times its impact on older works constantly changes, too. Nevertheless, this medium is always relatively fainter than what influenced contemporaries in the time it was created."[15] As Antonio Somaini has pointed out,[16] Benjamin does not use the word *medium* to refer to a technical dispositive (which he calls *Apparat* or *Apparatur*), but rather to the modalities with which a work, a language, or a technology actuates its mediation. In this sense, the term precisely indicates both the environment and the conditions of a perception—and therefore, if you will, the fabric of an experience. The same definition applies in this fragment. It indicates the fact that the "atmosphere" that is created around a work and that conditions its reception, both by contemporaries and by future generations, gradually becomes thinner and less dense with the passage of time. It is not that works change as such; rather, their modes of accessibility change. They loosen the bonds and the necessities that marked their birth (and, Benjamin observes in the same fragment, that rendered the medium so "dense" that the creator could not manage to penetrate its own creation fully).[17] Works acquire greater lightness. They can be more easily encountered, even outside their previous context.[18] And they can be understood in a more direct way, avoiding the resistance that they posed even to their creator.[19] This availability and immediacy has a positive effect: The works not only become a more familiar presence, but also come to show their true characteristics. What was hidden by an overly dense atmosphere can now appear with great clarity. Works finally speak to us about themselves.[20]

Let's return then to the cinema—and to a cinema that manifests itself in broad daylight. It seems to me that Benjamin's brief fragment can help us to understand its particular character. In this stage of its history, cinema becomes thinner and lighter. Compared with the "classical" era of studios and movie theaters, the "atmosphere" changes: Contact with a film is no longer signaled by a well-structured set of norms, constraints, and intentions, but it becomes easier and more direct. We can approach cinema under a variety of different circumstances. It is now free to relocate itself in new environments and into new devices. It can conquer new spaces,

such as the home; it can accompany us as we move about; it can enter into gray zones, between tradition and the new, such as art galleries; it can remain in the movie theater. In all of these cases, it penetrates into the folds of our daily life, and we find it there within arm's reach. We can simultaneously capture what it has been and what it still is. The thinning of the atmosphere that surrounds it brings its true nature to light. We increasingly discover what cinema is, what it wanted to be, and what it could have been. No longer protected by the density of an institution, it speaks fully of itself to us.

We are far, then, from any idea of decline or decay.[21] Relocated cinema represents a moment of the medium's fainting that allows for both the availability and the penetration of the object of our experience. Cinema exists in thousands of different situations: through the many faces it takes on, we can finally understand it.

THE PARADOXES OF RECOGNITION

The second element that allows for cinema's persistence takes us back to strategies of recognition. In the preceding pages, I have often emphasized the importance of the act of recognition. It not only allows us to identify who or what we have in front of us, even if it is in another guise (this is the case of Ulysses' dog, Argos, who recognizes his owner disguised as a beggar), but it also leads us to accept the identity of whoever or whatever does not yet have one (this is the case when a government gives recognition to a newly formed state). Recognition may be a detection or an acknowledgment. Through both of these aspects in combination, it is therefore that which makes something what it is.

It is no accident that André Gaudreault and Philippe Marion, in retracing the process that led to the birth of cinema,[22] attribute more importance to social recognition than to the introduction of a technology. The appearance of a technology simply opens the way to a series of possibilities. After this initial appearance, there must follow a phase in which procedures are established, possibilities are channeled, and practices are made recurrent. This moment leads to a third phase, in which there is a recognition of the *personality* that cinema has assumed and an awareness of its *potential* as a form of expression.[23] It is in this final phase

that cinema acquires a collectively perceived identity and is transformed into an institution.[24]

Today we find ourselves at a similar turning point, in which cinema, affected by a series of changes, asks for confirmation. It asks to be recognized as cinema, regardless of its guise. So how do we implement this recognition? In broad terms, we move from a certain idea of cinema that is part of our cultural patrimony, and we compare it with the situations in which we find ourselves implicated, careful to bring out the typical traits of cinema (identification) and to confirm the fact that what we have before us is cinema, no matter its appearance (acceptance). It is thanks to this double feat that we can solve spurious situations such as many of those created by the relocation of cinema, and we can recognize as cinematographic experiences those such as watching a film at home, on a trip, in a waiting room, on a DVD player, or on a computer, and chatting about what we are watching on a social network.

This operation comes at a cost that cannot be ignored. To place these situations within the sphere of our *idea of cinema*, we are compelled to force the schema and ignore certain elements. We accept these situations and minimize the distortions in favor of the canonical. We set aside the fact that we are not in a movie theater, that perhaps we are not seated, that we may be surrounded by a distracting environment, that the screen is fluorescent instead of reflective, that the duration of the film is not the traditional one, and perhaps that what we are viewing may not even be a film. Instead, we accentuate that, as before, we are viewing mechanically reproduced images, which must cope with reality and at the same time concretize fantasy. We remain attached to a model that we have in mind, and we manipulate what we have in front of us slightly in order to render it more compatible with what we know. We say, or we think: "It is cinema after all, even if it doesn't seem to be."

However, in the name of compatibility, we also slightly manipulate the *idea*. We force it into relation with the situation in which we find ourselves, so that the situation does not seem overly modified. We fudge certain traits of our model of reference; others we exalt, and still others we add. We imagine the cinema must be that thing that is reflected in the reality in front of us.

We do this with respect to the present, as well as with respect to the past. Not only do we attribute to cinema characteristics that are only

now emerging, but we also project these characteristics back, so that our model of reference can seem historically founded. In doing so, however, we "create" a sense of continuity that is deeply instrumental: It serves to avoid a conception of the past as a completed phase and to give a foundation to the contemporary cinema, in all its guises.

When I say "we," I am not only speaking of spectators, but also of scholars, critics, and even the industry itself, which has perhaps the most at stake in ensuring that cinema survives the changes it is experiencing.

I am thinking of the technology suppliers for home theaters who insist on the quality of couches, screen, sound, and who suggest that cinema has always been identified with a particular kind of environment of vision.[25] Historically speaking, they forget other essential aspects, but in return, they make sure that a model of the experience attainable at home appears aligned with a long-standing canon.

Similarly, we find directors who claim ancestors that allow their films to latch onto a tradition. Movies today have much in common with graphic novels, video games, or theme parks; however, if they pay allegiance to the past, and especially if they pay homage to the "fathers" of the sixth or seventh art (I am thinking of *Hugo* by Martin Scorsese), *voilà,* they become the "heart" of cinema.[26]

Additionally, there are critics who reconstruct remote influences, transforming new aspects into the development of old institutions.[27] There are historians who look back at history with the eyes of the present and find—and rightly so—that cinema has always been projected outdoors, or inside museums, or in the home.[28] And there are historians of theory who recuperate hypotheses of cinema that were never realized or that never went anywhere, but that seem to be undergoing a resurgence today.[29] It is in this way that contemporary cinema finds its roots.

I want to be clear: These direct and indirect revisitations all have their own legitimacy. They seek to profit from cinema's past. In particular, many current historiographic studies consistently contribute to the discovery of the "tributaries that join up to become the mighty river we know as the cinema," to use Thomas Elsaesser's words.[30] My point, however, is another. The relocation of cinema triggers a discursive strategy aimed at rendering the past and the present instrumentally compatible. In reading current situations in light of what cinema has been, we interpret in a somewhat forced way not only what we find before us, but also our

point of comparison itself. In this manner, we seem to "invent" a continuity. This is the price to be paid.

In exchange, however, the persistence of cinema finds a motivation, and does so in the right way. "Inventing" a continuity, we inevitably accept the difference of contemporary cinema in respect to its past. We no longer claim that it is the same; we know that it is discordant. Even so, we expand our frame of reference to include new possibilities, and then seek to see if these have already been realized. In this way, we give cinema an identity that links it not to a fixed model, fated to repeat itself perpetually (or to die definitively), but whose basis is in a continual process of transformation. In a word, we recognize identity based on difference. In this way, we allow cinema to continue to live. It is cinema precisely because it asks us to recognize it on the basis of how it diverges from what went before.

THE HISTORY OF CINEMA SEEN FROM ITS AFTERMATH

We have spoken of past and present and of the links between them. In recent years, the history of cinema has appeared more and more as a problem. Many now tend to consider it as a kind of "parenthesis" within a wider history,[31] while others try to reformulate the genealogy of cinema by taking its new conditions of existence as a point of departure, as Anne Friedberg called for already in 2000.[32]

The fainting of the medium and our paradoxical recognition of it paint an interesting picture. In the first case, we find a truth about the cinema that can only be realized when the atmosphere around it has lost its density. In the second case, we find a truth about the cinema that emerges from the past, but only when it is interrogated from the present. In both cases, we have a past and a present that are constructed in relation to one another.

Such a conception of history brings us back again to Walter Benjamin. In an extraordinary page in the appendix to "The Work of Art," Benjamin states: "The history of art is a history of prophecies. It can be written only by beginning from the point of view of a completely current present, since every age possesses its own new, though non-inheritable, occasion of interpreting exactly those prophecies that the art of past epochs

contained within itself."[33] So, the past offers examples that cast light on the present, but these examples may be focused only by the present. Moreover, only the present can make prophecies of these cases, as they do not provide clear statements—because in themselves they are not prophecies. Benjamin is clear: "No one of [these prophecies] in reality has ever fully determined the future, not even the most imminent future. On the contrary, in the work of art nothing is more difficult to grasp than the obscure and nebulous references to the future that the prophecies—never occurring singly, but always in a series, no matter how intermittent—have brought to light along the course of the centuries."[34] If these cases become prophecies, and therefore antecedents of what is happening nowadays, it is only because particular conditions now exist that make possible the attribution of an exemplarity to the past. Benjamin indeed writes: "In order for these prophecies to become comprehensible, the circumstances which the work of art has often already covered centuries or even just years before, must first arrive at maturation."[35]

This point of maturation is coincidental "on the one hand with certain social transformation that changes the function of art, and on the other hand with certain mechanical inventions."[36] But what explicitly allows a reconsideration of the past in light of the present, and an insight into the present in light of the past, are the images that Benjamin, in his great fresco of the Paris *passages*, identifies as "dialectical." They are those "flashing images"[37] that succeed in making "legible" both yesterday and today, linking them together outside of the usual parameters of consequentiality. Thanks to these images, yesterday is consigned to today's consciousness: "the historical index of the images not only says that they belong to a particular time; it says, above all, that they attain to legibility only at a particular time."[38] And it is thanks to these images that today can be made knowable to itself: "Every present day is determined by the images that are synchronic with it; each 'now' [*Jetzt*] is the now of a particular recognisability."[39] Dialectical images make us look simultaneously back and around them, giving a meaning to what is seen. They simultaneously provide a vision and a perspective. But the mutual illumination of past and present that dialectical images permit undermines the idea of consequential development: Yesterday does not determine today any more than today determines yesterday. Rather than a timeline, we should speak of a constellation: "It's not that what is past casts its light on

what is present, or what is present its light on what is past; rather, image is that wherein what has been comes together in a flash with the now [*Jetzt*] to form a constellation."[40]

At issue here are prophecies that are only retrospectively recognized, elements that ensure the legibility of both yesterday and today, and a link between past and present that is not characterized by chronological linearity, but by a constellatory configuration. Benjamin's lesson is clear, and it explains well the idea of cinema history we have in mind when we find ourselves implicated in the processes of relocation. When a new situation begs recognition as cinematographic, we ask the past to shed light on it while simultaneously reading the past in light of this new situation; we see in this situation the maturation of preceding conditions, while we construct, in parallel, what should be its premises. We use yesterday to define today, while also creating a yesterday because today asks to be defined. We therefore break the sense of a chronology—though we pretend to respect it—and make of each moment the consequence of the other. In essence, relocation offers us provocative cases that function as "dialectical situations." Thanks to them, we are able to rethink cinema and its history. We create a constellatory temporality, far from a progressive and causal logic, but, on the contrary, a kind of back and forth that moves us in many different directions and opens for us many different paths. In this way, we do not only pay attention to a more subtle sense of time,[41] but also we fully capture the dialectics underlying identity.

BETWEEN SURVIVAL AND REINVENTION

Cinema is still among us, relocating itself outside of the darkened theater. On the one hand, it acquires an attenuated character that allows it to insinuate itself in the crevices of our social world: It becomes lighter, more accessible, attainable, and polymorphous, and yet remains part of its own history. On the other hand, cinema redefines its identity: It asks us to accept the transformations it has undergone, and even to project them back in time into its history; only in this way can we establish a bridge between past and present that guarantees that we are in fact still dealing with cinema. In short, cinema's persistence is based on greater flexibility

on the one hand, and a sort of continuous self-reinvention on the other, which is entrusted to us and which allows us to recognize what we have before us as cinema and as the "same" cinema, despite all its modifications. Lightness and reinvention: If cinema is to remain among us, these are the conditions that allow it to do so.

This brings us to a final observation, with which I would like to conclude this book. Between 1946 and his death in 1948, Sergei M. Eisenstein embarked on an ambitious project: the writing of a history of cinema.[42] His idea was to place it within the frame of the history of the arts—not as their final outcome, but rather, on the contrary, as the agent capable of drawing out from other artistic fields what they were unable to display on their own, particularly the anthropological need to capture ephemeral phenomena. In this project, cinema is seen as an active, dynamic force that breaks down a consolidated situation and draws new aspects from it. I would say that cinema is what relocates the old arts, leading them out of a bottleneck in which they would otherwise risk extinction.

If we compare the Eisensteinian scenario with what is currently taking place, we have to reverse the terms somewhat: Today it is cinema that is being relocated into new devices and into new social environments; it is cinema that is seeking a way out of its own bottleneck. It is cinema that has been called into question, and which must find a new terrain in which to assert its own lesson. No longer capable of aiding the other arts, it is now cinema that is in need of assistance.

The feeling that cinema currently finds itself in a perilous situation is widespread, and it is precisely in order to face up to this danger that we recall an idea of cinema and use it to attribute a cinematicity to borderline situations, even at the cost of a biased rereading of history. We do this because we are convinced that it is the permanence of this idea—the permanence of a form of experience—that guarantees the survival of cinema. In other words, it is the possibility, and perhaps even the imminence, of its demise that motivates and moves us. However, this lends our action a somewhat tragic cast: The idea of cinema to which we are attached ends up functioning above all as a medicine or an exorcism. It is the cure that is administered to the patient, whose case we hope is not terminal. It is the rite we celebrate in an attempt to ward off an impending disaster. In any case, it is something that at most prolongs survival.

If it is true that the current situation is permeated by a sense of mourning, it is also true that it also possesses an equally strong sense of vitality. We could in fact think, following Eisenstein, that cinema is today doing to itself what it did in the past to the other arts—searching out a new terrain in order to be able to look inward and find new and unexpressed stances. In the living room, in public squares, on the computer, alongside other media and mixed in with other languages, it could be attempting to become what it has never fully been, but could be. In this sense, its shift would make possible a real renewal, not simply a mere survival.

Two perfectly aligned conclusions may be drawn from this—two conclusions with which I would like to bring to an end this long exploration of the future of cinema. On the one hand, cinema's continuous relocation into other dispositives and environments has the smell of death about it. Cinema's permanence is nothing more than a desperate deferment of the end. Its history, which we rewrite in order to create a sense of continuity, reads like a last will and testament. Cinema is a posthumous object. On the other hand, instead, cinema relocates itself in order to finally discover its identity in its entirety. It becomes other in order to find itself better. By recognizing its presence under new guises—or better, by reinventing it and its history—we come closer to its truth. Cinema is still an object to be discovered.

Notes

INTRODUCTION

1. *Chambre 666*, Wim Wenders (France–West Germany, 1982).

2. Susan Sontag, "The Decay of Cinema," *New York Times*, February 25, 1996, available at www.nytimes.com/books/00/03/12/specials/sontag-cinema.html.

3. We find this line of thought in authors ranging from Lev Manovich, "Digital Cinema and the History of Moving Image," in *The Language of New Media* (Cambridge, Mass.: MIT Press, 2000), 293–333, to David Rodowick, *The Virtual Life of Film* (Cambridge, Mass.: Harvard University Press, 2007).

4. This orientation of thought is present in authors ranging from Anne Friedberg, "The End of Cinema: Multimedia and Technological Change," in Christine Gledhill and Linda Williams, eds., *Reinventing Film Studies* (London: Arnold, 2000), 438–52, to Laura Mulvey, *Death 24 x a Second. Stillness and the Moving Image* (London: Reaktion, 2006).

5. This thesis is developed by Paolo Cherchi Usai in *The Death of Cinema: History, Cultural Memory, and the Digital Dark Age* (London: British Film Institute, 2005), but also reemerges, with a different emphasis, in Hito Steyerl, "In Defense of the Poor Image," *e-flux*, 11, 2009 (available at www.e-flux.com/journal/view/94), then in her *The Wretched of the Screen* (Berlin: Sternberg Press, 2012), 31–45.

6. Clifford Coonan, "Greenaway Announces the Death of Cinema—and Blames the Remote-Control Zapper," *Independent*, October 10, 2007, available at www.independent.co.uk/news/world/asia/greenaway-announces-the-death-of-cinema—and-blames-the-remotecontrol-zapper-394546.html. Greenaway's comment is of course a provocation; after all, September only has thirty days.

7. MPAA Theatrical Market Statistics 2012, available at www.mpaa.org/resources/3037b7a4-58a2-4109-8012-58fca3abdf1b.pdf.

8. The title of an article about a new type of screen, for example, indicates this tendency: "The iPad Enables a New Age of Personal Cinema," available at www.forbes.com/sites/anthonykosner/2012/04/14/the-ipad-enables-a-new-age-of-personal-cinema-welcome-to-the-feelies/. Last accessed October 2013.

9. The expression "cinéma d'exposition" has been coined by Jean-Christophe Royoux, "Pour un cinéma d'exposition. Retour sur quelques jalons historiques," *Omnibus*, 20 (April 1997). This expression, and other similar ones, are discussed by Raymond Bellour in *La querelle des dispositifs. Cinéma-Installations-expositions* (Paris: POL, 2012). Bellour's book is an excellent exploration of this kind of cinema.

10. Philippe Dubois, ed., *Extended Cinema. La cinéma gagne du terrain* (Pasian di Prato: Campanotto, 2010); see also Jeanine Marchessault and Susan Lord, eds., *Fluid Screens, Expanded Cinema* (Toronto: University of Toronto Press, 2007). For an opposite point of view on the topic, see Jacques Aumont, *Que reste-t-il du cinema?* (Paris: Vrin, 2012), especially pp. 27–49.

11. See Jeffrey Shaw and Peter Weibel, eds., *Future Cinema. The Cinematic Imaginary After Film* (Cambridge, Mass.: MIT Press, 2003).

12. Pavle Levi, *Cinema by Other Means* (Oxford: Oxford University Press, 2012).

13. Luc Vancheri, *Cinémas contemporains. Du film à l'installation* (Lyon: Aléas, 2009).

14. In 2012, digital theaters made up about two thirds of the total number, while those equipped for 3-D represent about 35 percent of the total. See www.mpaa.org/resources/3037b7a4-58a2-4109-8012-58fca3abdf1b.pdf. Last accessed October 2013.

15. One example is ORBI, inaugurated in Yokohama on August 19, 2013, as a joint venture between the Sega video game company and BBC International. See http://orbiearth.com/en/.

16. See for example the new seats provided by AMC Theaters: "The Screen Is Silver, but the Seats Are Gold. AMC Theaters Lure Moviegoers with Cushy Recliners," *New York Times*, October 18, 2013.

17. Haidee Wasson has made a comparative analysis of products available online through QuickTime and films available in IMAX theaters; see Haidee Wasson, "The Networked Screen: Moving Images, Materiality, and the Aesthetic of Size," in *Fluid Screen, Expanded Cinema*, 74–95.

18. This tripartite division is suggested by Martin Jay, "Songs of Experience," in *Cultural Semantics: Keywords of our Time* (Amherst: University of Massachusetts Press, 1998), 44. Clearly, the idea of experience as *Erlebnis* and *Erfahrung*, as elaborated by Walter Benjamin, lies not too far off in the background. See "The Story-Teller: Reflections on the Works of Nicolai Leskov," translated from German by Harry Zohn, Chicago Review 16, n. 1 (Winter-Spring 1963), 80–101.—originally "Der Erzähler. Betrachtungen zum Werk Nikolai Lesskows," *Orient und Occident* (October 1936), now in *Gesammelte Schriften*, 2.2 (Frankfurt: Suhrkamp, 1977), 438–65; and the magnificent pages of "Experience and Poverty," *Selected Writings*, 2.II (Cambridge, Mass.: Belknap Press, 1999), 731–36; originally "Erfahrung und Armut," in *Gesammelte Schriften*, 2.1 (Frankfurt: Suhrkamp, 1972), 219. A historical revisitation of the idea of experience is Martin Jay, *Songs of Experience. Modern American and European Variations on a Universal Theme* (Berkeley: University of California Press, 2005).

19. Walter Benjamin, "Little History of Photography," in Michael W. Jennings, Brigid Doherty, and Thomas Y. Levin, eds., *The Work of Art in the Age of Its Technological Reproducibility, and Other Writings on Media* (Cambridge, Mass.: Belknap Press, 2008), 275.

20. John Belton, "Digital Cinema: A False Revolution?" *October*, 100 (Spring 2002), 98–114.

21. Stephen Prince, "True Lies: Perceptual Realism, Digital Images, and Film Theory," *Film Quarterly*, 49.3 (Spring 1996), 27–37. For Prince "A perceptual realistic image is one which structurally corresponds to the viewer's audiovisual experience of three-dimensional space" (p. 32). According to Prince, the digital image is perfectly able to "establish correspondences with the properties of physical space and living systems in daily life" (pp. 33–34).

22. Berys Gaut, *A Philosophy of Cinematic Art* (Cambridge: Cambridge University Press, 2010), in particular page 48 ("Given the similarity of generative methods, it is implausible to claim that one is a photograph and the other is not.") and page 97 ("all pictures are opaque. It follows that both traditional and digital cinematic images are opaque").

23. David Bordwell, *Pandora's Digital Box: Films, Files, and the Future of Movies* (Madison, Wis.: Irvington Way Institute Press, 2012), 8.

24. Noël Carroll, "Medium Specificity Arguments and the Self-Conscious Invented Arts: Film, Video and Photography," and "The Specificity of Media in the Arts," in *Theorizing the Moving Image* (Cambridge: Cambridge University Press, 1996), 3–36.

25. Edgar Morin, "Recherches sur le public cinématographique," *Revue Internationale de filmologie*, 12.4, (January-March 1953), 3–19.

26. In this sense, I feel close to the position expressed by Tom Gunning in his "Moving Away from the Index: Cinema and the Impression of Reality," *Differences*, 18.1 (2007), 29–52. Gunning retraces in film theory different ways of defining cinema. For example, we are accustomed to thinking that the main characteristic of the cinematic image is its existential link with what it reproduces; there is, however, a well-founded line of thinking that has placed the emphasis instead on the fact that it gives us images in movement.

27. Lynch adds, "You'll think you have experienced it, but you'll be cheated," and concludes, "Get real." See the advertisement at www.criticalcommons.org/Members/ironman28/clips/davidLynchMoviePhone.mov/view.

28. See Barbara Klinger, "Cinema's Shadows. Reconsidering Non-theatrical Exhibition," in Richard Maltby, Melvin Stokes, and Robert C. Allen, eds., *Going to the Movies. Hollywood and the Social Experience of Cinema* (Exeter, University of Exeter Press, 2007), 273–90.

29. In *Que reste-t-il du cinema?* Jacques Aumont claims that the cinematic dispositive might change, as it has never had one and only one instantiation; what must not change are two aspects, respectively the temporal continuity and unity of the screening and the capacity of cinema to "encounter" reality. Even if I do not agree completely with Aumont's argument (in particular, the idea of a continuous and entire vision is a quite recent habit), I agree with him on the fact that the re-articulation of cinema cannot drop the presence of some key features—it can just rearrange them. See Aumont, *Que reste*, especially the chapter "Permanences," pp. 73–111.

30. In *Oneself as Another*, trans. Kathleen Blamey (Chicago: University of Chicago Press, 1992) (originally *Soi-même comme un autre* [Paris: Seuil, 1990]), Paul Ricoeur opposes two ideas of identity, as sameness and as selfhood: the first is based on the permanence of the same aspects, on an "idem"; the second is a construct that includes

the differences, an "ipse." On identity not as repetition of the same, but as effect of difference, see also Gilles Deleuze, *Difference and Repetition*, trans. Paul Patton (New York: Columbia University Press, 1994); originally *Différence et repetition* (Paris: Presses universitaires de France, 1976).

31. Gilles Deleuze's "What Is a *Dispositif?*" in *Two Regimes of Madness: Texts and Interviews 1975–1995* (New York: Semiotext(e), 2006), 338–48; originally "Qu'est-ce qu'un dispositif?" in *Deux régimes de fous: textes et entretiens 1975–1995* (Paris: Éditions de Minuit, 2003), 316–25.

32. For a history of film presentation, see Douglas Gomery, *Shared Pleasure* (Madison: University of Wisconsin Press, 1992).

33. Michel Foucault, "Of Other Spaces," *Diacritics*, 16 (Spring 1986), 22–27; originally Michel Foucault, "Des espaces autres" (conférence au Cercle d'études architecturales, 14 mars 1967), *Architecture, Mouvement, Continuité*, 5 (October 1984), 46–49.

34. In my opinion, early film theories, if not film theories in general, must be considered as social discourses, occurring in time and space, penned not only by "great personalities" but also by almost anonymous writers, aiming to provide a definition of an unexpected reality (as cinema indeed was, in its granting the persistence of life, offering an unprecedented ubiquity and simultaneity, delivering a vision beyond human capacities, and so forth). From this standpoint, early film theories, and perhaps later ones as well, were above all "glosses" that provided a practical explication of what cinema is or could be; it was in this capacity that they established an intellectual framework for public discussion. See Francesco Casetti, "Theory, Post-theory, Neo-theories: Changes in Discourses, Change in Objects," *Cinémas*, 17.2–3 (Spring 2007), 33–45; and "Italy's Early Film Theories: Borders and Crossings," in Giorgio Bertellini, ed., *Italian Silent Cinema. A Reader* (New Barnet: John Libbey, 2013), 275–82.

1. RELOCATION

1. The exhibition was held from October 11, 2011, to March 11, 2012, and was part of the Unilever Series. It was accompanied by the catalog *Film: Tacita Dean*, ed. Nicholas Cullinan (London: Tate, 2011), in which a series of critics, artists, theoreticians, and filmmakers comment upon the importance of the film and of the analog image in the digital age.

2. Charlotte Higgins, "Tacita Dean Turbine Hall Film Pays Homage to a Dying Medium," available at www.guardian.co.uk/artanddesign/2011/oct/10/tacita-dean-film-turbine-hall.

3. See http://mas-studio.tumblr.com/post/9049039925/folly-for-a-flyover-by-assemble.

4. See www.whattoseeinparis.com/cinema-parks-paris/. (Last accessed November 2011)

5. See http://cairobserver.com/post/12731480069/cinema-tahrir-returns.

6. See the persuasive analysis by John T. Caldwell, "Welcome to the Viral Future of Cinema (Television)," *Cinema Journal*, 45.1 (2005), 90–97.

7. The increasing velocity in film distribution has been brilliantly analyzed, especially for the first decade of the twenty-first century, by Charles Ackland, "Theatrical

Exhibition: Accelerated Cinema," in Paul McDonald and Janet Wasko, eds., *The Contemporary Hollywood Film Industry* (Malden, Mass.: Blackwell, 2008), 83–105.

8. For example, see the video "A Day Made of Glass," which illustrates a series of screens imagined by Corning (www.youtube.com/watch_popup?v=6Cf7IL_eZ38&vq=medium), or the video "Productivity Future Vision," released by Microsoft Labs (www.microsoft.com/en-us/showcase/details.aspx?uuid=59099ab6-239c-42af-847a-a6705dddf48b), or the presentation of Samsung's screen/window (www.youtube.com/watch?v =mTVPVobDrms).

9. This question appears in the title of Malte Hagener's essay, "Where is Cinema (Today)? The Cinema in the Age of Media Immanence," *Cinema & Cie*, 11 (Fall 2008), 15–22. A re-reading of film theory in terms of a topology, instead of an ontology, is proposed by Vinzenz Hediger, "Lost in Space and Found in a Fold. Cinema and the Irony of the Media," in Gertrud Koch, Volker Pantenburg, and Simon Rothöhler, eds., *Screen Dynamics: Mapping the Borders of Cinema* (Vienna: Filmmuseum/Synema, 2012), 61–77.

10. "Experience" here refers not only to an exposure to images (and sounds) that engages our senses, but also to an awareness and to the practices that are consequent to such an exposure. We "experience" things when we encounter them, and we "have experience" because we have encountered things. On the experience of cinema, see the two diverging approaches of Vivian Sobchack, *The Address of the Eye: A Phenomenology of Film Experience* (Princeton, N.J.: Princeton University Press, 1992), and Miriam Bratu Hansen, *Cinema and Experience: Siegfried Kracauer, Walter Benjamin, and Theodor W. Adorno* (Berkeley: University of California Press, 2012). See also Janet Harbord, "Breaking with the Aura? Film as Object or Experience," in *Film Cultures* (London: Sage, 2002), 14–38, and Francesco Casetti, "Filmic Experience," *Screen*, 50.1 (Spring 2009), 56–66. A concise but effective consideration of what it means for a film historian to focus on the experience of cinema is in Robert C. Allen, "Reimagining the History of the Experience of Cinema in a Post-Moviegoing Age," in Richard Maltby, Daniel Biltereyst, and Philippe Meers, eds., *Explorations in New Cinema History. Approaches and Case Studies* (London: Wiley-Blackwell, 2011), 41–57.

11. On the distinction between Apparat and Medium in Benjamin, see the comprehensive and persuasive analysis by Antonio Somaini, " 'L'oggetto attualmente più importante dell'estetica.' Benjamin, il cinema come *Apparat*, e il '*Medium*' della percezione,' " *Fata Morgana*, 20 (2013), 117–46.

12. Rosalind Krauss, "*A Voyage on the North Sea.*" *Art in the Age of Post-medium Condition* (New York: Thames and Hudson, 1999), 57.

13. W. J. T. Mitchell and Mark B. N. Hansen, *Critical Terms for Media Studies* (Chicago: University of Chicago Press, 2010), xi.

14. Jean Epstein, "The Senses 1(b)," in Richard Abel, ed., *French Film Theory and Criticism: A History/Anthology, 1907–1939*, vol. 1 (Princeton, N.J.: Princeton University Press, 1984), 244. Originally "Le Sens 1 bis," in *Bonjour Cinéma* (Paris: Editions de la Siréne, 1921), 27–44. Parallel, and opposed to Epstein, see also the praise of the camera eye in Dziga Vertov, "Kinoks: A Revolution," in *Kino-Eye: The Writings of Dziga Vertov*, trans. Kevin O'Brien, ed. Annette Michelson (Berkeley: University of California Press, 1984), 11–12.

15. Antonello Gerbi, "Iniziazione alle delizie del cinema" ["An initiation to the delights of the cinema"], *Il Convegno*, 7.11–12 (November 25, 1926), 843.

16. Eugenio Giovannetti, *Il cinema, arte meccanica* (Palermo: Sandron, 1930). The same expression is used by Augusto Orvieto, "Spettacoli estivi: il cinematografo," in *Corriere della Sera*, Milano, 22.228 (August 21, 1907). In France, Marcel L'Herbier, in "Hermes et Silence," defines cinema as "a machine that imprints the life" ("machine à imprimer la vie"): see "Hermes and Silence," in Abel, 147–55—who translates the phrase as "machine-which-transmits-life," 147. Originally "Hermès et le silence," *Le Temps* (February 23, 1918), then in a larger version in *Intelligence du cinématographe* (Paris: Correa, 1946), 199–212. Emile Vuillermoz rephrases L'Herbier, saying that cinema is "the machine with which to imprint dreams" ("machine à imprimer les rêves"): see "Before the Screen: Hermes and Silence," in Abel, 157. Originally "Devant l'écran: Hermès et le silence," *Le Temps* (March 9, 1918), 3. On the mechanical dimension in arts, see also this passage by Jean Epstein: "Here the machine aesthetic—which modified music by introducing freedom of modulation, painting by introducing descriptive geometry, and all the art forms, as well as all of life, by introducing velocity, another light, other intellects—has created its masterpiece. The click of a shutter produces *photogénie* which was previously unknown." In Epstein, "The Senses 1(b)," in Abel, *French Film Theory*, 244.

17. Béla Balázs, *Visible Man, Or the Culture of Film*, in Erica Carter, ed., *Béla Balázs: Early Film Theory* (New York: Berghahn Books, 2010), 9. Originally Béla Balázs, *Der sichtbare Mensch oder die Kultur des Films* (Vienna: Deutsch-Österreichischer Verlag, 1924).

18. Ibid.

19. Ibid.

20. Giovanni Papini, "La filosofia del cinematografo," *La Stampa* (Turin) (May 18, 1907), 1.

21. Jean Epstein, "Magnification," in Abel, *French Film Theory*, 239. Originally "Grossissement," in *Bonjour Cinéma* (Paris: Editions de la Siréne, 1921), 93–108.

22. "This frightful lust in watching horror, fighting and death . . . is what hurries to the morgue and to the scene of the crime, to every chase and every brawl. . . . And it is what yanks the people in the movie theatre as possessed." Walter Serner, "Cinema and the Desire to Watch," in Richard W. McCormick and Alison Guenther-Pal, eds., *German Essays on Film* (New York: Continuum, 2004), 18. Originally "Kino und Schaulust," *Die Schaubüne* 9 (1913), 807–811.

23. The first commentators on cinema, just like the first theorists, were fascinated not only by cinema's capacity to reproduce reality—a capacity it shares with photography—but also and above all by its reproduction of the living world, of life. Two famous reports that followed the first Lumière projection at the Café des Capucines convey this fascination. *La Poste* writes, "It is life itself, it is movement captured in action," and "When these devices are delivered to the public, when all can photograph those who are dear to them no longer in immobile form but in movement, action, and familiar gestures, with a word on the tip of their tongue, death will cease to be absolute" (*La Poste*, 30 décembre 1895, in Daniel Banda and José Moure, eds., *Le cinéma: Naissance d'un art. 1895–1920*, Paris: Flammarion, 2008, 41). We find the same ideas in an article from *Le radical*, published the same day: "The spoken word has already been captured and reproduced; now so is life. One will, for example, be able to see one's family members move about again, long after they have passed away" (*Le radical*, 30 décembre 1895, in Daniel Banda and José Moure, eds., *Le cinéma*, 40). This theme

is taken up by other commentators and scholars; see in particular G. Fossa, "Orizzonti cinematografici avvenire," *La Scena Illustrata* (Firenze), XLIII.5 (1 marzo 1907), who in the name of the reproduction of life imagines that cinema needs to connect itself with the telegraph and the phonograph. Recently, two books, both of them praising the permanence of cinema also in a post-medium condition, highlight the relevance of this "encounter" with reality: Dudley Andrew, *What Cinema Is!* (Oxford: Wiley-Blackwell, 2010), and Jacques Aumont, *Que reste-t-il du cinéma?* (Paris:Vrin, 2012).

24. André Gay, "Le Cinématographe de MM. Auguste et Louis Lumiére," *Bulletin de Photo-Club de Paris*, 5 (1985), 311. The French expression is "la sensation saisissante du mouvement réel et de la vie."

25. Ricciotto Canudo, "The Birth of a Sixth Art," in Abel, *French Film Theory*, 60. Originally "Naissance d'un sixiéme art. Essai sur le Cinématographe," *Les Entretiens Idéalistes* (October 25, 1911).

26. Ricciotto Canudo, "Reflections on the Seventh Art," in Abel, *French Film Theory*, 295. Originally "Réflection sur la septiéme art," in *L'usine aux images* (Paris: Chiron, 1926), 29–47.

27. Canudo, Reflections, 296.

28. Blaise Cendars, "The Modern: A New Art, the Cinema," in Abel, *French Film Theory*, 182–83. Originally "Modernités—Un nouveau art: le cinema," *La rose rouge*, 7 (June 12, 1919), 108; later merged into "L'ABC du cinéma," in *Aujourd'hui* (Paris: Grasset, 1931), 55–66.

29. On the topic, see Tom Gunning, "An Aesthetic of Astonishment: Early Film and the [In]Credulous Spectator," *Art and Text* (Fall 1989); "Re-Newing Old Technologies: Astonishment, Second Nature, and the Uncanny in Technology from the Previous Turn-of -the-Century," in David Thorburn and Henry Jenkins, eds., *Rethinking Media Change The Aesthetics of Transition* (Cambridge, Mass.: MIT Press, 2003), 39–59; and "Uncanny Reflections, Modern Illusions: Sighting the Modern Optical Uncanny," in Jo Collins and John Jervis, eds., *Uncanny Modernity: Cultural Theories, Modern Anxieties* (London: Palgrave Macmillan, 2008), 68–90.

30. Balázs, *Visible Man*, 39.

31. Georg Lukács, "Thoughts on an Aesthetics of 'Cinema,' " in McCormick and Guenther-Pal, *German Essays on Film*, 12. Originally "Gedanken zu einer Ästhetik des Kino," in *Frankfurter Allgemeine Zeitung*, 251 (September 10, 1913), 1–2; a previous version appears in *Pester Lloyd* (Budapest) (April 16, 1911), 45–46.

32. Victor O. Freeburg, *The Art of Photoplay Making* (New York: Macmillan, 1918), especially chapter 6, "The Appeal of Imagination."

33. Dziga Vertov, "Kinoks: A Revolution," in *Kino-Eye: the Writings of Dziga Vertov*. Originally 1923.

34. Sergei Eisenstein, "The Cinematographic Principle and the Ideogram," *Film Form* and *The Film Sense* (New York: Meridian Books, 1957), 28–44.

35. Louis Delluc, "From Orestes to Rio Jim," in Abel, *French Film Theory*, 257. Originally "D'Oreste à Rio Jim," *Cinéa*, 32 (December 9, 1921), 14–15. See also "Le cinéma, art populaire," reprinted in *Écrits cinématographiques,* 2 vol., ed. Pierre Lherminier (Paris: Cinémathèque Française, 1985–1986), 2:279–88.

36. Faure claims that humankind has always needed "a collective spectacle . . . able to unite all classes, all ages, and, as a rule, the two sexes, in a unanimous communion exalting the rhythmic power that defines, in each of them, the moral order." Elie

Faure, *The Art of Cineplastics* (Boston: The Four Seas Company, 1923), 5. Originally "De la Cineplastique," in *L'arbre d'Eden* (Paris: Ed. Crest, 1922).

37. Freeburg focuses on the capacity of film to transform a crowd into a public, able to articulate a deliberate expression: "This deliberate expression is called public opinion," *The Art of Photoplay Making*, 8.

38. "The telephone, automobile, airplane and radio have so altered the limits of time and space within which civilizations have developed, that today man has ended up acquiring not so much a quickness of understanding unknown to the ancients, as a kind of ubiquity. Film seems the artistic reflection of this new condition of life, both material and spiritual." Sebastiano A. Luciani, *L'antiteatro. Il cinematografo come arte* (Roma: La Voce Anonima Editrice, 1928), 76.

39. Vachel Lindsay, *The Art of the Moving Picture* (New York: Macmillan, 1922), 290. The idea that cinema brings us back to a primitive condition and offers us an "originary" experience is largely present in early debates. An example is provided by Ricciotto Canudo: "[cinema] is bringing us with all our acquired psychological complexity back to the great, true, primordial, synthetic language, visual language, prior even to the confining literalness of sound." See Canudo, "Reflections" in Abel, *French Film Theory*, 296. On the relevance of "primitive" in film theory and in art theory during the 1920s and 1930s, see Antonio Somaini, *Ejženstejn. Il cinema, le arti, il montaggio* (Turin: Einaudi, 2011).

40. "An essential condition of a good work of art is indeed that the special attributes of the medium employed should be clearly and cleanly laid bare," Rudolf Arnheim, *Film* (London: Faber & Faber, 1933), 44. Originally *Film als Kunst* (Berlin: Ernst Rowohlt Verlag, 1932).

41. An excellent reconstruction of those years appears in Miriam Bratu Hansen, *Cinema and Experience*.

42. André Bazin, *What Is Cinema?*, 2 vols., trans. and ed. Hugh Gray (Berkeley: University of California Press, 2005). Originally *Qu'est ce que le cinéma?* (Paris: Ed. du Cerf): vol. 1, *Ontologie et langage* (1958); vol. 2, *Le cinéma et les autres arts* (1959); vol. 3, *Cinéma et Sociologie* (1961); and vol. 4, *Une esthétique de la réalité: le néo-réalisme* (1962).

43. Edgar Morin, *The Cinema, or, the Imaginary Man,* trans. Lorraine Mortimer (Minneapolis: University of Minnesota Press, 2005). Originally *Le cinéma ou l'homme imaginaire: Essai d'anthropologie sociologique* (Paris: Minuit, 1956).

44. Among the many contributions, see for instance Eric Feldmann, "Considération sur la situation du spectateur au cinéma," *Revue Internationale de Filmologie,* 26 (1956), 83–97.

45. Karel Teige, "The Aesthetics of Film and Cinégraphie," in Jaroslav Andel and Petr Szczepanik, eds., *Cinema all the Time: An Anthology of Czech Film Theory and Criticism* (Prague: National Film Archive, 2008), 147. Originally "Estetika filmu a kinografie," *Host*, 3.6–7 (April 1924), 143–54.

46. Luigi Pirandello, *Shoot!*, trans. C. K. Scott Montcrieff (Chicago: University of Chicago Press, 2005), 8. Originally *Si gira*, in *Nuova Antologia* (June 1–August 16, 1915), then in a single volume (Milan: Fratelli Treves, 1916). Republished with minor changes and a new title, as *Quaderni di Serafino Gubbio operatore* (Firenze: Edizioni Bemporad, 1925).

47. Ibid., 77–78. On Pirandello and his "cinematic vision," see Gavriel Moses, *The Nickel Was for the Movies: Film in the Novel Pirandello to Puig* (Berkeley: University of California Press, 1995).

48. Jean Paul Sartre, *The Words*, trans. Bernard Frechtman (New York: George Braziller, 1964), 122–23.

49. Jean Epstein, "The Cinema Seen from Etna" in Sarah Keller and Jason Paul, eds., *Jean Epstein: Critical Essays and New Translations* (Amsterdam: Amsterdam University Press, 2012), 289.

50. Epstein, The Cinema Seen from Etna, 292.

51. Michel de Certeau, *La faiblesse de croire* (Paris: Seuil, 1987), 210.

52. Paul Valéry, "The Conquest of Ubiquity," in *Aesthetics* (New York: Pantheon Books, 1964), 225–28. Originally "La conquête de l'ubiquité," in *Pièces sur l'art* (Paris: Darantière, 1931), 79–85. The essay first appeared in *De la musique avant toute chose* (Paris: Editions du Tamburinaire, 1928).

53. Ibid., 225.

54. Ibid., 225–26.

55. Ibid., 226.

56. Ibid., 226.

57. It should be noted that in these same years cinema is considered a medium capable of transporting emotions. Marcel L'Herbier writes, "the cinematograph seeks nothing other than to distribute human emotions, just as ephemeral as they are on the ephemeral film, but stretched out horizontally over the vaster expanse of the world." According to L'Herbier, this distribution is what opposes cinema to art: If the former spreads emotions that last only a few moments, also because on an ephemeral medium, art does the opposite, concentrating emotions in a work that tries to be perennial. See Marcel L'Herbier, "Esprit du cinématographe," *Les Cahiers du mois* 16–17 (1925), 29–35. The question, however, is whether the emotions raised by a film as such find means that let them go beyond the darkened room.

58. Ben Singer has shown the availability of dozens of projectors intended for amateur use in the home and elsewhere just two years after the appearance of Edison's Kinetoscope. See Ben Singer, "Early Home Cinema and the Edison Home Projecting Kinetoscope," *Film History* 2 (1988), especially pp. 42–45. On the long permanence of nontheatrical venues, after the movie theatee became the standard mode of exhibition, see Gregory A. Waller, "Locating Early Non-Theatrical Audiences," in Ian Christie, ed., *Audience* (Amsterdam: Amsterdam University Press, 2012), 81–95.

59. See Barbara Klinger, "Cinema-Shadow. Reconsidering Non-theatrical Exhibition," in Richard Maltby, Robert Stokes, and Robert C. Allen, eds., *Going to the Movies: Hollywood and the Social Experience of Cinema* (Exeter: University of Exeter Press, 2007), 273–90. Klinger strongly advocates for a larger consideration of film experience.

60. Research on the migration of cinema—and on the dissolution of its borders—has exploded recently. In the large bibliography, I want to mention at least *Screen Dynamics: Mapping the Borders of Cinema*, ed. Gertrud Koch, Simon Rothöhler, and Volker Pantenburg (Wien: Filmmuseum/Synema, 2012), and "Screen Attachments. New Practices of Viewing Moving Images," a special issue of the e-journal *Screening the Past*, 32 (2011), edited by Katherine Fowler and

Paola Voci. An extended and persuasive picture of cinema in the age of digital interaction is provided by Chuck Tryon, *Reinventing Cinema. Movies in the Age of Media Convergence* (New Brunswick, N.J.: Rutgers University Press, 2009), and *On-Demand Culture. Digital Delivery and the Future of Movies* (New Brunswick, N.J.: Rutgers University Press, 2013). The large industrial landscape in which such a migration takes place is masterly explored by John T. Caldwell in *Production Culture: Industrial Reflexivity and Critical Practice in Film and Television* (Durham, N.C.: Duke University Press, 2008); see also Anna Everett and John T. Caldwell, eds., *New Media: Theories and Practices of Digitextuality* (London: Routledge, 2003). A worldwide picture of the new Hollywood is Paul McDonald and Janet Wasko, eds., *The Contemporary Hollywood Film Industry* (Malden, Mass.: Blackwell, 2008): see in particular the analyses by Tom Schatz (on the "conglomerate" Hollywood), Janet Wasko (on finance and production), Philip Drake (distribution and marketing), and Charles Ackland (theatrical exhibition).

61. Jay David Bolter and Richard Grusin, *Remediation: Understanding New Media* (Cambridge, Mass.: MIT Press, 1999), 45.

62. Arjun Appadurai, *Modernity at Large: Cultural Dimensions of Globalization* (Minneapolis: University of Minnesota Press, 1996).

63. The concept of convergence can indeed be taken in this sense; see Henry Jenkins, *Convergence Culture: Where Old and New Media Collide* (New York: New York University Press, 2006).

64. Gilles Deleuze and Felix Guattari, *Anti-Oedipus: Capitalism and Schizophrenia*, trans. Robert Hurley, Mark Seem, and Helen R. Lane (New York: Viking Press, 1977). Originally *Anti-Œdipe* (Paris: Éditions de Minuit, 1972). See also *A Thousand Plateaus: Capitalism and Schizophrenia*, trans. Brian Massumi (London: Athlone Press, 1988).

65. Deleuze and Guattari make extensive reference to the dynamic of drives: In the processes of de- and re-territorialization, elements behave as libidinal charges, which can be bound or freed, and can configure systems that are either more compact or more labile. Such a reference reminds us that a medium may also be pushed into movement by a desire, and it is in relation to this desire that it either remains nomadic or allows itself to be trapped in one place.

66. See for example the analysis of the mode of seeing developed by mobile media in different contexts in Laura E. Levine, Bradley M. Waite, and Laura L. Bowman, "Mobile Media Use, Multitasking and Distractibility," *International Journal of Cyber Behavior, Psychology and Learning*, 2.3 (2012), 15–29. In a more sociological vein, see Rihannon Bury and Johnson Li, "Is it Live or it is Timeshifted, Streamed or Downloaded? Watching Television in the Era of Multiple Screens," *New Media and Society* (November 6, 2013). Some data (mostly from online reports) and amusing descriptions of media users as film spectators appear in Wheeler Winston Dixon, *Streaming. Movies, Media, and Instant Access* (Lexington: The University Press of Kentucky, 2013). It is possible to retrieve quantitative figures in the surveys by Nielsen.

67. A qualitative audience research on the re-enjoyment of films as films in a domestic environment is Uma Dinsmore-Tuli, "The Pleasures of 'Home Cinema,' or Watching Movies on Telly: An Audience Study of Cinephiliac VCR Use," *Screen*, 41.3 (2000), 315–27.

68. Mauro Carbone has written some important pages on the relationship between form and deformation in *An Unprecedented Deformation: Marcel Proust and the Sensible Ideas* (Albany, N.Y.: SUNY Press, 2010). Originally *Una deformazione senza precedenti. Marcel Proust e le idee sensibili* (Macerata: Quodlibet, 2004). My insistence that the form of an experience emerges from a situation, rather than being applied from the outside, as well as the connection that I propose between the "form of the cinematic experience" and the "idea of cinema," owes much to Carbone's book.

69. In "Seeing Theory: On Perception and Emotional Response in Current Film Theory," Malcom Turvey proposes applying Wittgenstein's concept of "seeing-as" to the recognition of filmic images. I am trying here to extend Turvey's claim, applying the concept not only to filmic images, but also to the spectator's situation, as well as noting that in the case of "seeing-as," differently than in that of "seeing," we also keep in mind the possibility of switching from one figure to the other. See Turvey, "Seeing Theory," in Richard Allen and Murray Smith, eds., *Film Theory and Philosophy* (Oxford: Oxford University Press, 1997), 431–57.

70. I strongly insisted on this quality of theory in "Theory, Post-theory, Neo-theories: Changes in Discourses, Change in Objects," *Cinémas*, 17.2–3 (Spring 2007), 33–45.

71. On the role of memory in our experience of cinema, see, among others, Annette Kuhn, *Dreaming of Fred and Ginger: Cinema and Cultural Memory* (New York: New York University Press, 2002).

72. Béla Balázs understood this quality quite well, writing that theory, which is expected to bring us such an idea, "is the road map for those who roam among the arts, showing them pathways and opportunities." Balázs, *Visible Man*, 3.

73. On the "idea of cinema" as a key element, see François Albera and Maria Tortajada, "Le dispositif n'existe pas," in François Albera and Maria Tortajada, eds., *Ciné-dispositifs* (Lausanne: L'Age d'Homme, 2011), 27ff. The need and effectiveness of an "idea of cinema" has recently been displayed by Dudley Andrew in *What Cinema Is!* (Oxford: Wiley-Blackwell, 2010). How an "idea of cinema" is extracted by imperfect situations is debated by Jacques Rancière in the preface of his *The Film Fables* (Oxford: Berg, 2006); originally *La fable cinématographique* (Paris: Seuil, 2001). Naturally, the "idea of cinema" takes us back to the "myth of cinema" discussed by André Bazin in *What Is Cinema?*.

74. This image appears in the essay, "Erfahrung und Armut," *Gesammelte Schriften*, vol 2., bk.1 (Frankfurt am Main: Suhrkamp, 1972), 219.

75. "7 Great Places to Watch Movies," available at http://movies.allwomenstalk.com/great-places-to-watch-movies.

76. "They sleep; their eyes no longer see. They are no longer conscious of their bodies. Instead, there are only passing images, a gliding and rustling of dreams." Jules Romains, "The Crowd at the Cinematograph" (1911), in Richard Abel, *French Film Theory*, 53.

77. Erica Jackson Curran, "Best Place to Watch Movies, Besides Bill Murray's In-House Theater in Beverly Hills: Movies in Marion Square," available at www.charlestoncitypaper.com/charleston/best-place-to-watch-movies-besides-bill-murrays-in-house-theater-in-beverly-hills/BestOf?oid=3169376.

78. See http://www.reallycleverhomes.co.uk/information-advice/create-the-authentic-cinema-experience-at-home/

79. "10 Tips for Better Movie Watching at Home," available at www.apartment-therapy.com/10-tips-for-better-movie-watching-at-home-178616. See also "The key rules of watching a movie at home properly," available at www.denofgeek.us/movies/18885/the-key-rules-of-watching-a-movie-at-home-properly.

80. "Watching Movies on Handheld Devices: Mobility Vs. Audio-Visual Clarity," available at http://movies.yahoo.com/news/watching-movies-handheld-devices-mobility-vs-audio-visual-20110128-083000-714.html.

81. "However, on a professional level, there is a major concern on the size of a typical phone's screen when showing a potential client some videos. It's just too small to make the visuals and even the sound coming from a very small speaker, well appreciated." Ibid.

82. See http://mubi.com/topics/can-you-watch-a-movie-on-a-plane.

83. See www.wikihow.com/Get-and-Watch-Free-Movies-on-iPad.

84. See www.i400calci.com/2013/03/400tv-jurassic-park/. In this case, the collective viewing was organized by the Italian online journal *I 400 calci. Rivista di cinema da combattimento*.

85. Blaise Cendrars, "The Modern: A New Art, the Cinema," in Abel, *French Film Theory*, 182–83.

86. Philippe Dubois, "Présentation," in Phlippe Dubois, Frédéric Monvoison, and Elena Biserna, eds., *Extended cinema: Le cinéma gagne du terrain* (Pasian di Prato: Campanotto, 2010), 13–14.

87. Philippe Dubois, Lucia Ramos Monteiro, and Alessandro Bordina, eds., *Oui, c'est du cinéma: formes et espaces de l'image en mouvement* (Paisan del Piave: Campanotto, 2009).

88. Raymond Bellour, *La querelle des dispositifs : cinéma—installations, expositions* (Paris: POL, 2012), 14.

89. Eric De Kuiper and Emile Poppe, "À la recherche du spectateur. Tentative du mise au clair," in *Extended cinema*, 61–69.

90. Miriam Hansen, "Early Cinema, Late Cinema: Transformations of the Public Sphere," in Linda Williams, ed., *Viewing Positions. Ways of Seeing Film* (New Brunswick, N.J.: Rutgers University Press, 1994), 134–52.

91. László Moholy-Nagy, *Painting, Photography, Film* (Cambridge, Mass.: MIT Press, 1969), 41. Originally *Malerei Photografie Film* (Munich: Albert Langen, 1925). Moholy-Nagy called the experiment "simultaneous or poly-cinema."

92. Anne Friedberg, "The End of Cinema: Multimedia and Technological Change," in Christine Gledhill and Linda Williams, eds., *Reinventing Film Studies* (London: Arnold, 2000), 438–52.

93. Walter Benjamin, *Origin of German Tragic Drama* (London: NLB, 1977). Originally *Ursprung des deutschen trauerspiels* (Berlin: E. Rowohlt, 1928). A useful reading of the prologue can be found in Carbone, *An Unprecedented Deformation*.

94. Benjamin, 46.

95. On this issue, see Mauro Carbone, *An Unprecedented Deformation*, 104.

96. Benjamin, 46.

97. Ibid., 45.

98. Ibid., 46.

99. Ibid.

2. RELICS/ICONS

1. Antonello Gerbi, "Iniziazione alle delizie del cinema," *Il Convegno*, 7.11–12 (November 25, 1926), 846.

2. Ibid.

3. One year before Gerbi, László Moholy-Nagy spoke of a "kinetic, projected composition, probably even with interpenetrating beams and mass of light floating freely in the room without a direct plane of projection." Moholy-Nagy, *Painting, Photography, Film* (Cambridge, Mass.: MIT Press, 1969), 26. Originally *Malerei Photografie Film* (Munich: Albert Langen, 1925). In the same volume, Moholy-Nagy also envisioned a simultaneous projection of two to four films on a semispherical screen, with images that converged and overlapped: he speaks of "simultaneous or poly-cinema" (see p. 41ff.). The 1920s was a decade that widely attempted new forms of projection; see Patrick de Haas, "Entre projectile et projet: Aspects de la projection dans les années vingt," in Dominique Paini, ed., *Projections, les transports de l'image* (Paris: Hazan /Le Fresnoy/AFAA, 1997), 95–126.

4. Robert C. Allen, "Reimagining the History of the Experience of Cinema in a Post-Moviegoing Age," in Richard Maltby, Daniel Biltereyst, and Philippe Meers, eds., *Explorations in New Cinema History. Approaches and Case Studies* (London: Wiley-Blackwell, 2011), 41.

5. For these figures, see *MPAA Theatrical Market Statistics 2012*, available at www.mpaa.org/resources/3037b7a4-58a2-4109-8012-58fca3abdf1b.pdf.

6. *BFI Statistical Yearbook 2013*, 11, available at www.bfi.org.uk/sites/bfi.org.uk/files/downloads/bfi-statistical-yearbook-2013.pdf. Last accessed October 2013.

7. The *BFI Statistical Yearbook 2013* summarizes such a trend, with particular focus on the United Kingdom: "Along with the USA and other western European countries, cinema-going in the UK declined sharply in the post-war era as incomes rose and new leisure activities became available. The largest competition came from the growth of television which allowed audiences to satisfy their appetite for screen entertainment in the comfort of their own homes. As cinema admissions fell so did the supply of screens, which led to further falling demand and more cinema closures. By the 1980s the number and quality of the remaining cinemas were at an all time low. The introduction of the VCR in the same decade had a further negative impact on admissions and the nadir was reached in 1984 with cinema-going down to an average of one visit per person per year. However, the introduction of multiplex cinemas to the UK from 1985 onwards reversed the trend and ushered in a new period of growth which saw admissions returning to levels last seen in the early 1970s." *BFI Statistical Yearbook 2013*, 12.

8. Figures are discussed by Kevin Collins at the Web site Home Theatre Forum and are based on a survey by the NPD Group. See www.hometheaterforum.com/topic/324706-npd-more-people-watch-discs-than-subscription-video-on-demand/. Last accessed November 2013.

9. *BFI Statistical Yearbook*, 146; see also pg. 8.

10. See www.npd.com/wps/portal/npd/us/news/press-releases/pr_120808b/. Last accessed November 2013.

11. BFI *Statistical Yearbook*, 144.

12. See http://torrentfreak.com/project-x-most-pirated-movie-of-2012-121227/. See also www.imdb.com/news/ni44361481/.

13. "Top 10 Most Pirated Movies of 2012," available at www.heyuguys.co.uk/top-10-most-pirated-movies-of-2012/.

14. I refer, naturally, to the theater that the cinema fashioned in its institutionalized phase, when it changed from a simple assembly point for a crowd, as the temporary canvas theater used by traveling exhibitors, to a stable and specific place where an audience gathered. The transition from early forms of exhibition to the rise of national theater chains is retraced by Douglas Gomery, *Shared Pleasure* (Madison, Wis.: University of Wisconsin Press, 1992), especially pp. 2–56. For Italy, see the exhaustive reconstruction of Aldo Bernardini, *Cinema muto italiano II. Industria e organizzazione dello spettacolo 1905–1909* (Bari-Rome: Laterza, 1981). The passage from a theater that was still a place of confusion to theater as a disciplinary place in the Foucauldian sense of the word was documented in Italy in Gualtiero Ildebrando Fabbri's novel *Al cinematografo* (Milan: P. Tonini, 1907), intended as a gift to the most assiduous spectators of Milanese theater of the day, and by articles such as Tullio Panteo's "Il cinematografo," *La Scena Illustrata*, 19.1 (October 1908), reprinted in Bernardini, *Cinema muto italiano II*, 236. Of course, we also must keep in mind that the nontheatrical exhibitions lasted for a long time, often intended for "specialized" audiences: on the topic, see Gregory A. Waller, "Locating Early Non-Theatrical Audiences," in Ian Christie, ed., *Audience* (Amsterdam: Amsterdam University Press, 2012), 81–95.

15. Regarding the home theater, see, among others, Barbara Klinger, "The New Media Aristocrats," in *Beyond the Multiplex: Cinema, New Technologies, and the Home* (Berkeley: University of California Press, 2006), 17–53.

16. The difference between modes of viewing at the cinema and in front of the television has been framed in various ways. See the distinctions between *gaze* and *glance* proposed by John Ellis and the distinctions between *viewing* and *monitoring* proposed by Stanley Cavell. See John Ellis, *Visible Fictions* (London: Routledge, 1992), and Stanley Cavell, "The Fact of Television," *Daedalus*, 111.4 (Fall 1982), 75–96, reprinted in *Cavell on Film*, ed. William Rothman (Albany, N.Y.: SUNY Press, 2005), 59–85.

17. *NBC Saturday Night at the Movies* was the first weekly program, beginning September 1961, to present relatively recent films, in color, in a time slot of ninety minutes. Prior to this program, television hosted only films in black and while, generally second-rate, and reduced to a length of one hour, or European films, not included in the mainstream market, and also often manipulated. NBC's program immediately had an influence on the programming of the other channels, which created rival series such as *The ABC Sunday Night Movie* or *The CBS Wednesday Night Movies*, but the programming of the same channel also expanded in the direction of cinema, with programs such as *The NBC Monday Movie* or *NBC Tuesday Night at the Movies*.

18. The main reason why VHS won over Betamax was the fact that VHS tapes were designed to record 120 minutes rather than 60—the length of an average movie, instead of that of a television program. See James Lardner, *Fast Forward. Hollywood, the Japanese, and the Onslaught of the VCR* (New York: Norton, 1987).

19. On the new temporality of DVDs, see Anne Friedberg, "The End of Cinema: Multimedia and Technological Change," in Christine Gledhill and Linda Williams, eds., *Reinventing Film Studies* (London: Arnold, 2000), 438–52.

20. Chuck Tryon, *On-Demand Culture. Digital Delivery and the Future of the Movies* (New Brunswick, N.J.: Rutgers University Press, 2013).

21. On the immersive view in museums, see Allison Griffiths, *Shivers Down Your Spine: Cinema, Museums and the Immersive View* (New York: Columbia University Press, 2008).

22. I read in this trend a direct influence of the New York World's Fair of 1964–1965, dedicated to "Man's Achievement on a Shrinking Globe in an Expanding Universe," in which the presentation of the most recent scientific and technological discoveries was made with the use of film clips often projected onto a multiple number of screens: the pavilions aimed not only at providing information and knowledge, but also at creating environments in which the visitors could immerse themselves.

23. See David Morley, "Public Issues and Intimate Histories: Mediation, Domestication and Dislocation," in *Media, Modernity and Technology* (London: Routledge, 2007), 210.

24. On the atmospheric theatre, and on the architecture of the interiors of cinemas between the two wars in general, see Giuliana Bruno, *Atlas of Emotions: Journeys in Art, Architecture, and Film* (London: Verso, 2002).

25. "This emphasis on the external has the advantage of being sincere. It is not externality that poses a threat to the truth. Truth is threatened only by the naïve affirmation of cultural values that has become unreal and by the careless misuse of concepts such as personality, inwardness, tragedy and so on—terms that in themselves certainly refer to lofty ideas but have lost much of their scope along with their supporting foundations, due to social changes." Sigfried Kracauer, "Cult of Distraction: On Berlin Movie Palaces," in *The Mass Ornament: Weimar Essays*, ed. and trans. Thomas Y. Levin (Cambridge, Mass.: Harvard University Press, 1995), 326. Originally *Das Ornament der Masse* (Frankfurt: Suhrkamp, 1963). The essay was written in 1927.

26. On the advent of cinema at the MoMA, see Haidee Wasson, "Studying Movies at the Museum: The Museum of Modern Art and Cinema's Changing Object" in Haidee Wasson and Lee Grieveson, eds., *Inventing Film Studies* (Durham, N.C.: Duke University Press, 2008), 121–48. Wasson recalls the three guiding principles for such an advent: "First, that the otherwise anamorphous phenomena called cinema should also be understood as a collection of individual films, *as an assemblage of objects that endured through time*; second, that these selected films *should be seen, requiring a form of distribution and exhibition of films outside of commercial movie theaters*; and, third, that viewing such films should be augmented by informed research materials, placing film in pertinent sociological, historical, political, and aesthetic dialogue" (pp. 122–23). Wasson also notes that Iris Barry "had a slide projector permanently installed in the museum's auditorium, equipped with a slide that read: 'If the disturbance in the auditorium does not cease, the showing of this film will be discontinued' " (pp. 126–27).

27. See Iris Barry, "A Short Survey of the Films in America Circulated by the Museum of Modern Art Film Library. Programs 1–5a" (New York, c. 1936–1937).

28. For example, Barry screened only the reels of *The Jazz Singer* with music and songs.

29. Louis Delluc, "The Crowd," in *French Film Theory and Criticism: A History/Anthology, 1907–1939,* ed. and trans. Richard Abel, 2 vols. (Princeton, N.J.: Princeton University Press, 1993), 1:159–64. Originally "La foule devant l'écran," in Delluc, *Photogenie* (Paris: de Brunoff, 1920), 104–118.

30. Robert Desnos, "Charlot," *Journal littéraire* (June 13, 1925). Reprinted in Desnos, *Cinéma* (Paris: Gallimard, 1966), 145–46.

31. See www.blockbuster.com/. Last accessed October 1, 2011.

32. See http://elite-theater.kalsow.com/. Last accessed October 1, 2011.

33. See www.familyleisure.com/planagram. Last accessed October 1, 2011.

34. See www.netflix.com/. Last accessed October 1, 2011.

35. Will Straw has observed that it is precisely the possibility of delivering a film through many channels that has made it an object with its own autonomy and identity: "As windows for the marketing of films proliferate, the branding of films as discrete entities is heightened, such that they maintain their distinctiveness across every channel of exhibition, from the retail videocassette to the pay-per-view event." Will Straw, "Proliferating Screens," *Screen*, 41 (Spring 2000), 117.

36. Roland Barthes, "Leaving the Movie Theater," in *The Rustle of Language*, trans. Richard Howard (Berkeley: University of California Press, 1986), 345–49. Originally "En sortant du cinéma," *Communications*, 23 (1975); reprinted in *Le bruissement de la langue: essais critiques IV* (Paris: Seuil, 1984), 407–412.

37. Haidee Wasson, "The Networked Screen: Moving Images, Materiality, and the Aesthetics of Size," in Jeanine Marchessault and Susan Lord, eds., *Fluid Screens, Expanded Cinema* (Toronto: University of Toronto Press, 2007), 88. Wasson speaks respectively of "cinema of attraction" and of "cinema of suggestion."

38. Lev Manovich notices an increasing fracture between an immersive gaze and a gaze devoted to control; see *The Language of New Media* (Cambridge, Mass.: MIT Press, 2001).

39. See Brett Anderson, *Theo Kalomirakis' Private Theaters* (New York: Abrams, 1997). See also TKtheaters, www.tktheaters.com.

40. "Like the great movie houses of the early 20th century, the theaters that Theo Kalomirakis designs lure the audience away from everyday life into a tantalizingly polished and detailed space. Visual refinements in color, light, and texture, as well as spatial transitions, from entering the outer lobby to taking a seat in the auditorium, prepare the client almost ritualistically for the proper experience of the movie. Regardless of their size, they all share a common trait—the theater experience." And again: "Theo Kalomirakis is the recognized pioneer in the design and development of opulent home theaters; his designs are the gold standard for clients who have the wherewithal, and the space, to dedicate to the ultimate residential cinematic experience"; see www.tktheaters.com.

41. For a discussion of Byzantine thought with regard to icons, see Charles Barber, *Figure and Likeness: On the Limits of Representation in Byzantine Iconoclasm* (Princeton, N.J.: Princeton University Press, 2002), and Marie-José Mondzain, *Image, Icon, Economy: The Byzanthine Origins of the Contemporary Imaginary*, trans. Rico Franses (Stanford: Stanford University Press, 2005). Originally *Image, icône, économie: les sources byzantines de l'imaginaire contemporain* (Paris: Editions du Seuil, 1996).

42. Bissera V. Pentcheva highlights this dialectic between presence and absence in "The Performative Icon," *The Art Bulletin*. 88.4 (December 2006), 631–55. Further remarks in the more recent *The Sensual Icon. Space, Ritual, and The Senses in Byzantium* (University Park: The Pennsylvania State University Press, 2010), 83–88.

43. Ricciotto Canudo, "The Birth of a Sixth Art," in Abel, *French Film Theory and Criticism*, 1:64–65. Originally "La naissance d'un sixiéme art. Essai sur le

Cinématographe," in *Les Entretiens Idéalistes* (October 1911), then in *L'usine aux images* (Paris: Séguier/Arte, 1995).

44. Vachel Lindsay, *The Art of the Moving Picture* (New York: Macmillan, 1922), 289–304; Antonello Gerbi, Iniziazione alle delizie del cinema, 841.

45. Antone de Baecque recognizes this religious basis of French cinephilia: "On a souvent comparé la salle obscure à un temple, et il est vrai que la cinéphilie, même tenue dans le réseaux les plus laïcs, est empreinte d'une grande religiosité dans ses cérémonies." ["The dark cinema has often been compared to a temple, and it is true that cinephilia, although it is carried out in the most secular of spaces, is marked by a great religiosity of its ceremonies."] Antoine de Baecque, *La cinéphilie. Invention d'un regard, histoire d'une culture. 1944–1968* (Paris : Fayard, 2003), 14. See also Antoine De Baecque and Thierry Frémaux, "La Cinéphilie ou l'invention d'une culture," *Vingtième Siècle*, 46 (1995), 133–42.

46. See http://projectcinephilia.mubi.com/. Last accessed October 2013. On the revival of cinephilia, see Marijke de Valck and Malte Hagener, eds., *Cinephilia. Movies, Love and Memory* (Amsterdam: Amsterdam University Press, 2005), and the dossier "Cinephilia. What is Being Fought for by Today's Cinephilia(s)?" in *Framework*, 50 (2009), 176–228. See also Jonathan Rosenbaum and Adrian Martin, eds., *Movie Mutations. The Changing Face of the World Cinephilia* (London: BFI Publishing, 2003), in particular 1–34.

47. Nico Baumbach, "All That Heaven Allows," in *Film Comment* (March 12, 14, and 16, 2012). Baumbach's essay is split into three parts: "What Is, or Was, Cinephilia?" (part one) at http://filmcomment.com/entry/all-that-heaven-allows-what-is-or-was-cinephilia-part-one; "What Is, or Was, Cinephilia?" (part two) at http://filmcomment.com/entry/all-that-heaven-allows-what-is-or-was-cinephilia-part-two-criticism; and "What Is, or Was, Cinephilia?" (part three) at http://filmcomment.com/entry/all-that-heaven-allows-what-is-or-was-cinephilia-part-three-cinephilia. This and the following quotations are in the third part. Last accessed November 2013.

48. André Bazin, "The Ontology of the Photographic Image," in *What Is Cinema? Vol. 1*, trans. Hugh Gray (Berkeley: University of California Press, 1967), 14. Originally "L'ontologie de l'image photographique," in Bazin, *Qu'est ce que le cinéma?* (Paris: Ed. du Cerf, 1958).

49. "Here one should really examine the psychology of relics and souvenirs which likewise enjoy the advantages of a transfer of reality stemming from the 'mummy complex.' Let us merely note in passing that the Holy Shroud of Turin combines the features alike of relic and photograph." Bazin, *The Ontology*, 14.

50. Bazin, *The Ontology*, 15. Bazin follows the sentence saying, "Photography actually contributes something of the order of natural creation instead of providing a substitute for it."

51. Bazin, *The Ontology*, 14.

3. ASSEMBLAGE

1. I am using the term *dispositive* here in order to distance myself from the traditional "theory of the apparatus" and to recuperate those aspects raised by French and Italian scholars on the issue—in particular by Foucault, Deleuze, and Agamben,

who use this term. I am following the suggestion made by Jeffrey Bussolini in his essay, "What Is a Dispositive?" *Foucault Studies*, 10 (November 2010), 85–107, where he offers an analysis of the differences in English, French, and Italian between apparatus/appareil/apparato and dispositive/dispositif/dispositivo. The term *dispositive* is also used in the important volume edited by François Albera and Maria Tortajada, *Cinema Beyond Film* (Amsterdam: Amsterdam University Press, 2010). Also worth noting is that the need to take a distance from the term *apparatus* already emerges in the English translation of Gilles Deleuze's "What Is a *Dispositif?*" in *Two Regimes of Madness: Texts and Interviews 1975–1995* (New York: Semiotext(e), 2006), 338–48. Originally "Qu'est-ce qu'un dispositif?" in *Deux régimes de fous: textes et entretiens 1975–1995* (Paris: Éditions de Minuit, 2003), 316–25. For the theory of the apparatus, see *The Cinematic Apparatus*, ed. Teresa de Lauretis and Stephen Heath (London: MacMillan, 1980), and *Narrative, Apparatus, Ideology*, ed. Philip Rosen (New York: Columbia University Press, 1986).

2. For a short history of the cell phone, see Jon Agar, *Constant Touch* (Cambridge: Icon Books, 2003). Roger Odin has devoted much attention to the cinema made with, and intended to be watched on, mobile phones. See "Spectator, Film and the Mobile Phone" in Ian Christie, ed., *Audience* (Amsterdam: Amsterdam University Press, 2012), 155–69; "Cinéma et téléphone portable. Approche sémio-pragmatique," *Théorème*, 15 (2012); "Quand le téléphone rencontre le cinéma," in Laurence Allard, Laurent Creton, and Roger Odin, eds., *Cinéma et création* (Paris: Armand Colin, 2013).

3. See Philippe-Alain Michaud, "Le mouvement des images," *Mouvement des images/The Movement of Images* (Paris: Centre Pompidou, 2006), 15–30.

4. Many of the following observations are supported by an ethnographic study that I conducted in Italy in fall 2010, together with Sara Sampietro, which had as its object the consumption of cinematic material on the iPhone. The results were published in Francesco Casetti and Sara Sampietro, "With Eyes, with Hands: The Relocation of Cinema into the iPhone," in Pelle Snickars and Patrick Vonderau, eds., *Moving Data: The iPhone and the Future of Media* (New York: Columbia University Press, 2012), 19–32.

5. For a discussion of "bubbles" and "spheres" in general, see Peter Sloterdijk's in-depth study *Bubbles: Spheres Volume I* (Los Angeles: Semiotext(e), 2011). Originally *Sphären, Band I: Blasen* (Frankfurt am Main: Suhrkamp, 1998).

6. As one of the subjects in my ethnographic research reports: "You can stick yourself in a corner of the train with your headphones on: this way you are a little protected." Another says: "Watching movies on the train is also a way of passing the time: if you don't, you end up staring out of the windows for hours, and you get bored." See Casetti and Sampietro, "With Eyes," 24.

7. Michael Bull, "To Each Their Own Bubble: Mobile Spaces of Sound in the City," in Nick Couldry and Anna McCarthy, eds., *MediaSpace: Place, Scale and Culture in a Media Age* (London: Routledge, 2003), 285.

8. Bull, "To Each," 283.

9. For more on this topic, see David Morley, "What's 'Home' Got to Do with It?: Contradictory Dynamics in the Domestication of Technology and the Dislocation of Domesticity," *European Journal of Cultural Studies*, 6.4 (November 2003), 435–58.

10. The spectator's itinerary—from being exposed to the gazes of others when the lights are still on to the progressive level of concentration on the narrated world—is

described well by Erich Feldmann in "Considérations sur la situation du spectateur au cinema," *Revue Internationale de Filmologie*, 26 (1956), 83–97.

11. A comment from the ethnographic research: "If you want, you can even watch something together with someone else. You just have to concentrate on the screen and stay together. I have watched tons of stuff together with my friends." Casetti and Sampietro, "With Eyes," 28.

12. See www.constellation.tv. Last accessed March 2013.

13. Mariagrazia Fanchi, in *Spettatore* (Milan: Il Castoro, 2005), distinguishes between epidermal, multitask, and intimate forms of consumption. The first is characterized by "a mobile and inattentive gaze, bored and fickle" (p. 41). The second consists in "an attentive yet dispersive gaze, which does not concentrate in a single object, but devotes its attention impartially to various elements" (p. 43). Here, the act of vision is woven together with disparate activities (chatting with one's neighbor, monitoring the surrounding space, and so forth). Finally, *intimate* consumption is "an experience centered on the screen, and characterized by an exclusive relationship with the text" (p. 39). Casetti and Sampietro, in "With Eyes," have verified the existence of these three forms of consumption in mobile vision.

14. Lucilla Albano, "Cinema and Psychoanalysis: Across the Dispositifs," *American Imago*, 70.2 (Summer 2013), 191–224.

15. "Any invention or technology is an extension or self-amputation of our physical bodies, and such extension also demands new ratios or new equilibrium among the other organs and extensions of the body." Marshall McLuhan, *Understanding Media: The Extensions of Man* (New York: McGraw-Hill, 1964), 49.

16. François Albera and Maria Tortajada, "Le dispositif n'existe pas," in François Albera and Maria Tortajada, eds., *Ciné-dispositifs* (Lausanne : L'Age d'Homme, 2011), 13–38.

17. Jean-Louis Baudry, "Ideological Effects of the Basic Cinematographic Apparatus," in Philip Rosen, ed., *Narrative, Apparatus, Ideology* (New York: Columbia University Press, 1986), 286–98. Originally "Cinéma: effets idéologiques produits par l'appareil de base," *Cinéthique*, 7–8 (1970), 1–8.

18. Jean-Louis Baudry, "The Apparatus: Metapsychological Approaches to the Impression of Reality in the Cinema," *Camera Obscura*, 1 (Fall 1976), 104–126. Originally "Le Dispositif," *Communications*, 23 (1975), 56–72.

19. It is worthy of attention that Baudry uses the term *appareil* in reference to movie camera and projector and the term *dispositif* in reference to the triad of projector, screen, and darkened theater. But despite the difference in terminology, what Baudry has in mind are two aspects of the same entity.

20. For the "apparatus theory," see Teresa de Lauretis and Stephen Heath, eds., *The Cinematic Apparatus* (London: MacMillan, 1980), and Philip Rosen, ed., *Narrative, Apparatus, Ideology* (New York: Columbia University Press, 1986). Among the various elements that contribute to the "theory of the apparatus," we should not overlook the idea of the "ideological state apparatus." See Louis Althusser, "Ideology and Ideological State Apparatuses," in *Lenin and Philosophy and Other Essays*, trans. Ben Brewster (New York: Monthly Review Press, 1978), 85–126. Originally "Idéologie et appareils idéologiques d'État: Notes pour une recherche," *La Pensée*, 151 (June 1970); reprinted in *Positions (1964–1975)* (Paris: Les Éditions sociales, 1976), 67–125.

21. David Bordwell and Noël Carroll, *Post-theory: Reconstructing Film Studies* (Madison: University of Wisconsin Press, 1996).

22. Christian Metz, *Imaginary Signifier. Psychoanalysis and Cinema* (Bloomington: Indiana University Press, 1982). Originally *Le signifiant imaginaire: Psychanalyse et cinema* (Paris: UGE, 1977).

23. Especially in the field of media there were many contributions that tried to escape such a deterministic orientation. See in particular Raymond Williams, *Television: Technology and Cultural Form* (New York: Schocken Books, 1974). First of all, according to Williams, technology should be viewed in close relation not only to a subject, but also to production processes and social structures—two elements that both influence technology and are influenced by it. Second, technology never offers singular solutions, but rather a series of possibilities, which, in turn, are measured against social and individual needs in a confrontation in which neither side has the last word. Finally, the path that leads to the creation of a technical device is never immediate or linear. On the one hand, it is guided by an idea, based on available possibilities, but on the other hand, it depends on political and social contingencies, which bring to the fore different priorities.

24. Jonathan Crary, *Techniques of the Observer: On Vision and Modernity in the Nineteenth Century* (Cambridge, Mass.: MIT Press, 1990).

25. Rosalind Krauss, *Voyage on the North Sea: Art in the Age of the Post-Medium Condition* (New York: Thames & Hudson, 2000).

26. Krauss, *Voyage*, 44.

27. Giorgio Agamben, *What Is an Apparatus?* (Stanford: Stanford University Press, 2009). Originally *Che cos'è un dispositivo?* (Rome: Nottetempo, 2006). The translation of Agamben's book adopts "apparatus" as more respectful of the tradition in the English-speaking debate, but it misses the differences that Agamben puts forward with the framework of the "apparatus theory."

28. Agamben, *Apparatus*, 12.

29. Ibid., 15.

30. Ibid., 20.

31. Agamben argues against the idea of the "correct use" of a device. If "correct use" signifies the facile release from the enslaving chains of a device, he is quite right. However, if it means that it is impossible for the subject to move outside of the position assigned to her, then he has fallen into a contradiction. Who could possibly "profane" a device if it entirely generates its subject? Is profanation introduced by the device itself, thereby neutralizing itself? Or by a non-human agent—which is for sure a possibility? Or is it introduced by a mythical, nonsubjugated individual—let's say, a philosopher without a cell phone?

32. See Giorgio Agamben, "In Praise of Profanation," in *Profanations* (New York: Zone Books, 2007), 73–92. Originally "Elogio della profanazione," in *Profanazione* (Rome: Nottetempo, 2005), 83–106.

33. Deleuze, "What Is a Dispositif?" in *Two Regimes of Madness*.

34. Ibid., 338.

35. Ibid., 345.

36. Ibid., 345.

37. Ibid., 342.

38. Gilles Deleuze, "Eight Years Later: 1980 Interview," in *Two Regimes of Madness*, 179. Originally "Huit ans après: entretien 80," in *Deux régimes de fous*, 162–66.

39. Roberto De Gaetano, "Dispositivi, concatenamenti, incontri," in *La potenza delle immagini: Il cinema, la forma e le forze* (Pisa: ETS, 2012), 181–89.

40. François Albera and Maria Tortajada, *Cinema Beyond Film*. See especially "Introduction to an Epistemology of Viewing and Listening Dispositives" (pp. 9–22) and "The 1900 Episteme" (pp. 25–44). See also *Ciné-dispositifs*, ed. Albera and Tortajada (Lausanne: L'Age d'Homme, 2011), especially "Le dispositif n'existe pas."

41. For an analysis of the cinematic dispositive in terms of aggregate and focused on the current changes, see Thomas Elsaesser, "Entre savoir et croire: le dispositif cinématographique après le cinéma," in Albera and Tortajada, *Ciné-dispositifs*, 39–74.

42. See André Bazin, "The Ontology of Photographic Image" and "The Myth of Total Cinema," in *What Is Cinema?* Ed. and trans. Hugh Gray, 2 vols. (Berkeley: University of California Press, 1967), 1:9–16 and 1:17–22.

43. Edgar Morin, *Cinema, or the Imaginary Man*, trans. Lorraine Mortimer (Minneapolis: University of Minnesota Press, 2005). Originally *Le cinéma ou l'homme imaginaire* (Paris: Éditions de Minuit, 1956).

44. On the process of de-territorialization and re-territorialization, see Gilles Deleuze and Felix Guattari, *Anti-Oedipus: Capitalism and Schizophrenia* (New York: Viking Press, 1977). Originally *L'Anti-Oedipe* (Paris: Minuit, 1972), 291 and 306–307.

45. On the processes of negotiation in the field of media, and on the structure of the cinema as a machine of negotiation, see Francesco Casetti, *Communicative Negotiations in Cinema and Television* (Milan: VeP, 2001), and *Eye of the Century* (New York: Columbia University Press, 2008).

46. Edgar Morin, "Recherches sur le public cinématographique," *Revue Internationale de Filmologie*, 12.4 (January–March 1953), 3–19.

47. On this "suture," see Jean Pierre Oudart, "Cinema and Suture," *Screen*, 18 (Winter 1977–78), 35–47. Originally "La suture," *Cahiers du Cinéma*, 211 (1969); see also "La suture II," *Cahiers du Cinéma*, 212 (1969), and "L'effet de réel," *Cahiers du cinéma*, 228 (1971), 19–26. See also Stephen Heath, "Notes on Suture," *Screen*, 18 (Winter 1977–78), 66–76.

48. See Albert Michotte, "Le caractére de 'réalité' des projections cinematographiques," *Revue Internationale de Filmologie*, 3–4 (1948), 249–61.

49. Stanley Cavell, *The World Viewed* (New York: Viking Press, 1971).

50. Albera and Tortajada write of a "notion clé" that frames both the basic elements and the concepts that these draw attention to. See "Le dispositive n'existe pas," 27.

51. Bruno Latour, *Reassembling the Social. An Introduction to Actor-Network-Theory* (New York: Oxford University Press, 2005).

52. The dream that media and especially new media are intrinsically emancipatory affects also Hans Magnus Enzesbergerger's "Constituents of a Theory of the Media," *New Left Review*, 64 (1970), 13–36, especially in the section "Democratic Manipulation." See also an interesting note by Félix Guattari, "Towards a Post-Media Era," in Clemens Apprich, Josephine Berry Slater, Antony Iles, and Oliver Lerone Schultz, eds., *Provocative Alloys: a Post-Media Anthology* (Mute-Posty Media Lab, 2013), 26–27.

53. We can also say that spectators look for an increasing emancipation from the "machine," but at the same time technology progressively continues to "innervate"

them. On innervation, see Walter Benjamin, "The Work of Art in the Age of Its Technological Reproducibility. Second Version," in Michael W. Jennings, Brigid Doherty, and Thomas Y. Levin, eds., *Work of Art in the Age of Its Technological Reproducibility, and Other Writings on Media* (Cambridge, Mass.: Belknap Press of Harvard University Press, 2008), 19–55.

54. "Une seule chose est sure: le cinéma vivra en tant qu'il y aura des films produits pour être projetés ou montrés en salle." ["One single thing is certain: cinema will live as long as there are films produced to be projected or shown in cinemas."] And moreover: "Le dispositif de projection est la seule évidence permettant, depuis toujours, mais d'autant plus en ces temps de mélange et de crise larvée, de spécifier le cinéma comme tel à l'intérieur de la sphère de jour en jour plus vaste des images en mouvement et des innombrables dispositifs propres à les accueillir." ["For a long time, but even more in these times of mixing and of incipient crisis, the projector is the only evidence that allows us to define cinema as such, within an ever-growing sphere of moving images and innumerable particular apparatuses that host them."] Raymond Bellour, *La Querelle des dispositifs* (Paris: POL, 2012), 19 and 33.

55. "Du cinéma hors la salle, hors les murs, hors 'le' dispositif. Fini le noir, les sièges, le silence, la durée impose. Démultiplication folle des formes de présence de l'image lumineuse en mouvement. La pellicule n'est plus le critère, ni la sale, ni l'écran unique, ni la projection, ni mêmes les spectateurs. Oui, c'est du cinéma." ["Cinema outside of the theater, outside of walls, outside of 'the' apparatus. Gone is the darkness, the seats, the silents, the imposed duration. Mad proliferation of the luminous and moving image's forms of presence. Film is no longer the criterion, nor is the theater, or the single screen, or the projection, or even the spectators. Yes, that's cinema."] Philippe Dubois, "Introduction," in Philippe Dubois, Lucia Ramos Monteiro, and Alessandro Bordina, eds., *Oui, C'est du Cinéma* (Paisan di Prato: Campanotto, 2009), 7.

56. On grassroots practices, useful examples are given in Chuck Tryon, *Reinventing Cinema: Movies in the Age of Media Convergence* (New Brunswick, N.J.: Rutgers University Press, 2009). An analysis of the mash-up practices is given in Stefan Sonvilla Weiss, *Mashup Cultures* (Wien: Springer Verlag-Vienna, 2010). Useful observations occur in Pelle Snickars and Patrick Vonderau, eds., *The YouTube Reader* (Stockholm: National Library of Sweden, 2009).

57. Putting grassroots practices and the idea of profanation side by side can be useful to avoid the weakness of sociological approaches, which look at the former, and in general at the practices of appropriation, as an action by a free subject "on" a dispositive and not "from inside" it. Such an approach erases the fact that a reconquest is taking place within a forest of intersecting determinations. The idea of profanation can restore to grassroots practices their true profile.

58. See Agamben, "In Praise of Profanation." Agamben, however, also suggests that playful emptying out has now become a widespread practice in capitalistic processes, and this therefore renders profanation increasingly difficult.

59. On *Zen for Film* and in general on Fluxfilms, see Bruce Jenkins, "Fluxfilms in Three False Starts," in Janet Jenkins, ed., *In the Spirit of Fluxus* (Minneapolis: Walker Art Center, 1993), reprinted in Tanya Leighton, ed., *Art and the Moving Image. A Critical Reader* (London: Tale and Afterall, 2008), 53–71.

60. On Carolee Schneeman and Valie Export, see Pamela Lee, "Bare Lives," in Leighton, *Art*, 141–57.

61. On Exploding Plastic Inevitable, see the accurate reconstruction by Branden W. Joseph, "My Mind Split Open. Andy Warhol's Exploding Plastic Inevitable," *Greyroom*, 8 (2002), 80–107.

62. Valie Export, "Expanded Cinema as Expanded Reality," in *Senses of Cinema*, 28 (2003), available at http://sensesofcinema.com/2003/28/expanded_cinema/.

63. On bricolage, see the pages by Claude Levi-Strauss in *The Savage Mind* (Chicago: University of Chicago Press, 1966), in particular pp. 15–30. Originally *Le pensée sauvage* (Paris: Plon, 1962).

64. Raymond Bellour, in *La querelle des dispositifs*, reconstructs in a masterly way this landscape.

65. László Moholy-Nagy, *Painting, Photography, Film* (Cambridge, Mass.: MIT Press, 1969), 41. Originally *Malerei Photografie Film* (Munich: Albert Langen, 1925). Moholy-Nagy called the experiment "simultaneous or poly-cinema."

66. Moholy-Nagy, *Painting*, 26.

67. Oskar Schlemmer, László Moholy-Nagy, and Farkas Molnár, *The Theater of the Bauhaus* (Middletown, Conn.: Wesleyan University Press, 1961).

68. László Moholy-Nagy, *The New Vision: Fundamentals of Design, Painting, Sculpture, Architecture* (New York: W. W. Norton, 1938; reprinted New York: Wittemborn, 1947), pp. 50–51 for the projections of light and pp. 83–86 for painting with light. Originally "Von Material zu Architektur," *Bauhaus Buch* (Munich: Langen, 1929), 14.

69. Velimir Khlebnikov, "The Radio of the Future," in *The King of Time*, trans. Paul Schmidt (Cambridge, Mass.: Harvard University Press, 1985), 155–59.

70. Sergei Eisenstein, "The Dynamic Square," in Jay Leyda, ed., *Film Essays, with a Lecture* (New York: Praeger, 1970), 48–65.

71. See Sergei Eisenstein, *Glass House*, ed. François Albera (Dijon: Les Presses du Réel, 2009). For a detailed analysis of the project, see Antonio Somaini, *Ejzenstejn* (Turin: Einaudi, 2011), 101–108.

72. "There are frames for which the entire screen assumes a distressing Saharian vastness, while for others it is restricted: the former want to be enclosed in an intimate framing, while the latter would like to be projected beyond the walls of the theater or descend, descend to the feet of the spectators." Enrico Toddi, "Rettangolo-Film (25 × 19)," *In penombra*, 1.3 (August 25, 1918), 121–23.

73. Karel Teige, "The Aesthetics of Film and Cinégraphie," in Jaroslav Andel and Petr Szczepanik, eds., *Cinema All the Time: An Anthology of Czech Film Theory and Criticism* (Prague, National Film Archive, 2008), 145–54. Originally "Estetikafilmu a kinografie," *Host*, 3.6–7 (April 1924), 143–52.

74. Roger Odin, *Cinéma et production de sens* (Paris: Armand Colin, 1990).

75. Raymond Bellour, *L'Entre-Images: photo, cinéma, vidéo* (Paris: La Différence, 1990), and *L'Entre-Images 2: mots, images* (Paris: P.O.L., 1999); see also *La Querelle des dispositifs*.

76. See, in particular, Raymond Bellour, "An Other Cinema," in Tanya Leighton, ed., *Art and the Moving Image: A Critical Reader* (London: Tate Publishing-Afterall, 2008), 406–422.

77. Thomas Elsaesser speaks of a "gray zone" in "Entre savoir et croire," 65.

78. Of course, there is no shortage of gestures aimed at a total break, rather than at conciliation. Many film and video artists of the 1970s were moved by an antagonistic spirit: for them, "other" meant "no longer cinema." Nevertheless, it is no coincidence

that the essay that best captured the sense of these artistic experiments, *Expanded Cinema* by Gene Youngblood, imagined those new territories precisely as an "expansion" rather than as an "alternative." For Youngblood—who was more attentive to the role of cinema in the media system than to questions of style—"other" meant "even more." See Gene Youngblood, *Expanded Cinema* (New York: Dutton, 1970).

4. EXPANSION

1. Since January 2012, the "Director's cut" has also been viewable on YouTube (www.youtube.com/watch?v=7ezeYJUz-84) and Vimeo (www.vimeo.com/34948855).

2. Gene Youngblood, *Expanded Cinema* (New York: Dutton, 1970).

3. "A whole new area of film and film-like art has appeared in the sixties: *expanded cinema*. Expanded cinema is not the name of a particular style of film-making. It is the name for a spirit of inquiry that is leading in many different directions. It is cinema expanded to include many different projectors in the showing of one work. It is cinema expanded to include computer-generated images and electronic manipulation of images on television. It is cinema expanded to the point at which the effect of film may be produced without the use of film at all." Sheldon Renan, *An Introduction to the American Underground Film* (New York: Dutton, 1967), 227. For a recent reconsideration of the expanded cinema, see David Curtis, A. L. Rees, Duncan White, and Steven Ball, eds., *Expanded Cinema: Art, Performance, Film* (London: Tate Publishing, 2011).

4. "What happens to our definition of 'intelligence' when computers, as an extension of the human brain, are the same size, weight and cost as transistor radios?" But also: "What happens to our definition of 'man' when our next door neighbor is a cyborg (a man with inorganic parts)?" Youngblood, *Expanded Cinema*, 52. For Youngblood, the same questions could be asked of the concepts of morality, creativity, family, and progress.

5. Youngblood, *Expanded Cinema*, 58.

6. Ibid., 76–77.

7. Ibid., 130.

8. Ibid., 65.

9. Ibid., 135.

10. Ibid., 189.

11. Ibid., 419.

12. An interesting re-reading of Youngblood's book is in Volker Pantemburg, "1970 and Beyond," in Gertrud Koch, Volker Pantemburg, and Simon Rothöler, eds., *Screen Dynamics: Mapping the Borders of Cinema* (Vienna: Sinema, 2012), 78–92.

13. I borrow the idea of "light cinema" from Paola Voci, who connects it in particular with the small-screen practices: see Paola Voci, *China on Video: Smaller-Screen Realities* (London: Routledge, 2010), in particular pp. 179–187. See also Paola Voci, "Online Small-Screen Cinema: The Cinema of Attractions and the Emancipated Spectator," in Carlos Rojas and Eileen Chow, eds., *The Oxford Handbook of Chinese Cinemas* (Oxford: Oxford University Press, 2013), 377–97.

14. Henry Jenkins, *Textual Poachers: Television Fans and Participatory Culture* (New York: Routledge, 1992), and *Fans, Bloggers, Gamers: Exploring Participatory Culture* (New York: NYU Press, 2006).

15. See, for example, www.youtube.com/user/TrailerWars.

16. Chuck Tryon, *Reinventing Cinema: Movies in the Age of Media Convergence* (New Brunswick, N.J.: Rutgers University Press, 2009), 149.

17. Jonathan Gray, *Show Sold Separately: Promos, Spoilers, and Other Media Paratexts* (New York: NYU Press, 2010), 20. Gray's book focuses on "how hype, synergy, promos, narrative extensions, and various forms of related textuality position, define, and create meaning for film and television" (p. 3).

18. John T. Caldwell, "Hive-Sourcing Is the New Out-Sourcing: Studying Old (Industrial) Labor Habits in New (Consumer) Labor Clothes," *Cinema Journal*, 49.1 (Fall 2009), 160–67. Chuck Tryon, too, writes of "studio appropriation of movie remixes" in *Reinventing Cinema* (p. 171). These positions stand in contrast to Henry Jenkins's idea of a conflict between the two dimensions, according to which grassroots production follows a logic of participatory culture, while Hollywood follows the logic of convergence culture. See Henry Jenkins, "Quentin Tarantino's Star Wars?: Digital Cinema, Media Convergence, and Participatory Culture," in Meenakshi Gigi Durham and Douglas M. Kellner, eds., *Media and Cultural Studies* (New York: Wiley-Blackwell, 2012), 549–76.

19. Henry Jenkins, "Transmedia Story-telling 101," March 22, 2007, available at http://henryjenkins.org/2007/03/transmedia_storytelling_101.html. Jenkins's analysis starts with "Searching for the Origami Unicorn: The Matrix and Transmedia Storytelling," in *Convergence Culture: Where Old and New Media Collide* (New York: NYU Press, 2006), 93–130, and continues with "The Revenge of the Origami Unicorn: Seven Principles of Transmedia Storytelling" at http://henryjenkins.org/2009/12/the_revenge_of_the_origami_uni.html (first part); http://henryjenkins.org/2009/12/revenge_of_the_origami_unicorn.html (second part).

20. The Web site http://disney.go.com/pirates is exemplary, as it refers, one after the other, to movies, television, music, videos, live events, games, books, theme park and travels, and a store.

21. Jenkins, "Origami Unicorn," 95.

22. Ibid., 95.

23. Chuck Tryon, "Toppling the Gates: Blogging as Networked Film Criticism," in *Reinventing the Cinema,* 125–48.

24. Christian Metz, *The Imaginary Signifier: Psychoanalysis and Cinema* (Bloomington: Indiana University Press, 1982), 3–16. Originally *Le significant imaginaire: Psychanalyse et cinéma* (Paris: UGD, 1977), 9–25.

25. On the advent of digital, see W. J. T. Mitchell, *The Reconfigured Eye: Visual Truth in the Post Photographic Era* (Cambridge, Mass.: MIT Press, 1992), and Thomas Elsaesser, "Digital Cinema: Delivery, Event, Time," in Thomas Elsaesser and Kay Hoffman, eds., *Cinema Futures: Cain, Abel, or Cable. The Screen Arts in the Digital Age* (Amsterdam: Amsterdam University Press, 1998), 201–222. See also the counterevidence offered by John Belton, "Digital Cinema: A False Revolution," *October*, no. 100 (Spring 2002), 98–114.

26. David Rodowick, *The Virtual Life of Film* (Cambridge, Mass.: Harvard University Press, 2007).

27. Lev Manovich, *The Language of New Media* (Cambridge, Mass.: MIT Press, 2002).

28. Tom Gunning, "The Sum of Its Pixels," *Film Comment*, 43.5 (September–October 2007), 78; and "Moving Away from the Index: Cinema and the Impression of Reality," *differences*, 18.1 (2007), 29–52. In: "Sutured Reality: Film, from Photographic to Digital," *October*, no. 138 (Fall 2011), 95–106, I have suggested that the impression of reality relies on four components: the indexicality of the sign, the verisimilitude of the content, the veridiction (telling-as-true) by the author, and the trust of the audience.

29. Stephen Prince, "True Lies: Perceptual Realism, Digital Images, and Film Theory," *Film Quarterly*, 49.3 (Spring 1996), 27–37.

30. It is no coincidence that the term *expansion* is used to designate also this kind of emigration. See, for example, *Fluid Screens, Expanded Cinema*, ed. Jeanne Marchessault and Susan Lord (Toronto: University of Toronto Press, 2007).

31. For Serge Daney, where the *visual* is characterized by the indistinct, while the *image*—which is typical of cinema—brings difference with it: "The visual, then, is the optical verification that things are functioning on a purely technical level: there are no reverse shots, nothing is missing, everything is sealed in a closed circuit, rather like the pornographic spectacle which is no more than the ecstatic verification that the organs are functioning. The opposite would be true for the image—the image that we have adored at the cinema to the point of obscenity. The image always occurs on the border between two force fields; its purpose is to testify to a certain alterity, and although the core is always there, something is always missing. The image is always both more and less than itself." Serge Daney, "Montage obligé. La guerre, le Golfe et le petit écran," in *Devant la recrudescence des vols de sacs à main: cinéma, télévision, information (1988–1991)* (Lyon: Aléas, 1991), 163.

32. See www.labiennale.org/en/cinema/70th-festival/.

33. See www.cinematheque.fr/fr/musee-collections/musee/the-museum.html.

34. *The Academy Museum of Motion Pictures* (Beverly Hills: Academy of Motion Picture Arts and Sciences, 2013), 8–9. Available at www.oscars.org/academymuseum/brochure/index.html.

35. See www.filmarchive.org.nz/.

36. See www.criterion.com/library.

37. See www.imdb.com/.

38. Marshall McLuhan, *Understanding Media: The Extensions of Man* (New York: McGraw-Hill, 1964).

39. McLuhan, *Understanding*, 23.

40. Ibid., 288.

41. "Typographic man took readily to film just because, like books, it offers an inward world of fantasy and dreams," McLuhan, *Understanding*, 292.

42. "The giving to man an eye for an ear by phonetic literacy is, socially and politically, probably the most radical explosion that can occur in any social structure. This explosion of the eye, frequently repeated in 'backward areas,' we call Westernisation." McLuhan, *Understanding*, 55.

43. Ibid., 291.

44. Jean Epstein, "Magnification," in Richard Abel, ed., *French Film Theory and Criticism: A History/Anthology, 1907–1939*, 2 vols. (Princeton, N.J.: Princeton University Press, 1988), 1:235.

45. Béla Balázs, *Visible Man, Or the Culture of Film*, in *Béla Balázs: Early Film Theory*, ed. Erica Carter (New York: Berghahn Books, 2010), 39.

46. Giovanni Papini, "Philosophical Observations on the Motion Picture," *La Stampa* (May 18, 1907), 1–2.

47. Ricciotto Canudo, "The Birth of a Sixth Art," in Abel, *French Film Theory*, 61.

48. John Belton, *Widescreen Cinema* (Cambridge, Mass.: Harvard University Press, 1992).

49. Sergei Eisenstein, "About Stereoscopic Cinema," *The Penguin Film Review*, 8 (January 1949), 37.

50. Ibid., 39.

51. Ibid., 38.

52. Miriam Ross, "The 3-D Aesthetic: Avatar and Hyperhaptic Visuality," *Screen*, 53.4 (Winter 2012), 381–97.

53. See Thomas Elsaesser, "Il ritorno del 3-D: Logica e Genealogie dell'Immagine del XXI Secolo," *Imago*, 3.1 (2011), 49–68.

54. Eisenstein, "Stereoscopic Cinema." 41ff.

55. Hito Steyerl, "In Defense of the Poor Image," *e-flux* 11 (2009), available at www.e-flux.com/journal/view/94, then in *The Wretched of the Screen* (Berlin: Sternberg Press, 2012), 31–45; quote p. 32.

56. "The past mechanical time was hot, and we of the TV age are cool." McLuhan, *Understanding*, 27.

57. Ibid., 293.

58. "The principle that during the stages of their development all things appear under form opposite to those that they finally present is an ancient doctrine." McLuhan, *Understanding*, 34.

59. Ibid., 53.

60. Ibid., 48.

61. "In the physical stress of superstimulation of various kinds, the central nervous system acts to protect itself by a strategy of amputation or isolation of the offending organ, sense or function." McLuhan, *Understanding*, 46.

62. Ibid., 55.

63. On Farocki, see the excellent *Harun Farocki: Working on the Sightlines*, ed. Thomas Elsaesser (Amsterdam: Amsterdam University Press, 2004); in particular, my argument is akin to Christa Blumingler's essay "Harun Farocki: Critical Strategies," in *Harun Farocki*, pp. 315–22.

64. We should recall that these were remade by De Palma because of the impossibility of using ones found online or taken from the soldiers, but the difference in image quality is respected.

65. Jean Epstein, "The Senses 1(b)," in Abel, *French Film Theory*, 244. Originally "Le Sens 1 bis," in *Bonjour Cinéma* (Paris: Editions de la Siréne, 1921), 27–44.

66. The concept of "reality effect" has largely been discussed in film studies. Nevertheless, it could be useful to recall that its roots are in research on the perception of filmic images and on the sensorial density (we may say: the "high definition") that they possess compared with other kinds of images. See Albert Michotte, "Le caractére de 'réalité' des projections cinematographiques," *Revue Internationale de Filmologie*, 3–4 (1948): 249–61.

67. Georges Didi-Huberman, *Images in Spite of All: Four Photographs from Auschwitz*, trans. Shane B. Lillis (Chicago: The University of Chicago Press, 2008). Originally *Images malgré tout* (Paris: Minuit, 2003).

68. In the same year as *Zero Dark Thirty*, a film with an extremely suggestive title, *End of Watch* (David Ayer, USA, 2012), was also released: The film is largely made up of video footage shot on a hand-held camera by one of the protagonists, but the effect is purely superficial, without any sense of self-reflexivity.

69. See www.youtube.com/watch?annotation_id=annotation_443208&feature=iv&src_vid=RBaKqOMGPWc&v=eUTtt14G31c.

70. See www.youtube.com/watch?v=RBaKqOMGPWc.

71. "I call the distribution of sensible the system of self-evident facts of senses perception that simultaneously discloses the existence of something in common and the delimitations that define the respective parts and positions within it." Jacques Rancière, *The Politics of Aesthetics: The Distribution of the Sensible* (New York: Continuum, 2004), 12. Originally *Le partage du sensible* (Paris: Fabrique, 2000).

72. Giovanni Fossi, in 1907, in one of the first essays dedicated to the cinematic public, noted: "It is, in sum, a bit of democracy that is spread in customs. Or better, it is the new custom, the new invention, that invites the spread of the democratic spirit." Giovanni Fossi, "Il pubblico del cinematografo," *Il Secolo Illustrato* (Milan), March 27, 1908; later in *La Rivista Fono-Cinematografica*, February 11, 1908, p. 20.

73. In his 1907 description of a film screening, the journalist Angiolo Orvieto observed: "From every point in the room, one must be able to see well, equally well, the entire scene." Angiolo Orvieto, "Spettacoli estivi: il cinematografo," *Corriere della Sera* (Milan), no. 228 (August 21, 1907); now also in: *Cinema/Studio* 4.4–16 (April–December 1994), 18–21.

74. Jacques Rancière, *The Future of the Image*, trans. Gregory Elliot (London: Verso, 2007), 43. Originally *Le destin des images* (Paris: Fabrique, 2003).

75. Ibid., 45.

76. Ibid., 45. The solution, for Rancière, would be to find an ordering principle that is not imposed, but rather allows for a rearticulation of the territory. This ordering principle is offered by montage: Beyond its application to cinema, montage presents itself "as a measure of that which is measureless or as a disciplining of chaos." Ibid., 48.

77. See Rancière on the naked image, the ostensive image, and the metamorphic image; *The Future*, 22–29.

78. It is worthy of attention that the distinction between *hot* and *cool* allows McLuhan to evaluate also the social and political weight of various media. He demonstrates that hot media of the mechanical era tend to favor the diffusion of professional specialization, logical-linear thinking, individualism, nationalism, and detribalization of culture, while cool media of the electronic age tend instead to favor a return to forms of knowledge that are integral, nonlinear, and simultaneous, as well as a return to a renovated unity of social community and new forms of tribalism. See McLuhan, *Understanding*, 27ff.

79. On the amateur film in *Muriel*, see Roger Odin, "Le film de famille dans l'institution familiale," in Roger Odin, ed., *Le film de famille, usage privé, usage public* (Paris: Méridiens-Klincksieck, 1995), 27–42.

80. On this presumption, see Franco Marineo, "Il cinema nell'era dell'intermedialità. Redacted di Brian De Palma," in Gianni Canova, ed., *Drammaturgie multimediali. Media e forme narrative nell'epoca della riproducibilità digitale* (Milan: Unicopli, 2009), 11–22.

5. HYPERTOPIA

1. For more on the mega-screen in Piazza del Duomo, see Miriam De Rosa and Glenda Franchin, "Forme dell'abitare. Pratiche di tracciabilità tra mondo e reale," *Comunicazioni sociali online* 1 (2009), available at http://comunicazionisocialionline.it/2009/issue/.

2. It is no coincidence that for special public events, sporting events in particular, a smaller screen is temporarily erected in the same spot, which briefly transforms the square into an enormous stage.

3. "Public events now occur, simultaneously, in two different places: the place of the event itself and that in which it is watched and heard. Broadcasting mediates *between* these two sites." Paddy Scannel, *Radio, Television and Modern Life. A Phenomenological Approach* (Oxford: Blackwell, 1996), 76. See also Shaun Moores, "The Doubling of Place: Electronic Media, Time-Space Arrangements and Social Relationships," in Nick Couldry and Anna McCarthy, eds., *Media Space: Place, Scale and Culture in a Media Age* (London: Routledge, 2004), 21–37. On how television merges spaces, see Joshua Meyrowitz, *No Sense of Place* (New York: Oxford University Press, 1985).

4. Henri Lefebvre, *The Production of Space* (Oxford: Blackwell, 1991). Originally *La production de l'espace* (Paris: Editions Anthropos, 1974).

5. Arjun Appadurai, "The Production of Locality," in *Modernity at Large: Cultural Dimensions of Globalization* (Minneapolis: University of Minnesota Press, 1996), 178–99.

6. Michel de Certeau, "Walking in the City," "Railway Navigation and Incarceration," and "Spatial Stories," in *Practice of Everyday Life* (Berkeley: University of California Press, 1984), 91–130. Originally "Marches dans la ville," "Naval et carcéral," and "Récits d'espace," in *L'invention du quotidien* (Paris: Union générale d'éditions, 1980).

7. See in particular de Certeau, *Practice*, 117ff. To him, a place is "the order (of whatever kind) in accord with which elements are distributed in relationship of coexistence," which is to say, a simply topological structure; while space "occurs as the effect produced by the operations that orient it, situate it, temporalize it, and make it function in a polyvalent unity of conflictual programs or contractual proximities. . . . In short, space is a practiced place."

8. On the construction of space as a speech act or as an act of enunciation, see de Certeau, *Practice*, 97ff.

9. Ben Singer, "Early Home Cinema and the Edison Home Projecting Kinetoscope," *Film History*, 2.1 (Winter 1988), 37–69.

10. Barbara Klinger, *Beyond the Multiplex. Cinema, the New Technologies, and the Home* (Berkeley: University of California Press, 2006), in particular, pp. 17–53.

11. Maeve Connolly, "Temporality, Sociality, Publicness: Cinema as Art Project," *Afterall*, 29 (Spring 2012), 4–15.

12. Connolly, "Temporality," 15.

13. Mary Ann Doane, "Scale and the Negotiation of 'Real' and 'Unreal' Space in the Cinema," in Lúcia Nagib and Cecília Mello, eds., *Realism and the Audiovisual Media* (New York: Palgrave Macmillan, 2009), 63. On the scale of the screen, see also Haidee Wasson, "The Networked Screen: Moving Images, Materiality, and the Aesthetics of Size," in Jeanne Marchessault and Susan Lord, eds., *Fluid Screens, Expanded Cinema* (Toronto: University of Toronto Press, 2007), 74–95.

14. Erkki Huhtamo, "Messages on the Wall. An Archaeology of Public Media Displays," in Scott McQuire, Meredith Martin, and Sabine Niederereds, eds., *Urban Screen Reader* (Amsterdam: Institute of Network Cultures, 2009), 15–28.

15. "[The process of gulliverisation is] a two-directional optical and cultural mechanism that worked against the idea of a common anthropomorphic scale." Huhtamo, "Messages," 20.

16. See Thomas Y. Levin, "Rhetoric of the Temporal Index: Surveillant Narration and the Cinema of 'Real Time,' " in *CTRL [SPACE]: Rhetorics of Surveillance from Bentham to Big Brother* (Cambridge, Mass.: MIT Press, 2002), 578–93. An interesting parallel between three old media for different reasons akin to cinema—photography, the phonograph, and the telephone—and the new media as devices for surveillance is Josh Lauer, "Surveillance History and the History of New Media: an Evidential Paradigm," *New Media and Society*, 14.4 (2012), 566–82.

17. Barbara Klinger, *Beyond the Multiplex*, 37.

18. In 2013, the chain AMC Theaters replaced the old seats with what it called "plush power recliners," openly to compete with the home theaters placed in living rooms and bedrooms. See the description of the new film theaters in "The Screen Is Silver, but the Seats Are Gold. AMC Theaters Lure Moviegoers With Cushy Recliners," *New York Times*, October 18, 2013, available at www.nytimes.com/2013/10/18/movies/amc-theaters-lure-moviegoers-with-cushy-recliners.html?_r=0. Last accessed October 2013.

19. See the idea of a "sociality at large" in Scott McQuire, "The Politics of Public Space in the Media City," in *First Monday. An Electronic Journal*, 4 (February 2006), special issue "Urban Screens," available at http://firstmonday.org/htbin/cgiwrap/bin/ojs/index.php/fm/article/view/1544/1459.

20. See an interesting description of such a situation in the account that Ryan Lambie gives of an in-flight vision: "Blissfully unaware of its content, I chose *The Disappearance of Alice Creed* as my in-journey entertainment, only to discover that its protagonist, played by Gemma Arterton, spends much of the movie naked, handcuffed, and screaming for help. I was travelling alone, and the person sitting next to me was a lady who I was convinced would look over at what I was watching at any moment and think I was some sort of sociopath. On arriving at yet another scene of nudity and screaming, my nerve left me and I put *Iron Man 2* on instead. It wasn't very good, but it was better, I thought, than sitting in fear of what the person sitting next to me might think." "The Weird Experience of Watching Movies on Planes," available at www.denofgeek.us/movies/21761/the-weird-experience-of-watching-movies-on-planes.

21. Anne Friedberg, "The End of Cinema: Multimedia and Technological Change," in Christine Gledhill and Linda Williams, eds., *Reinventing Film Studies* (London: Arnold, 2000), 438–52.

22. Laura Mulvey, *Death 24x a Second* (London: Reaktion Books, 2006).

23. Boris Groys, "Iconoclasm as an Artistic Device. Iconoclastic Strategies in Film," in *Art Power* (Cambridge, Mass.: MIT Press, 2008), 67–81.

24. On the film spectator as a flaneur, see Anne Friedberg, *Windows Shopping* (Berkeley: University of California Press, 1993), and Giuliana Bruno, *Streetwalking on a Ruined Map* (Princeton, N.J.: Princeton University Press, 1993), and *Atlas of Emotion* (London: Verso, 2002).

25. I take here the concept of environment as parallel to the *Umwelt*: see Jacob von Uexküll, *Umwelt und Innenwelt der Tiere* (Berlin: Springer, 1909).

26. To understand the nature of cinema as an occurrence in its early years, it is enough to read the great texts of Jean Epstein from the first half of the 1920s.

27. Victor Burgin, *The Remembered Film* (London: Reaktion Books, 2006), 8–9.

28. Victor Burgin, *In/different Spaces: Place and Memory in Visual Culture* (Berkeley: University of California Press, 1996), 22.

29. "Collecting such metonymic fragments in memory, we may come familiar with a film we have not actually seen." Burgin, *In/different Spaces*, 23.

30. Eric Feldmann, "Considérations sur la situation du spectateur au cinéma," *Revue Internationale de Filmologie*, 26 (1956), 83–97.

31. Antonello Gerbi, "Iniziazione alle delizie del cinema," *Il Convegno*, 7.11–12 (November 25, 1926), 836–48; Roland Barthes, "Leaving the Movie Theater," in *The Rustle of Language*, trans. Richard Howard (Berkeley: University of California Press, 1986), 345–49. Originally "En sortant du cinéma," *Communications*, 23 (1975); reprinted in *Le bruissement de la langue: essais critiques IV* (Paris: Seuil, 1984), 407–412.

32. See also "The Delights of the Cinema Begin Immediately After Buying Your Ticket," Gerbi, *Iniziazione*, 836.

33. Feldmann, "Considérations," 90.

34. Ibid., 91.

35. "Moviegoers are clients of trades people; they are members of the audience and at the same time members of the group in which they find themselves; but they are not spectators in the true sense of the word, until the representation begins." Feldmann, "Considérations," 37.

36. Ibid., 91. The mechanism of projection-identification as constituent of participation and as belonging to film at all levels is analyzed in Edgar Morin's important volume *Cinema, or, the Imaginary Man* (Minneapolis: University of Minnesota Press, 2005). Originally *Le cinéma ou l'homme imaginaire. Essai d'anthropologie sociologique* (Paris: Éditions de Minuit, 1956). Morin's work is quite close to Feldmann's study, and it was published in the same year.

37. Feldmann, "Considérations," 92. Stanley Cavell, in analyzing the situation of the theater spectator, reaches the same conclusion: The "catharsis" is not triggered by a full identification with the destiny of a character, but on the contrary by the impossibility of intervening on this destiny. Stanley Cavell, "The Avoidance of Love. A Reading of King Lear," in *Must We Mean What We Say?* (Cambridge: Cambridge University Press, 1969), 267–353.

38. In *Eye of the Century* (New York: Columbia University Press, 2009), I argued that the impossibility for a spectator to "merge" with the depicted world facilitates the possibility of a fusion with the audience.

39. Michel Foucault, "Of Other Spaces," *Diacritics*, 16 (Spring 1986), 22–27. Originally Michel Foucault, "Des espaces autres" (conférence au Cercle d'études

architecturales, 14 mars 1967), in *Architecture, Mouvement, Continuité*, 5 (October1984), 46–49.

40. "There is probably not a single culture in the world that fails to constitute heterotopias." Foucault, "Of Other Spaces," 24. Foucault adds that traditional societies were mostly interested in the elaboration of so-called *heterotopias of crisis*, that is, "privileged or sacred or forbidden places, reserved for individuals who are, in relation to society and to the human environment in which they live, in a state of crisis: adolescents, menstruating women, pregnant women, the elderly, etc." Contemporary society instead constructs *heterotopias of deviation*: "those in which individuals whose behavior is deviant in relation to the required mean or norm are placed. Cases of this are rest homes and psychiatric hospitals, and of course prisons" (pp. 24–25).

41. Ibid., 26.
42. Ibid., 25.
43. Ibid., 26.
44. Ibid., 27.
45. Ibid., 24.
46. Per the *Oxford English Dictionary*.
47. Jürgen Habermas, "The Public Sphere: An Encyclopedia Article," in Meenaskshi Gigi Durham and Douglas M. Keller, eds., *Media and Cultural Studies* (Malden, Mass.: Blackwell, 2006), 73–78.
48. Stuart Hall, "Encoding/Decoding," in Stuart Hall, Dorothy Hobson, Andrew Lowe, and Paul Willis, eds., *Culture, Media, Language* (London: Routledge, 2002), 128–38.
49. Per the *Oxford English Dictionary*.
50. Lev Manovich, *The Language of New Media* (Cambridge, Mass.: MIT Press, 2001), in particular the chapter "Navigable Space," 244ff.
51. Manovich, *Language*, 245.
52. Ibid., 253.
53. Ibid., 257.
54. Ibid., 253. Also: "The VMRL universe . . . does not contain space as such but only objects that belong to different individuals" (p. 258).
55. Sergei Eisenstein, "About Stereoscopic Cinema," *The Penguin Film Review*, 8 (1949), 38.
56. Philip Sander, "Out of the Screen and into the Theater: 3-D Film as Demo," *Cinema Journal*, 50.3 (Spring 2011), 67.
57. Ibid.
58. Ibid.
59. "Reading the 3D TV Revolution," available at www.directv.com/technology/3d. Last accessed May 8, 2013.
60. Walter Benjamin, "The Work of Art in the Age of Its Technological Reproducibility. Second Version," in Michael W. Jennings, Brigid Doherty, and Thomas Y. Levin, eds., *Work of Art in the Age of Its Technological Reproducibility, and Other Writings on Media* (Cambridge, Mass.: Belknap Press of Harvard University Press, 2008), 39–40. In a very fine essay, Andrea Pinotti reconstructs the various meanings of the legend of the Chinese painter in Benjamin. If, in *Berlin Childhood around 1900*, the possibility of entering into an artwork is considered a positive movement, tied to the diminishing of the subject, in "The Work of Art" this gesture is associated with contemplation

and with the old forms of cult. Pinotti also brings to light the more general aspects of the near/far opposition and their role in Benjamin's thought. See Andrea Pinotti, "Sindrome cinese. Benjamin e la soglia auratica dell'immagine," *Rivista di Estetica*, 52 (2013), 161–80.

61. The "percussive effect on the spectator" refers specifically to the change of scenes and focus in film: Benjamin, "The Work of Art," 39. Benjamin also notices: "From an alluring visual composition or an enchanting fabric of sounds, the Dadaist turned the artwork into a missile. It jolted the viewers, taking on a tactile quality."

62. "Every day the urge grows stronger to get hold of an object at close range in an image, or, better, in a facsimile, a reproduction." Benjamin, "The Work of Art," 23.

63. Giovanni Papini, "La filosofia del cinematografo," *La Stampa* (May 18, 1907), 1–2.

64. Gerbi, "Iniziazione," 845.

65. Ibid., 846.

66. "The mounted group approached ever closer; at first the horses were as small as moles, then as big as hares, then finally life-sized as they grazed the edges of the screen with their quick-moving hooves. Then something extraordinary happened to me: in a flash the mounted knights entered into the theater, climbed the bright path of light emitted from the projector, and I was carried off." Camillo Mariani dell'Anguillara, "Una avventura cinematografica," *Lo Schermo* (August 23, 1926), 11–12. Published again with a few variations in *Avventura cinematografica* (Milan: Orior, 1929). I owe this reference and the following one to the generosity of Luca Mazzei.

67. Massimo Bontempelli, "La mia morte civile," in *Corriere della Sera* (October 21, 1924), 3, then in *Miracoli. 1923–1929* (Milan: Mondadori, 1938), 48–57.

68. Examples of two other films that represent this movement from the screen to the audience are René Clair's *Entr'Acte* (1924), in which the word *FIN* appears on a white background after the magician has made all the characters disappear (including himself). However, this background turns out to be a screen through which Francis Picabia erupts in close-up. In *Sherlock Junior* (1924), Buster Keaton—amateur detective and projectionist by necessity—walks to the front of the theater and enters into the screen: the first time he will fall back into the theater; only on the second attempt will he find a place in the narrated world.

69. Tom Gunning, "The Cinema of Attraction: Early Film, Its Spectator, and the Avant-Garde," *Wide Angle*, 8.3–4 (1986), 63–70.

70. Sergei Eisenstein, *Nonindifferent Nature*, trans. H. Marshall (Cambridge: Cambridge University Press, 1987), 34. Originally *Neravnodušnaja priroda*, in *Izbrannye proizvedenija v šesti tomach* (Moscow: Iskusstvo, 1963–1970, vol. III).

6. DISPLAY

1. For a useful reconstruction of the history of the split screen, see Malte Hagener, "The Aesthetics of Displays: From the Window on the World to the Logic of the Screen," in Leonardo Quaresima, Laura Ester Sangalli, and Fedrico Zecca, eds., *Cinema e fumetto/Cinema and Comics* (Udine: Forma, 2009), 145–55.

2. Not by chance, two years later the television series *24* adopted the split screen as one of its characteristic features.

3. "That which is used to cover, to shield something or someone from external agents, inclement weather, harmful elements, or to hide from view." Salvatore Battaglia, *Grande dizionario della lingua italiana*, vol. 17 (Turin: Utet, 1994).

4. "At once I thought of making this lovely lady a screen to hide the truth [. . .]." Dante Alighieri, *Vita nuova*, par. 5, trans. Mark Musa (Bloomington: Indiana University Press, 1973).

5. "A contrivance for warding off the heat of a fire or a draught of air." *Oxford English Dictionary*.

6. "A frame covered with paper or cloth, or a disk or plate of thin wood, cardboard, etc. (often decorated with painting or embroidery) with a handle by which a person may hold it between his face and the fire; a hand-screen. Also applied to a merely ornamental article of similar form and material." *Oxford English Dictionary*.

7. "A contrivance [. . .] for affording an upright surface for the display of objects for exhibition." *Oxford English Dictionary*. In the same period, the term *screen-cell* also arose to describe "a part of a gaol where a prisoner may be kept under constant observation." *Oxford English Dictionary*.

8. *Richardson's Handbook of Projection*, fourth ed. (New York: Chalmers, 1923), 226–33, lists seven classes of screens, in particular "(1) white wall, (2) the cloth screen, (3) the kalsomine screen, (4) the painted screen, (5) the metallized surface screen, (6) the glass or mirror screen, and (7) the translucent screen" (p. 226).

9. For more on the history of the word *screen*, see Erkki Huhtamo, "Elements of Screenology: Toward an Archaeology of the Screen," *ICONICS: International Studies of the Modern Image*, 7 (2004), 31–82.

10. Jean Epstein, "The Senses 1(b)," in Richard Abel, ed., *French Film Theory and Criticism: A History/Anthology, 1907–1939*, 2 vols. (Princeton, N.J.: Princeton University Press, 1984), 1:235–41. Originally "Le Sens 1 bis," in *Bonjour Cinéma* (Paris: Editions de la Siréne, 1921), 27–44.

11. Béla Balázs, *Early Film Theory: Visible Man and The Spirit of Film*, ed. Erica Carter (New York: Berghahn Books, 2010).

12. "[At the cinema] what matters is feeling calmly as if one is an indifferent spectator, as if at the window, of whom neither intelligence of judgment, nor the exertion of observation, nor the nuisance of investigation is required." Tullio Panteo, "Il cinematografo," *La scena illustrata*, 19.1 (October 1908).

13. André Bazin developed the metaphor in "Theater and Cinema," in *What Is Cinema?* Ed. and trans. Hugh Gray (Berkeley, University of California Press, 1967), 1, 76–124.

14. This reference is to the title of Siegfried Kracauer's volume *Theory of Film: The Redemption of Physical Reality* (New York: Oxford University Press, 1960).

15. For example, Freeburg observes that one of the conditions of cinema is that "it must practically always fill a rectangular frame of unvarying shape." Freeburg, *The Art of Photoplay Making* (New York: MacMillan, 1918), 39. See also *Pictorial Beauty on the Screen* (New York: MacMillan, 1923), in which Freeburg explores various types of composition and their effects on the spectator.

16. For just such a consideration of the screen, an exemplary approach is Sergei Eisenstein's. See his contributions, from "The Dynamic Square" (in *Close Up*,

March–June 1931), to "A Dialectic Approach to the Film Form" (firstly and partially translated as "The Principles of Film Form" in *Close Up* [September 1931], reprinted in *Film Form*, ed. and trans. Jay Leyda [New York: Harcourt, 1969]), to *Non-Indifferent Nature*, trans. Herbert Marshall (Cambridge: Cambridge University Press, 1987).

17. "Sitting before the white screen in a motion picture theatre we have the impression that we are watching true events, as if we were watching through a mirror following the action hurtling through space." Giovanni Papini, "La filosofia del cinematografo," *La Stampa* (May 18, 1907), 1–2.

18. Not surprisingly, the idea of the mirror leads Jean-Louis Baudry to suggest that in cinema we mistake a representation for a perception. See "The Apparatus: Metapsychological Approaches to the Impression of Reality in Cinema," in Philip Rosen, ed., *Narrative, Apparatus, Ideology* (New York: Columbia University Press, 1986), 299–318. Originally "Le dispositif: approches métapsychologiques de l'impression de réalité," *Communications*, 23 (1975), 56–72.

19. Thomas Elsaesser and Malte Hagener, in *Film Theory: An Introduction through the Senses* (New York: Routledge, 2010), provide a general definition of cinema following the great metaphors for it. For the idea of cinema as window, frame, and mirror, see also Vivian Sobchack, *Address of the Eye* (Princeton, N.J.: Princeton University Press, 1992), 14–15; and Charles Altman, "Psychoanalysis and Cinema: The Imaginary Discourse," *Quarterly Review of Film Studies*, 2.3 (1977), 260–64.

20. Jean Epstein, "Magnification," in Abel, *French Film Theory*, 237. Originally "Grossissement," in *Bonjour Cinéma*, 93–108. In more recent times, the equivalence between screen and skin has been reaffirmed by Laura U. Marks, *The Skin of the Film* (Durham, N.C.: Duke University Press, 2000).

21. In defining the constituents of cinema, Élie Faure reminds that between the author and the public there are "three intermediaries, the actor—let us call him the cinemimic—the camera and the photographer." Élie Faure continues: "I do not speak of the screen, which is a material accessory, forming a part of the hall, like the setting in the theatre." Élie Faure, *The Art of Cineplastics* (Boston: The Four Seas Company, 1923), 22. Originally "De la cinéplastique," in *L'arbre d'Eden* (Paris: Éd. Crès, 1922).

22. Antonello Gerbi, "Iniziazione alle delizie del cinema," *Il Convegno*, 7.11–12 (1926), 842.

23. "From the uniform rows of spectators (or of the faithful? Or of wandering lovers?) not even the light murmur of a prayer rises up: this perfect adoration is carried out, following the teachings of all of those learned in mysticism, in perfect silence." Gerbi, "Iniziazione," 840–41.

24. "Today, after more than a century of electric technology, we have extended our central nervous system itself in a global embrace, abolishing both space and time as far as our planet is concerned. Rapidly, we approach the final phase of the extension of man—the technological simulation of consciousness, when the creative process of knowing will be collectively and corporately extended to the whole of human society, much as we have already extended our senses and our nerves by the various media." Marshall McLuhan, *Understanding Media: The Extensions of Man* (London: Routledge, 2001 [1964]), 3–4.

25. Already in 1937, Rudolf Arnheim underlined the conceptual continuity between cinema and television: "Television will not only reproduce the world like cinema—its images will be colored and perhaps even plastic—but it will render this

reproduction even more fascinating by making us take part, not in events which have simply been recorded and conserved, but in far-away events at the very moment in which they occur." See Rudolf Arnheim, *La radio cerca la sua forma* (Milan: Hoepli, 1937), 271. Nevertheless, the two media possess quite different characteristics: Cinema is a medium of expression, while television is a medium of transmission. The chapter "La televisione" in *La radio* takes up and expands "Vedere lontano," published in *Intercine*, 2 (February 1935), 71–82. "A Forecast of Television," included in *Film as Art* (Berkeley: University of California Press, 1957), 188–198, is also a rewriting, more than a translation, of "Vedere lontano." The sentence quoted above appears only in *La radio*. On Italian writings by Arnheim, see Adriano D'Aloia, *I baffi di Charlot* (Turin: Kaplan, 2009). For more on Arnheim and television, see Doron Galili, "Television from Afar: Arnheim's Understanding of Media," in Scott Higgins, ed., *Arnheim for Film and Media Studies* (London: Routledge, 2011), 195–212.

26. Lynn Spiegel documents how the television functioned as a domestic cinema in its early phases in "Designing the Smart House: Posthuman Domesticity and Conspicuous Production," *Electronic Elsewheres*, ed. Chris Berry, Soyoung Kim, and Lynn Spigel (Minneapolis: University of Minnesota Press, 2010), 55–92.

27. See Beatriz Colomina, "Enclosed by Images: The Eameses Multimedia Architecture," *Grey Room*, 2 (Winter 2001), 6–29. The Eameses' project was preceded by a multiscreen projection of their Glimpses of the USA at the American National Exhibition in Moscow in 1959. During the New York World's Fair, Francis Thompson also made a great impression by projecting the film *To Be Alive* on three screens.

28. Andy Warhol employed multiscreen projections also for the performances of his Exploding Plastic Inevitable. On the topic, see Branden W. Joseph, "My Mind Split Open. Andy Warhol's Exploding Plastic Inevitable," *Grey Room*, 8 (2002), 80–107.

29. Anne Friedberg reminds us that in 1985, only 20 percent of American households had a VCR; by 1997, the total had reached 88 percent. See "The End of Cinema: Multimedia and Technological Change," in Christine Gledhill and Linda Williams, eds., *Reinventing Film Studies* (London: Arnold, 2000). The Sony Betamax was introduced in 1975 and the VHS was marketed by JVC in 1976; see Luís M. B. Cabral, *Introduction to Industrial Organization* (Cambridge, Mass.: MIT Press, 2000), 317–18. Atari's Pong console, the first to enjoy significant success, was designed in 1966 and introduced in 1972, while the consecration of the video-game console occurred in 1977 with the Atari 2600; see Computer History Museum, "Timeline of Computer History: Graphics & Games" (2006), available at www.computerhistory.org/timeline/?category=gg.

30. The Minitel was introduced in France in 1982.

31. The desktop computer began to grow in popularity at the end of the 1970s and beginning of the 1980s: the Apple II debuted in 1977 (see Computer History Museum in note 29); the IBM PC in 1981, the Commodore 64 in 1982, and the Macintosh Portable in 1989 (see Benj Edwards, "The [Misunderstood] Mac Portable Turns 20" [2009], available at www.pcworld.com/article/172420/the_misunderstood_mac_portable_turns_20.html), while the ThinkPad 700 came out in 1992 (see Scott Mueller, *Upgrading and Repairing Laptops* [Indianapolis: Que, 2004], 33).

32. The first commercially automated cellular network (1G: first generation) was launched in Japan by NTT in 1979; see Guy Klemens, *The Cellphone: The History and Technology of the Gadget that Changed the World* (Jefferson, N.C.: McFarland, 2010),

65–66. The GSM, which represents the second generation (2G) of cell phones, came online in 1991; see Theodoros Pagtzis, "GSM: A Bit of History" (2011), available at www.cs.ucl.ac.uk/staff/t.pagtzis. The 3G began operation in 2001; see BBC News, "First 3G Launched in Japan" (October 1, 2001), available at http://news.bbc.co.uk/1/hi/business/1572372.stm.

33. The DVD dates back to 1995; see Toshiba, "DVD Format Unification" (1995), available at www.toshiba.co.jp/about/press/1995_12/ pr0802.htm.

34. Noteworthy among the early palm devices are the Tandy Zoomer (1992) and the Apple Newton Message Pad (1993). See Dean Evans, "10 Memorable Milestones in Tablet History," TechRadar (January 31, 2011), available at www.techradar.com/news/mobile-computing/10-memorable-milestones-in-tablet-history-924916.

35. Among the early tablets was the GRiDPad, released by GRiDPad System Corporation in 1989 (Evans, "Ten Memorable"). The Amazon Kindle was first introduced to the market by Amazon.com's subsidiary Lab126 in November 2007 (ibid.). Apple released the first iPad in April 2010 (ibid.).

36. Lev Manovich, "Screen and Users" and "Screen and Body" in *The Language of New Media* (Cambridge, Mass.: MIT Press, 2000), 94–115.

37. Michel Foucault, *Discipline and Punish: The Birth of the Prison* (New York: Vintage, 1979). Originally *Surveiller et punir. Naissance de la prison* (Paris: Gallimard, 1975).

38. Gilles Deleuze, "Postscript to Societies of Control," *October*, 59 (1992), 3–7.

39. Sometimes they imply a mechanical gaze. Drones in war zones gather images that a machine examines to highlight any discrepancies with prior surveillance of a given area—and it is only after this first "gaze" that an analyst is summoned to intervene, in order to give (or not give) the order for an attack on a possible enemy.

40. See the self-introduction of the controversial online forum 4chan: "4chan is a simple image-based bulletin board where anyone can post comments and share images," available at www.4chan.org/.

41. For the concepts of dialogism and heteroglossia in Mikhail Bakhtin, see in particular his essay "Discourse in the Novel," in *The Dialogic Imagination: Four Essays*, ed. Michael Holquist (Austin: University of Texas Press, 1981 [originally 1934–1935]).

42. Edgar Morin, *The Cinema, or, the Imaginary Man*, trans. Lorraine Mortimer (Minneapolis: University of Minnesota Press, 2005). Originally *Le cinéma ou l'homme imaginaire: Essai d'anthropologie sociologique* (Paris: Minuit, 1956).

43. Dudley Andrew reaches the same conclusion regarding the computer screen: "Monitor and display seem more apt terms than screen to designate the visual experience that computers deliver." See "The Core and the Flow of Film Studies," *Critical Inquiry*, 35 (Summer 2009), 915.

44. Vilém Flusser writes fascinating pages on just such a touching; see *Into the Universe of Technical Images* (Minneapolis: University of Minnesota Press, 2010), 23–32. Originally *Ins Universum der technischen Bilder* (Berlin: European Photography, 1985). On the genealogy of the touch screen, see Wanda Strauven, "Early Cinema's Touch(able) Screen: From Uncle Josh to Ali Barbouyou," *Necsus*, (1), 2, (2012), available at www.necsus-ejms.org/early-cinemas-touchable-screens-from-uncle-josh-to-ali-barbouyou/.

45. On the opposition of the dimensions of push and pull, both in new media and in the wider culture, see James Lull, "The Push and Pull of Global Culture," in James Curran and David Morley, eds., *Media and Cultural Theory* (London: Routledge, 2006), 44–58.

46. An excellent analysis of how computers and cell phones are used in China to share images devoted to document or to denounce, in the tradition of cinema, can be found in Paola Voci, *China on Video: Smaller-Screen Realities* (London: Routledge, 2010).

47. Harold Lasswell, "The Structure and Function of Communication in Society," in Lyman Bryson, ed., *The Communication of Ideas* (New York: Institute for Religious and Social Studies, 1948), 37–52.

48. McLuhan, *Understanding Media*.

49. Raymond Williams, *Television: Technology and Cultural Form* (New York: Schocken Books, 1974).

50. The idea that the screen constitutes a moment in which circulation slackens speed is well illustrated by David Joselit's concept of the "slow down trajective." See *Feedback: Television against Democracy* (Cambridge, Mass,: MIT Press, 2007).

51. Flusser, *Into the Universe*, 31

52. Ibid.

53. Flusser opens his book with a genealogical reconstruction of the various phases of the history of images. The process Flusser describes is one of increasing abstraction with respect to the concreteness of immediate experience: During the first moment (first rung), "natural man" (*Naturmensch*) lives a concrete and purely sensorial experience, like that of other animals. Then man dedicates himself to the creation of functional, tridimensional artifacts. In a third phase, "traditional" images appear—paintings, drawings, sculptures—which structure the relation between man and the world in magical-imaginative terms. The fourth moment is one in which writing appears, and, therefore, conceptual thought. The fifth phase is the one where we now find ourselves, in which abstraction has led to a loss of the "representability" of concrete phenomena. See *Into the Universe*, 5–10. For another "history of the image," which is set up according to a schema not distant from Flusser's, see Régis Debray, *Vie et mort de l'image: une histoire du regard en Occident* (Paris: Gallimard, 1992).

54. "The production of technical images occurs in a field of possibilities: in and of themselves, the particles are nothing but possibilities from which something accidentally emerges." Flusser, *Into the Universe*, 16.

55. "From now on, concepts such as 'true' or 'false' refer only to unattainable horizons." Flusser, *Into the Universe*, 17. I want to note that Flusser, while denying the "certitude" of a relation between technical images and reality, claims that the technical image can find such a relation after all. His orientation deserves more attention, and it could be compared with the idea of "precession of simulacra" foregrounded by Jean Baudrillard in *Simulacra and Simulation*, trans. Sheila Glaser (Ann Arbor: University of Michigan Press, 1994), 1–42. It suffices here to mention the question.

56. "Envision should refer to the capacity to step from the particles universe back into the concrete." Flusser, *Into the Universe*, 34. And moreover: via technical images, "are we able to turn back to concrete experience, recognition, value and action and away from the world of abstraction from which these things have vanished" (p. 38).

57. Peter Sloterdijk notes that "The res publica arises from this act of capturing objects" and emphasizes the way in which this process is based first of all on a series of techniques for recording the spoken word. "To this extent, democracy is preceded by a prepolitical dimension in which the means to slow down the flow of speech/es

is made available." See Peter Sloterdijk, "Atmospheric Politics," in Bruno Latour and Peter Weibel, eds., *Making Things Public: Atmospheres of Democracy* (Cambridge, Mass.: MIT Press, 2005), 944–51, in particular 949ff., in which Sloterdijk discusses "a media-based foundation of the polis."

58. On the end of the "grand narratives" in the postmodern condition, see Jean-François Lyotard, *The Postmodern Condition* (Minneapolis: University of Minnesota Press, 1984).

59. On different aspects of contingency in the current cinema, see Janet Harbord, *The Evolution of Film* (Cambridge: Polity Press, 2007), in particular pp. 123–127.

60. Ricciotto Canudo, "Trionfo del cinematografo," *Il Nuovo Giornale* (December 25, 1908), 3; and "La naissance d'un sixiéme art: Essai sur le Cinématographe," in *Les Entretiens Idéalistes* (October 1911). For the English translation of the latter, see "The Birth of a Sixth Art," in Abel, *French Film Theory*, 1:58–66.

61. See, for example, Erich Feldmann, "Considérations sur la situation du spectateur au cinéma," in *Revue Internationale de Filmologie*, 26 (1956), 83–97. Boris Groys suggests that the immobility of the spectators risks functioning as a parody of the "active life," which films seem to celebrate; see *Art Power* (Cambridge, Mass.: MIT Press, 2008), especially pp. 71–72.

62. It would be useful here to recall Siegfried Kracauer's farsighted definition of the cinemas as a "shelter for the homeless." Today's shelter is simply open to inclemency of every kind, and the homeless are mobile subjects. Siegfried Kracauer, "Shelter for the Homeless," in *The Salaried Masses: Duty and Distraction in Weimar Germany* (London: Verso, 1998), 88–95. Originally "Die Angestellten. Aus dem neusten Deutschland," serial publication in *Frankfurter Zeitung* (1929), then as a book (Frankfurt: Societats Verlag, 1930).

7. PERFORMANCE

1. This is an episode in the omnibus film *Chacun son cinéma ou Ce petit coup au coeur quand la lumière s'éteint et que le film commence* (France, 2007). Produced by the Cannes Film Festival, it is a film directed by thirty-six different directors, from Theo Angelopoulos to Zhang Yimou.

2. Beyond the fact that Egoyan is the author of *Artaud Double Bill* and of one of the two films that the two spectators go to see, *The Adjuster*, and the fact that Arsinée Kahnijan, who plays the role of Nicole, also acts in *The Adjuster*, the film that Nicole watches.

3. I owe to Carol Jacobs the observation that the anagrams in this film work not only on the side of the female characters (let's also notice that Anna, the spectator of Godard's film, shares the name of the film's actress, Anna Karina), but also on the side of the film director: Ego-yan echoes Je-an of Jean-Luc Godard, putting a "first person"—Ego, Je— before the character's name—An, Anna.

4. For discussion on hypertexts, see the classic works by George Landow, in particular: *Hypertext 2.0* (Baltimore, Md.: Johns Hopkins University Press, 1997), and *Hypertext 3.0: Critical Theory and New Media in an Era of Globalization* (Baltimore, Md.: Johns Hopkins University Press, 2006).

5. For more on the network of social discourses, see Francesco Casetti, "Adaptations and Mis-adaptations: Film, Literature, and Social Discourses," in Robert Stam and Alessandra Raengo, eds., *A Companion to Literature and Film* (Oxford: Blackwell, 2005), 81–91.

6. For distracted perception, see Walter Benjamin, "The Work of Art in the Age of Its Technological Reproducibility. Second Version," in Michael W. Jennings, Brigid Doherty, and Thomas Y. Levin, eds., *Work of Art in the Age of Its Technological Reproducibility, and Other Writings on Media* (Cambridge, Mass.: Belknap Press of Harvard University Press, 2008), 19–55.

7. John Ellis formulated the gaze/glance opposition in *Visibile Fictions* (London: Routledge, 1982).

8. Stanley Cavell proposes the viewing/monitoring opposition in "The Fact of Television," *Daedalus*, 3.4 (1982); reprinted in *Cavell on Film* (Albany, N.Y.: SUNY Press, 2005), 59–85.

9. In this sense, we may say that between the gaze and the glance, Anna and Nicole activate a third viewing style, that of multicentered watching, at once attentive and divided. For more on the multicentered gaze, see Fanchi, *Spettatore* (Milan: Il Castoro, 2005), 43ff.

10. This surfing, particularly in the moment at which Anna captures the image of Artaud on the screen in front of her, recalls the "scan-and-search" analyzed by Tara McPherson in "Reload: Liveness, Mobility, and the Web," in Wendy Hui Kyong Chun and Thomas Keenan, eds., *New Media, Old Media* (London: Routledge, 2006), 199–208.

11. On cinematic catharsis and on its capitulation, see the perceptive observations of Gabriele Pedullà, *In Broad Daylight* (London: Verso, 2012), 123ff. Originally *In piena luce* (Milan: Bompiani, 2008). Pedullà takes up and develops further Stanley Cavell's important intuition in "The Avoidance of Love: A Reading of *King Lear*," in *Must We Mean What We Say? A Book of Essays* (New York: Cambridge University Press, 1976), 267–353.

12. Roland Barthes, "Leaving the Movie Theater," in *The Rustle of Language* (Oxford: Blackwell, 1986), 345–49. Originally published as "En sortant du cinéma," *Communications*, no. 23 (1975), 104–107.

13. Stanley Cavell sums up this condition when, for example, he observes that at the movie theater, "we wish to see . . . the world itself," and at the same time, "we are wishing for the condition of seeing as such." Stanley Cavell, *The World Viewed: Reflections of the Ontology of Film, Enlarged Edition* (Cambridge, Mass.: Harvard University Press, 1979), 101–102.

14. Concerning contemporary practices of collecting and of cult, see Barbara Klinger, "The Contemporary Cinephile: Film Collecting in the Post Video Era," in Melvyn Stokes and Richard Maltby, eds., *Hollywood Spectatorship. Changing Perceptions of Cinema Audiences* (London: British Film Institute, 2001), 131–51.

15. An ample space of negotiation has opened up to the new spectators, who find themselves first having to draw a mediatic cartography, then having to assign roles and functions to the various platforms, and finally having to perform a demiurgic action on the device, defining its times, modes, and the situation in which it is to be used. See Mariagrazia Fanchi, "L'esperienza della visione," in Francesco Casetti and Severino Salvemini, eds., *E' tutto un altro film. Più coraggio e più idee per il cinema italiano* (Milan: Egea, 2007), 90.

16. The term *performance* is used by Robert C. Allen to designate one of the four components of reception: "By this I mean the immediate social, sensory, performative context of reception." Robert C. Allen, "From Exhibition to Reception. Reflections on the Audience in Film History," *Screen*, 31.4 (1990), 352. I will use the term *performance* not just to designate an active component of film-going (what I call *attendance* also implies a large set of actions, and in that I follow Allen), but to underline that spectators today must largely "construct" the conditions of their own vision, while traditional spectators found these conditions largely "constructed" by the institution.

17. For more on the emotional dimension in a cognitive perspective, see Carl Plantinga and Greg M. Smith, eds., *Passionate Views* (Baltimore, Md.: Johns Hopkins University Press, 1999), Carl Plantinga, *Moving Viewers: American Films and the Spectator's Experience* (Berkeley: University of California Press, 2009), and Torben Grodal, *Embodied Visions: Evolution, Emotion, Culture and Film* (Oxford: Oxford University Press, 2009). For a different perspective, see Mathias Brütsch et al., eds., *Kinogefühle. Emotionalität und Film* (Marburg: Schüren, 2005).

18. See Chuck Tryon, *On-Demand Culture. Digital Delivery and the Future of the Movies* (New Brunswick, N.J.: Rutgers University Press, 2013), in particular chapter 6, "Twitter Effect: Social Media and Digital Delivery" (pp. 117–135).

19. Some theoretical remarks on this type of *doing* in Francesco Casetti and Mariagrazia Franchi, eds., *Terre incognite* (Florence: Carocci, 2006).

20. For more on self-construction on blogs, see Guido Di Fraia, *Blog-grafie. Identità narrative in rete* (Milan: Guerini e assoc., 2007); and Jan Schmidt, "Blogging Practices: An Analytical Framework," in *Journal of Computer-Mediated Communication*, 12.4 (2007), 1409–1427. Concerning the processes of identity construction on social networks, see Sonia Livingstone, "Taking Risky Opportunities in Youthful Content Creation: Teenagers' Use of Social Networking Sites for Intimacy, Privacy and Self-Expression," *New Media and Society*, 10.3 (2008), 393–411

21. For more on the public's *textual doing*, see Nick Abercrombie and Brian Longhurst, *Audiences: A Sociological Theory of Performance and Imagination* (London: Sage, 1998).

22. See Barbara Klinger, "Cinema's Shadows. Reconsidering Non-theatrical Exhibition," in Richard Maltby, Melvin Stokes, and Robert C. Allen, eds., *Going to the Movies: Hollywood and the Social Experience of Cinema* (Exeter: University of Exeter Press, 2007), 273–90.

23. For more on the synaesthetic involvement of the spectator, see Alain J. J. Cohen, "Virtual Hollywood and the Genealogy of Its Hyper-Spectator," in Melvyn Stokes and Richard Maltby, eds., *Hollywood Spectatorship*, 131–51.

24. See in particular Jennifer Barker, *The Tactile Eye* (Berkeley: University of California Press, 2009), and Laura U. Marks, *Skin of the Film. Intercultural Cinema, Embodiment, and the Senses* (Durham, N.C.: Duke University Press, 2000).

25. Allen, "From Exhibition to Reception," 352.

26. See among others John Fiske, *Television Culture* (London, Routledge, 1987). A critique to the notion of spectator as bricoleur is given in David Morley, *Television, Audiences and Cultural Studies* (London: Routledge, 1992).

27. For Pro-Am, see Charles Leadbeater and Paul Miller, *The Pro-Am Revolution: How Enthusiasts Are Changing Our Economy and Society* (London: Demos, 2004); for produsage, see Axel Bruns, *Blogs, Wikipedia, Second Life, and Beyond: From Production to*

Produsage (New York: Peter Lang, 2008). Concerning the manipulative action of the public, Alvin Toffler's description of the *prosumer* may still be of interest: Alvin Toffler, *The Third Wave* (New York: Bantam, 1980). A synthetic but enlightening analysis of these concepts is Mariagrazia Fanchi, *L'audience* (Bari: Laterza, 2014).

28. Claude Lévi-Strauss, *The Savage Mind* (Chicago: University of Chicago Press, 1966), 17. Originally *Le pensée sauvage* (Paris: Plon, 1962).

29. Lévi-Strauss, *Savage Mind*, 18.

30. Lévi-Strauss, *Savage Mind*, 21.

31. See Michel de Certeau, "Reading as Poaching," in *The Practices of Everyday Life* (Berkeley: University of California Press, 1984), 165–76. Originally *L'Invention du Quotidien*, 2 vol. (Paris: Union générale d'éditions, 1980).

32. Régis Debray, writing on the passage to the "videosphere," speaks of the "end of spectacle," associating it with a broader weakening in the role of vision. See *Vie et mort de l'image. Une histoire du regard en Occident* (Paris : Gallimard, 1992).

33. For more on fan activity—not limited to the accumulation of clips, but involving the actual reconstruction of the cult object—see Henry Jenkins's classic study, *Textual Poachers: Television Fans and Participatory Culture* (New York: Routledge, 1992), and the extremely rich Chuck Tryon, *Reinventing Cinema. Movies in the Age of Media Convergence* (New Brunswick, N.J.: London: Rutgers University Press, 2009).

34. On mobility, see John Urry, *Sociology Beyond Societies: Mobilities for the Twenty-First Century* (New York: Routledge, 2000); on mobile communication, and in particular the sense of being part of a community as opposed to the sense of individuality and isolation, see Rich Ling and Scott W. Campbell, eds., *Mobile Communication. Bringing Us Together and Tearing Us Apart* (New Brunswick, N.J.: Transaction Publishers, 2011). Interesting remarks on mobility and leisure in Araba Sey and Peppino Ortoleva, "All Work and No Play? Judging the Use of Mobile Phones in Developing Countries," in *Information Technologies and International Development*, 1, 3 (2014), 1–17

35. Jacques Aumont, *Que reste-t-il du cinéma?* (Paris: Vrin, 2012), 80–83.

36. Laura Mulvey, *Death 24X a Second: Stillness and the Moving Image* (London: Reaktion Books, 2006), 161.

37. The concept of the "pensive spectator" was introduced by Raymond Bellour in "Un spectateur pensif," in *Le corps du cinéma* (Paris: POL, 2009), 179–221.

38. Mulvey, *Death*, 186.

39. Ibid., 147.

40. Ibid., 191.

41. McPherson speaks of three major new directions in which the Web spectator moves: volition mobility, scan-and-search, and anxiety for transformation. See "Reload," in *New Media, Old Media*.

42. The presence of a composite spectacle, with components that do not directly belong to the cinema (what French criticism often calls "hors cinéma"), brings back the film theater to the stages of the film history in which it has been a multifunction and a multimedia environment.

43. On the rearticulation of film-going, see Charles Acland, *Screen Traffic* (Durham, N.C.: Duke University Press, 2003). For the new typologies of film theater, see Laurent Creton and Kira Kitsopanidou, *Les salles de cinema. Enjeux, defies et perspectives* (Paris: Armand Colin, 2013). For a historical account, see Janet Harbord, *Film Cultures* (London: Sage, 2002).

44. The relevance of a "territorialization" in media has been highlighted by David Morley. See part four of *Media, Modernity and Technology* (London: Routledge, 2007).

45. Louis Delluc, "La foule devant l'ecran," in *Photogenie* (Paris: de Brunoff, 1920), 104–118. A previous version has been translated as "The Crowd," in *French Film Theory and Criticism: A History/Anthology, 1907–1939*, vol. 1, ed. Richard Abel (Princeton, N.J.: Princeton University Press, 1984), 159–64.

46. On convergence, see Henry Jenkins, *Convergence Culture: Where Old and New Media Collide* (New York: New York University Press, 2006). On convergence and new products, see Simone Murray, "Brand Loyalties: Rethinking Content Within Global Corporate Media," *Media, Culture and Society*, 27.3 (2005), 415–35, and Ivan D. Askwith, *Television 2.0: Reconceptualizing TV as an Engagement Medium*, M.Sc. thesis, Massachusetts Institute of Technology, 2007, available at http://cms.mit.edu /research/tese/IvanAswith2007. Last accessed November 22, 2010. On convergence and new strategies of consumption, see Will Brooker and Deborah Jermyn, eds., *The Audience Studies Reader* (London: Routledge, 2003), 323–25.

47. On contemporary media's channeling of experience, see the perceptive analysis of Pietro Montani, *Bioestetica* (Firenze: Carocci, 2007).

48. On the very nature of the event of the experience of cinema, see Robert C. Allen, "Reimagining the History of the Experience of Cinema in a Post-Moviegoing Age," in Richard Maltby, Daniel Biltereyst, and Philippe Meers, eds., *Explorations in New Cinema History. Approaches and Case Studies* (London: Wiley-Blackwell, 2011), 41–57.

49. On this theme, it is interesting to note the parallel tendency of the television public to go physically to the place where television footage is being shot and to participate *on the ground* in big events involving single programs (for example, the "MTV Day" event). For more on this, see Nick Couldry, "The View from Inside the Simulacrum: Visitors' Tales from the Set of *Coronation Street*," *Leisure Studies*, 17.2 (1998), 94–107, and Matthew Hills, "Cult Geographies: Between the 'Textual' and the 'Spatial,' " in *Fan Cultures* (London: Routledge, 2003). See also Anna Sfardini, *Reality TV: Pubblici, fan, protagonisti, performer* (Milan: Unicopli, 2009).

8. THE PERSISTENCE OF CINEMA IN A POST-CINEMATIC AGE

1. Antonello Gerbi, "Iniziazione alle delizie del cinema," *Il Convegno*, 7.11–12 (November 25, 1926), 836–48.
2. Gerbi, "Iniziazione," 837.
3. Ibid., 838.
4. Ibid., 840.
5. Jules Romains, "The Crowd at the Cinematograph," in *French Film Theory and Criticism: A History/Anthology, 1907–1939*, ed. and trans. Richard Abel, 2 vols. (Princeton, N.J.: Princeton University Press, 1993), 1:53–54. Originally "La foule au cinématographe," *Les puissances de Paris* (Paris: Eugène Figuière, 1911), 118–20.

6. Giovanni Papini, "La filosofia del cinematografo" ("Philosophical observations on the motion picture"), *La Stampa* (May 18, 1907), 1–2.

7. Walter Serner, "Cinema and the Desire to Watch," in Richard W. McCormick and Alison Guenther-Pal, eds., *German Essays on Film* (New York: Continuum, 2004), 17–20. Originally "Kino und Schaulust," *Die Schaubüne*, 9 (1913), 807–811.

8. "By showing the women that they could sit in the dark only a few centimeters away from a man who was not closely related without having to faint with fear, the motion picture theater made its contribution towards moral education in provincial towns, strengthening the awareness of respectful behavior, moderating personal character and conduct. The darkness of the motion picture theater put a stop to the problem of jealousy." Emilio Scaglione, "Il cinematografo in provincia," *L'Arte Muta* (Naples), no. 6–7 (December 15, 1916–January 15, 1917), 14–16.

9. Roland Barthes, "Leaving the Movie Theater," in *The Rustle of Language*, trans. Richard Howard (Berkeley: University of California Press, 1986), 345–49. Originally "En sortant du cinéma," *Communications*, 23 (1975), 104–107; reprinted in *Le bruissement de la langue: essais critiques IV* (Paris: Seuil, 1984), 407–412.

10. Hollis Frampton, "A Lecture," in Bruce Jenkins, ed., *On Camera Arts and Consecutive Matters* (Cambridge, Mass.: MIT Press, 2009), 125.

11. A reconstruction of this episode can be found in Francesco Casetti and Silvio Alovisio, "Il contributo della Chiesa alla moralizzazione degli spazi pubblici," in Dario Viganò and Ruggero Eugeni, eds., *Attraverso lo schermo. Cinema e cultura cattolica in Italia, vol. 1* (Rome: Ente dello Spettacolo, 2006), 97–127, and 108–110 in particular.

12. To remain in Italy, there were many attempts at projections in full light: thanks to screens with a metallic surface or covered with a "white varnish mixed with celluloid" to reflect the projector's rays (see Stanislao Pecci, "A proposito di schermi," *La Cine-Fono e la Rivista Fono-cinematografica*, 5.180 [December 16, 1911], 7), or thanks to rear-projection onto parchment-like screens (see "La cinematografia in piena luce," *La Cine Fono e la Rivista Fono-cinematografica*, 8.284 [June 13, 1914], 71). There was also a screen structured in hexagonal cells like a bees' nest and patented by the Milan firm M. Ganzini & C., which could display movement images "in the bright afternoon light" ("La cinematografia in piena luce," *La Cinematografia Italiana ed Estera*, 2.55–56 [June 15–31, 1909], 322). In the United States, starting from 1910, "Roxy" Rothafel developed the "daylight pictures," which were installed in many theaters, from Cincinnati to Detroit, and from New York to California. See the accurate reconstruction of this episode in Ross Melnick, *American Showman: Samuel "Roxy" Rothafel and the Birth of the Entertainment Industry, 1908–1935* (New York: Columbia, 2012), 60–64.

13. Gabriele Pedullà has written a volume on the departure of cinema from the darkened theater, the title of which, symptomatically, is *In Broad Daylight* (London: Verso, 2012). Originally *In piena luce* (Milan: Bompiani, 2008).

14. "Un fin qui n'en finit pas de ne pas finir." Raymond Bellour, *La querelle des dispositifs*, 13.

15. Walter Benjamin, *Selected Writings, vol. I, 1913–26* (Cambridge, Mass.: The Belknap Press of Harvard University Press, 1996), 235. Originally *Gesammelte Schriften*, VI (Frankfurt: Suhrkamp, 1991), 126–27, Fragment 96.

16. Antonio Somaini, " 'L'oggetto attualmente più importante dell'estetica.' " Benjamin, il cinema come *Apparat*, e il '*Medium* della percezione,' " *Fata Morgana*, 20 (2013), 117–46.

17. "For the creator the Medium surrounding his work is so dense, that he cannot cross through it from the same position that the work demands from the spectators. He can cross through it only in an indirect way." Benjamin, Fragment 96, *Gesammelte Schriften, VI*, 127. The English *Selected Writings* does not include this part of the fragment.

18. Benjamin will develop such a topic in his "The Work of Art in the Age of Its Technological Reproducibility." For the Second Version of the essay, see *Work of Art in the Age of Its Technological Reproducibility, and Other Writings on Media*, ed. Michael W. Jennings, Brigid Doherty, and Thomas Y. Levin, trans. Edmund Jephcott (Cambridge, Mass.: Belknap Press of Harvard University Press, 2008), 19–54.

19. Benjamin highlights the resistance of the artwork to its own creator, due to the thick atmosphere around it. This gives rise to a paradox, namely the necessity of approaching the work through other senses: "The composer would perhaps see his music, the painter hear his image, the poet touch his poem, if he tried to come close enough to it." Benjamin, "Fragment 96" (also this part of the fragment is not included in the English *Selected Writings*).

20. With Benjamin, we may say that the fainting of the medium allows music to become audible again, the poem readable, and the painting visible.

21. Susan Sontag, "The Decay of Cinema," *New York Times*, February 25, 1996, available at www.nytimes.com/books/00/03/12/specials/sontag-cinema.html.

22. André Gaudreault and Philippe Marion, "A Medium is always born twice ...," *Early Popular Visual Culture*, 3.1 (May 2005), 3–15.

23. "This implies, on the one hand—that of reception—a recognition of the 'personality' and often increasingly specific use of the medium, and on the other—that of production—a consciousness of its potential for an original, medium-specific expression capable of disassociating the medium from other media or generic 'expressibles' that have already been distinguished and are being practised." André Gaudreault and Philippe Marion, "A Medium," 3.

24. Gaudreault writes of a "second birth": I would like to suggest that it is more accurately a "baptism," thanks to which something that exists in an undefined form acquires a name, and therefore becomes what it is.

25. See the following presentation by the company Home Cinema Modules, the title of which is "The Ultimate Home Cinema Experience": "From trendy modern to antique picture palace from the Fifties, Home Cinema Modules offers you everything you need to make your Home Theatre in a style recreating the atmosphere that you are looking for in your home environment." Available at http://homecinemamodules.nl/english/. Last accessed July 2013.

26. See how the following review takes this approach: "Taking their cue from Brian Selznick, author of the popular source novel, Scorsese and screenwriter John Logan focus their attention on French director Georges Méliès, best known for the 1902 silent 'A Trip to the Moon.' Méliès, an early master of cinematic legerdemain, paved the way for the modern film fantasists, from Ray Harryhausen to Terry Gilliam to the James Cameron of *Avatar*. Méliès' mix of music-hall magic and in-camera tricks, Scorsese reminds us, was, and remains, the stuff that dreams are made of." Glenn Lovell, "Hugo: A Clockwork Fantasy," *Cinemadope*. Available at http://cinemadope.com/reviews/hugo-%E2%9C%AE%E2%9C%AE%E2%9C%AE/.

27. An example of this is James Cameron's interview in the *Telegraph*, in which his output is ascribed to a precocious fascination with *2001: A Space Odyssey*. "As a teenager Cameron was so astounded at Stanley Kubrick's *2001: A Space Odyssey* that he saw it 10 times and became inspired to experiment with 16mm filmmaking and model-building. From his earliest filmmaking days—he first gained recognition for writing and directing *The Terminator* in 1984—he has been a leading science-fiction auteur and special-effects visionary." John Hiscock, "James Cameron Interview for Avatar," *Telegraph*, December 3, 2009, available at www.telegraph.co.uk/culture/film/6720156/James-Cameron-interview-for-Avatar.html.

28. Two excellent examples among others: Haidee Wasson, *Museum Movies: The Museum of Modern Art and the Birth of Art Cinema* (Berkeley: University of California Press, 2005); Alison Griffiths, *Shivers Down Your Spine* (New York: Columbia University Press, 2008).

29. See the special issue of *Cinema & Cie*, 2 (Spring 2003), edited by Leonardo Quaresima, on "Dead Ends/Impasses," in which contributors trace back early discourses on cinema and three-dimensionality (Paola Valentini) or cinema and hypnosis (Ruggero Eugeni) and simultaneously analyze recent realizations that look back to pre-cinema (Leonardo Quaresima).

30. Thomas Elsaesser, "The New Film History as Media Archaeology," *Cinémas*, 14.2–3 (2004), 85–86.

31. Lev Manovich, *The Language of New Media* (Cambridge, Mass.: MIT Press, 2001), 293–333; Siegfried Zielinski, *Cinema and Television as entr'actes in History* (Amsterdam: Amsterdam University Press, 1999).

32. Anne Friedberg, "The End of Cinema: Multimedia and Technological Change," in Christine Gledhill and Linda Williams, eds., *Reinventing Film Studies* (London: Arnold, 2000), 438–52.

33. Walter Benjamin, "Paralipomena und Varia zur zweiten Fassung von Das Kunstwerk im Zeitalter seiner technischen Reproduzierbarkeit," in *Gesammelte Schriften*, vol. 1, bk. 3, 1046.

34. Ibid. The sentence ends with these words: "in ways that clearly differentiate inspired works from those less successful."

35. Ibid.

36. Ibid.

37. "The dialectical image is an image that emerges suddenly, in a flash. What has been is to be held fast—as an image flashing up in the now of its recognizability." Walter Benjamin, *The Arcades Project*, trans. Howard Eiland and Kevin McLaughlin (Cambridge, Mass.: Belknap Press of Harvard University Press, 1999), 473 (N9, 7). Originally "Das Passagenwerk," in *Gesammelte Schriften,* vol. 5, bks. 1–2 (Frankfurt am Main: Suhrkamp, 1982). On dialectical images, see especially Susan Buck-Morss, *The Dialectics of Seeing: Walter Benjamin and the Arcades Project* (Cambridge, Mass.: MIT Press, 1989).

38. Benjamin, *Arcades*, 462 (N3, 1).

39. Ibid., 462–63 (N3, 1).

40. Ibid., 473 (N2a, 3).

41. The same sense of time underpins Mieke Bal's *Quoting Caravaggio: Contemporary Art, Preposterous History* (Chicago: University of Chicago Press, 1999). In her analysis of a series of contemporary works that quote Caravaggio and the Baroque,

Bal notes that the source becomes one inasmuch as the work authorizes it to do so. This leads to a reversal of the chronological order, "which puts what came chronologically first ('pre') as an effect behind ('post') its later recycling" (p. 7). I would like to add that such a process not only echoes relevant pages by Benjamin, but also recalls the deep rethinking of some traditional notions such as genealogy, causality, origin, and repetition that punctuates the twentieth century. Let's take for instance the Freudian concept of *Nachträglichkeit* (translated as *afterwardness* or *deferred action*): It emphasizes how the cause of a trauma is brought to light and constituted by the presumed effects that it creates (Sigmund Freud, "From the History of an Infantile Neurosis," in *Standard Edition of the Complete Psychological Works of Sigmund Freud*, vol. 17 [London: Hogarth Press, 1953–1974], 1–122). Or let's take the way in which Jacques Derrida empties out the idea of origin, erased by the intervention of a constant—and constituent—deferment (Jacques Derrida, *Of Grammatology*, trans. Gayatri Spivak [Baltimore, Md.: Johns Hopkins University Press, 1976]. Originally *De la Grammatologie* [Paris: Editions de Minuit, 1967]).

42. Eisenstein's project is reconstructed in *Notes for a General History of Cinema*, ed. Naum Kleiman and Antonio Somaini (Amsterdam: Amsterdam University Press, 2014). See also Antonio Somaini, *Ejženstejn. Il cinema, le arti, il montaggio* (Turin: Einaudi, 2011), 383–408.

Bibliography

"10 Tips for Better Movie Watching at Home," available at www.apartmenttherapy.com/10-tips-for-better-movie-watching-at-home-178616.

"7 Great Places to Watch Movies," available at http://movies.allwomenstalk.com/great-places-to-watch-movies.

Abel, Richard. *French Film Theory and Criticism: A History/Anthology, 1907–1939* (Princeton, N.J.: Princeton University Press, 1988).

Abercrombie, Nick and Brian Longhurst. *Audiences: A Sociological Theory of Performance and Imagination* (London: Sage, 1998).

Acland, Charles. *Screen Traffic* (Durham, N.C.: Duke University Press, 2003).

——. "Theatrical Exhibition: Accelerated Cinema," in Paul McDonald and Janet Wasko, eds., *The Contemporary Hollywood Film Industry* (Malden, Mass.: Blackwell, 2008), 83–105.

Acland, Charles, ed. *Residual Media* (Minneapolis: University of Minnesota Press, 2007).

Agamben, Giorgio. *Profanations* (New York: Zone Books, 2007). Originally *Profanazione* (Rome: Nottetempo, 2005).

——. *What Is an Apparatus?* (Stanford: Stanford University Press, 2009). Originally *Che cos'è un dispositivo?* (Rome: Nottetempo, 2006).

Agar, Jon. *Constant Touch* (Cambridge: Icon Books, 2003).

Albera, François and Maria Tortajada. *Cinema Beyond Film* (Amsterdam: Amsterdam University Press, 2010).

Albera, François and Maria Tortajada, eds. *Ciné-dispositifs* (Lausanne: L'Age d'Homme, 2011).

Allen, Robert C. "From Exhibition to Reception. Reflections on the Audience in Film History," *Screen*, 31.4 (1990), 347–56.

———. "Reimagining the History of the Experience of Cinema in a Post-Moviegoing Age," in Richard Maltby, Daniel Biltereyst, and Philippe Meers, eds., *Explorations in New Cinema History*, (London: Wiley-Blackwell, 2011): 41–57.

Altman, Charles. "Psychoanalysis and Cinema: The Imaginary Discourse," *Quarterly Review of Film Studies*, 2.3 (1977), 260–64.

Anderson, Brett. *Theo Kalomirakis' Private Theaters* (New York: Abrams, 1997).

Andrew, Dudley. "The Core and the Flow of Film Studies," *Critical Inquiry*, 35 (Summer 2009), 879–915.

———. *What Cinema Is!* (Oxford: Wiley-Blackwell, 2010).

Appadurai, Arjun. *Modernity at Large: Cultural Dimensions of Globalization* (Minneapolis: University of Minnesota Press, 1996).

Arnheim, Rudolf. *Film* (London: Faber & Faber, 1933). Originally *Film als Kunst* (Berlin: Ernst Rowohlt Verlag, 1932).

———. *La radio cerca la sua forma* (Milan: Hoepli, 1937).

———. *Film as Art* (Berkeley: University of California Press, 1957).

Aumont, Jacques. *Que reste-t-il du cinéma?* (Paris: Vrin, 2012).

Balázs, Béla. *Visible Man, Or the Culture of Film*, in *Béla Balázs: Early Film Theory*, ed. Erica Carter (New York: Berghahn Books, 2010), 1–90. Originally Béla Balázs, *Der sichtbare Mensch oder die Kultur des Films* (Vienna: Deutsch-Österreichischer Verlag, 1924).

Banda, Daniel and José Moure, eds. *Le cinéma: Naissance d'un art. 1895–1920* (Paris: Flammarion, 2008).

———. *Le cinéma: L'art d'une civilisation. 1920–1960* (Paris: Flammarion, 2011).

Barber, Charles. *Figure and Likeness: On the Limits of Representation in Byzantine Iconoclasm* (Princeton, N.J.: Princeton University Press, 2002).

Barker, Jennifer. *The Tactile Eye* (Berkeley: University of California Press, 2009).

Barthes, Roland. "Leaving the Movie Theater," in *The Rustle of Language*, trans. Richard Howard (Berkeley: University of California Press, 1986), 345–49. Originally "En sortant du cinéma," *Communications*, 23 (1975), 104–107; reprinted in *Le bruissement de la langue: essais critiques IV* (Paris: Seuil, 1984), 407–412.

Baudrillard, Jean. *Simulacra and Simulation*, trans. Sheila Glaser. (Ann Arbor: University of Michigan Press, 1994).

Baudry, Jean-Louis. "The Apparatus: Metapsychological Approaches to the Impression of Reality in the Cinema," *Camera Obscura*, 1 (Fall 1976), 104–126. Originally "Le Dispositif," *Communications*, 23 (1975), 56–72.

———. "Ideological Effects of the Basic Cinematographic Apparatus," in Philip Rosen, ed., *Narrative, Apparatus, Ideology* (New York: Columbia University Press, 1986), 286–98. Originally "Cinéma: *effets idéologiques* produits par l'appareil de base," *Cinéthique*, 7–8 (1970), 1–8.

Baumbach, Nico. "All That Heaven Allows," *Film Comment*, March 12, 14, and 16 (2012).

Bazin, André. *What Is Cinema?*, 2 vols., trans. and ed. Hugh Gray (Berkeley: University of California Press, 2005). Originally *Qu'est ce que le cinéma?* (Paris: Ed. du Cerf), vol. 1, *Ontologie et langage* (1958); vol. 2, *Le cinéma et les autres arts* (1959); vol. 3, *Cinéma et Sociologie* (1961); and vol. 4, *Une esthétique de la réalité: le néo-réalisme* (1962).

Bellour, Raymond. *L'Entre-Images: Photo, Cinéma, Vidéo* (Paris: La Différence, 1990).
———. *L'Entre-Images 2: mots, images* (Paris: POL, 1999).
———. *Le corps du cinéma* (Paris: POL, 2009).
———. *La querelle des dispositifs. Cinéma-Installations-expositions* (Paris: POL, 2012).
Belton, John. *Widescreen Cinema* (Cambridge, Mass.: Harvard University Press, 1992).
———. "Digital Cinema: A False Revolution?" *October*, 100 (Spring 2002), 98–114.
Benjamin, Walter. "Paralipomena und Varia zur zweiten Fassung von Das Kunstwerk im Zeitalter seiner technischen Reproduzierbarkeit," in *Gesammelte Schriften*, I/3, 1044–1051.
———. *Origin of German Tragic Drama* (London: NLB, 1977). Originally *Ursprung des deutschen trauerspiels* (Berlin: E. Rowohlt, 1928).
———. *Selected Writings*, ed. Michael W. Jennings et al. (Cambridge, Mass.: Belknap Press of Harvard University Press, 1996–2003). Originally *Gesammelte Schriften*, R. Tiedeman and H. Schweppenhäuser, eds, 7 vol. (Frankfurt: Suhrkamp, 1974–1989).
———. *The Arcades Project*, trans. Howard Eiland and Kevin McLaughlin (Cambridge, Mass.: Belknap Press of Harvard University Press, 1999). Originally "Das Passagenwerk," in *Gesammelte Schriften,* vol. 5.2 (Frankfurt am Main: Suhrkamp, 1982).
———. "Little History of Photography," in Michael W. Jennings, Brigid Doherty, and Thomas Y. Levin, eds., *The Work of Art in the Age of Its Technological Reproducibility, and Other Writings on Media* (Cambridge, Mass.: Belknap Press of Harvard University Press, 2008), 274–98. Originally "Kleine Geschichte der Photographie," in *Die Literarische Welt*, 38 (September 19, 1931), 3ff.; 39 (September 25, 1931), 3ff.; 40 (October 2, 1931), 7ff.
———. "The Work of Art in the Age of Its Technological Reproducibility. Second Version," in Michael W. Jennings, Brigid Doherty, and Thomas Y. Levin, eds., *Work of Art in the Age of Its Technological Reproducibility, and Other Writings On Media* (Cambridge, Mass.: Belknap Press of Harvard University Press, 2008), 19–55.
Berry, Chris, Janet Harbord, and Rachel Moore, eds. *Public Space, Media Space* (London: Palgrave MacMillan, 2013).
Berry, Chris, Soyoung Kim, and Lynn Spigel, eds. *Electronic Elsewheres* (Minneapolis: University of Minnesota Press, 2010).
BFI Statistical Yearbook 2013. Available at www.bfi.org.uk/sites/bfi.org.uk/files/downloads/bfi-statistical-yearbook-2013.pdf.
Blümlinger, Christa. *Kino aus zweiter Hand. Zur Ästhetik materieller Aneignung im Film und in der Medienkunst* (Berlin: Vorwerk 8, 2009).
Bolter, Jay David and Richard Grusin. *Remediation: Understanding New Media* (Cambridge, Mass.: MIT Press, 1999).
Bordwell, David. *Pandora's Digital Box: Films, Files, and the Future of Movies* (Madison, Wis.: Irvington Way Institute Press, 2012).
Brooker, Will and Deborah Jermyn, eds., *The Audience Studies Reader* (London: Routledge, 2003).
Bruno, Giuliana. *Atlas of Emotions: Journeys in Art, Architecture, and Film* (London: Verso, 2002).
Bruns, Axel. *Blogs, Wikipedia, Second Life, and Beyond: From Production to Produsage* (New York: Peter Lang, 2008).

Brütsch, Mathias et al., eds., *Kinogefühle. Emotionalität und Film* (Marburg: Schüren, 2005).
Buchsbaum Jonathan and Elena Gorfinkel, eds., "Cinephilia. What is Being Fought for by Today's Cinephilia(s)?" *Framework*, 50 (2009), 176–228.
Bull, Michael. "To Each Their Own Bubble: Mobile Spaces of Sound in the City," in Nick Couldry and Anna McCarthy, eds. *MediaSpace*, 275–93.
Burgin, Victor. *In/different Spaces : Place and Memory in Visual Culture*. (Berkeley: University of California Press, 1996).
———. *The Remembered Film* (London: Reaktion Books, 2006).
Bury, Rihannon and Li Johnson, "Is It Live or Is It Timeshifted, Streamed or Downloaded? Watching Television in the Era of Multiple Screens," *New Media and Society* (November 6, 2013), 1–16.
Caldwell, John T. "Welcome to the Viral Future of Cinema (Television)," *Cinema Journal*, 45.1 (2005), 90–97.
———. *Production Culture: Industrial Reflexivity and Critical Practice in Film and Television* (Durham, N.C.: Duke University Press, 2008).
———. "Hive-Sourcing Is the New Out-Sourcing: Studying Old (Industrial) Labor Habits in New (Consumer) Labor Clothes," *Cinema Journal*, 49.1 (Fall 2009), 160–67.
"Can you Watch a Movie on a Plane?" Available at http://mubi.com/topics/can-you-watch-a-movie-on-a-plane.
Canudo, Ricciotto. "Trionfo del cinematografo," *Il Nuovo Giornale*, December 25 (1908), 3.
———. "Reflections on the Seventh Art," in Abel, *French Film Theory*, 291–303. Originally "Réflection sur la septiéme art," in *L'usine aux images* (Paris: Chiron, 1926), 29–47.
———. "The Birth of a Sixth Art," in Abel, *French Film Theory*, 58–67. Originally "Naissance d'un sixiéme art. Essai sur le Cinématographe," in *Les Entretiens Idéalistes*, October 25 (1911), then in *L'usine aux images* (Paris: Séguier/Arte, 1995).
Carbone, Mauro. *An Unprecedented Deformation: Marcel Proust and the Sensible Ideas* (Albany, N.Y.: SUNY Press, 2010). Originally *Una deformazione senza precedenti. Marcel Proust e le idee sensibili* (Macerata: Quodlibet, 2004).
Carroll, Noël. *Theorizing the Moving Image* (Cambridge: Cambridge University Press, 1996).
Casetti, Francesco. *Communicative Negotiations in Cinema and Television* (Milan: VeP, 2001).
———. *Eye of the Century* (New York: Columbia University Press, 2008).
———. "Filmic Experience," in *Screen*, 50.1 (Spring 2009), 56–66.
Casetti, Francesco and Sara Sampietro. "With Eyes, with Hands: The Relocation of Cinema into the iPhone," in Pelle Snickars and Patrick Vonderau, eds., *Moving Data*, 19–32.
Casetti, Francesco and Mariagrazia Franchi, eds., *Terre incognite* (Florence: Carocci, 2006).
Cavell, Stanley. "The Avoidance of Love. A Reading of King Lear," in *Must We Mean What We Say?* (Cambridge: Cambridge University Press, 1969), 267–353.
———. *The World Viewed* (New York: Viking Press, 1971).

———. "The Fact of Television," *Daedalus*, 111.4 (Fall 1982), 75–96, reprinted in *Cavell on Film*, ed. William Rothman (Albany, N.Y.: SUNY Press, 2005), 59–85.
Cendars, Blaise. "The Modern: A New Art, the Cinema," in Abel, *French Film Theory*, 182–83. Originally "Modernités—Un nouveau art: le cinema," *La rose rouge*, 7 (June 12, 1919), 108; later merged into "L'ABC du cinéma," in *Aujourd'hui* (Paris: Grasset, 1931), 55–66.
Cherchi Usai, Paolo. *The Death of Cinema: History, Cultural Memory, and the Digital Dark Age* (London: British Film Institute Publishing, 2005).
Christie, Ian, ed. *Audience* (Amsterdam: Amsterdam University Press, 2012).
Cohen, Alain J. J. "Virtual Hollywood and the Genealogy of its Hyper-Spectator," in Melvyn Stokes and Richard Maltby, eds., *Hollywood Spectatorship*, 131–51.
Colomina, Beatriz. "Enclosed by Images: The Eameses Multimedia Architecture," *Grey Room*, 2 (Winter 2001), 6–29.
Computer History Museum. *Timeline of Computer History: Graphics & Games* (2006). Available at http://www.computerhistory.org/timeline/?category=gg.
Connolly, Maeve. "Temporality, Sociality, Publicness: Cinema as Art Project," *Afterall*, 29 (Spring 2012), 4–15.
Couldry, Nick. "The View from Inside the Simulacrum: Visitors' Tales from the Set of *Coronation Street*," *Leisure Studies*, 17.2 (1998), 94–107.
Couldry, Nick and Anna McCarthy, eds. *MediaSpace: Place, Scale and Culture in a Media Age*. (London: Routledge, 2003).
Crary, Jonathan. *Techniques of the Observer: On Vision and Modernity in the Nineteenth Century* (Cambridge, Mass.: MIT Press, 1990).
Creton, Laurent and Kira Kitsopanidou. *Les salles de cinema. Enjeux, defies et perspectives* (Paris: Armand Colin, 2013).
Cubitt, Sean. The Cinema Effect. (Cambridge, Mass.: MIT Press, 2004).
Curtis, David, A. L. Rees, Duncan White, and Steven Ball, eds., *Expanded Cinema: Art, Performance, Film* (London: Tate Publishing, 2011).
Daney, Serge. *Devant la recrudescence des vols de sacs à main. Cinéma, télévision, information: 1988–1991* (Lyon: Aléas, 1991).
de Certeau, Michel. *Practice of Everyday Life* (Berkeley: University of California Press, 1984). Originally *L'invention du quotidien* (Paris: Union générale d'éditions, 1980).
De Baecque, Antoine. *La cinéphilie. Invention d'un regard, histoire d'une culture. 1944–1968* (Paris : Fayard, 2003).
De Gaetano, Roberto. *La potenza delle immagini. Il cinema, la forma e le forze* (Pisa: ETS, 2012).
de Haas, Patrick. "Entre projectile et projet: Aspects de la projection dans les années vingt," in Dominique Paini, ed., *Projections, les transports de l'image* (Paris: Hazan / Le Fresnoy/AFAA, 1997), 95–126.
de Lauretis, Teresa and Stephen Heath, eds. *The Cinematic Apparatus* (London: MacMillan, 1980).
de Valck, Marijke and Malte Hagener, eds., *Cinephilia. Movies, Love and Memory* (Amsterdam: Amsterdam University Press, 2005).
Debray, Régis. *Vie et mort de l'image: une histoire du regard en Occident* (Paris: Gallimard, 1992).

Deleuze, Gilles. "Eight Years Later: 1980 Interview," in *Two Regimes of Madness*, 179. Originally "Huit ans après: entretien 80," in *Deux régimes de fous*, 162–66.

———. "Postscript to Societies of Control," *October*, 59 (1992), 3–7.

———. *Difference and Repetition*, trans. Paul Patton (New York: Columbia University Press, 1994). Originally *Différence et repetition* (Paris: Presses universitaires de France, 1976).

———. "What Is a *Dispositif?*" in *Two Regimes of Madness: Texts and Interviews 1975–1995* (New York: Semiotext(e), 2006), 338–48. Originally "Qu'est-ce qu'un dispositif?" in *Deux régimes de fous: textes et entretiens 1975–1995* (Paris: Éditions de Minuit, 2003), 316–25.

Deleuze, Gilles and Felix Guattari, *Anti-Oedipus: Capitalism and Schizophrenia*, trans. Robert Hurley, Mark Seem, and Helen R. Lane (New York: Viking Press, 1977). Originally *Anti-Œdipe* (Paris: Éditions de Minuit, 1972).

Delluc, Louis. "From Orestes to Rio Jim," in Abel, *French Film Theory*, 257. Originally "D'Oreste à Rio Jim," *Cinéa*, 32 (December 9, 1921), 14–15.

———. "The Crowd," in Abel, *French Film Theory*, 1:159–64. Originally "La foule devant l'écran," in Delluc, *Photogenie* (Paris: de Brunoff, 1920), 104–118.

Didi-Huberman, Georges. *Images in Spite of All: Four Photographs from Auschwitz*, trans. Shane B. Lillis (Chicago: The University of Chicago Press, 2008). Originally *Images malgré tout* (Paris: Minuit, 2003).

Dinsmore-Tuli, Uma. "The Pleasures of 'Home cinema,' or Watching Movies on Telly: An Audience Study of Cinephiliac VCR Use," *Screen*, 41.3 (2000), 315–27.

Dixon, Wheeler Winston. *Streaming. Movies, Media, and Instant Access* (Lexington: The University Press of Kentucky, 2013).

Doane, Mary Ann. "Scale and the Negotiation of 'Real' and 'Unreal' Space in the Cinema," in Lúcia Nagib and Cecília Mello, eds., *Realism and the Audiovisual Media* (New York: Palgrave Macmillan, 2009), 63–81.

Dubois, Philippe, Lucia Ramos Monteiro, and Alessandro Bordina, eds., *Oui, c'est du cinéma: formes et espaces de l'image en mouvement* (Paisan del Piave: Campanotto, 2009).

Dubois, Philippe, Frédéric Monvoison, and Elena Biserna, eds. *Extended cinema: Le cinéma gagne du terrain* (Pasian di Prato: Campanotto, 2010).

Edwards, Benj. "The (Misunderstood) Mac Portable Turns 20" (2009). Available at www.pcworld.com/article/172420/the_misunderstood_mac_portable_turns_20.htmlo.

Eisenstein, Sergei. "About Stereoscopic Cinema," *The Penguin Film Review*, 8 (January 1949), 35–45.

———. *Film Form* and *The Film Sense* (New York: Meridian Books, 1957).

———. "The Dynamic Square," in Jay Leyda, ed., *Film Essays, with a Lecture* (New York: Praeger, 1970), 48–65.

———. *Glass House*, ed. François Albera (Dijon: Les Presses du Réel, 2009).

———. *Notes for a General History of Cinema*, ed. Naum Kleiman and Antonio Somaini (Amsterdam: Amsterdam University Press, 2014).

Ellis, John. *Visible Fictions* (London: Routledge, 1992).

Elsaesser, Thomas. "The New Film History as Media Archaeology," *Cinémas*, 14.2–3 (2004), 85–86.

Elsaesser, Thomas, ed. *Harun Farocki: Working on the Sightlines* (Amsterdam: Amsterdam University Press, 2004).

Elsaesser, Thomas and Malte Hagener. *Film Theory: An Introduction through the Senses* (New York: Routledge, 2010).

Elsaesser, Thomas and Kay Hoffman, eds. *Cinema Futures: Cain, Abel, or Cable. The Screen Arts in the Digital Age.* (Amsterdam: Amsterdam University Press, 1998).

Epstein, Jean. "Magnification," in Abel, *French Film Theory*, 235–41. Originally "Grossissement," in *Bonjour Cinéma* (Paris: Editions de la Siréne, 1921), 93–108.

——. "The Senses 1(b)," in Abel, *French Film Theory*, 1 :241–46. Originally "Le Sens 1 bis," in *Bonjour Cinéma* (Paris: Editions de la Siréne, 1921), 27–44.

——. "The Cinema Seen from Etna," in Sarah Keller and Jason Paul, eds., *Jean Epstein: Critical Essays and New Translations* (Amsterdam: Amsterdam University Press, 2012), 287–92. Originally "Le Cinématographe vu de l'Etna," *Comoedia*, December 4 (1924), then in *Le Cinématographe vu de l'Etna* (Paris: Les Ecrivains Reunies, 1926).

Evans, Dean. "10 Memorable Milestones in Tablet History," *TechRadar* (January 31, 2011). Available at www.techradar.com/news/mobile-computing/10-memorable-milestones-in-tablet-history-924916.

Export, Valie. "Expanded Cinema as Expanded Reality," *Senses of Cinema*, 28 (2003). Available at http://sensesofcinema.com/2003/28/expanded_cinema/.

Fabbri, Gualtiero Ildebrando. *Al cinematografo* (Milan: P. Tonini, 1907).

Fanchi, Mariagrazia. *Spettatore* (Milan: Il Castoro, 2005).

——. *L'audience* (Bari, Laterza, 2014).

Faure, Elie. *The Art of Cineplastics* (Boston: The Four Seas Company, 1923). Originally "De la Cineplastique," in *L'arbre d'Eden* (Paris: Ed. Crest, 1922).

Feldmann, Eric. "Considérations sur la situation du spectateur au cinéma," *Revue Internationale de Filmologie,* 26 (1956), 83–97.

Flusser, Vilém. *Into the Universe of Technical Images* (Minneapolis: University of Minnesota Press, 2010). Originally *Ins Universum der technischen Bilder* (Berlin: European Photography, 1985).

Fossi, Giovanni. "Il pubblico del cinematografo," *Il Secolo Illustrato* (Milan), March 27 (1908); later in *La Rivista Fono-Cinematografica*, February 11 (1908), 20.

Foucault, Michel. "Of Other Spaces," *Diacritics* 16 (Spring 1986), 22–27. Originally Michel Foucault, "Des espaces autres" (conférence au Cercle d'études architecturales, 14 mars 1967), in *Architecture, Mouvement, Continuité*, 5 (October 1984), 46–49.

Fowler Katherine and Paola Voci, eds. "Screen Attachments. New Practices of Viewing Moving Images," a special issue of the e-journal *Screening the Past*, 32 (2011).

Freeburg, Victor O. *The Art of Photoplay Making* (New York: Macmillan, 1918).

Friedberg, Anne. "The End of Cinema: Multimedia and Technological Change," in Christine Gledhill and Linda Williams, eds., *Reinventing Film Studies* (London: Arnold, 2000), 438–52.

Gaudreault, André and Philippe Marion, "A Medium Is Always Born Twice …," *Early Popular Visual Culture*, 3.1 (May 2005), 3–15.

Gaut, Berys. *A Philosophy of Cinematic Art* (Cambridge: Cambridge University Press, 2010).

Geiger, Jeffrey, and Karen Littau, Cinematicity in media history (Edinburgh : Edinburgh University Press, 2013)
Gerbi, Antonello. "Iniziazione alle delizie del cinema," *Il Convegno*, 7.11–12 (November 25, 1926), 836–48.
Giovannetti, Eugenio. *Il cinema, arte meccanica* (Palermo: Sandron, 1930).
Gledhill, Christine and Linda Williams, eds. *Viewing Positions. Ways of Seeing Film* (New Brunswick, N.J.: Rutgers University Press, 1994).
Gomery, Douglas. *Shared Pleasure. A History of Movie Presentation in the United States* (Madison: Wisconsin University Press, 1992).
Gray, Jonathan. *Show Sold Separately: Promos, Spoilers and Other Media Paratexts* (New York: NYU Press, 2010).
Griffiths, Allison. *Shivers Down Your Spine: Cinema, Museums and the Immersive View* (New York: Columbia University Press, 2008).
Groys, Boris. "Iconoclasm as an Artistic Device. Iconoclastic Strategies in Film," in *Art Power* (Cambridge, Mass.: MIT Press, 2008), 67–81.
Guattari, Félix. "Towards a Post-Media Era," in Clemens Apprich, Josephine Berry Slater, Antony Iles, and Oliver Lerone Schultz, eds., *Provocative Alloys: A Post-Media Anthology* (Mute-Posty Media Lab, 2013), 26–7.
Gunning, Tom. "Re-Newing Old Technologies: Astonishment, Second Nature, and the Uncanny in Technology from the Previous Turn-of-the-Century," in David Thorburn and Henry Jenkins, eds., *Rethinking Media*, 39–59.
——. "The Cinema of Attraction: Early Film, Its Spectator, and the Avant-Garde," *Wide Angle*, 8.3–4 (1986), 63–70.
——. "An Aesthetic of Astonishment: Early Film and the [In]Credulous Spectator," *Art and Text* (Fall 1989).
——. "Moving Away from the Index: Cinema and the Impression of Reality," *Differences*, 18.1 (2007), 29–52.
——. "The Sum of Its Pixels," *Film Comment*, 43.5 (September–October 2007), 78.
Habermas, Jürgen. "The Public Sphere: An Encyclopedia Article," in Meenaskshi Gigi Durham and Douglas M. Keller, eds., *Media and Cultural Studies* (Malden, Mass. : Blackwell, 2006), 73–78.
Hagener, Malte. "The Aesthetics of Displays: From the Window on the World to the Logic of the Screen," in Leonardo Quaresima, Laura Ester Sangalli, and Fedrico Zocca, eds., *Cinema e fumetto / Cinema and Comics* (Udine: Forma, 2009), 145–55.
——. "Where Is Cinema (Today)? The Cinema in the Age of Media Immanence," *Cinema & Cie*, 11 (Fall 2008), 15–22.
Hansen, Mark B. N. *New Philosophy for New Media* (Cambridge: MIT Press, 2004)
Hansen, Miriam. "Early Cinema, Late Cinema: Transformations of the Public Sphere," in Christine Gledhill and Linda Williams, eds. *Viewing Positions*, 134–52.
Hansen, Miriam Bratu. *Cinema and Experience: Siegfried Kracauer, Walter Benjamin, and Theodor W. Adorno* (Berkeley: University of California Press, 2012).
Harbord, Janet. *Film Cultures* (London: Sage, 2002).
——. *The Evolution of Film* (Cambridge: Polity Press, 2007).
Heath, Stephen. "Notes on Suture," *Screen*, 18 (Winter 1977–78), 66–76.
Hediger, Vinzenz. "Lost in Space and Found in a Fold. Cinema and the Irony of the Media," in Gertrud Koch and Volker Pantenburg, eds., *Screen Dynamics*, 61–77.

Huhtamo, Erkki. "Messages on the Wall. An Archaeology of Public Media Displays," in Scott McQuire, Meredith Martin, and Sabine Niederereds, eds., *Urban Screen Reader*, 15–28.

———. "Elements of Screenology: Toward an Archaeology of the Screen," *ICONICS: International Studies of the Modern Image*, 7 (2004), 31–82.

Jay, Martin. *Songs of Experience. Modern American and European Variations on a Universal Theme* (Berkeley: University of California Press, 2005).

Jenkins, Bruce. "Fluxfilms in Three False Starts," *In the spirit of Fluxus*, ed. Janet Jenkins (Minneapolis: Walker Art Center, 1993), reprinted in Tanya Leighton, *Art and the Moving Image*, 53–71.

Jenkins, Henry. "The Revenge of the Origami Unicorn: Seven Principles of Transmedia Storytelling." Available at http://henryjenkins.org/2009/12/the_revenge_of_the_origami_uni.html (first part); http://henryjenkins.org/2009/12/revenge_of_the_origami_unicorn.html (second part).

———. *Convergence Culture: Where Old and New Media Collide* (New York: New York University Press, 2006).

———. *Fans, Bloggers, Gamers: Exploring Participatory Culture* (New York: NYU Press, 2006).

———. "Transmedia Story-telling 101" (March 22, 2007). Available at http://henryjenkins.org/2007/03/transmedia_storytelling_101.html.

Joselit, David. *Feedback: Television against Democracy* (Cambridge, Mass.: MIT Press, 2007).

Joseph, Branden W. "My Mind Split Open. Andy Warhol's Exploding Plastic Inevitable," *Greyroom*, 8 (2002), 80–107.

Klemens, Guy. *The Cellphone: The History and Technology of the Gadget that Changed the World* (Jefferson, N.C.: McFarland, 2010).

Klinger, Barbara. "Cinema's Shadows. Reconsidering Non-theatrical Exhibition," in Richard Maltby, Melvin Stokes, and Robert C. Allen, eds., *Going to the Movies*, 273–90.

———. "The Contemporary Cinephile: Film Collecting in the Post Video Era," in Melvyn Stokes and Richard Maltby, eds., *Hollywood Spectatorship*, 131–51.

———. *Beyond the Multiplex. Cinema, the New Technologies, and the Home* (Berkeley: University of California Press, 2006).

Koch, Gertrud, Simon Rothöhler, and Volker Pantenburg, eds. *Screen Dynamics: Mapping the Borders of Cinema* (Wien: Filmmuseum/Synema, 2012).

Kracauer, Sigfried. *The Mass Ornament: Weimar Essays*, ed. and trans. Thomas Y. Levin (Cambridge, Mass.: Harvard University Press, 1995). Originally *Das Ornament der Masse* (Frankfurt: Suhrkamp, 1963).

Krauss, Rosalind. *Voyage on the North Sea: Art in the Age of the Post-Medium Condition* (New York: Thames & Hudson, 2000).

Kuhn, Annette. *Dreaming of Fred and Ginger: Cinema and Cultural Memory* (New York: New York University Press, 2002).

L'Herbier, Marcel. "Hermes and Silence," in Abel, *French Film Theory*, 147–55. Originally "Hermès et le silence," in *Le Temps*, February 23 (1918), then in a larger version in *Intelligence du cinématographe* (Paris: Correa, 1946), 199–212.

———. "Esprit du cinématographe," *Les Cahiers du mois*, 16–17 (1925), 29–35.

Landow, George. *Hypertext 3.0: Critical Theory and New Media in an Era of Globalization* (Baltimore, Md.: Johns Hopkins University Press, 2006).
Lardner, James. *Fast Forward. Hollywood, the Japanese, and the Onslaught of the VCR* (New York: Norton, 1987).
Latour, Bruno. *Reassembling the Social. An Introduction to Actor-Network-Theory* (New York: Oxford University Press, 2005).
Lauer, Josh. "Surveillance History and the History of New Media: an Evidential Paradigm," *New Media and Society*, 14.4 (2012), 566–82.
Leadbeater, Charles and Paul Miller. *The Pro-Am Revolution: How Enthusiasts are Changing our Economy and Society* (London: Demos, 2004).
Lee, Pamela. "Bare Lives," in Tanya Leighton, ed., *Art and the Moving Image*, 141–57.
Leighton, Tanya, ed. *Art and the Moving Image. A Critical Reade.* (London: Tate and Afterall, 2008).
Levi, Pavle. *Cinema by Other Means* (Oxford: Oxford University Press, 2012).
Levin, Thomas Y. "Rhetoric of the Temporal Index: Surveillant Narration and the Cinema of 'Real Time,' " in *CTRL [SPACE]: Rhetorics of Surveillance from Bentham to Big Brother* (Cambridge, Mass.: MIT Press, 2002), 578–93.
Levine, Laura E., Bradley M. Waite, and Laura L. Bowman. "Mobile Media Use, Multitasking and Distractibility," *International Journal of Cyber Behavior, Psychology and Learning*, 2.3 (2012), 15–29.
Lindsay, Vachel. *The Art of the Moving Picture* (New York: Macmillan, 1922).
Livingstone, Sonia. "Taking Risky Opportunities in Youthful Content Creation: Teenagers' Use of Social Networking Sites for Intimacy, Privacy and Self-Expression," *New Media and Society*, 10.3 (2008), 393–411.
Lukács, Georg. "Thoughts on an Aesthetics of 'Cinema,' " in Richard W. McCormick and Alison Guenther-Pal, eds., *German Essays on Film*, 11–16. Originally "Gedanken zu einer Ästhetik des Kino," *Frankfurter Allgemeine Zeitung*, 251 (September 10, 1913), 1–2; a previous version appears in *Pester Lloyd* (Budapest), April 16 (1911), 45–46.
Lull, James. "The Push and Pull of Global Culture," in James Curran and David Morley, eds., *Media and Cultural Theory* (London: Routledge, 2006), 44–58.
Maltby, Richard and Melvyn Stokes, eds. *Hollywood Abroad: Audiences and Cultural Exchange* (London, BFI, 2004).
Maltby, Richard, Daniel Biltereyst, and Philippe Meers, eds. *Explorations in New Cinema History. Approaches and Case Studies* (London: Wiley-Blackwell, 2011).
Maltby, Richard, Philippe Meers, and Daniel Biltereyst, eds. *Audiences, Cinema and Modernity: New Perspectives on European Cinema History* (London: Routledge, 2012).
Maltby, Richard, Melvyn Stokes, and Robert C. Allen, eds. *Going to the Movies: Hollywood and the Social Experience of Cinema* (Exeter: University of Exeter Press, 2007).
Manovich, Lev. *The Language of New Media* (Cambridge, Mass.: MIT Press, 2000).
Marchessault, Jeanine and Susan Lord, eds. *Fluid Screens, Expanded Cinema* (Toronto: University of Toronto Press, 2007).
Marks, Laura U. *The Skin of the Film. Intercultural Cinema, Embodiment, and the Senses* (Durham, N.C.: Duke University Press, 2000).
McCormick, Richard W. and Alison Guenther-Pal. *German Essays on Film* (New York: Continuum, 2004).

McDonald, Paul and Janet Wasko, eds. *The Contemporary Hollywood Film Industry* (Malden, Mass.: Blackwell, 2008).

McLuhan, Marshall. *Understanding Media: The Extensions of Man* (New York: McGraw-Hill, 1964).

McPherson, Tara. "Reload: Liveness, Mobility, and the Web," in Wendy Hui Kyong Chun and Thomas Keenan, eds., *New Media, Old Media* (London: Routledge, 2006), 199–208.

McQuire, Scott. "The Politics of Public Space in the Media City," *First Monday. An Electronic Journal,* 4 (February 2006). Available at http://firstmonday.org/htbin/cgiwrap/bin/ojs/index.php/fm/article/view/1544/1459.

McQuire, Scott, Meredith Martin, and Sabine Niederereds, eds. *Urban Screen Reader* (Amsterdam: Institute of Network Cultures, 2009).

Melnick, Ross. *American Showman: Samuel "Roxy" Rothafel and the Birth of the Entertainment Industry, 1908–1935* (New York: Columbia University Press, 2012).

Metz, Christian. *The Imaginary Signifier: Psychoanalysis and Cinema* (Bloomington: Indiana University Press, 1982). Originally *Le significant imaginaire: Psychanalyse et cinéma* (Paris: UGD, 1977).

Meyrowitz, Joshua. *No Sense of Place* (New York: Oxford University Press, 1985).

Michaud, Philippe-Alain. *Le mouvement des images / The Movement of Images* (Paris: Centre Pompidou, 2006).

Michotte, Albert. "Le caractére de 'réalité' des projections cinematographiques." *Revue Internationale de Filmologie,* 3–4 (1948), 249–61.

Mitchell, W. J. T. *The Reconfigured Eye: Visual Truth in the Post Photographic Era* (Cambridge, Mass.: MIT Press, 1992).

Mitchell, W. J. T. and Mark B. N. Hansen. *Critical Terms for Media Studies* (Chicago: University of Chicago Press, 2010).

Moholy-Nagy, Lázló. *The New Vision: Fundamentals of Design, Painting, Sculpture, Architecture* (New York: W. W. Norton, 1938; reprinted New York: Wittemborn, 1947). Originally "Von Material zu Architektur," *Bauhaus Buch* 14 (Munich: Langen, 1929)

——. *Painting, Photography, Film* (Cambridge, Mass.: MIT Press, 1969). Originally *Malerei Photografie Film* (Munich: Albert Langen, 1925).

Mondzain, Marie-José. *Image, Icon, Economy: The Byzantine Origins of the Contemporary Imaginary,* trans. Rico Franses (Stanford: Stanford University Press, 2005). Originally *Image, icône, économie: les sources byzantines de l'imaginaire contemporain* (Paris: Editions du Seuil, 1996).

Montani, Pietro. *Bioestetica* (Firenze: Carocci, 2007).

——. *L'immaginazione intermediale* (Bari: Laterza, 2010).

Moores, Shaun. "The Doubling of Place: Electronic Media, Time-Space Arrangements and Social Relationships," in Nick Couldry and Anna McCarthy, eds. *Media Space,* 21–37.

Morin, Edgar. "Recherches sur le public cinématographique," *Revue Internationale de Filmologie,* 12.4 (January–March 1953), 3–19.

——. *The Cinema, or, the Imaginary Man,* trans. Lorraine Mortimer (Minneapolis: University of Minnesota Press, 2005). Originally *Le cinéma ou l'homme imaginaire: Essai d'anthropologie sociologique* (Paris: Minuit, 1956).

Morley, David. *Television, Audiences and Cultural Studies* (London: Routledge, 1992).

———. "What's 'Home' Got to Do with It?: Contradictory Dynamics in the Domestication of Technology and the Dislocation of Domesticity," *European Journal of Cultural Studies*, 6.4 (November 2003), 435–58.

———. *Media, Modernity and Technology* (London: Routledge, 2007).

MPAA Theatrical Market Statistics 2012, available at www.mpaa.org/resources/3037b7a4-58a2-4109-8012-58fca3abdf1b.pdf.

MPAA Theatrical Market Statistics 2013, available at www.mpaa.org/wp-content/uploads/2014/03/MPAA-Theatrical-Market-Statistics-2013_032514-v2.pdf.

Mulvey, Laura. *Death 24X a Second: Stillness and the Moving Image* (London: Reaktion Books, 2006).

Odin, Roger. *Cinéma et production de sens* (Paris: Armand Colin, 1990).

———. "Spectator, Film and the Mobile Phone," in Ian Christie, ed., *Audience* (Amsterdam: Amsterdam University Press, 2012), 155–69.

Odin, Roger, ed. *Le film de famille, usage privé, usage public* (Paris: Méridiens-Klincksieck, 1995).

Oudart, Jean Pierre. "La suture II," *Cahiers du Cinéma*, 212 (1969).

———. "L'effet de réel," *Cahiers du cinéma*, 228 (1971), 19–26.

———. "Cinema and Suture," *Screen*, 18 (Winter 1977–78), 35–47. Originally "La suture," *Cahiers du Cinéma*, 211 (1969).

Pantemburg, Volker. "1970 and Beyond," in Gertrud Koch, Volker Pantemburg, Simon Rothöler, eds., *Screen Dynamics*, 78–92.

Papini, Giovanni. "La filosofia del cinematografo," *La Stampa*, May 18 (1907), 1–2.

Pedullà, Gabriele. *In Broad Daylight* (London: Verso, 2012). Originally *In piena luce* (Milan: Bompiani, 2008).

Pirandello, Luigi. *Shoot!* trans. C. K. Scott Montcrieff (Chicago: University of Chicago Press, 2005). Originally *Si gira*, in *Nuova Antologia* (June 1–August 16), 1915, then in a single volume (Milan: Fratelli Treves, 1916). Republished with minor changes and a new title, as *Quaderni di Serafino Gubbio operatore* (Firenze: Edizioni Bemporad, 1925).

Plantinga, Carl. *Moving Viewers: American Films and the Spectator's Experience* (Berkeley: University of California Press, 2009).

Prince, Stephen. "True Lies: Perceptual Realism, Digital Images, and Film Theory," *Film Quarterly*, 49.3 (Spring 1996), 27–37.

Quaresima, Leonardo, ed. "Dead Ends/Impasses," special issue of *Cinema & Cie*, 2 (Spring 2003).

Rancière, Jacques. *The Politics of Aesthetics: The Distribution of the Sensible* (New York: Continuum, 2004). Originally *Le partage du sensible* (Paris: Fabrique, 2000).

———. *The Film Fables* (Oxford: Berg, 2006). Originally *La fable cinématographique* (Paris: Seuil, 2001).

Renan, Sheldon. *An Introduction to the American Underground Film* (New York: Dutton, 1967).

Rodowick, David. *The Virtual Life of Film* (Cambridge, Mass.: Harvard University Press, 2007).

Romains, Jules. "The Crowd at the Cinematograph," in Abel, *French Film Theory*, 1:53–54. Originally "La foule au cinématographe," *Les puissances de Paris* (Paris: Eugène Figuière, 1911), 118–20.

Rombes, Nicholas. *Cinema in the digital age* (London and New York : Wallflower Press, 2009).

Rosen, Philip ed. *Narrative, Apparatus, Ideology* (New York: Columbia University Press, 1986).

Ross, Miriam. "The 3-D Aesthetic: Avatar and Hyperhaptic Visuality," *Screen*, 53.4 (Winter 2012), 381–97.

Sander, Philip. "Out of the Screen and into the Theater: 3-D Film as Demo," *Cinema Journal*, 50.3 (Spring 2011), 62–78.

Scaglione, Emilio. "Il cinematografo in provincia," *L'Arte Muta* (Naples), no. 6–7 (December 15, 1916–January 15, 1917), 14–16.

Scannel, Paddy. *Radio, Television and Modern Life. A Phenomenological Approach* (Oxford: Blackwell, 1996).

Schlemmer, Oskar, László Moholy-Nagy, and Farkas Molnár. *The Theater of the Bauhaus* (Middletown, Conn.: Wesleyan University Press, 1961).

Schmidt, Jan. "Blogging Practices: An Analytical Framework," *Journal of Computer-Mediated Communication*, 12.4 (2007), 1409–1427.

Serner, Walter. "Cinema and the Desire to Watch," in Richard W. McCormick and Alison Guenther-Pal, eds., *German Essays on Film*, 17–20. Originally "Kino und Schaulust," in *Die Schaubühne*, 9 (1913), 807–811.

Shaw, Jeffrey and Peter Weibel, eds. *Future Cinema. The Cinematic Imaginary After Film* (Cambridge, Mass.: MIT Press, 2003).

Singer, Ben. "Early Home Cinema and the Edison Home Projecting Kinetoscope," *Film History*, 2.1 (Winter 1988), 37–69.

Sloterdijk, Peter. *Bubbles: Spheres Volume I* (Los Angeles: Semiotext(e), 2011). Originally *Sphären, Band I: Blasen* (Frankfurt am Main: Suhrkamp, 1998).

Snickars, Pelle and Patrick Vonderau, eds. *The YouTube Reader* (Stockholm: National Library of Sweden, 2009).

——. *Moving Data: The iPhone and the Future of Media* (New York: Columbia University Press, 2012).

Sobchack, Vivian. *The Address of the Eye: A Phenomenology of Film Experience* (Princeton, N.J.: Princeton University Press, 1992).

Somaini, Antonio. " 'L'oggetto attualmente più importante dell'estetica.' Benjamin, il cinema come *Apparat*, e il '*Medium* della percezione,' " *Fata Morgana*, 20 (2013), 117–46.

Sontag, Susan. "The Decay of Cinema," *New York Times*, February 25, 1996. Available at www.nytimes.com/books/00/03/12/specials/sontag-cinema.html.

Sonvilla Weiss, Stefan. *Mashup Cultures* (Wien: Springer Verlag-Vienna, 2010).

Spiegel, Lynn. "Designing the Smart House: Posthuman Domesticity and Conspicuous Production," in Chris Berry, Soyoung Kim, and Lynn Spigel, eds. *Electronic Elsewheres*, 55–92.

Steyerl, Hito. "In Defense of the Poor Image," *e-flux* 11 (2009). Available at www.e-flux.com/journal/view/94, then in *The Wretched of the Screen* (Berlin: Sternberg Press, 2012), 31–45.

Stokes, Melvyn and Richard Maltby, eds. *American Movie Audiences: From the Turn of the Century to the Early Sound Era* (London: BFI, 1999).

——. *Identifying Hollywood's Audiences* (London: BFI, 1999).

———. *Hollywood Spectatorship: Changing Perceptions of Cinema Audiences* (London: BFI, 2001).

Strauven, Wanda. "Early Cinema's Touch(able) Screen: From Uncle Josh to Ali Barbouyou," *Necsus*, (1), 2 (2012). Available at www.necsus-ejms.org/early-cinemas-touchable-screens-from-uncle-josh-to-ali-barbouyou/.

Straw, Will. "Proliferating Screens," *Screen*, 41 (Spring 2000), 115–19.

Teige, Karel. "The Aesthetics of Film and Cinégraphie," in Jaroslav Andel and Petr Szczepanik, eds., *Cinema All the Time: An Anthology of Czech Film Theory and Criticism* (Prague: National Film Archive, 2008), 147. Originally "Estetika filmu a kinografie," *Host*, 3.6–7 (April 1924), 143–54.

"The iPad Enables a New Age of Personal Cinema," available at www.forbes.com/sites/anthonykosner/2012/04/14/the-ipad-enables-a-new-age-of-personal-cinema-welcome-to-the-feelies/.

"The Key Rules of Watching a Movie at Home Properly," available at www.denofgeek.us/movies/18885/the-key-rules-of-watching-a-movie-at-home-properly.

"The Most Pirated Movies," available at http://torrentfreak.com/project-x-most-pirated-movie-of-2012-121227/.

"The Screen Is Silver, but the Seats Are Gold. AMC Theaters Lure Moviegoers With Cushy Recliners," *New York Times*, October 18 (2013).

"The Ultimate Home Cinema Experience," available at http://homecinemamodules.nl/english/.

"The Weird Experience of Watching Movies on Planes," available at www.denofgeek.us/movies/21761/the-weird-experience-of-watching-movies-on-planes.

Thorburn, David and Henry Jenkins, eds. *Rethinking Media Change. The Aesthetics of Transition* (Cambridge, Mass.: MIT Press, 2003).

Toddi, Enrico. "Rettangolo-Film (25 x 19)," *In penombra* 1.3 (August 25, 1918), 121–23.

Toffler, Alvin. *The Third Wave* (New York: Bantam, 1980).

"Top 10 Most Pirated Movies of 2012," available at www.heyuguys.co.uk/top-10-most-pirated-movies-of-2012/.

Tryon, Chuck. *Reinventing Cinema. Movies in the Age of Media Convergence* (New Brunswick, N.J.: Rutgers University Press, 2009).

———. *On-Demand Culture. Digital Delivery and the Future of Movies* (New Brunswick, N.J.: Rutgers University Press, 2013).

Turvey, Malcom. "Seeing Theory," in Richard Allen and Murray Smith, eds., *Film Theory and Philosophy* (Oxford: Oxford University Press, 1997), 431–57.

Urry, John. *Sociology beyond Societies: Mobilities for the Twenty-First Century* (New York: Routledge, 2000).

Valéry, Paul. "The Conquest of Ubiquity," in *Aesthetics* (New York: Pantheon Books, 1964), 225–28. Originally "La conquête de l'ubiquité," in *Pièces sur l'art* (Paris: Darantière, 1931), 79–85. First version: *De la musique avant toute chose* (Paris: Editions du Tamburinaire, 1928).

Vancheri, Luc. *Cinémas contemporains. Du film à l'installation* (Lyon: Aléas, 2009).

Vertov, Dziga. "Kinoks: A Revolution," in *Kino-Eye: The Writings of Dziga Vertov*, trans. Kevin O'Brien, ed. Annette Michelson (Berkeley: University of California Press, 1984), 11–12.

Voci, Paola. *China on Video: Smaller-Screen Realities* (London: Routledge, 2010).

———. "Online Small-Screen Cinema: The Cinema of Attractions and the Emancipated Spectator," in Carlos Rojas and Eileen Chow, eds., *The Oxford Handbook of Chinese Cinemas* (Oxford: Oxford University Press, 2013), 377–97.

Vuillermoz, Emile. "Before the Screen: Hermes and Silence," in Abel, *French Film Theory*, 155–159. Originally "Devant l'écran: Hermès et le silence," in *Le Temps*, March 9 (1918), 3.

Waller, Gregory A. "Locating Early Non-Theatrical Audiences," in Ian Christie, ed., *Audience*, 81–95.

Wasson, Haidee. "The Networked Screen: Moving Images, Materiality, and the Aesthetic of Size," in Jeanine Marchessault and Susan Lord, eds., *Fluid Screen, Expanded Cinema*, 74–95.

———. *Museum Movies: The Museum of Modern Art and the Birth of Art Cinema* (Berkeley: University of California Press, 2005).

Williams, Raymond. *Television: Technology and Cultural Form* (New York: Schocken Books, 1974).

Youngblood, Gene. *Expanded Cinema* (New York: Dutton, 1970).

Zielinski, Siegfried. *Cinema and Television as entr'actes in History* (Amsterdam: Amsterdam University Press, 1999).

Index

"About Stereoscopic Cinema" (Eisenstein), 116–17, 147
absent subject, 84
Academy of Motion Picture Arts and Sciences, 113
acceptance, 32, 209
access, 145–46
adaptation, 83–84
adhesion, 11, 124
The Adjuster, 179–83
advertisements, 19
aestheticization, 136–37
aesthetics, 64; technology fused with, 103
afterwardness, 263
Agamben, Giorgio, 78–79, 88–89, 236n27
agencement (assemblage), 81
agnition, 32
airplanes (in-flight films), 36–37, 224n38
Albano, Lucilla, 74
Albera, François, 75, 81
Allen, Robert C., 45, 189, 257n16
allwomenstalk.com, 35
AMC Theaters, 246n18
Anger, Kenneth, 91
anti-essentialism, 6

Antonioni, Michelangelo, 2
apartmenttherapy.com, 36
Appadurai, Arjun, 29, 132
apparatus, 14, 69, 75; assemblage and, 80; cinematic dispositive as, 75–78; theory, 77, 235n20, 236n27
Apple Newton Message Pad, 253n34
Arab Spring, 18, 172
Arnheim, Rudolf, 24, 251n25–252n25
Arnold, Jack, 116, 147
art: cinema, 95; cinema compared to, 18; essential condition of, 224n40; mechanical, 21; performance, 90; resistance to, 261n18; sixth, 63–64
Artaud, Antonin, 179, 183
Artaud Double Bill, 180, 184, 194
Arts and Crafts movement, 125
Asia Pacific market, 3
AskJack, 187
assemblage, 10, 69; apparatus and, 80; cinematic dispositive as, 81–87;; emergence of, 78–81
astonishment, 23
attendance, 185–86, 195; performance and, 199–200

attention, 13; multitasking and, 30–31
attraction: cinema of, 150; force of, 187
audience: dispersed, 184; imagined, 73; movie watching with, 55. *See also* semi-audiences
augmented reality, 165–66
Aumont, Jacques, 192, 219*n*29
authenticity, 10, 40–42; of relocated cinema, 63–66
Auto Kino, 134
automatism, 85–86
automobile, 224*n*38
avant-garde cinema, 111
Avatar, 117, 123, 147
The Avengers, 47
awareness, 11

back-to-the-cinema experience, 31, 33
Bal, Mieke, 262*n*41–263*n*41
Balázs, Béla, 21, 23, 115, 158
Barry, Iris, 54–55, 231*n*26
Barthes, Roland, 56–57, 141, 184, 204
Battleship Potemkin, 152–53
Baudelaire, Charles, 145
Baudry, Jean-Louis, 76–77
Bauhaus school, 93
Baumbach, Nico, 64–65
Bazin, André, 24, 65–66
become-cinema, 112–14
behavior, rules of, 133
Bellour, Raymond, 39, 87–88, 94, 206, 238*n*54
Belson, Jordan, 103
Belton, John, 6
Benjamin, Walter, 20, 24, 26, 34, 40–41, 148–49, 207, 211–13, 261*n*18, 262*n*37
Bergman, Ingrid, 159
Betamax, 51, 230*n*17
BFI Statistical Yearbook 2013, 46, 229*n*7
bifurcation, 135
Bigelow, Kathryn, 104, 120
billboards, 51–52, 135
Bin Laden, Osama, 120
"The Birth of a Sixth Art" (Canudo), 22, 115
blackboards, 164–65
Blade Runner, 52

The Blair Witch Project, 121
Blockbuster, 18, 55
blogs, 108, 166, 187, 257*n*20
Blu-ray Discs, 46, 148
Bontempelli, Massimo, 150
Bordwell, David, 6, 77
The Bourne Identity, 123
The Bourne Ultimatum, 123–24
box office returns, 45–46
Brakhage, Stan, 103
bricolage, 92
bricoleur, 189–90
British Film Institute, 18, 46
bubble, 71–72; existential, 73
bulletin boards, 164–65
Burgin, Victor, 140
business cards, 135

Cage, John, 104
Caldwell, John, 107
camera obscura, 76
Cameron, James, 117, 123, 147, 261*n*26, 262*n*27
Cannes Film Festival, 1
canon, 14
Canudo, Ricciotto, 22, 63–64, 115, 176
Carbone, Mauro, 227*n*68
Carpenter, John, 200
Carrol, Noël, 6, 77
catharsis, 183, 256*n*11
Cavell, Stanley, 85, 182, 256*n*13
cell phone: in China, 254*n*46; history of, 234*n*2; screens, 30
cellular networks, 252*n*32
celluloid film, 64
Cendrars, Blaise, 23, 38
Certeau, Michel de, 26, 132, 245*n*7
CGI. *See* computer-generated imagery
Chambre 666, 1–2
Charleston City Paper, 35
Chelsea Girls, 161
China, 254*n*46
Chinese Theatre, 61
cinema: of adhesion, 124; aftermath of, 211–13; art, 95; art compared to, 18; assemblage, 81–87; of attractions, 150; beyond, 160–62; components

of, 69; conditions of, 250n15; of consciousness, 124; contradictory presence of, 173–74; cybernetic, 104; definition of, 251n19; of dispersion, 124; domestic, 252n26; environments of, 133–37; expanded, 3–4, 11, 91, 127, 240n3; expanded, circa 1970, 102–5; expanded, circa 2013, 105–10; extended, 3; flexibility of, 95–96; heart of, 210; as hieroglyphs, 66; history of, 211–14; home, 94; as icon, 61–63; idea of, 14, 33–35, 209, 227n73; identity of, 15; indexicality of, 110; instability of, 90–92; invasion of, 149–50; light, 106, 240n13; mechanical, 222n16; media interconnected with, 104; migration of, 225n60–226n60; as modality, 56; multifaceted profile of, 122–24; needs for, 84; as object, 55–56; as pedagogy, 51; perimeters of, 92–95; permanence of, 215, 223n29; persistence of, 4, 8, 38–40, 211; as portal, 175–77; recognition of, 33; as relic, 61–63; reproduced reality in, 222n23; as ritual, 35; as sixth art, 63–64; topography of, 196; transformation of, 7–8. See also relocated cinema; *specific cinema types*
cinema-beyond-cinema experience, 31, 33
cinéma d'auteur, 122
cinéma d'exposition, 3, 218n9
Cinema Paradiso, 43–45, 59, 62–63
CinemaScope, 96
Cinémathèque Française, 113
cinematic dispositive, 69, 74–75, 237n41; as apparatus, 75–78. See also dispositive
cinematic experience, 4–8; back-to-the-cinema, 31–33; bifurcation of, 56–57; of cinema-beyond-cinema, 31–33; classic, 141–42; contagiousness of, 26; redefinition of, 37–38; re-experiencing, 60; schism of, 53–57
cinematicity, 139, 214
cinematic language, 6

cinematic narration, in new media, 110
cinematographic experience (as opposed to filmic experience), 56–57
Cinemax, 50
cinephilia, 64–65, 233n45
Circorama, 96
Clair, René, 159, 249n68
Clayton, Jack, 118
cognitive acts, 5
cognitive doing, 186
collaboration, 100
Comingsoon.net, 108–9
composite spectacles, 258n42
computer films, 104
computer-generated imagery (CGI), 109–10
computers, 109–10, 145; in China, 254n46; desktop, 252n31
computer screens, 30
concentration (as opposed to distraction), 148
Connolly, Maeve, 134
"The Conquest of Ubiquity" (Valery), 26–7
consciousness, 124
consecration, 79
"Considérations sur la situation du spectateur au cinéma" (Feldmann), 141–42
Constellation TV, 72
consumption: distraction and, 74; forms of, 235n13; practices of, 82; production and, 111
contemporary cinemas, 3
contingence, 139–41
convergence, 14, 198, 259n46
Crary, Jonathan, 77–78
creativity: diffused, 103; mass, 106; of recognition, 39
The Creature from the Black Lagoon, 116, 147
Criterion Collection, 114
cult films, 188
cult objects, 185–86
cultural forms, 19

cybernauts, 146
cybernetic cinema, 104

Daney, Serge, 112, 242*n*31
The Dark Knight Rises, 47
darkness, 203–5, 260*n*8; loss of, 205; sacred, 203; as suturing element, 84
data: recuperation, 170; whirlwind of, 173
Dean, Tacita, 17–21, 42
Death 24X a Second: Stillness and the Moving Image (Mulvey), 192–93
de Baecque, Antoine, 233*n*45
Debord, Guy, 90–91
Debray, Régis, 258*n*32
decentralization, 181–82
de-cinematization, 74
Deep Play, 119
deferred action, 138, 263
deformation, 227*n*68
De Gaetano, Roberto, 81
De Kuyper, Eric, 39
Deleuze, Gilles, 10, 29–30, 79–81, 87, 226*n*65
delivery, 50–53; fragments and, 60; relic and, 62
Delluc, Louis, 23–24, 55, 197
De Palma, Brian, 120
Derrida, Jacques, 263*n*41
desire to watch, 22
Desnos, Robert, 55
deterministic orientation, of media, 236*n*23
deterritorialization, 29–30, 237*n*44
De Toth, André, 116, 147
devices, 7; correct use of, 236*n*31; display, 12–13; image-capturing, 191; palm, 253*n*34; technological, 21, 52. *See also* mobile devices
dialectical images, 212–13
dialectical situations, 213
The Dictator, 47
didactic cinema, 111
Didi-Huberman, Georges, 121
digital imagery, 109–10
digital movies, 6
digital technology, 2, 134

digital television screens, 30
digital terrestrial television (DTT), 47
DIRECTV, 148
dispersion, 11, 124
displays: devices, 12–13; move towards, 168–69
dispositif, 78
dispositive, 233*n*1–234*n*1; as assemblage, 81; redefinition of, 80; subjectivity and, 79. *See also* cinematic dispositive
distraction, 148; consumption and, 74
distribution: directionality of, 173; film, 220*n*7; new forms of, 18–19; points, 73; of sensible, 124–27
Doane, Mary Ann, 135
documentaries, 19, 174
doing, 199–200; cognitive, 186; emotional, 187; expressive, 188; relational, 187, 191–92; sensory, 188–89; technological, 187; textual, 188
Dolby system, 106
domestication, 197
donna schermo (screen woman), 157
Doom, 145
doors, 159
downloading, 146
Dragon Inn, 177
Dreyer, Carl, 179–83
drives, dynamic of, 226*n*65
D3D, 117
DTT. *See* digital terrestrial television
Dubois, Philippe, 38, 88
DVDs, 9, 46, 185; Criterion Collection, 114; players, 2; rentals, 18; viewing, 192
DVR, 46

Eames, Charles, 161
Eames, Ray, 161
Edinburgh International Film Festival, 64
Edison Home Projecting Kinetoscope, 134
Egoyan, Atom, 179–84, 194
Eisenstein, Sergei, 23, 93, 116–17, 152–53, 214–15

Elite Home Theater Architects, 56
Ellis, John, 182
Elsaesser, Thomas, 117, 210, 251*n*19
elsewheres, 151–52
Emmy Awards, 100
emotional doing, 187
emotions, transporting, 225*n*57
encounters, 221*n*10
Entr' Acte, 159, 249*n*68
environments: adaptable, 69; ambiguity of, 133; arrangement of, 51 as component of assemblage, 82; bifurcation of, 135; of cinema, 133–37; cinematicity of, 139; distracting, 71; experiential, 53; media, 53; mediatized, 102; migration toward new, 198; new, 20–21; relocation of, 49–50; re-relocation and, 195; resonances in, 136; search for new, 175; teledynamic, 104. See also setting
envision, 172, 254*n*56
Enzensberger, Hans Magnus, 237*n*52
epiphany, 12, 159–60
Epstein, Jean, 21–22, 25–26, 115, 121, 158–59
event: film as, 199–200; public, 245*n*3
everyday life, 15
The Execution of Mary Queen of Scots, 55
expanded cinema, 91, 127, 240*n*3; circa 1970, 102–5; circa 2013, 105–10
Expanded Cinema (Youngblood), 102–5
expansion, 3–4, 11
experience, 4–5, 19–25, 29; back-to-the-cinema, 31, 33; of cinema-beyond-cinema, 31, 33; cinematographic, 56–57; classic filmic, 141–42; configuration of, 31–32; context and, 131; displacement of, 29; encounters and, 221*n*10; filmic, 56–57; integrated, 136–37; need for, 198; relocation of, 20. See also cinematic experience
Exploding Plastic Inevitable events, 91
exploration, 191
expressive doing, 188
extended cinema, 3
external, 231*n*25

externality, 54
Eye/Machine, 119

Facebook, 15, 167
fainting, of medium, 206–8
Family Leisure, 56
Fanchi, Mariagrazia, 74, 235*n*13
fans: activity, 258*n*33; grassroots production by, 106–7; intervention of, 101
Farocki, Harun, 119–20
Faure, Elie, 24, 159, 223*n*36
feature-film format, 19
feedback, 103–4, 108
Feldmann, Erich, 141–42, 149
festivals, 113
fetishism, 193
Figgis, Mike, 155–56
file sharing, 199
Film, 17, 42
film experimentation, 15
filmic experience (as opposed to cinematographic experience), 56–57
filmic séance, 23
Filmology movement, 24
films: characterization of, 81–82; computer, 104; cult, 188; distribution, 220*n*7; as events, 199–200; feedback between spectators and, 103–4; genre, 200–201; and installations, 17–18, 88, 91–92; intervening with, 88; meanings of, 181; re-enjoyment of, 226*n*67; relocation and, 47–48; watching, 180–84
film theory: experiential approach to, 24; retracing, 219*n*26; as social discourse, 220*n*34
filtering, 111
flaneurs, 145, 247*n*24
Flaubert, Gustave, 125
flows, 29
Flusser, Vilém, 171–72, 253*n*44, 254*n*53
Fluxus, 90
fog, 93
forums, 108
Fossi, Giovanni, 244*n*72

Index 285

Foucault, Michel, 12, 78, 80, 142–43, 163, 248n40
fragments, 59–62
frames, 158, 250n6
Frampton, Hollis, 204–5
Freeburg, Victor, 23–24, 158
Freud, Sigmund, 138, 263
Friedberg, Anne, 40, 211, 252n29
functional norms, 86
"Future Cinema," 3

galaxies, 16
Gaudreault, André, 208
Gault, Berys, 6
Gay, André, 22
gaze, 230n16, 256n9; mechanical, 253n39
Genital Panic, 91
genre films, 200–201
geography, of media, 124
Gerbi, Antonello, 21, 44, 64, 141, 149–50, 159–60, 203–5
Gilliam, Terry, 261n26
Giovannetti, Eugenio, 21, 222n16
The Girl with the Dragon Tattoo, 47
glance, 230n16, 256n9
The Glass House, 93
globalization, 126–27
Global Positioning System (GPS), 163–64
Godard, Jean-Luc, 1, 69, 179–83
Goodbye, Dragon Inn, 177
Google Earth, 169
GPS. *See* Global Positioning System
grassroots practices, 88–89, 123, 238n57
grassroots production, 106–7
Gray, Jonathan, 107
great parataxis, 125–26
Greenaway, Peter, 3
Greengrass, Paul, 123
GRiDPad, 253n35
Gropius, Walter, 93
Groys, Boris, 138
Guardian, 17, 187
Guattari, Felix, 29–30, 80–81, 226n65
Gulliverization, 136
Gunning, Tom, 110, 150, 219n26

Hagener, Malte, 251n19
Haggis, Paul, 127–28
Hall, Stuart, 145
Hansen, Mark B. N., 20
Hansen, Miriam, 39
Harryhausen, Ray, 261n26
HBO, 50
Hearsay of the Soul, 96–97
Hellman, Monte, 1
here, 151–52
Herzog, Werner, 1, 96–97, 174
heterochrony, 143
heterogeneity, 139–41
heterotopias, 12, 142–44, 151, 248n40
hieroglyphs, 66
Higgins, Charlotte, 17
high definition, 11, 115, 117–21; poor images in, 123
Hollywood cinema, 122
holographic movies, 105
homage, 210
home cinema, 94
Home Cinema Modules, 261n25
homeless, 255n62
home pages, 165
home theaters, 35–36, 56; aestheticization and, 136–37; screens, 58
House of Wax, 116, 147
Hugo, 210, 261n26
Huhtamo, Erkki, 135–36
Hulu, 18
humankind, 223n36
Hurlements en faveur de Sade, 90–91
hypertext, 181, 255n4
hypertopias, 11–12, 131; relocated cinema and, 144; roots of, 148–50; transition to, 142–44
hypertrophy of narcissism, 74

Ice Age: Continental Drift, 47
icon, 9; cinema as, 61–63; cinephilia and, 64–65; Bizantyne debate on, 62–63
idem-identity, 8
identification, 209, 247n36
identity, 8; of cinema, 15; screens and, 132

286 *Index*

ideological effects, 76
illusion machine, 121
image-capturing devices, 191
images: albums, 191; dialectical, 212, 262n37; filmic, 101, 115, 227n69; flashing, 212; history of, 254n53; intercepted, 176–77; localizing, 175; as opposed to visual, 242n31; perceptual realistic, 219n21; poor, 118, 123; screened, 11; social, 33, 85; technical, 172–73
The Imaginery Signifier (Metz), 77
imagination, 23, 33–34, 172
imagined audiences, 73
imagined public, 73
IMAX, 4, 106, 116; screens, 57
IMDB, 114
imperfection, 40
Inception, 176–77
"In Defense of the Poor Image" (Steyerl), 118, 217n5
indexicality, of cinema, 110
inexperience, 34
influences, remote, 210
information, circulation of, 170
"Iniziazione alle delizie del cinema" ("Initiation to the Delights of Cinema", Gerbi), 149, 203-5
innervation, 237n53–238n53
installations, 17-18, 88, 91-2; multiscreen, 161
instances, 83
institution, need for, 197–98
intensity, 115
intermedia theater, 104
Internet, 15, 19; virtual spaces in, 145–46
Internet protocol television (IPTV), 47
In the Mouth of Madness, 200–201
In the Valley of Elah, 127–28
Into the Universe of Technical Images (Flusser), 171–72
iPad, 37, 161
iPhone, 7, 234n4
ipse-identity, 8
IPTV. *See* Internet protocol television

Jacobs, Carol, 255n3
Jenkins, Henry, 106, 108
Jones, Jesse, 134
Jurassic Park, 37

Kalomirakis, Theo, 61, 232n40
Keaton, Buster, 249n68
Khlebnikov, Velimir, 93
Kindle, 161
kinetic (as opposed to cinematic), 110–12
Kinetoscope, 55, 135
Kittler, Friedrich, 5
Klinger, Barbara, 134, 136–37
Kodak, 17
Kracauer, Siegfried, 24, 54, 231n25, 255n62
Krauss, Rosalind, 20, 78
Kubrick, Stanley, 262n27

Lambie, Ryan, 246n20
Lang, Fritz, 134
Lasswell, Harold, 170
Latour, Bruno, 87
Lefebvre, Henri, 132
Le Grice, Malcolm, 91
Lemaître, Maurice, 91
Levi, Pavle, 3
Levin, Thomas Y., 247n16
Lévi-Strauss, Claude, 190
L'Herbier, Marcel, 222n16, 225n57
light: cinema, 106, 240n13; projections in full, 260n12; regimes of, 206
Liman, Doug, 123
Lindsay, Vachel, 64, 66, 224n39
lines of breaking, 87
locality, 29
localization, 175
Logan, John, 261n26
The Lord of the Rings, 187
low definition, 117–21
Lucas, George, 99
Lukács, Georg, 23
Lumières' Cinématographe, 135
Lynch, David, 7

Index 287

mainstream cinema, 111
manipulation, 191
Mann, Delbert, 118
Manovich, Lev, 110, 145–46, 162
maps, 133
Mariani dell'Anguillara, Camillio, 150
Marion, Philippe, 208
marketing, do-it-yourself, 190
Marty, 118
Masculin Féminin. 15 faits precis, 67–69, 70
material conditions, 31
The Matrix, 176–77
maturation, 212
McCall, Anthony, 91
McLuhan, Marshall, 5, 16, 74, 114, 118–19, 160, 170, 251n24
McPherson, Tara, 193
mechanical art, 21
mechanical gaze, 253n39
media: aggregate, 171; cinema interconnected with, 104; convergence of, 198; cool, 114, 244n78; as cultural form, 19; definition of, 19–20; delivery, 53; deterministic orientation of, 236n23; environment, 53; expansion of, 2; fainting of, 206–8; geography of, 124; hot, 114–17, 244n78; hybrid, 119; mobile, 226n66; new, 110, 237n52; in new environment, 20–21; permanence of, 29; specificity of, 27; as support, 19; system of sensations in, 28; theories, 15; transformation of, 170–73; transporting, 52–53; two faces of, 19–20. *See also* new media
media façades, 30, 161
mediatized spectator, 191–92
Méliès, Georges, 261n26
memory, 33
metonymy, 60
Metropolis, 177
Metz, Christian, 77, 109
Microsoft Office, 53
Minitel, 161
Minority Report, 176–77
mirrors, 158–59, 251n18
Mission: Impossible - Ghost Protocol, 47

Mitchell, W. J. T., 20
mobile devices, 36; space and, 131; strategies of repair and, 71. *See also* palm devices
mobile home, 71–72
mobility, 258n34
modalities, 181
modernity, 125
Moholy-Nagy, László, 92–93, 229n3
MOMA. *See* Museum of Modern Art
monitoring, 182
monitors, 163
Moon Light Festival, 18
Moore, Michael, 174
Morin, Edgar, 6, 24, 83–84, 167
Morris, Errol, 174
motherland, return to, 196–200
The Motion Picture, 1914-1934, 54–55
movie camera, 76, 121
The Movie Channel, 50
moviegoers, 247n35. *See also* spectators
movie theaters, 9, 183; architecture of, 54; cinema outside, 45–47; digital, 218n14; domestication of, 137; films as events in, 199–200; growth of, 3; as heterotopia, 144; hypertopia and, 12; palaces, 61; spectators in, 141–42; 3-D, 218n14; transition of, 230n14
movie watching: on airplanes, 36–37; with audiences, 55; linearity of, 54; mobile, 36; outdoors, 35; as performance, 13, 186–89; progressiveness of, 54
"Moving Away from the Index: Cinema and the Impression of Reality" (Gunning), 219n26
mubi.com, 36–37
multitasking, 30–31
Mulvey, Laura, 138, 192–93
Muriel, 128
Museo del Novecento, 129–30
Museum of Modern Art (MOMA), 54–55
museums, 51, 87–88, 113
musical clips, 19
Myrick, Daniel, 121
Myst, 145

288 *Index*

Nachträglichkeit (afterwardness), 263
narcissism, hypertrophy of, 74
narration, 173; cinematic, 110; self, 192
NBC Saturday Night at the Movies, 50, 230*n*17
needs: for cinema, 84; symbolic, 82–83
negotiation, 83–84, 237*n*45, 256*n*15
Netflix, 18
network, of social discourses, 181
networking, 162
"New Cinephilia," 64
new media, 237*n*52; cinematic narration in, 110
newspaper, 28
New York World's Fair, 161, 231*n*22
New Zealand Film Archive, 113
Nintendo Wii, 53
Nolan, Christopher, 176
no-longer cinema, 95, 239*n*78
non-theatrical exhibition sites, 45
notion clé, 237*n*50

occurrence (cinema as), 140, 152
Ode to the Dawn of Man, 96
Odin, Roger, 94, 234*n*2
"Of Other Spaces" (Foucault), 142–44, 248*n*40
oikonomia (administration of God), 78
once-again cinema, 96
on-demand subscriptions, 46
openness, 152
The Origin of German Tragic Drama (Benjamin), 40–41
origins, 40–42, 263*n*41

Paik, Nam June, 90–91, 161
Palazzo Reale, 129–30
palm devices, 253*n*34
Panopticon, 163
panoramic format, 93
Pantages Theater, 61
Panteo, Tullio, 158
Papini, Giovanni, 22, 115, 149, 158–59, 204
paratexts, 107
Paris qui dort, 177
partitioning, 107–8
La passion de Jeanne d'Arc, 179–83

Pathé Baby, 94, 134
pay-to-view on-demand, 46
Pedullà, Gabriele, 260*n*13
percussive, 148
performance, 13, 257*n*16; art, 90; attendance and, 185–86, 199–200
performers, 189–90
persistence, of cinema, 4, 8, 38–40, 211
Persona, 159
personality, 208, 261*n*23
Phenakistoscope, 135
photograms, 76
photography, 65
Photoshop, 169
Piazza Duomo, 129–31
Picabia, Francis, 249*n*68
pictorial composition, 158
piracy, 47
Pirandello, Luigi, 25
Pirates of the Caribbean, 108
The Politics of Aesthetics: The Distribution of the Sensible (Rancière), 124–27
poor images, 118; in high definition, 123
Poppe, Emile, 39
portals, 175–77
post-cinema, 39–40
potential, 208
Prince, Stephen, 6, 110
printing press, 21
Pro-Am, 189
production: consumption and, 111; grassroots, 106–7; tracking, 114
produsage, 189
profanation, 79, 87–90; grassroots practices and, 238*n*57
projection, 21; in full light, 260*n*12; simultaneous, 229*n*3
projection-identification, 247*n*36
projective gestures, 39
projectors, 76; availability of, 225*n*58; domestic, 94; on planes, 37; portable, 27
Project X, 47
promemoria, 113, 164
Prometheus, 123
propaganda cinema, 111
proximity, 115

public events, 245*n*3
public opinion, 224*n*37
public spaces, 57–58, 176; monumentalization of, 137
public sphere, 15
Pugh, Casey, 100
Putrih, Tobias, 134

Quaresima, Leonardo, 262*n*29

radio, 119, 224*n*38
Radio City Movie Hall, 61
Rancière, Jacques, 124–27
rarefaction, 126
ratification, 32, 109
realism, tradition of, 173
reality: augmented, 165–66; effect, 121, 243*n*66; fragmentation of, 171–72; reproduced, 222*n*23
rearticulation, 8
reception, 174, 257*n*16
recognition: of cinema, 33, 38–40; creativity of, 39; paradox of, 206, 208–11; of personality, 261*n*23; point of reference and, 41; practices of, 32–34
re-consecration, 90
recursivity, 85
Redacted, 120
Redbox, 18
re-enchantments, 87–90
"Reflections on the Seventh Art," (Canudo), 223*n*26, 224*n*39
Reijseger, Ernst, 96
reinvention of cinema, 213–15
relational doing, 187, 191–92
relic, 9; cinema as, 61–63; cinephilia and, 64–65
relocated cinema, 28–30; authenticity of, 63–66; hypertopias and, 144
relocation, 8–9, 162; alteration during, 30–32; domestication and, 197; of environment, 49–50; of experience, 20; films and, 47–48; paths of, 47–50; re-relocation and, 194–98
remain-cinema, 112–14
remediation, 14, 28–29

The Remembered Film (Burgin), 140
remixes, 106–7
remote influences, 210
Renan, Sheldon, 102
repair, strategies of, 70–74, 89–90
reproduction, 26–27
re-relocation, 194–98
Resnais, Alain, 128
resonances, 136
retailers, 51
retakes, 106–7
reterritorialization, 29–30, 237*n*44
retrospective gestures, 39
Ricoeur, Paul, 8, 219*n*30
ritual, 35
Rocky Horror Picture Show, 88, 188
Rodowick, David, 110
Romains, Jules, 204
Room at the Top, 118
Royoux, Jean-Christophe, 218*n*9
Ryang, Robert, 107

Sabatier, Roland, 91
Sampietro, Sara, 234*n*4
Sanchez, Eduardo, 121
Sander, Philip, 147
Sartre, Jean-Paul, 25
Scaglione, Emilio, 204
Schneemann, Carolee, 104
Scipione l'Africano, 150
Scorsese, Martin, 210, 261*n*26
Scott, Ridley, 52, 123
scrapbooks, 166
screenic (as opposed to cinematic), 110–12
screens: as altarpiece, 160; as blackboard, 164; cinematic, 157–60; classes of, 250*n*8; concave hemispherical, 40; diffusion of, 136; for display, 12–13; as displays, 168–69; epiphany and, 12–13; evolution of, 12–13; expansion of, 161; fog as, 93; formats, 93; as frame, 158; home theater, 58; identity and, 132; IMAX, 57; as mirror, 158–59; new metaphors for, 162–67; as monitor, 163; in non-theatrical exhibition sites, 45; at

Piazza Duomo, 129–31; portable, 57; rearticulation of space and, 132–33; reconfiguration of, 91; reflective, 4; rules of behavior and, 133; scale of, 135; as scrapbook, 166; small-scale, 138–39; split, 249n1; as suturing element, 84; tablets, 30, 161; technology, 161–62; television compared to movie, 160; touch, 168; transformation of, 156; types of, 30; urban public, 57–58; as wall, 166–67; as window, 157–58. *See also specific screen types*
second birth, 261n24
Second Council of Nicaea, 63
seeing-as, 227n69
Segers, Hercules, 96
self-consciousness, 34
self-construction, 257n20
self-narration, 192
semi-audiences, 138
sensible, distribution of, 124–27
sensorial dimension, 124–27
sensory doing, 188–89
Sensory Reality, 25–28
Serner, Walter, 22
setting, 50–53; icon and, 62–63; as substitute, 60–61. *See also* environments
Sharits, Paul, 91
Shaw, Jeffrey, 3
Sherlock Holmes: A Game of Shadows, 47
Sherlock Junior, 249n68
The Shining, 107
Shoot (Pirandello), 25
short forms, 174
Showtime, 50
Singer, Ben, 134, 225n58
Sirk, Douglas, 134
sixth art, 63–64
Sloterdijk, Peter, 254n57–255n57
Smith, Damon, 64
Snow, Michael, 103
social discourses: film theories as, 220n34; network of, 181
social image, 33, 85

social networks, 166–67; spectators and, 194
social strategies, 112–13
Somaini, Antonio, 207
Sontag, Susan, 2
La sortie des usines, 136
spaces: contrapositions and, 131; of control, 136; darkness of, 84; dedicated, 139; public, 57–58, 137, 176; rearticulation of, 132–33; urban, 144; value of, 130–31; virtual, 145–46; of vision, 132–33. *See also* environments.
specificity, 14
spectators, 13; actions of, 185–86; as component of assemblage, 83, 86–87; as *bricoleurs*, 189–90; in distracting environments, 71; existence of, 192–94; feedback between films and, 103–4; as flaneurs, 247n24; itinerary, 234n10–235n10; mediatized, 191–92; movie cameras and, 76; in movie theaters, 141–42; options for, 185–86; pensive, 192–93; percussive effect on, 249n61; possessive, 192; social networks and, 194; state of, 72–73; watching films, 180–84; Web, 258n41
spectatorship, 77; new regimes of, 137–39; as attendance, 185–86; as performance, 186–89
Spherical Theater, 93
Spiegel, Lynn, 252n26
Spielberg, Steven, 1–2, 176
spreadability, 162
standardization, 86
Star Trek, 88–89
Star Wars, 88–89, 188
Star Wars Uncut, 99–102
stereoscopic vision, 77–78, 116–17. *See also* 3-D
Steyerl, Hito, 118, 217n5
Strange Days, 104
strategies of repair, 70–74, 89–90
Straw, Will, 232n35
streaming, growth of, 46–47
subjectivity, dispositives and, 79
substitutes, 59–61

Index 291

subversion, 123
Sunset Cinema, 134
superficiality, 54
survival, 213–15
Šušteršič, Apolonija, 134
suture, 84; suturing elements, 84
symbolic needs, 82–83
synaesthetic cinema, 103
synesthesia, 126
system of sensations, 28

tablets, 253*n*35; screens, 30, 161
tactility, 188–89
Tahrir Square, 18, 172
Tandy Zoomer, 253*n*34
Tate Modern, 17
Tati, Jacques, 26
Taylor, Kate, 64
Techniques of the Observer (Crary), 77
technological doing, 187
technology, 21–22, 69; aesthetics fused with, 103; in assemblage cinema, 83, 85–86; digital, 2, 134; electric, 251*n*24; new, 106; renouncing, 19; screen, 161–62. *See also* digital technology
Teige, Karel, 24, 94
teledynamic environments, 104
Telegraph, 262*n*27
telephone, 224*n*38
television, 46, 251*n*25–252*n*25; delivery to, 50; screens, 160; series, 19; space and, 131; 3-D, 148
The Terminator, 262*n*27
territoriality, 196–97
territorialization, 259*n*44
textual doing, 188
theme parks, 108
third machine, 109
Third World cinema, 122
3-D, 106, 147–48; adoption of, 122; movie theaters, 218*n*14; reemergence of, 116–17; signals, 11; television, 148
Timecode, 155–56, 176
TiVo, 46
Toddi, Enrico, 93
topography, of cinema, 196
Tornatore, Giuseppe, 44–45

torrentfreak.com, 47
Tortajada, Maria, 75, 81
Total Theater, 93
touch screens, 168
trailers: fake, 106–7; honest, 123
transmedia storytelling, 108
transmission, 26
tributes, 113
A Trip to the Moon, 261*n*26
true stories, 174
truth, 231*n*25; effect, 121; need for, 174
Tryon, Chuck, 51, 108
Tsai Ming-Liang, 177
Tumblr, 166
Turner, Ted, 50
Turvey, Malcolm, 227*n*69
TV Cello, 161
Twain, Mark, 145
12 Angry Films, 134
24, 250*n*2
21 Jump Street, 47
The Twilight Saga Breaking Dawn Part 1, 47
Twitter, 167
2001: A Space Odyssey, 262*n*27

Understanding Media (McLuhan), 114–15, 118–19, 244*n*78, 251*n*24
urban spaces, 144
Usai, Paolo Cherchi, 217*n*5
U2, 176

Vachel, Lindsay, 66, 224*n*39
Valery, Paul, 26–27
Valie Export, 91
valorization, 109
Vancheri, Luc, 3
VanDerBeek, Stan, 91
van der Pol, Bik, 134
VCR, 51, 252*n*29
Venetian, Atmospheric, 134
Venice Film Festival, 113
Vertov, Dziga, 23
VHS, 51, 230*n*17
Video-Drome, 91
video games, 53, 165
videographic cinema, 105

videosphere, 258n32
video viewing, 192
video wall, 161
viewing spaces, 12
vision: cinematographic, 31; darkness of space of, 84; mobile, 73; object of, 73–74; perspectival, 77; practices of, 186–89; semi-cinematic, 139; semi-continuous, 138; semi-private, 138; space of, 132–33; stereoscopic, 77–78, 116–17
visuals, 242n31
Vitascope, 135
Vivre sa vie, 179–83
Voci, Paola, 240n13, 254n46

Voyage on the North Sea: Art in the Age of the Post-Medium Condition (Krauss), 78
voyeurism, 193

Wachowski, Andy, 176
Wachowski, Larry, 176
Wadsworth Atheneum, 54–55
walls, 166
Warhol, Andy, 91, 161, 252n28
Wasson, Haidee, 57, 231n26

"What Is an apparatus?" (Agamben), 78–79
"What Is a Dispositif?" (Deleuze), 79–81
Web 2.0, 166
Web harvesting, 171
Web sites, 108, 114, 165
Web spectators, 258n41
Weibel, Peter, 3
Weininger, Andor, 93
Wenders, Wim, 1
Westernisation, 242n42
Whitney Museum Biennial, 96–97
Williams, Raymond, 170, 236n23
windows, 157–58
workability, 133
"The Work of Art in the Age of Mechanical Reproduction" (Benjamin), 26, 148–49, 211–13
WTCG-TV, 50

Youngblood, Gene, 102–5, 240n78
YouTube, 15, 18, 88, 174, 192

Zen for Film, 90–91
Zero Dark Thirty, 120
ZooTV Tour, 176

FILM AND CULTURE
A series of Columbia University Press
Edited by John Belton

What Made Pistachio Nuts? Early Sound Comedy and the Vaudeville Aesthetic
Henry Jenkins

Showstoppers: Busby Berkeley and the Tradition of Spectacle
Martin Rubin

Projections of War: Hollywood, American Culture, and World War II
Thomas Doherty

Laughing Screaming: Modern Hollywood Horror and Comedy
William Paul

Laughing Hysterically: American Screen Comedy of the 1950s
Ed Sikov

Primitive Passions: Visuality, Sexuality, Ethnography, and Contemporary Chinese Cinema
Rey Chow

The Cinema of Max Ophuls: Magisterial Vision and the Figure of Woman
Susan M. White

Black Women as Cultural Readers
Jacqueline Bobo

Picturing Japaneseness: Monumental Style, National Identity, Japanese Film
Darrell William Davis

Attack of the Leading Ladies: Gender, Sexuality, and Spectatorship in Classic Horror Cinema
Rhona J. Berenstein

This Mad Masquerade: Stardom and Masculinity in the Jazz Age
Gaylyn Studlar

Sexual Politics and Narrative Film: Hollywood and Beyond
Robin Wood

The Sounds of Commerce: Marketing Popular Film Music
Jeff Smith

Orson Welles, Shakespeare, and Popular Culture
Michael Anderegg

Pre-Code Hollywood: Sex, Immorality, and Insurrection in American Cinema, 1930–1934
Thomas Doherty

Sound Technology and the American Cinema: Perception, Representation, Modernity
James Lastra

Melodrama and Modernity: Early Sensational Cinema and Its Contexts
Ben Singer

Wondrous Difference: Cinema, Anthropology, and Turn-of-the-Century Visual Culture
Alison Griffiths

Hearst Over Hollywood: Power, Passion, and Propaganda in the Movies
Louis Pizzitola

Masculine Interests: Homoerotics in Hollywood Film
Robert Lang

Special Effects: Still in Search of Wonder
Michele Pierson

Designing Women: Cinema, Art Deco, and the Female Form
Lucy Fischer

Cold War, Cool Medium: Television, McCarthyism, and American Culture
Thomas Doherty

Katharine Hepburn: Star as Feminist
Andrew Britton

Silent Film Sound
Rick Altman

Home in Hollywood: The Imaginary Geography of Hollywood
Elisabeth Bronfen

Hollywood and the Culture Elite: How the Movies Became American
Peter Decherney

Taiwan Film Directors: A Treasure Island
Emilie Yueh-yu Yeh and Darrell William Davis

Shocking Representation: Historical Trauma, National Cinema, and the Modern Horror Film
Adam Lowenstein

China on Screen: Cinema and Nation
Chris Berry and Mary Farquhar

The New European Cinema: Redrawing the Map
Rosalind Galt

George Gallup in Hollywood
Susan Ohmer

Electric Sounds: Technological Change and the Rise of Corporate Mass Media
Steve J. Wurtzler

The Impossible David Lynch
Todd McGowan

Sentimental Fabulations, Contemporary Chinese Films: Attachment in the Age of Global Visibility
Rey Chow

Hitchcock's Romantic Irony
Richard Allen

Intelligence Work: The Politics of American Documentary
Jonathan Kahana

Eye of the Century: Film, Experience, Modernity
Francesco Casetti

Shivers Down Your Spine: Cinema, Museums, and the Immersive View
Alison Griffiths

Weimar Cinema: An Essential Guide to Classic Films of the Era
Edited by Noah Isenberg

African Film and Literature: Adapting Violence to the Screen
Lindiwe Dovey

Film, A Sound Art
Michel Chion

Film Studies: An Introduction
Ed Sikov

Hollywood Lighting from the Silent Era to Film Noir
Patrick Keating

Levinas and the Cinema of Redemption: Time, Ethics, and the Feminine
Sam B. Girgus
Counter-Archive: Film, the Everyday, and Albert Kahn's Archives de la Planète
Paula Amad
Indie: An American Film Culture
Michael Z. Newman
Pretty: Film and the Decorative Image
Rosalind Galt
Film and Stereotype: A Challenge for Cinema and Theory
Jörg Schweinitz
Chinese Women's Cinema: Transnational Contexts
Edited by Lingzhen Wang
Hideous Progeny: Disability, Eugenics, and Classic Horror Cinema
Angela M. Smith
Hollywood's Copyright Wars: From Edison to the Internet
Peter Decherney
Electric Dreamland: Amusement Parks, Movies, and American Modernity
Lauren Rabinovitz
Where Film Meets Philosophy: Godard, Resnais, and Experiments in Cinematic Thinking
Hunter Vaughan
The Utopia of Film: Cinema and Its Futures in Godard, Kluge, and Tahimik
Christopher Pavsek
Hollywood and Hitler, 1933–1939
Thomas Doherty
Cinematic Appeals: The Experience of New Movie Technologies
Ariel Rogers
Continental Strangers: German Exile Cinema, 1933–1951
Gerd Gemünden
Deathwatch: American Film, Technology, and the End of Life
C. Scott Combs
After the Silents: Hollywood Film Music in the Early Sound Era, 1926–1934
Michael Slowik
"It's the Pictures That Got Small": Charles Brackett on Billy Wilder and Hollywood's Golden Age
Edited by Anthony Slide
Plastic Reality: Special Effects, Technology, and the Emergence of 1970s Blockbuster Aesthetics
Julie A. Turnock
Maya Deren: Incomplete Control
Sarah Keller